P9-DWE-024

Preserving What Is Valued

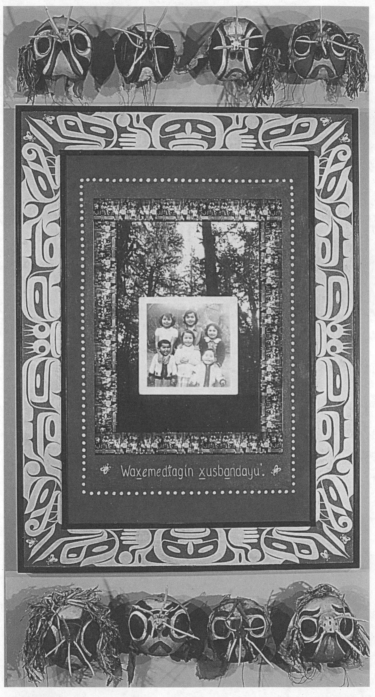

Waxemedlagin xusbandayu' (Even though I am the last one, I still count), by Marianne Nicolson. See Note about the Cover, p. xi.

Miriam Clavir

Preserving What Is Valued
Museums, Conservation,
and First Nations

*A UBC Museum of Anthropology
Research Publication*

UBCPress · Vancouver · Toronto

This book is printed in Canada on acid-free paper that is 100% ancient-forest free (100% post-consumer recycled), processed chlorine free, and printed with vegetable-based, low-VOC inks.

National Library of Canada Cataloguing in Publication Data

Clavir, Miriam, 1948-
 Preserving what is valued

 (UBC Museum of Anthropology research publication)
 Includes bibliographical references and index.
 ISBN 0-7748-0860-8 (bound); 0-7748-0861-6 (pbk.)

 1. Indians of North America – British Columbia – Antiquities – Collection and preservation. 2. Cultural property – Conservation and restauration. 3. Anthropological museums and collections. 4. Museums – Social aspects. 5. Museum conservation methods. I. Title.

E78.B9C49 2002 06'.089'970074 C2001-911420-6

This book has been published with the help of a grant from the Humanities and Social Sciences Federation of Canada, using funds provided by the Social Sciences and Humanities Research Council of Canada, and the help of the Museum of Anthropology.

UBC Press acknowledges the financial support of the Government of Canada through the Book Publishing Industry Development Program (BPIDP) for our publishing activities.

Canadä

We also gratefully acknowledge the support of the Canada Council for the Arts for our publishing program, as well as the support of the British Columbia Arts Council.

UBC Press
The University of British Columbia
2029 West Mall, Vancouver, BC V6T 1Z2
Ph: (604) 822-5959 Fax: (604) 822-6083
E-mail: info@ubcpress.ca
www.ubcpress.ca

For John Donlan, who wrote:

> *Some currents of our inner ocean*
> *Follow the first hand that set them moving.*

("Wear," in Green Man*)*

Contents

Illustrations, Figures, and Tables

Figures

Tables

Note about the Cover

Waxemedlagin xusbandayu'
(Even though I am the last one, I still count)

In the early 1960s my grandfather, Charles Eaton Willie, sold these eight bumblebee masks. They became the property of the Museum of Anthropology. In 1998 my Uncle Ernest Peter Willie hosted a potlatch in Kingcome Inlet. As part of the ceremonies, replicas of these eight masks were created by my Uncle Don Willie and danced by the young children of our families.

The Bumblebee dance is a children's dance. Amongst the Musgamagw Dzawada'enuxw, it is often one of the first dances a child participates in during the Winter Ceremonial. A father and mother bee lead progressively smaller bees out onto the dance floor one by one. When the children are led back into their "beehive" at the end of the dance, one child is discovered missing. The father bee circles the floor four times searching for this lost child. On the fourth round the child is found hidden amongst the spectators and is led home.

"Even though I am the last one, I still count" is part of a children's rhyme, and I have used it in reference to this dance. The central photograph depicts my aunts and uncles as children. My Uncle Don Willie, who carved the replica masks in 1998, is the young boy on the left. Two sisiutl (double-headed sea serpents), four wolves, and two parent bees form the painted borders.

Though my grandfather was forced to sell these masks in the early 1960s due to social/economic circumstances, I created this piece to recognize that the rights and privileges that they embodied are still active and integral to the Musgamagw Dzawada'enuxw people. He sold the masks at a time when the future of our traditional culture was in doubt. It is with great pride that I am able to look back and know that each generation of my family has participated in this dance, and feel assured that the continuance of its practice is now without doubt. There are four keepers of this dance; the member of our family who currently holds this place is my cousin Charlene Dawson, who inherited it from her mother Florence Amy Willie.

—Marianne Nicolson, Kwakwaka'wakw

Preface

This book is the result of a significant dilemma I faced as a conservator at the Museum of Anthropology (MOA) at the University of British Columbia. In the early 1980s, a few years after I began working there, I was asked to agree to the loan of objects catalogued into the museum's collection for use by a First Nations community member. More requests soon followed. Most of the material was being loaned back to the contemporary artist who had created it; nonetheless, my obligation as a professional conservator was to serve as an advocate for the preservation of cultural property. Use often results in wear and loss to the original physical object, and I saw the loaning of museum collections for uses in dances and ceremonial events as being in opposition to the professional codes of ethics adhered to by conservators. Removing weavings and masks, for example, from the museum environment so that they may be worn and danced during ceremonies involves the potential risk of damaging the object. The professional dilemma of how to resolve the apparently opposing needs of First Nations members and my responsibility as a conservator was also a personal dilemma: was I ready either to be drummed out of MOA for not signing the loan forms or to be drummed out of my profession for willingly putting museum objects at physical risk?

At the time, I saw that preserving the physical integrity of an object and preserving its conceptual integrity were very much in conflict. In attempting to resolve this conflict, I began to think about the meaning of "preservation," the meaning of "use," the meaning of "object," and the meaning of the phrase "integrity of the object." Conservators believe that their values are consistent with the best methods of preservation. How does this fit with the kind of preservation represented by dancing a mask (i.e., cultural preservation)? When I think of the materials housed in museums as "material culture" or "collections" or "objects," what am I telling their originators

about their heritage? What role do museums have or want, especially today, in "preservation"?

Working to resolve my dilemma before I was drummed out of anything led to more research, and, in 1998, to a doctorate entitled "Preserving What Is Valued: An Analysis of Museum Conservation and First Nations Perspectives." This dissertation was written for the Department of Museum Studies, University of Leicester, England, and it forms the basis of this book.

I wrote this book for people interested in conservation, museum studies, and the diverse areas involving First Nations perspectives. The most fundamental part of it, however, I did not write; I only recorded. The information First Nations people shared about their own thoughts on preservation is at the heart of this publication. I sincerely hope that this book can serve as a means to present what they told me about preservation and museums.

Acknowledgments

My grateful thanks are given first and foremost to the First Nations people who contributed so much knowledge and who were willing to share their insights with me. A list of their names can be found in Appendix A.

I would also like to honour the memory of two people whose work and vision remain an inspiration to all of us who participate in the changing relationships between museums and First Nations. The first is the late Mina McKenzie of Palmerston North, Manawatu, New Zealand. She is of Rangitane descent, and her wisdom, remarkable presence, generosity, and commitment contributed so much to her people and country, to the presence of Maori perspectives in numerous aspects of heritage preservation and museums, and to those from around the world (including myself) who were fortunate enough to spend time with her. I am also grateful to have met the late Deborah Doxtator, a Mohawk woman whose keen insights and intelligent writing provide an underpinning to several of the discussions in this book.

I would also like to honour the memory of Barbara Whitney Keyser, a paintings conservator who made tremedous and unique intellectual contributions to her field.

Special thanks are given to Jean Wilson and Darcy Cullen of UBC Press for their excellent editorial advice. I very gratefully acknowledge John Donlan and Perry Millar for their wonderful assistance in both editorial and reference capacities. I am indebted to Don Bain for his outstanding compilation of web resources. Peter Macnair's comments on the book and his generosity in sharing his own knowledge and experience have been invaluable. I greatly appreciate the transcription work provided by Chris Turnbull and Laura Beresford. I am especially indebted to Marianne Nicolson, who allowed me to use her artwork on the cover of this book.

I would also like to thank the many people who were willing to discuss and debate the ideas that evolved over the course of writing this book. In the text the reader will find references to conservators in North America and in England, to academics at the University of British Columbia in

Canada, the University of Leicester in England, and elsewhere, to museum professionals in several countries, and to First Nations people in all of these (and other) fields, all of whom contributed to the shaping and reshaping of this work. I thank you all, as well as friends and colleagues who contributed to my understanding through their work or our conversations.

I gratefully acknowledge the Canadian Museums Association, the British Columbia Arts Council, the Cultural Services Branch of the Provincial Government of British Columbia, and the University of British Columbia Museum of Anthropology for their financial support.

I am very grateful for the great amount of help I have received during the conception and completion of this book. Some of that help was in the form of interviews and recorded conversations, and in all citations I have tried to represent accurately what people said and agreed to have published. Where citations are based on notes, on material handed out at conferences, or on other unpublished sources, I have tried, wherever possible, to verify the statements with those quoted. Any errors or omissions are, of course, entirely my own responsibility, and I would be glad to be advised of them.

Introduction

Most people would agree that it is important to preserve heritage, but what exactly is being preserved, and how does one determine the best way to do it? *Preserving What Is Valued* compares the perspectives of two groups of people for whom heritage preservation is fundamental: (1) museum conservators and (2) a group of First Nations individuals, mainly from British Columbia, Canada.[1] I hope that an exploration of how each of these groups regards preservation will give the reader a deeper understanding of its meaning as well as further knowledge of a contested and continually evolving area – the changing relationship between First Nations and museums.

My starting point in discussing the preservation of what is valued is a phrase used by Nancy-Marie Mithlo (Mitchell), a Native American cultural anthropologist. She described "junctures of ... impasses" as having the potential to provide illuminating information on cultural negotiations (Mitchell 1992, 10) *(Mitchell/Mithlo: Chiricahua Apache)*. Conservators approach preserving the cultural significance of a heritage object by preserving its physical integrity (which they can "read" through scientific evidence) and its aesthetic, historic, and conceptual integrity (which is interpreted through scholarship in related disciplines as well as "read" through physical evidence). Many First Nations, on the other hand, view the preservation of the cultural significance of a heritage object as inseparable from the preservation of traditions, oral history, community, and identity as First Nations; preservation is about people, and objects have their role in cultural preservation. The "juncture of impasses" that prompted me to write this book concerned whether or not it is possible to balance the preservation of the physical integrity of First Nations collections in museums with the preservation of their conceptual integrity – an integrity that derives from the living culture from which the objects originate.

1 "First Nations" is one of the terms used in Canada by and for indigenous or Aboriginal peoples, and I will use it here. I use it interchangeably as a noun and as an adjective, as is current practice with the word "Canadian."

In the last decade, in British Columbia and in other areas where issues of Aboriginal land (and other) rights are actively being negotiated and settled, traditional museum norms and practice, including conservation, have been called into question. "An object's acquisition by a museum, and the museum's subsequent efforts to preserve it are, indeed, in some instances, looked upon by the originating peoples as a perversion of the natural order of things" (Moses 1995, 18) *(Moses: Delaware/Mohawk)*. Furthermore, "in some situations the relationship between museums and indigenous peoples is very complex, as there is a lack of trust, insight, and knowledge on both sides relating to museum policies, cultural beliefs, and the significance of the preservation of objects from a living culture" (Harris 1993, 31) *(Harris: Cayuga)*. However, from the point of view of professional conservators, "to make decisions it is necessary to know exactly what the object represents" (Jedrzejewska 1976, 6). Preserving conceptual integrity or cultural significance is the ideal and ultimate goal of conservation; for example, for many years the Canadian code of ethics for conservators stated: "The purpose of conservation is to study, record, retain, and restore the culturally significant qualities of the object with the least possible intervention" (IIC-CG and CAPC 1989, 18). It is only in the year 2000 that this definition was amended to "culturally significant qualities of the cultural property as embodied in its physical and chemical nature." This makes clear that it is the physical aspects of an object that concern the conservator while other aspects, such as the spiritual, belong to the culture from which the object originates.[2] (See Appendix B, which contains excerpts from the conservation codes of ethics of several countries.)

Preserving What Is Valued begins with an examination of the professional field of conservation; I explore the history of conservation as well as the values and beliefs within which it is embedded. In particular, I look at the powerful paradigms of science, professionalization, and museums. With regard to the latter, I examine the context of North American museum practice, current societal trends (such as cutbacks in funding to cultural institutions), and the contemporary relationship between museums and First Nations. Part 1 serves as a background that enables the reader to understand the practice of conservation of objects in museums. Part 2 focuses on First Nations perspectives, and it begins with a chapter that discusses what First Nations people have written or said in public forums regarding heritage preservation. Later chapters offer detailed excerpts from interviews and conversations I have had with First Nations people in British Columbia and in New Zealand regarding museum preservation and conservation practices.

2 The International Institute for Conservation, Canadian Group (now the Canadian Association for Conservation [CAC]), revised its Code of Ethics in 2000.

This book has a somewhat narrow focus in that it concentrates on preservation, and specifically, on the difference between museum practices and beliefs regarding the preservation of collections, called conservation, and First Nations beliefs regarding heritage preservation. It does not discuss such major aspects of the relationship between museums and First Nations as representation, repatriation, and the protection of indigenous knowledge. These are already the focus of excellent discussions in a literature that continues to grow.

In many areas, standard museum practice has been criticized by First Nations, who do not see it as being in their interests. Although First Nations voices have been implicitly present even in conventional museums as, for example, makers of objects, sources of objects, keepers of knowledge, and (sometimes) staff, these voices have, until recently, been largely unheard. They have been dominated by the power and authority that Western society has traditionally given to academically trained, usually non-indigenous, museum curators and other personnel to explain, exhibit, and present knowledge about First Nations. Now First Nations are asserting their own right to have and represent their heritage.

In the literature that examines the relationships between museums and First Nations, *conservation practice* has not often been critiqued. That a primary mandate of museums is to preserve the objects they house has been considered a truism. Conservation practices that accomplish this mandate through scientifically developed and proven techniques, in conjunction with a code of ethics whose goal is to preserve the original integrity of the object, have been considered undebatable. My intention is not to question this conservation practice; rather, it is simply to elaborate its values and to explore them as historically and culturally grounded. The values of conservation may or may not be shared by the originators of the objects in museum collections, people whose own values are also historically and culturally grounded. A very important focus of this book, then, is the presentation of how First Nations people articulate their regard for preservation.

Surrounding Environment

In several countries, First Nations are now sharing some of the power traditionally held by the museum. For anthropology museums, or other museums holding ethnographic collections,[3] especially those located in the same country (province, state, or territory) as the indigenous peoples who created the collections, the traditional cultural triangle of "museums, objects, collections" (Pearce 1992, 1) is in the process of being opened up. It is becoming "museums, objects, collections, people," incorporating the perspectives of the First Nations (Ames 1992b).

3 For a discussion of the term "ethnographic," see Clavir (2001).

"Contemporary societies are becoming more multicultural or multiethnic in composition and these diversities are becoming more visible and more politically active. What is significant, as Geertz [1986, 120-1] points out, is that the location of diversity is changing, from elsewhere to here" (Ames 1991, 7). Although the First Nations have been here much longer than non-First Nations, it is only in the last two decades that their political, judicial, economic, and cultural activities have made Aboriginal viewpoints highly visible in Canadian society. Material culture studies have traditionally held that artifacts constitute "mute evidence" that is interpreted by research (Hodder 1994); First Nations consider artifacts to be part of living cultures, for which they are the spokespeople. According to Mitchell (1992, 2), "Terminology such as curation and ownership might therefore mean very different things to both parties." I propose that this also holds true for "preservation," with conservators focusing on the conservation of material culture and indigenous peoples focusing on continuing and renewing cultural traditions important to their identity and well-being as First Nations, both as individuals and as members of a larger community.

The question of who wields the power to control identity is a current subject of struggle and debate. Postmodernism has contributed to this debate the recognition of the validity of multiple perspectives and a critique of the presumed authority of the Western perspective. At the same time, Aboriginal peoples, as well as other minorities, are assuming the right to speak for themselves and to gain control over the future direction of their territorial, political, and economic spheres. This includes control over heritage resources. Landmark legal decisions and enactments, such as the Native American Graves Protection and Repatriation Act (NAGPRA), 1990, in the United States and the Nisga'a Final Agreement in British Columbia (initialled in 1998, passed by the BC Legislature and federal House of Commons in 1999), confirm Aboriginal rights in areas pertaining to museums as well as to larger societal spheres. At the same time, most museums serve a broad, diverse public; rely on the generosity of a small number of donors; and have, for many years, played an important role in preserving and exhibiting collections. In addition, for several decades now museums have been doing this in collaboration with the various communities from whom their collections originate.

Developments in other areas of Canadian society offer some parallels with the changing relationship of First Nations and museums. In the 1990s innovative programs began to incorporate Aboriginal viewpoints and lifeways into such traditionally Western systems as the Canadian justice system and policing practices. For example, traditional Native methods of punishment have, in several cases, been substituted for the usual Canadian legal methods. In other areas of Canadian society as well, those who consider themselves

as central participants, or "stakeholders," are currently enlarging their rights to negotiate, to voice opinions, and to be part of the decision-making process. This is reflected, for example, in the medical field in the evolving patient/doctor relationship. The "non-expert" – the patient – is being increasingly considered as a partner in the health care process. The doctor now discusses with the patient what treatment might be appropriate rather than simply dictating what is to be done. A professional medical conference in Montreal was termed a landmark conference because, for the first time, breast cancer patients spoke of their experiences as receivers of treatment, sharing the platform with researchers and doctors (Mickleburgh 1993). Likewise, fishers in the Canadian Maritime fishery provided experiential information to scientists in a collaborative effort to deal with diminishing fish stocks. Recognition of the value of experiential as well as scientific evidence represents a questioning of science as sole authority.

Conservation is a twentieth-century profession that developed out of art and archaeology restoration. Conservation, unlike restoration, is based on the scientific and technical analysis of collections deterioration with a view to stabilizing cultural property. Questions of appearance, which are of primary importance in restoration, are part of conservation, but the values upon which decisions are based are often fundamentally different. For example, two traditional values not found in restoration are (1) concern with preserving the integrity of the object and (2) an emphasis on scientific methodology. The "integrity," or "true nature," of the object has been defined as including "evidence of its origins, its original constitution, the materials of which it is composed and information which it may embody as to its maker's intentions and the technology used in its manufacture" (Ashley-Smith 1982, 2). Only in the last decade or so have attributes of the object not necessarily seen in its physical nature, such as its spiritual meaning or cultural significance to its originating people, been acknowledged in conservation codes of ethics (IIC-CG and CAPC 1989; ICOMOS 1993).

The underlying focus of museum conservation remains, however, understanding the physical attributes of objects, materials, and their environment, with the aim of materially preserving the objects as well as knowledge about them. Conservation is practised according to what the profession believes to be appropriate ethical principles; these have been codified and are similar in most Western countries. In each country the same code and guidance for practice apply to all subdisciplines within the field. Collections from indigenous peoples, which are preserved by "ethnographic conservators," as they are termed within the profession, are treated within these parameters.

Museum conservation is influenced and surrounded by other elements in the larger political, economic, and social gestalt. Contemporary changes

have led many museums to focus on serving communities or "clients" rather than such traditional mandates as preservation and research. This focus has obvious implications for conservation, which has been situated within the conventional view of the museum as being collections-centred. The changes have involved a reconceptualization of the terms of discussion as well as the content of the discussion itself. Especially in North America in the late 1980s and 90s, this reflects, in part, a reconceptualization of the conditions and values within which museums and other cultural organizations operate. For example, a report commissioned by the Ontario Association of Art Galleries used the language of commerce to define what galleries should be doing (less emphasis on the product and more emphasis on the philosophy of service) (Taylor 1994). This is similar to the marketing of a North American exhibition of paintings from the Barnes collection, wherein what was emphasized was the collection's monetary worth rather than its artistic importance (Rhodes 1994). I examine the impact of the reconceptualization of museological terms, especially in North America, where the de-emphasis on collections in favour of the visitor experience ("the authentic experience" rather than "the authentic object") is affecting the role of conservation in contemporary museums. Interestingly, conservation is undergoing changes within its own canon; major issues, such as the standards for environmental protection of collections, have been reassessed (Michalski 1994a; Erhardt et al. 1995; Schultz 1995; Real 1995; Lull 1995). Indeed, the question of how preserving "the physical object" balances with preserving "the cultural object" can be said to represent a reconceptualization of the norms for ethnographic conservation.

In museum practice it has been recognized that parallel paths may accomplish mutually acceptable goals. This follows a model proposed by the late Deborah Doxtator *(Doxtator: Mohawk)* who said that museum/First Nations relationships were often hindered "by the fact there is no one shared goal. There are instead parallel goals" (Doxtator 1996, 65). Rather than attempting to provide an illusory shared goal, a project could serve the different goals of the two parties involved.

Perspectives
Preserving What Is Valued presents the viewpoints of a number of First Nations individuals concerning conservation, museums, and heritage preservation. I researched these viewpoints through interviews and conversations mainly with people from British Columbia, but also with a First Nations conservator from Ontario and with people involved in heritage preservation in New Zealand. The focus on British Columbia provides an in-depth discussion of the viewpoints of people from different First Nations. I talked to people of both genders and all ages, some of whom have worked with larger

urban museums, some with community museums, a few who have not worked with museums; all participated in various ways, in the traditional culture of their heritage. Most but not all of the people had had some kind of contact with the UBC Museum of Anthropology, where I am a conservator.

There are many perspectives that could not, at the time, be included in this work. To name a few, there are no Haida, Nisga'a, Nuu-Chah-Nulth, Nuxalk, Tlingit, or Interior Salish represented in the longer conversations, and this is a very large lacuna indeed. In addition, while some elders are represented, it would have been beneficial to hear from more members of this generation. Furthermore, only one person, through her official position on her band council, could be said to express a community position. The quotations from First Nations people represent individual opinions. These opinions are invaluable, and it is important to hear more of them and to build on them in order to achieve a larger and more comprehensive understanding of First Nations perspectives.

I chose to include New Zealand because, at the time I was writing this book, it was the only country with a group of professionally trained conservators of indigenous ancestry. I was able to explore with them how they managed to balance the cultural concerns that went with their being of Maori descent with their scientific training as conservators.

I also represent a particular perspective. For the last twenty years I have been the conservator at the Museum of Anthropology (MOA) at the University of British Columbia in Vancouver, Canada, and this has given me both experiential learning as well as a particular perspective on the topics explored in *Preserving What Is Valued*.

As already mentioned, First Nations are in the process of reclaiming control over their territories, resources, and knowledge as well as how these are used and represented. With regard to my project, for example, First Nations control is demonstrated by the necessity to obtain a research permit from the Musqueam Band Council in order to interview band members as well as the need to obtain permission for publication from all those to whom I talked. I acknowledge the desire of First Nations to represent themselves rather than to be represented by Western scholarship by attempting to balance my academic analysis with direct and detailed quotations from the people I spoke with. Nonetheless, my role as intermediary is inescapable. I excerpted the quotations from longer conversations and imposed an organizational scheme upon them. I look forward to a literature on conservation and preservation that will include more works that are co-authored by, or written from the perspectives of, members of different communities.

In summary, conservators of aboriginal objects are facing situations that fundamentally challenge their ethics and practice. First Nations are asserting that their cultural heritage belongs to them; however, while the larger

issues involved in Aboriginal rights are being settled in the courts, day-to-day museum practice, including conservation, must continue. Now is an opportune time to examine the concept of preserving what is valued.

Editorial Comments

Quotations from all of the interviews/conversations are reprinted with the permission of the speaker. In addition, the reader should note that First Nations community, band, and nation names have been written without their diacritical marks. Not all sources include diacritical marks in their orthography and, rather than use it for some names but not all, I decided to use the spellings that are most often seen in English. For example, in the preceding section, the reader will find "Nisga'a" rather than "Nisga'a." I apologize for any misunderstandings that this decision may cause.

Part 1
Preservation and Museums

1

The Historical Development of Conservation and Its Values

Conservation, as the word is used in relation to museum collections, can be defined as: "All actions aimed at the safeguarding of cultural property for the future" (Canadian Association for Conservation of Cultural Property [CAC] and Canadian Association of Professional Conservators [CAPC] 2000, 13).

According to the *Shorter Oxford English Dictionary* (1956), since medieval times various forms of the words "conservancy," "conservatory," and "conservator" have connoted stewardship, keeper in safety, or preserving from destructive influences. All of these words derive from the Latin *conservare*, meaning to preserve. Through the centuries these words have been applied to guardians of rivers, sewers, forests, tender plants, orphans, and the disabled – to those people who cannot look after themselves or to those natural resources that require care and regulation in order to prevent destruction. The *New Shorter Oxford English Dictionary* (1993) adds "careful preservation" to these meanings of the word conservation. Museum conservators have assumed the role of guardians of the welfare of objects that "cannot speak for themselves," although the idea that objects constitute "mute evidence" is now being challenged by some First Nations.

The word "conservationist," which is currently being used in the field of ecology, is considered to be inappropriate within the context of museum collections. "Conservator" not only has more similarity with its antecedent "restorer" than does "conservationist," it also has more similarity with "curator". Furthermore, in German the word "conservation" was used from the very beginning with regard to museum collections (see Rathgen's publications, as listed in Gilberg 1987), while in English words such as "restoration" and "preservation" were favoured. (In French, *restaurateur* has continued to be used, while *conservateur* is translated as "curator." In France, contemporary conservators use either *restaurateur* or *conservateur-restaurateur*.) Today, the phrase "conservation professional" is sometimes used instead of "conservator" as it includes conservation scientists, conservation administrators, and others who work in the discipline but who are not necessarily performing

conservation treatments on cultural property. Hodges (1987) could find no English use of the word "conservation" in relation to material cultural heritage before the establishment of the International Institute for the Conservation of Historic and Artistic Works (IIC) in the early 1950s. However, in a report in the *Museums Journal* of September 1906, the director of a museum is described as having given his fullest attention to "the growth, the conservation and the arrangement of the collections" (Anon. 1906, 108). This example appears rather isolated, however, and may be a borrowing from continental usage.

The conservation of historic objects and works of art has developed into a distinct professional occupation. A conservator is different from a restorer and/or from colleagues in allied museum fields. Conservation differs from other museum disciplines in such fundamentals as philosophy and qualifications, and, at the same time, conservators themselves share much in common, even internationally. As a relatively new occupation, conservation exhibits most of the traits of a profession and can certainly be said to be well into the process of professionalization. Conservation has its own codes of ethics (which are similar from country to country), its own training programs, a sense of duty to public service, and public acknowledgment of expertise. In many countries the field of conservation has articulated criteria for accepting individuals into the profession. These criteria include a common understanding of what constitutes knowledge, a common understanding of what constitutes an advancement of that knowledge, and the means for sharing that knowledge. Practitioners can earn their living as conservators. Rewards come not only in the form of professional salaries, but also in the form of recognition within the field. Conservation encompasses distinct areas of specialization, but all of these share the same professional principles.

How and why did conservation emerge from restoration? Why did it come to define its field according to two values that are in marked contrast not only to the values of restoration, but also to some First Nations values? These two values are: (1) a belief in the fundamental need to preserve the integrity of the physical object (as well as its aesthetic and other qualities) and (2) a belief in scientific inquiry as the basis for the proper preservation and treatment of collections. This chapter begins by examining factors that led to the emergence of conservation as a way of confronting the problem of deterioration in collections.

Conservation: Origins

Repairing objects when they break or wear out is as old as antiquity (see, for example, Caldararo 1987; Corfield 1988; Oddy 1992). Restoration, however, expands on the definition of strict repair to include changes made for non-utilitarian reasons (e.g., to alter or to "improve" the appearance of the

objects). Apart from repair, motivation for these modifications may include changes in social context (e.g., changes in fashion or political or religious acceptability) or the desire to return the object to an appearance it is believed to have had before the passage of time altered its features.

In Europe,[1] an increased demand for the restoration of fine works occurred following the Renaissance and the establishment of large private collections (Coremans 1969; Oddy 1992). It has been noted that restoration was usually carried out by artists and craftsmen in their workshops and that these people were highly secretive about their methods and discoveries (Coremans 1969; Ruggles 1982; Caldararo 1987; Hartin 1990; Oddy 1992). Restoration was not a unified or unchanging field, however. Hartin (1990) notes that, at the time of the opening of the Louvre in 1793, a distinction was made between the restorer and the artist/restorer. In addition to cleaning and repairing paintings – the work involved in traditional restoration – the artist/restorer could add missing parts. Roche (1972, 132), in describing the history of paintings restoration, notes that, as early as the eighteenth century, picture restorers were using techniques such as transposition and cradling as well as cleaning. These techniques are continuing to be developed and used in modern conservation. Lining a canvas support with an additional canvas, another practice that has continued to be used in modern conservation, was first developed into a standard procedure in the eighteenth and nineteenth centuries (*New Grolier Multimedia Encyclopedia* 1992).

With objects, as with paintings, the restorer cleaned, repaired, and carried out changes in their appearance. During the seventeenth century through to the twentieth century, fashionable taste favoured antiquities as well as two-dimensional works of art that had the appearance of being whole. Missing parts were often added to objects, which could be as diverse as fragmentary classical sculpture (in the seventeenth and eighteenth centuries) and Haida argillite pipes (in the nineteenth century). The artists of the day crafted contemporary additions to complete the missing areas or used similar pieces from entirely different objects. Oddy (1992, 9-10) has illustrated the latter with examples from the collections of the British Museum. As Coremans (1969, 8) has said, there was much satisfaction with "aesthetic surgery ... which gave a work of art a pleasant appearance, even if such surgery greatly accelerated its deterioration. Thus, at this stage the restorer restored, but did not yet conserve."

One could not claim, however, that science was never used in restoration. Caldararo (1987, 86) writes that scientific knowledge was used in some restoration, as may be seen Bonnardot's 1846 "Essai sur l'art de restaurer

1 Since conservation developed in Europe, I focus on a Euro-based practice that spread internationally. Areas such as Asia are omitted in the discussions (for example, in that on connoisseurship).

les estampes et les livres" ("Essay on the restoration of prints and books"). Although conservation, as separate from restoration, was not internationally recognized before 1930, scientific influences did occur in the world of restoration. It is important to see that these helped pave the way towards a conservation-oriented view that diverged from the traditional restoration-oriented view.

Today, restoration continues as a dominant practice in the art market. It can also form one element of a professional conservator's practice; indeed, restoration, guided by conservation codes of ethics, is considered to be part of conservation. In other words, in museums and galleries the new discipline of conservation has not replaced restoration but, rather, has continued it under another set of principles and methodology.

The recognition of scientific conservation as a field can be said to have occurred in 1930 with the international conference in Rome, which was organized by the International Museums Office of the League of Nations. The Conférence internationale pour l'étude des méthodes scientifiques appliquées à l'examen et à la conservation des oeuvres d'art (International conference for the study of scientific methods applied to the examination and conservation of works of art) convinced participants of the utility of laboratory research as an auxiliary to studies in the history of art and museology (Office International des Musées 1930). Many of the founders of conservation either attended, or worked for those who attended, that conference.

It should be noted that, although the use of science in the treatment of objects increased after the First World War, not all practitioners had received appropriate training. Iona Gedye wrote that, in the early 1930s, conservation training did not exist, although Dr. (later Sir) Mortimer Wheeler, founder of the Institute of Archaeology, University of London, very much wanted to find formal training for Gedye and her co-worker. Gedye (1987, 16) was forced to approach her work through experimentation: "Armed with Dr. Harold Plenderleith's first small book on the Conservation of Antiquities and a few basic chemicals, [we] started a 'hit or miss' attack on the remaining finds."

The professionalization of the conservation field helped to standardize the training and methods of conservators and to ensure a systematic approach to the treatment of collections. Conservation was recognized as a professional field in 1950 with the establishment in England of the International Institute for the Conservation of Museum Objects (becoming, in 1959, the International Institute for the Conservation of Historic and Artistic Works [IIC]). According to a historical note that appeared in an IIC publication, the institute was formed to continue the international exchange of conservation information that had benefited conservators just after the Second World War (Anon. 1993b).[2] The Institute was also concerned with

2 For a more extensive history of the IIC, see Brooks (2000).

promoting the professionalization of the field, acting in the following areas: "[i] the status of conservators, by forming a professional self-electing body; (ii) publications: abstracts of the technical literature, and original work with a scientific bias – the end of the 'secrets of the Old Masters'; and (iii) training, with the aim of raising standards" (Anon. 1993b).

Shift to a Scientific Approach

A key period for the shift from conservation to restoration occurred between 1888 (when the first museum laboratory concerned with the preservation and restoration of collections was opened in Berlin) and 1930 (when the Rome Conference was held). However, 100 years before the establishment of the Chemical Laboratory of the Royal Museums of Berlin, laboratory chemists and other men of science had begun experimenting with methods of preserving ancient materials. In the eighteenth and nineteenth centuries eminent scientists such as Chaptal, Davy, and Faraday were asked for solutions to problems pertaining to the restoration of materials as diverse as papyrus, ancient pigments, leather bookbindings, and bronzes. An 1898 conference was devoted to the preservation of archives and paper. There are examples of collaborative committees composed of scientists and scholars in the late nineteenth and early twentieth centuries (Caldararo 1987, 86), and there are examples of individual consultations between scientists and museum and historic sites personnel with regard to various preservation problems (see, for example, the report in the British *Museums Journal* of 1910 regarding stone deterioration [Anderson 1910]).

The answer to why scientists rather than restorers were brought in for these problems can be found in the combination of a number of factors, two of which focus directly on the object. These two are (1) the nature of the materials and (2) the condition of the materials. Note that the mere fact of systematically analyzing the object according to these factors shows that a conservation, rather than a restoration, approach was already being taken.

The fundamental common factor in the problems posed by these materials was that they were deteriorating to an extent that had not been seen before. Furthermore, the traditional methods of restoration were not designed for, nor were they successful in, arresting the deterioration of these materials. Two primary causes for the degraded condition of the many objects in various collections occurred in the eighteenth and nineteenth centuries. The first was the increasingly polluted atmosphere in a progressively industrialized Europe. This pollution derived chiefly from the expanded use of coal and gas, especially fuels with a high sulphur content. In 1843 Faraday had linked the deterioration of leather bookbindings to the use of gas lamps.

A second cause of deterioration was the fact that large numbers of archaeological objects were now entering collections. The eighteenth and nineteenth

centuries witnessed large-scale excavations. According to Caldararo (1987, 85), "the tragedies which befell antiquities found at Herculaneum, Pompeii and Stabia at the hands of restorers certainly influenced the scholars and scientists of the period of their discovery." (Caldararo notes that the first chemical analysis of archaeological material was published in 1798, with many more being published in the next eighty years.) Deterioration of archaeological objects is often the result of reactions to the environment. The increased interest in, and availability of, these objects may have fuelled the desire to be able to see them in their original state (i.e., cleaned and whole). At the same time, some of the materials being found, particularly the metals, could become unstable in archaeological environments; this instability often worsened upon excavation unless physical-chemical measures were taken. The nature of the materials invited problem-solving on the part of chemists, especially when restorers' methods proved inadequate. This connection between restoration and archaeology also meant that collections of objects and works of art were associated with a field that was becoming increasingly connected to scientific disciplines and approaches (more so than art history or text-based classical studies). In addition, greater value may have been placed on the physical remains of the original object in archaeology than in art history or classical studies (Caldararo 1987, citing Hulmer 1955), and this may have been one antecedent to the importance placed by conservators on "physical integrity." As previously mentioned, respect for the integrity of the object and for a systematic analytical approach to preserving it are two of the factors that distinguish conservation from restoration.

Archaeological objects were by no means the only area of collections in which the work of restorers was being questioned. Many authors have cited the problems encountered with restoration work in paintings. The following two examples illustrate the problems associated with the work of certain restorers.

An article in the 1906 British *Museums Journal* describes a painting by Velazquez, which is now part of the collection of the National Gallery in London (*Philip IV Hunting Wild Boar* [*La tela real*]. An enquiry fifty years before had revealed that a large part of the canvas had been retouched: "Moreover, he (the restorer) claimed to have painted into the picture whole groups of figures" (Anon. 1906).[3] A second example, from the late nineteenth

3 The extent of the dissatisfaction with restoration in this case can be understood from the full account.

 The story Lance told was this. While the "Boar Hunt" was the property of Lord Cowley it was sent to a dealer or restorer to be relined. Unfortunately, in ironing the back of the picture too great a degree of heat was applied, with the result that the paint was blistered and the canvas in places laid bare ... According to Lance,

and early twentieth centuries, concerns a restored painting that Bernard Berenson, the noted connoisseur, had described as being not a Giorgione but "of exquisite quality" and in a state of "deplorably bad preservation." Seventeen years later this same painting was described by Berenson as an admirably preserved "splendid portrait," which he attributed to Giorgione Sixty years later it was revealed that the painting had been severely overcleaned, and it became "this sad, but still moving ghost of a picture" attributed to Titian (Samuels 1987, 151). According to Samuels, by 1929 the tide had turned against extensive restoration, and he quotes a letter from the artist Modigliani to the *Times* regarding "incredible" alterations to Italian paintings. The letter states, in part, "Today, restoration does not go beyond repairing the actual damage ... in the background or less important parts of a picture" (Samuels 1987, 376).

The field of architecture also displayed the development of a set of attitudes about appropriate restoration that paralleled that of the conservation approach, including systematic analysis and a respect for the integrity of the object. According to Bonelli (1968, 195), between 1880 and 1890 one of the new concepts that arose was based on the "advances in scholarship and the conviction that each monument is a distinct and separate entity ... The restorer defined as an 'artist-re-creator' who sought to identify himself with the original architect was replaced by the 'historian-archivist' who based his activity exclusively on established evidence ranging from documents in archives to paintings, and from thorough analysis of the monument to the literary texts of its time."

A Scientific Attitude

As mentioned earlier, scientific knowledge and methodology had been brought to bear on questions regarding works of art and antiquities in the eighteenth and nineteenth centuries, long before conservation became a

when the picture was (subsequently) placed in his hands the whole of the centre was destroyed, although there were slight indications here and there of figures. The arena, he said, looked like a dissolving view, and there was one piece of canvas bare as large as a sheet of foolscap. "And on that bare canvas you painted the figures we see now?" he was asked. "Exactly," said Lance. "What guide had you in repainting those groups?" "Not any."

The report continues with the observation that, even after the painting was returned, Lord Cowley "was never aware of the misfortune that had befallen his Velasquez." "He [Lance] estimated that when the 'Boar Hunt' was purchased by the nation one-eighth of the canvas was the pure untouched painting of the original master."

Not only had Lance falsified and overpainted large areas of the work, but his own efforts did not last. At the time he examined the painting shortly before the enquiry, "he thought that it was not in the same condition as when he left it after the repainting. 'The surface was mine,' he said, 'but I am sorry to say it is now almost gone back to Velasquez mutilated" (Anon. 1906).

separate and recognized discipline. With the Enlightenment, the influence of science had grown in many areas of European thinking and society, including art and collections. As Pearce (1992, 2) has written:

> Modernity was concerned with the development of meta-narratives, overarching discourses through which objective realities and eternal truths could be defined and expressed. At bottom this rested on the belief – and it *was* a belief – that objective reality existed and that human beings as essential individuals shared in it and could therefore appreciate it. This gave rise to the discourse of scientific knowledge and understanding arrived at by the operation of human reason upon the observed phenomena of the natural world, for which museums and their collections were perceived as the principal repositories of primary evidence.

The advancement and acceptance of science meant not only that new knowledge had been discovered, but also that a new paradigm of thinking had been developed. A rigorous, logical, and systematic method of observation, experimentation, validation, and prediction was basic to the scientific worldview. What was being sought was a rational explanation of the organization and interrelatedness of systems of knowledge. This approach and the continuing expansion of knowledge has been important in the pure sciences, in the applied sciences, and in the technological developments since the Enlightenment. And it has been of fundamental importance in defining the field of conservation.

The combination of a scientific climate and archaeological collections as the basis for the beginnings of a conservation approach is well illustrated by the circumstances surrounding the setting up of the first museum preservation laboratory in Berlin in 1888, as well as by the outlook of its director, Dr. Frederich Rathgen, a chemist who has been called "The Father of Modern Archaeological Conservation" (Gilberg 1987). According to Gilberg (107), Rathgen wrote that his appointment as director was

> due largely to the efforts of the eminent German chemist Otto Olshausen ... In 1887 Olshausen was approached by his close friend and colleague Adolf Erman, the Director of the Egyptian Collection at the Royal Museums of Berlin, for advice with regard to what he described as the unusually rapid decay of many of the bronze and stone antiquities in the collection. Many of these antiquities had been deposited in the collection some fifty years earlier ... Olhausen, who had previously demonstrated a keen interest in the scientific study of antiquities, recommended the establishment of a permanent position for a trained chemist who would be responsible for their care and preservation.

Gilberg (106) also states: "Rathgen was quick to recognize the need for a more systematic approach to the conservation of antiquities."

It should not be presumed, however, that because Rathgen was the first chemist employed on a permanent basis to preserve a museum's collections that chemical methods had not been used previously by museum personnel. For example, Brinch Madsen (1987) gives an excellent account of the preservation of early Danish archaeological specimens in the National Museum in Copenhagen, which began in 1807 as "The Commission for the Preservation of Artefacts." The materials – rusted iron, other metals, and wet wood – were often extremely friable. The man appointed as secretary to the commission in 1816, Christian Jurgensen Thomsen, began to catalogue, repair, and restore the objects acquired. Brinch Madsen gives accounts from Thomsen's letters, which discuss the difficulty of preserving archaeological specimens and recommend using excavation techniques that ensure that the objects do not disintegrate. These techniques included allowing urns to dry and "harden" before too much handling and, by 1845, coating bronze objects with shellac immediately upon excavation (343-4).

Although these methods proved successful, they differ significantly from Rathgen's approach thirty years later. Rathgen is said to have sought, "an explanation for their [objects'] deterioration through an understanding of the mechanism by which archaeological materials, such as clay, stone, and metal, corrode or decay" (Gilberg 1987, 106). His 1898 handbook, *Die Konservierung von Altertumsfunden (The Conservation of Antiquities)*, shows this approach in Part 1, which was devoted to the causes of deterioration of archaeological objects before and after excavation. Thomsen's methods, on the other hand, were comprised of techniques derived empirically from working with the objects. These techniques were much like a restorer's techniques, although they were aimed at the arresting of deterioration. Neither Thomsen nor his archaeological assistant C.F. Herbst were chemists, although Thomsen's letters show some familiarity with chemistry. Before 1850, in addition to simple cleaning with water or spirits, many of the methods they used successfully during excavations appear to have been not analytical but, rather, preventive. They used barrier coats as treatments rather than attempting to analyze the inherent causes of the material's ongoing deterioration. However, at least after 1850, Herbst did conduct empirical experiments with chemical methods and achieved a remarkable success in 1859. He discovered a method of preserving waterlogged wood with an alum solution – a method which, with modifications, became a standard treatment in the Danish National Museum for the next 100 years (Brinch Madsen 1987, 344).

It would be incorrect to assume that, even by modern conservation standards, preservation methods developed by trained chemists were necessarily

the only good and successful ones. It would also be incorrect to assume that, because the men mentioned above were not chemists, they did not see themselves solving problems through the use of science. (It should be noted that the word "scientist" itself was not coined until 1833 [Morrell 1990, 983].) A further example is provided by the first textile conservation studio conceived to operate under "scholarly control." This studio was organized in 1908 by two Stockholm museum directors under the leadership of Agnes Branting, and it was a place where "scientific research and analysis were applied to the conservation of all types of textiles, including archaeological textiles" (Caldararo 1987, 90).

It was not just scientific methodology and chemical research that was applied to museum collections. Scientific research into the nature of materials and technological innovations also contributed new knowledge about objects in collections. In the eighteenth and nineteenth centuries, the fashion for antiquities and the increased number of objects available to private and public collections prompted an interest in detecting fakes and in establishing provenance. At the same time, scholars were becoming interested in questions concerning the nature and structure of materials and manufacturing techniques. These new questions regarding works of art bore a relationship to new technologies. For example, the microscope had practical applications in art as well as in the natural sciences. Röntgen published his work on radiography in 1895. "Shadowgraphs" of paintings were made shortly thereafter, with Faber establishing the scope of radiography for the study of paintings in 1913 (Burroughs 1938, viii). Thirty years later, the Fogg Art Museum at Harvard hired a radiographer even before it hired a chemist.

In the late nineteenth/early twentieth centuries, an optimistic belief in science as the key to human progress and to a better understanding of the universe prevailed in Western society. Pearce (1992, 3) points out that those who adopted the concepts of progress and rationality believed themselves to occupy a "higher moral ground." This certainly was part of the climate favourable to the emergence of conservation. The following examples of the belief that science is the key to the future come from the presidential addresses of the British Association for the Advancement of Science (BAAS) in the decade between 1922 and 1931:

All thinking men are agreed that science is at the basis of national progress. (BAAS 1922, 8)

The extensive territory which has been conquered by science. (BAAS 1924, 3)

The general aim [of science] was summed up in an almost consecrated formula: "to subdue the forces of Nature to the service of man." (BAAS 1926, 1)

It has been borne in on me more and more that if civilization is to go on, it can only progress along a road of which the foundations have been laid by scientific thought and research. More than that, I have come to realize that the future solution of practically all of the domestic and social difficulties with which we have to grapple nowadays will only be found by scientific methods. (BAAS 1927, 2)

Nothing in the progress of science, and more particularly of modern science, is so impressive as the growing appreciation of the immensity of what awaits discovery. (BAAS 1929, 18)

It may fairly be said that science is perhaps the clearest revelation of God in our Age. (BAAS 1932, 13)

Chemistry is the major scientific discipline involved in the development of conservation. Dr. Stephen Straker cited Robert Kohler's point that, in the nineteenth century, chemists had developed a very resourceful "toolkit" and that they were prepared to apply it to many fields and areas of inquiry. The "imperialism of chemistry" has been alluded to because chemists felt that their discipline had the ability to discover the nature of the world. According to Straker, who is a professor in the history of science at the University of British Columbia, "They seized every opportunity to get something under their domain." Biochemistry emerged and began to analyze the "chemistry of life." The Rockefeller Foundation, for example, paid physical chemists to become biochemists in order to discover the causes of mental illness. Chemists were optimistic in their belief that all of this was possible, and it was a "civic-minded" enterprise. Chemistry "was a vocation" (Straker, personal communication, 17 June 1994).

Museums
In the nineteenth century the growth of the public museum, with its board of trustees, had some influence on the concept of the importance of preserving the physical objects in its care. The boards had a mandate to preserve the collections, which were considered to be in the public trust. The material preservation of the object as well as its aesthetic importance became a matter of increasing concern, and the development of significant public collections brought the work of the restorer under closer scrutiny. In the same period the collections policies of these museums, particularly their pursuit of archaeological objects through organized excavations, created the conditions under which large numbers of unstable objects had to be treated before they could take their place in the collections and be put on public view.

Logical, systematic methodologies were increasingly important in nineteenth-century museums, especially in museums of natural history. Appropriate methods for cataloguing specimens and for acquiring particular collections were determined on the basis of logical systems. Indeed, comprehending the nature of the universe was seen, especially in the post-Darwinian era, as something that required a systematic study of its many components. It is interesting to note that, in the 1888 meeting that created the Museums Association of Great Britain, the goals for this new association did not mention preservation but did mention plans for arranging natural history collections and schemes for acquiring comprehensive collections through securing reproductions and exchanging duplicate and surplus specimens (Teather 1983, 238). In the same year, however, the British Association for the Advancement of Science had finished a two-year report on museums in the United Kingdom. This report "outlined the common purpose of museums on which there was not great difference of opinion," that common purpose being the preservation of collections (Teather 1983). Although science was part of the museum, people of science working on preservation problems were not. In 1888, Rathgen became the first scientist to be made a member of a museum staff.

Museums not only used scientific methodology, but their collections served the purposes of science. The 1906 *Museums Journal* carries a report from the Liverpool museum stating that "a considerable number of scientific men have used the collections for research" (Anon. 1906, 108). The same report notes an agreement between the museum in Liverpool and the University Institute of Commercial Research to attain research laboratory space and the services of a scientist and a technician (ibid.).

Collecting itself was conducted for "scientific purposes." Although this could be expected with regard to natural history collections, it was also considered appropriate for ethnographic collections to be exhibited in museums of natural history (Cole 1996, 50). In an article in the 1909 *Museums Journal* one author bemoans the neglect of "ethnographical specimens" because of their great financial and scientific value (Knocker 1909, 196). Archaeological material might be collected with increasing attention to scientific rigour, but many of the finds still remained "antiquities." The use of the term "specimen" for ethnographic material placed it squarely within the realm of science.

Cole (1996) documents in detail the collecting practices of museums with regard to the gathering of material culture from the North American Northwest Coast in the nineteenth and early twentieth centuries. He describes the nineteenth-century belief that material culture had to be urgently and massively collected before the cultures disappeared or became assimilated, and he documents the use of indigenous people as living dioramas in world fairs and expositions. He also describes the interest in collecting human

remains for scientific study of "the races." Again, ethnographic material was distinguished from the (non-technical) material heritage of European peoples as it was placed in the domain of science and science museums. The museums then presented this material as if the people to whom it belonged no longer existed, with the older material considered to be authentic and the newer material considered to be tainted by European influence. This approach only added to the image of museums as places that preserved the past. In museums, living indigenous peoples were either display specimens or non-existent. It is not surprising that many museum conservators, whose profession was born and bred in traditional museums, find it difficult to answer the current questions being posed to them by First Nations.

In this context, it is interesting to note a difference that Stocking (1990) draws between British and American anthropology. Ethnographic research by British museum ethnologists was much further removed, in terms of the geographic distance between museum and research area, from the living subjects of its research than was American ethnology, and Stocking (720) describes the differences this made to the content of the research. Keeping in mind that conservators in Great Britain contributed tremendously to the professionalization of conservation, it may be that this same isolation was, until recently, a factor in the ethnographic conservators' complete acceptance of the break between objects in museums and their originators.

With regard to archaeology and public museums, the particular needs of curators were likely a driving force behind the need to find solutions to preservation problems. For example, Ruggles (1982, 6-7) quotes Charles Trick Currelly, the first curator/director of the Canadian Royal Ontario Museum, as follows:

> I had spent a good deal of money in Egypt on iron objects of the Roman period, and many of them were badly rusted. I had always had a hope that in some way or other I would learn to get rid of the rust ... Very few of the museums had been buying rusted iron, and one of the men at the British Museum advised me never to touch it, that it would break my heart, as after a few years one would have nothing but a pile of rust in the case. This wasn't pleasant, as I had spent altogether too much money on Roman iron.

Currelly goes on to describe a method he had learned in Munich and brought back to Toronto that enabled him to successfully treat his Roman iron.

The first clearly defined preservation problem tackled by Gettens and Stout (two pioneers of conservation in the United States whose work will be described shortly) at the Fogg Art Museum at Harvard – the transfer of Asian wall paintings – came about because the museum's curator of Asiatic art "had explored cave temples and other sites in western China. Paintings on the temple walls he found to be of high quality and generally neglected. His

associates had experimented with a process to take the paintings from the walls and let them be taken to places where they would be safe" (Stout 1977, 13). As this process had proved unsatisfactory, Gettens and Stout began to look into the problem.

These examples illustrate the intertwining of the history of conservation and the history of museums, including areas such as collecting practices. Although cataloguing methods and the subject matter of collections were being rationalized and systematized, this does not mean that the subjective and practical sides of collecting practices were being ignored. For example, although Roman iron was considered important, it could not be preserved and was therefore not collected. While Gettens and Stout worked on the technical problems associated with the transfer of the wall paintings, they, and presumably others (such as the curator and director), put preservation before questions of cultural significance to the originating people in that they assumed the museum had the right to remove the paintings from Asia and bring them to North America. It is precisely these sorts of assumptions that are being debated today.

One characteristic of modern conservation that distinguishes it from restoration is its emphasis on preventive conservation. Although as early as 1691 there are references to the importance of taking measures to prevent a damaging environment from harming museum collections (e.g., Elias Ashmole, letters, cited in Corfield 1988), the restoration of moveable cultural property concerned itself primarily with the work done on the object. Some of the early scientific studies on the deterioration of materials had repercussions for preventive conservation (e.g., a 1787 study on the deterioration of lead caused by the acidic fumes of certain woods) (Corfield 1988, 4). Keyser (personal communication, 23 December 1994) writes that, in the nineteenth century, there was already some good information on the preventive conservation of works of art. However, the first reports from the Berlin museum laboratory, written by Dr. Rathgen, concerned only the objects themselves and not the museum environment. Corfield reports that Georg Rosenberg, an artist who, for forty years, was instrumental in preserving collections at the National Museum of Denmark, was concerned with environmental control and preventive conservation, although his major interest was in the preservation of organic materials (especially wood). An awareness of the importance of preventive conservation can also be found in occasional remarks in the *Museums Journal*. For example: "As far as the protection of the pictures and frames from thoughtless handling on the part of visitors is concerned, in most places it is customary to use a barrier" (Quick 1906, 99). During the First World War collections were exposed to particularly harmful environments (this, and its impact on the development of conservation, will be discussed below). The 1930 Rome Conference highlighted the importance of the environment in the first recommendation of

the Commission spéciale pour la restauration des peintures et l'application des vernis, which was concerned with establishing the best museum environment for works of art (Office International des Musées 1930, 129).

The Art World

Two important general contexts for examining the development of conservation as distinct from restoration have been discussed thus far: science and museums. A third context that is crucial to the examination of conservation is the art world. Were there developments in the art world that increasingly linked science with art? Were there developments that promoted greater respect for the integrity of the object per se as distinct from its historical context or its stylistic features?

In the eighteenth and nineteenth centuries, science directly influenced art, both in technical matters (e.g., studies of the permanence of pigments) and in general art theory. Keyser writes about this influence in her discussions of the connection between colour science and art theory in Victorian England. She links theories of knowledge to representations in paintings. She considers, for example, the influence of Newton's *Opticks* on eighteenth-century discussions of colour and the influence of philosophers such as Kant, Schopenhauer, and Schelling on the knowledge of phenomena in relation to artistic representation. She concludes that "a traditional approach to nineteenth-century colour theory cannot encompass the connection of the sciences to art theory, which had become extremely complex in the course of the eighteenth century ... Furthermore, a significant aspect of the history of nineteenth century art and art theory was the challenge to Renaissance values by science, technology and industrialization" (Keyser 1993, 1).

Studies such as this have shown that there was a significant relationship between art and science in the eighteenth and nineteenth centuries. New technologies were also part of this relationship. Technological advances such as the invention of photography and its evolution into an available popular format, both for users and viewers, profoundly influenced ways of seeing and redefined the role of the traditional artist (Copplestone 1985, 15-7). The use of x-rays on collections has already been noted. Industry's creation of new and inexpensive colours led to their extensive use in works of art and objects.

Ties of another nature existed between applied scientific research and the arts. Industrialization had allowed fortunes to be made, and art collecting and good taste have long been prestigious in Western society. Several of the important art collectors in Britain in the first quarter of the twentieth century were also major chemical industrialists. William Hesketh Lever, Viscount Leverhulme, whose business interests were in soap manufacturing, donated several buildings for art galleries (e.g., the London Museum, an art gallery at Port Sunlight), and the Leverhulme Trust funds the arts in Great Britain. Samuel Courtauld's fortune was made in the textile industry, where

chemical manufacturing processes (in his case the production of rayon) and the chemical dyeing of textiles are very significant. Courtauld was twice chairman of the National Gallery Board of Trustees as well as a trustee of the Tate Gallery, and he endowed the Courtauld Institute of the Arts. In addition, he and his wife acted as benefactors to the Tate Gallery, which enabled the gallery to purchase a number of French Impressionist and Post-Impressionist paintings. The celebrated chemist Ludwig Mond bequeathed his extensive collection of paintings to Great Britain. Julius Mond directed the major British chemical house Imperial Chemical Industries (ICI) and was an art collector and connoisseur.

Copplestone (1985, 11) describes another major connection between art and science at the end of the nineteenth century and the beginning of the twentieth: "Physicists investigated the nature of colour while painters such as Seurat attempted to codify its emotional content. Around the turn of the century the new, self-conscious use of science in aid of art was one of the many elements that promoted the belief that art itself should be new and different." The extent of this difference is succinctly expressed by Chipp (1968, 193) in his description of Cubism: "The Cubist movement was a revolution in the visual arts so sweeping that the means by which images could be formalized in a painting changed more during the years from 1907 to 1914 than they had since the Renaissance."

The early part of the twentieth century saw the emergence of movements such as Cubism, Surrealism, Orphism, and Constructivism. While abstract art expressed the artist's inner as well as outer realities, the influence of science and technology on the style of the representations and, with certain painters, on the representations themselves can be clearly seen. Some painters saw in Cubism "a special affinity with the geometric precision of engineering that made it uniquely attuned to the dynamism of modern life" (Janson 1962, 529). In 1910 the Futurists "issued a manifesto violently rejecting the past, and exalting the beauty of the machine" (529).

Just prior to the First World War, movements such as Orphism sought to make "objective" art free of the influence of the material world and of the painter and to base it, instead, on universal laws. These artists believed that "laws existed for art as well as for geometry, that supreme example of perfect relationships, and that therefore it might even be possible to construct works of art by means of the intellect" (Chipp 1968, 309). As a parallel, the methodology of conservation could be said to preserve works of art first by means of the intellect, with technical skills being left to implement the results of intellectual analysis. In Russia, artists such as Tatlin and Malevich created abstract art "motivated by a complete acceptance of the contemporary world of machinery and mass-produced objects" (312). Both Constructivism and Suprematism, the respective movements of which these two artists were leaders, "set up an ideal world based upon the absolute

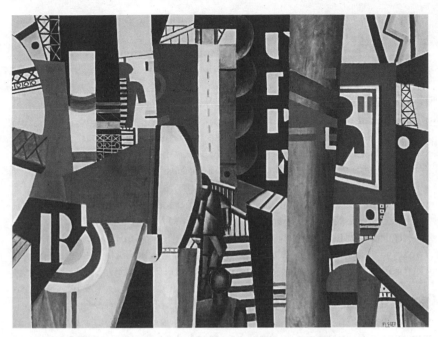

The City by Fernand Léger, 1919. © Estate of Fernand Léger/ADAGP (Paris)/ SODRAC (Montreal) 2001. The mechanized utopia represented in *The City* is a prime example of the link made by early twentieth-century artists between art, science, and technology. (Philadelphia Museum of Art)

functionalism of machinery and the efficiency of the materials of industry" (312).

Fernand Léger's 1919 painting *The City* has been described as "buoyant with optimism and pleasurable excitement, it conjures up a mechanized utopia" (Janson 1962, 529). Even after the First World War his vision of technology was not discouraged, and he continued to express the belief that "machinery was not only the most successful of man's creations aesthetically but also his most significant" (Chipp 1968, 197). Léger also expressed sentiments that indicated his belief in the integrity of the object. In 1924 he wrote: "Every object, picture, piece of architecture, or ornamental organization has a value in itself; it is strictly absolute and independent of anything it may happen to represent" (Léger 1924, "The Aesthetic of the Machine," cited in Chipp 1968, 217). In a 1926 article entitled, "A New Realism – the Object," Léger wrote: "Every effort in the line of spectacle or moving-picture should be concentrated on bringing out the values of the *object*" (Léger, cited in Chipp 1968, 279).

The abstract tradition of Tatlin and Malevich was carried on in Germany in the Bauhaus. The Bauhaus dedicated itself to the ideal of the unity of the applied and fine arts. One teacher, Johannes Itten, "proposed that the sources

of creation lay in an intellectual and sensual understanding of the true physical nature of materials ... and that contemporary technology with its host of new possibilities was the guiding inspiration" (Chipp 1968, 313).[4]

The preceding examples provide a brief overview of the conceptual links between art, science, and technology in the first quarter of the twentieth century. It was not only the artist who was enthusiastic about the physical properties of objects. Connoisseurs emphasized the importance of the formal elements, the visual evidence, in appreciating a work of art. As early as the eighteenth century connoisseurship was being regarded as a science (Argan 1968). Bernard Berenson, one of the best known art connoisseurs of the late-nineteenth and the twentieth centuries, began by following the methods of "scientific connoisseurship" founded by Giovanni Morelli. Scientific connoisseurship involved a disciplined visual analysis of the morphological details of paintings, especially in order to verify attribution. Both conservation and connoisseurship emphasized the importance of the physical properties of objects. According to Calo (1994, 171), "the priority of formal elements in the evaluation and appreciation of painting [was] a position that, at the time, required the devaluation of subject matter as the primary signifier in a work of art." Berenson opposed "an excessive interest in meaning at the expense of what he regarded as properly artistic qualities" (171). Form itself was the vehicle through which significance was expressed.

The following statements show that other methods and beliefs within connoisseurship were similar to those within conservation. Berenson (cited in Calo 1994, 3), for example, wrote: "In every instance we shall begin with the decorative[5] elements, and while doing so we shall ignore the other elements whether spiritual or material, social or political." As Calo (3) points out, "Berenson's legacy to art history is that the object speaks to the viewer in a unique way." Berenson's aesthetics stressed "intrinsic values, the value of the work of art as contained entirely within itself" (13). Calo (4) says that "[a] persuasive case has been made for the fundamental relationship between connoisseurship as Berenson practiced it and the development of formalist art history." The belief that one needs to carefully examine and analyze the formal qualities of a work in order to produce an objective evaluation, the emphasis on intrinsic values, and the relative lack of interest in the work's content and socio-political context are all attributes common to both conservation and connoisseurship.

This discussion of the art world in the years preceding the emergence of conservation shows that science and technology had numerous influences

4 Henderson (1986) reports on the impact that Einstein's "Special Relativity Theory" had on artists when it was first proposed.

5 As Berenson uses the term, "decorative" refers to the formal qualities, or the artistic properties, in a general sense, not simply to the superficial ornamentation or pattern (Calo 1994, 9).

on art. It also shows that the climate in the art world was favourable to the development of the values expressed by conservation. In addition, the art world respected not only its style and iconography, but also the physical nature and integrity of the object per se.

The First World War and the Twentieth Century

In post-Victorian society, science and technology were increasingly seen as the way of the future. While this atmosphere provided a nurturing environment for the emergence of scientific conservation, one key event at this time, the First World War, had a catalytic effect on its development. This war, of course, had a momentous impact on Europe as a whole: "The whole complexion of the world – material, social, economic, political, moral, spiritual – has been changed" (BAAS 1922, 22). What is pertinent to this book is that the Great War caused extensive damage to cultural property while, at the same time, accelerating the general development of new technological and material resources.

The British Museum removed a large proportion of its collections to safer locations during the war. The measures taken and the moves themselves have been described in detail in Kavanagh (1994) and in some of the histories of the British Museum (e.g., Caygill [1981]). According to Kavanagh (1994, 31), "the best of the removable antiquities and coins were lodged in ... a new section of underground railway. This was a line coinciding with Holborn and Oxford Street ... Forty to seventy feet below the surface, it was certainly safe from air attack, but there was a great risk from damp ... It was prepared to receive the collections ... by the installation of floors, a lift, ventilation apparatus, electric radiators, hygrometers and thermometers."

These measures successfully protected the British Museum's collections from bomb damage but at a cost to the condition of the objects themselves. Kavanagh writes that the director of the British Museum at the time, Sir Frederick Kenyon, admitted that there had been some minor damage to the collections, but she quotes Andrew Oddy, Keeper of Conservation at the British Museum at the time she wrote, as saying that the damage was much more extensive. He explains that bronze disease and ongoing rusting had broken out on archaeological metals, salt efflorescence was appearing on pottery and stone, and foxing was appearing on paper (Kavanagh 1994, 34). All these conditions are related to inherent vice or destabilizing elements in the pieces, such as residues from an archaeological environment remaining in the object and being affected by prolonged high humidity. Kavanagh (35) reports that the collections of the National Gallery also suffered from damp conditions during temporary wartime storage.

This damage to the collections became the catalyst that prompted the British Museum to call in scientists to assist in the preservation of its collections. The formation of the British Museum's Department of Scientific

Research is outlined below. This significant step had far-reaching importance and began England's development as a centre for the field of conservation: England was the location of the *International* Institute for Conservation (my emphasis added), the publisher of the major international peer-reviewed journal *Studies in Conservation,* which helped ensure that English was established as the principal language for professional publication in conservation. It must be left to historians to determine whether the instability of Germany as a result of the war contributed to shifting the balance in what had initially been a German strength in museum conservation.

Why were scientists, not restorers, called in to work on the British Museum's collections? I have already discussed many of the factors contributing to a favourable climate for scientists to examine and solve problems regarding deteriorated artifacts. There is also an important socio-economic factor to add. After the First World War, for the first time the British government gave large-scale financial support to scientific research that was considered to be in the national interest, and to this end it created the centralized Department of Scientific and Industrial Research (DSIR).[6] "The establishment of the Department marks an epoch in our history. No such comprehensive organization for the application of science to national needs has ever been created by any other State. We may say we owe it directly to the Great War" (Thorpe 1921, 12). The department concerned itself with, for example, issues in mining, fuel consumption, forestry, and building and food technologies. In addition, "[it] also direct[ed] inquiries on the preservation and restoration of antique objects deposited in the British Museum" (9). Dr. Alexander Scott, FRS, a past president of the Chemical Society, began directing the stabilization and preservation of the collections in 1919. The laboratory was moved to the British Museum in 1922, although it was not formally incorporated as a department until 1931.

In 1927, Edward Forbes, the director of the Fogg Art Museum at Harvard, invited Rutherford John Gettens to be the first chemist in the United States

6 Salomon speaks of "a closer link between science and the state provided by WWI." He writes: "The age of institutionalized science policy only really started when scientific activities began to have a direct effect on the course of world affairs, thereby causing the state to become aware of a field of responsibility which it now could not evade" (Salomon 1977, 47).

The maintenance of national cultural identity has been a federal activity in many countries. It is interesting to note that, in Canada, the establishment of heritage preservation as an official government priority, with its attendant funding, was instrumental in the promotion of the field of conservation. The establishment and maintenance of the Canadian Conservation Institute, the large laboratories of Parks Canada, and the conservation segment of the federally funded Museums Assistance Program are examples of the vital influence federal action has had in this area. Equally, government decisions to cut back in the budgets of all these organizations have also had a pronounced effect.

to be permanently employed by an art museum. Forbes had also engaged a radiographer and a gilder, and a year later he employed George L. Stout (another founder of American conservation, then a graduate student in fine arts) to assist in instructing Harvard's fine arts students. Forbes himself taught a course in the materials and methods of paintings, including studio experience that involved the students practising techniques of fresco, egg tempera, mixing colours, and gilding. As Stout (1977, 13) wrote: "Without knowing it, we were on the edge of the wide field of conservation."

Forbes could be said to have truly provided a context for the development of conservation in the United States. Seventy-five years later, his approach remains the foundation of what is still taught to conservation students. The fine arts students at the Fogg Art Museum learned about the nature of raw materials, causes of deterioration, and ways of stopping deterioration: Forbes specifically wanted a chemist who could contribute to these areas. Gettens and Stout worked on many technical projects (reporting on one of them at the Rome Conference), and, in 1932, they began the publication *Technical Studies in the Field of the Fine Arts*. While a radiographer worked on questions of attribution and history, Gettens and Stout "tried to learn about the entire state of any work that came our way – materials, construction, workmanship, design content, degradation" (Stout 1977, 96). Not surprisingly, considering the approach of the team at the Fogg, resources drawn from industry and research science contributed to early conservation at that institution. One of the first projects that Gettens and Stout worked on has already been mentioned: the transfer of Asian wall paintings. Gettens found a synthetic material, "polymerized vinyl acetate," which was still in the process of being developed at the Mellon Institute in Pittsburgh (16). Gettens notes that he and Stout picked the brains of the scientific people in Boston and Cambridge and that "the picking was good" (96). In the early 1930s Forbes had approached the president of the Chemical Foundation for a donation, and it was this foundation that financed the publication of *Technical Studies*. In US museums, many buildings, collections, and foundations bear the name of their industrialist donors.

In Canada, research chemists were not employed by museums until much later than they were in the United States. At the Royal Ontario Museum, several men who worked as cabinet makers or preparators used their skills in the preservation of objects, following methods tried successfully in European museums (Ruggles 1982). Gettens and Stout were asked to assist the Royal Ontario Museum in the transfer of Chinese wall paintings in 1933 (by this time they had worked on wall paintings for three other museums). In 1929 Douglas Leechman published a short monograph on the preservation of anthropological specimens for the National Museum of Canada. Leechman had begun working as a preparator at the National Museum in 1924, while continuing his education, receiving a BSc and, later, an MA and

a PhD for theses on anthropological topics (Gilberg 1982). Gilberg writes that Leechman, although not formally a restorer or conservation scientist, was keenly interested in, and familiar with, the standard works on preservation. Gilberg quotes Leechman's introduction to his monograph to show that he espoused some of the basic methods of conservation, such as beginning by identifying the materials, understanding the chemistry of their deterioration, and understanding the effect the proposed treatment would have on the materials. The introduction shows that Leechman also clearly believed in some of the same values that underlie conservation (e.g., the importance of preserving the integrity of the object) (43-4).

In the fine arts in Canada, various restorers, often recommended by a well-known artist or another gallery, were employed by the National Gallery (Ruggles 1982). In 1938 Charles Mervyn Ruggles became the first person with a chemistry background to be taken on by its restoration studio, although the National Gallery photographer was already using such methods as ultraviolet and infrared light in documentation photography. Ruggles learned his restoration and conservation through an apprenticeship and went on to become Head of Conservation at the National Gallery.

Conclusion

The evolution of conservation as a distinct field developed out of the tradition of restoration in Europe and in the United Kingdom, and it was spurred by urgent and sometimes new problems within a climate that acknowledged the necessity and the legitimacy of the scientific model. The first practitioners in the field of conservation were either scientists, who derived their goals and values from their respective fields (usually chemistry) or individuals with technical or fine hand skills, such as preparators-restorers or artist-restorers, whose backgrounds varied greatly.[7] Conservation, like science, is an activity as well as a body of knowledge. It is not surprising that it shows continuity with the "pre-conservation" activities that were devoted to the same goals. Conservation and restoration overlap, but they do not coincide. Conservation did not eliminate restoration: the two co-existed, much as in the nineteenth century the rise of the professional scientist did not supplant the amateur. Conservation, however, exerted its legitimacy, grew in association with the large and powerful public museums, solidified itself as a profession (redefining "good" restoration according to its own values), and became more and more associated with beliefs about how works *should* be preserved. Conservation could maintain this power and status because of its claim to be scientific in an era during which

7 For more in-depth historical details on conservation and its early practitioners, see A. Oddy, ed., *Past Practice – Future Prospects* (Occasional Paper Series, no. 115), (London: Bristish Museum).

science was being increasingly revered. The dominance of science – its methodology, knowledge, and values – with regard to defining the distinction between conservation and traditional restoration is significant.

It is not surprising that conservators found themselves unprepared, professionally speaking, to respond to First Nations requests relating to objects in museums. Many of the values in the field of conservation – such as respect for what is found physically, or intrinsically, in the object (as distinct from what is attributed to the object) or the belief that museums are valuable institutions and that preserving the objects they house is important – may not be shared by some First Nations people. First Nations people may ask to use heritage objects that are now in museums, and these requests are often in conflict with established conservation practices.

As a discipline, conservation has developed to the point where it is very much self-generating, even as an applied field. Thomas Kuhn (1968, 81), in describing the attributes of mature scientific disciplines, says about their methodology: "The concepts used to resolve these problems are normally close relatives of those supplied by prior training for the specialty." Although conservation might not yet be referred to as a mature science, it is easy to see that the problems presented by First Nations requests are not, historically, "close relatives of those supplied by training"; little in the development of conservation's technical outlook has prepared conservators to consider the cultural significance of objects to living indigenous peoples. In other words, until very recently conservators could not situate First Nations requests either within the goals and values of their profession or within its historical development and internally-defined parameters. While conservation training programs and professional papers have now begun to rectify this situation, such attempts have often been limited to those countries inhabited by Aboriginal peoples and to the training of "objects" and, especially, "ethnographic" conservators rather than to the training of all students.

2
Conservation Values and Ethics

Ethics and Values: Framework

Discussions of ethics can be found in the literature of many academic disciplines, especially philosophy. These disciplines examine ethics from theoretical and practical perspectives in both Western and non-Western societies. In addition, various professional fields, ranging from medicine to education, have literatures that are concerned with questions of values and ethical practice. In summarizing the thinking of six basic schools of ethical theory, Winter (1984, 37) says that the theories "range from a total denial of the intelligible meaning of value statements, to a social process view of ethics, to theological, metaphysical, and intuitive theories that refer moral concepts to deities or immutable principles."

Museum ethics have been of concern to most museum professionals and organizations, and the literature includes both broad books such as Edson (1997) and specialized discussions in diverse forums ranging from registrars' publications to law reviews. In archaeology, Wildesen (1984) presents a discussion of ethics and values that shows a certain analogy between that discipline and conservation in that both respect scientific methodology and the contemporary "conservation ethic" pertaining to the preservation of heritage resources. In addition, both disciplines have used the salvage, or "rescue," paradigm. Selections from conservation codes of ethics can be found in Appendix B.

Ethics have been defined as "any and all sets of moral principles and values that govern individual and group behavior" (White 1959, cited in Winter 1984). Abbott (1988, 3) quotes several definitions of "values" from social scientists: "the central organizing principle(s) of any society," "what is regarded as good and desirable," and "conception(s), explicit or implicit, distinctive of an individual or ... group, of the desirable which influences the selection of available modes, means, and ends to action." Professional values provide a moral framework guiding actions and representing choices.

Winter distinguishes between ethics and values as follows: "At the group level, ethics are the laws, mores, traditions, and other codes that regulate individual actions and maintain group welfare. At the individual level, ethics take the form of value statements (e.g., commands, assertions, conclusions) that involve right, wrong, desirable, undesirable, good, bad, and related behavior" (Winter 1984, 37).

A significant dimension of ethics involves moral authority. While it is outside the scope of this book to discuss ethical philosophies in detail, it is important to underline one practical consequence of the association between ethics and authority: ethics not only provide a framework to guide actions, but they are also intertwined with the social structure, its powerful institutions, and its understanding of "good" and "bad." Later I discuss how First Nations are taking issue not only with how their material heritage is being preserved, but also with who has control over it.

Conservation Values, Beliefs, and Practices in Context

The professional ethics and values with which I am most concerned are those pertaining to how conservators view objects, especially ethnographic objects, and the purpose and the parameters of the work that is done on them. Three major areas have influenced these ethics and values: (1) the context of conservation within museums and the values expressed by these institutions; (2) the scientific outlook that has led to conservation as a field separate from restoration; and (3) the growth of conservation as a profession along with the attributes common to those disciplines that consider themselves "professional." These three areas will be considered in turn.

Museum Values

Much has been written about the cultural values represented by museums. The social history of museums repeatedly shows that value-based choices have been made concerning what to collect, how to collect, what to do with what has been collected, and for whom and for what purposes the collections are kept. The importance of collections is fundamental to conservation. Pearce (1992, x) and others believe that a museum's collections "will always be, and should always be, at the heart of the museum operation." Many of the objects become cultural icons, symbolizing values and providing tangible evidence of them. The museum, as an institution, becomes a signifier as well as a creator of cultural meanings. Museums, therefore, have a vested interest in preserving their collections, and preservation is a primary mandate of most museum policies. At the same time, the cultural value of collections can be the product of a circular and self-fulfilling path in museums. Museums have the power to designate which objects have cultural value by choosing them for their collections. Conservators then assert that these objects must be preserved since, being in a museum's collection, they have cultural value.

At the same time, "knowledge is now well understood as the commodity that museums offer" (Hooper-Greenhill 1992, 2). Objects in museums can be used as primary data: "the underlying premise is that objects made or modified by man reflect, consciously or unconsciously, directly or indirectly, the beliefs of individuals who made, commissioned, purchased or used them, and by extension the beliefs of the larger society to which they belonged" (Prown 1982, 1). From a conservator's perspective, the objects contain knowledge in their very fabric and should be preserved intact so that this knowledge can be gleaned either now or in the future. If the objects are unique and irreplaceable, then not preserving them means a permanent loss of knowledge. As well, according to the ethics of conservation, not preserving objects represents for conservators the loss of the intrinsic authenticity represented by the object as a tangible link with the past. There are, therefore, reasons to preserve the object per se. According to MacDonald and Alsford, however, "preservation of heritage objects is not an end in itself, but serves to maximise (over time) the access to the information encoded in them" (MacDonald and Alsford 1991, cited in Keene 1994). Many conservators, while agreeing on the importance of the information, believe in the immediate value of preserving objects as an end in itself.

MacDonald's arguments are based on a contemporary view of knowledge and what this means for museums. Writing when he directed the Canadian Museum of Civilization, he says: "Information and experience replace commodities as the basis of wealth" (MacDonald 1987, 213). In his opinion the dominant paradigm of the museum as educator is outdated, especially if it focuses on presenting artifacts in static displays. Education today emphasizes learning (i.e., what the participant learns as much as what is taught), and learning can occur in many ways. In the new museum, "the old artifact-centricity is abandoned in favour of the total experience, which (to simplify) comes from recontextualizing artifacts in environmental simulations and then animating the environments to show people and artifacts interacting. Only in this way can the intangibles of culture – ideas, beliefs, values – be expressed. Artifacts thus become only one of several resource bases essential to museums" (MacDonald and Alsford 1988, 9).

MacDonald represents a point of view that distances itself from traditional museology, the context within which conservation developed. MacDonald (1987, 213) states: "Collections have suddenly become something of a burden to museums. Most museum directors now feel like directors of geriatric hospitals whose budgets are devastated by patients whose survival for another day depends on expensive, high technology support systems. Conservators in museums are like a host of relatives who guard the wall plug of the life-support machines." Later, in 1992, he appears to moderate his perspective on the preservation of objects: "[While] all museums are, at the most fundamental level, concerned with information ... [the]

museum's principal resource – their collections of material remnants of the past – are of value, and are worth preserving, primarily for the information embodied in them. The information may be intellectual, aesthetic, sensory, or emotional in nature (or more likely some combination), depending on the object and its associations" (MacDonald 1992, 160).

However, MacDonald goes on to state that the same value applies to the newer collections museums are developing (e.g., oral histories, audio-visual materials, replicas, and re-enacted processes). Again, most conservators and some museologists would part company with MacDonald because they would make a distinction between (1) items that have been catalogued into the museum's collection and are preserved according to conservation guidelines and (2) items that need not appear as originals (i.e., replicas or copies serve as well). In summary, most museums include preservation of collections as a fundamental mandate of their institution; however, in contemporary museology, especially in North America, this view is being challenged by the idea that the museum should be a "presenter of culture, not of objects" (MacDonald 1993). The following sections summarize other values and attributes represented by museums, and these will later be discussed in relation to values and principles expressed by various Aboriginal peoples.

Museum Values

Secular, Scientific, and European

The "museum" under consideration in this book is a European institution that represents Enlightenment-based beliefs and Western cultural values. Some of these are: (1) the belief in the separation of the religious and the secular; (2) the belief that science can provide objective knowledge about the nature of the universe; (3) a belief in the value of knowledge gained from enquiry; and (4) the belief that one has a right to gain this knowledge and to use it to educate others.

Works of Art

In Western cultural values, the fine arts enjoy a pre-eminent position among other expressions of material creativity. For the most part, the field of conservation reflects, in both principles and practices, Western values regarding fine arts and archaeological "treasures" rather than the values of the non-Western creators of some of these collections. I discuss this in more detail in subsequent sections dealing with individual conservation values.

Authenticity

The traditional museum, in addition to subscribing to the above values, places a high value on objects considered to be "authentic." These represent "the real objects, the actual evidence, the true data as we would say, upon which

in the last analysis the materialistic meta-narratives [of European culture] depended for their verification" (Pearce 1992, 4). Authenticity bestows a numinous quality on the object, which, by virtue of its survival, maintains a direct and unique relationship to past events. Conservators are important to the museum in that they ensure the continued survival of the object.

Ownership

One of the meta-narratives in Western culture concerns the importance of ownership. This subject is too vast to be adequately explored here, but a few points will underline its importance to the relationship between museums and First Nations. Ownership of ethnographic and other collections is currently being disputed on several fronts: repatriation claims challenge a museum's right to cultural property obtained in various ways; the current context of the assertion of Aboriginal rights challenges the Western concept and legality of "ownership" itself; and moral or "extralegal" claims regarding objects in museums are being recognized as having increasing validity (Ames et al. 1987). That is, following the copyright model, the creator of the object is considered to have certain rights even after the object is sold.

Owning culturally valued material bestows power and prestige on the museum, its directors, and it curators. Herle (1993) has characterized curators and museums as "intrinsically possessive." It is to be expected that, in this high-stakes atmosphere, different and often contestatory concepts of ownership exist between museums and indigenous peoples and that decisions about collections, and who has the authority to make those decisions, is a key issue. Indeed, there is a continual undercurrent of conflict in the contemporary relationship between museums and First Nations. Ethnographic conservators and conservation in general have been firmly enmeshed in Western values; however, recently they have been challenged on many fronts to acknowledge the perspectives of Aboriginal communities and creators of objects found in museums. I discuss below parallels between this situation and the treatment of contemporary art and artists. The conversations with First Nations people that are reported in this book explore several questions concerning ownership; the focus is on who they believe has the authority to make decisions regarding objects housed in museums and their ideas about resolving conflicts between museum practice and First Nations wishes.

The Decontextualized Physical Object

Objects generally have been more valuable to collections when they have been in excellent condition and if they have had an accurate provenance or attribution. Museum objects have been referred to as "treasures" because they were associated with, or created by, people deemed important in Western

tradition, or because of their uniqueness, their history, or the materials from which they were made. The value-rich appellation "treasure" can apply, and often was applied, to objects far removed from their original context. Objects could have value, both monetary and cultural, in and of themselves because of what they represented, apart from any utilitarian purpose or cultural context, beyond the accompanying written documentation.

Although there have been debates concerning ethnology collections and how much of any culture could be represented by objects alone, in the nineteenth and twentieth centuries, objects continued to be collected because it was believed that they represented ways of life that were disappearing or that had already disappeared. For this reason, preserving objects in museums, although often a great distance from their cultures of origin, was considered a worthy endeavour.

The Past

Museums also represent the value of knowing about and preserving the past. Age is often considered a positive value in relation to an object and one of the museum's primary mandates, as an important institution of Western society, has been to "preserve the past." Until recently, ethnographic collections were considered primarily as witnesses to the past rather than as part of the cultures of people living in the twentieth and twenty-first centuries. That they could be both, and that they could catalyze a dynamic two-way relationship benefiting the people who created them as well as the museums who house them, is a principle many museums are now embracing. As recently as the mid-1980s, however, two conservation publications – "Ethnographic and Archaeological Conservation in the United States" (National Institute for the Conservation of Cultural Property 1984) and "Ethical and Practical Considerations in Conserving Ethnographic Museum Objects" (Rose 1988) – placed the parameters of conservation almost exclusively within the object's value to the museum and the scholar. Between them, these lengthy documents made only one reference to the relationship between museum objects and contemporary First Nations perspectives. Again, I must emphasize that it is the norm in all the subdisciplines of conservation to focus on the objects and the professionals who curate, analyze, and conserve them; however, it is precisely this worldview that is currently being challenged by First Nations and by the contemporary museum context within which ethnographic conservation is taking place.

European Superiority

In many museums' histories, the preservation of historical artifacts supported meta-narratives of European nationalism, pinnacle achievements, alleged European superiority to other cultures, and European roots in

the Classical world. Indigenous collections were systematized within this perspective.

Static Moments in Linear Time
The value placed on preserving objects from the past as discrete pieces of evidence also involves a belief in the "authentic moment" in a culture's history. Freezing a culture's history at one moment in time in museum displays, the "ethnographic present" (as it has been termed in anthropology) creates an understanding of indigenous cultures' history as being important only within a constructed, fixed period in the past. This lent support to the view that museums promoted static representations and that they themselves were static.

Democracy
Modern museums, especially those that are public, non-profit institutions, place a high value on democracy in that they believe they must serve a large public. In many countries, taxpayer-supported museums have either charged no entrance fees or low entrance fees, and in many cases accessibility is written into their original charters. A fundamental museum mandate is that of education, and museums evolved from institutions that educated passively through displays to institutions that educate actively through public programming. Museums, especially in the United States, are supporting the principle of accessibility through equal opportunity employment practices and through modifications that extend access (e.g., wheelchair-accessible buildings or displays developed for visually-impaired visitors). First Nations, however, may request restricted access to certain collections based on gender (e.g., women should not see or handle certain men's regalia) or other "undemocratic" criteria. Michael Ames, former director of the UBC Museum of Anthropology, has written on the democratic aspect of museums and how this relates to the representation of diverse groups (see, for example, Ames 1992a, 1992b, 1993).

Uniqueness
"Uniqueness," in this discussion, refers to a quality of the objects housed in museums rather than to a quality of the museum itself. Within the museum perspective, "uniqueness" and "irreplaceability" have a value that goes beyond the laws of scarcity. Uniqueness derives from the fact that an object is hand-made, and it is added to by the particular history of that object; the latter makes even machine-made objects unique. Uniqueness is also a valued paradigm in Western aesthetics and is applied to artists, their visions, and their works.

Conservation as Part of the Museum Enterprise

In general, conservators believe in the norms and values presented above. A more detailed discussion of the values of conservation, as demonstrated by its practitioners, is presented below.

Importance to the Curatorial Mandate

Conservators play an important role in supporting the values of authenticity and objects as historical evidence. The technical examinations conducted by conservators provide what is considered to be objective support or refutation of curatorial theories regarding provenance and authenticity of components of the object as well as of the whole. New discoveries – such as hidden signatures, underlying images, or materials previously not recognized as being present – are made during conservation examinations and treatments. At the same time, conservation includes restoration procedures, and the skills of conservator-restorers are used to ensure that objects are presented as curators believe they should be seen.

Conservation is expected to clarify the meaning of the object. Equally, by preserving the integrity of the object, conservation is supposed to guarantee that important information is not destroyed. One curator defines the curatorial role as being responsible for the intellectual care of collections (Hill 1990, 19), and many conservators agree with this definition, emphasizing that they, as conservators, are responsible only for the physical care of objects. Significantly, this means that some conservators would say that the decisions concerning what kind of cultural parameters and cultural significance apply to an object should be made by the curatorial department and do not concern the conservation department (e.g., Barclay 1989). Conservators and curators alike recognize the role of conservation in supporting curatorial and institutional mandates (e.g., Hill 1990).

Importance to the Object: Objects Having a "Museum Appearance"

The question of appearance is riddled with value judgments. Within museums, ethnographic objects have usually been allowed to keep a "dirtier" appearance than other categories of objects (e.g., those belonging to the decorative arts). Appelbaum (1991, 219) has said that "the practice of ethnographic conservation includes the idea of preserving objects in their 'as-used' rather than their 'as-created' state." The National Institute for the Conservation of Cultural Property (1984, 4) in the United States elaborated on this principle: "Whereas art conservation often seeks to return a work of art to its original condition, ethnographic and archaeological conservation should seek to preserve the object's life history at the time of collection."

Watkins (1989, 41) presents the following example:

The newly opened National Museum of African Art in Washington, D.C., for example, offered the following explanation in a label attached [to an object in] the exhibition *The Royal Treasures of Benin:* "The red earth of Benin still adheres to this plaque. Unlike many copper-alloy objects, it is undamaged by Western chemical polishes and tinted waxes." Such an object more accurately represents the visual context in which the Benin people understood it, but nevertheless, in comparison with similar but restored pieces, it appears dirty. By attaching the label, the museum carefully validates an appearance that the general public would consider to represent neglect.

The origin of keeping "ethnographic dirt" on objects, and the symbolic value of doing so, is not clear; however, it could follow from two benign conservation principles:

1 Intervention with regard to an object should go no further than is indicated from the evidence pertaining to it.
2 Removal of anything that comes with the object, including from its surface, constitutes irremediable alteration if it is subsequently shown that the removed feature was part of the object's integrity.

The origins of leaving "ethnographic dirt" on objects might also follow from Western twentieth-century values about cleanliness and proper appearance – values that are applied to "our" objects but not to "theirs."

With regard to how objects look, Lowenthal (1994) succinctly documents some of the values expressed by Western society's changing tastes concerning the appearance of age. Signs of wear on objects have marked the status of families as old and established, fuelled Victorian romanticism, and signified authenticity. For example, decay could signify "real life" in unrestored or "ungentrified" buildings. Some marks of wear are deliberately left unchanged in order to preserve the historic integrity of the piece (e.g., keeping the bloodstains on the shirt Abraham Lincoln was wearing when he was shot). Oddy (1994) analyzes these and other examples in his discussion of the implications of cleaning objects.

Pearce (1990) discusses the complex relationship between (1) the appearance of archaeological objects before and after treatment and (2) archaeological information. She says that "the object as it emerges from the ground is an encapsulation of its history up to that moment; but the unravelling of that history by the modern investigative techniques of the conservator inevitably involves the destruction of evidence as much as the preservation of a version of the artefact" (Pearce 1990, 106). Conservators may believe that they are revealing the "true nature" of the object; however, Pearce believes that what they are actually revealing is a version of the object – one in which the irreversible processes inherent in the excavation, cleaning, and

consolidation of archaeological materials preclude the possibility of verifying information that may have been present pre-excavation or pre-treatment.

If we examine the relationship between conservation and appearance from another angle, that of the individual object in a museum, then conservation treatment can be seen to validate its worth as an important object – one worthy of this kind of attention and expense (Watkins 1989; Pearce 1992).

Within Western culture, when value lies in a new object appearing old, great care is taken so that the signs of wear appear natural and not contrived. This is one of the hallmarks, for example, of reproductions made for the antique trade. An example from popular culture in the late 1980s and 1990s is blue jeans that have been "stone washed" to appear worn and faded, and the many articles of clothing deliberately ripped to make a statement about the wearer's unconventionality and economic sympathies, if not her/his status. One of the major decisions made with regard to the conservation of collections involves determining the final appearance of the object. The very fact that this is so carefully considered shows the importance given to achieving the "right" look.

Differences between Conservators and Curators

Although conservation values are embedded in museum values, conservators consider themselves to be different from other museum professionals, and this belief is returned (e.g., by museum curators and directors). Conservators regularly attend different conferences than do other museum personnel, they have a background that is technical/scientific, and often arts-related, and they view objects differently than do other museum professionals. In addition, in England, as Ashley-Smith (1995, 89) points out: "After the Second World War there was a notable class gulf between the curator/owner and the craftsman/conservator. Only in the field of paintings and sculpture was there sufficient intellectual interest in the outcome of treatment to allow a dialogue that bridged this class barrier."

Disagreements between conservators and curators have been recognized. In some museum circles, conservators have gained a reputation as naysayers, too often coming into conflict with museum curators and directors (Ward 1986; Canadian Museums Association 1991; Clavir 1995). This has occurred, in part, for the following reasons. Curators have viewed conservators as imposing impossible standards, thus making mandates other than preservation difficult to realize (as well as excellence in the area of preservation too costly to achieve). Conservators have, on occasion, questioned initiatives from senior staff or fundraisers if they have felt the safety of the collections was being compromised. In addition, some conservators have expressed a loyalty to the collections that, at times, supersedes their loyalty to the policies of the institution (see the following section on professional values).

The specific values over which these conflicts have developed are (1) the conservator's belief that the integrity of the object should not be compromised by museum activity and (2) the curator's traditional belief that knowledge is what is most important, that objects are sources of knowledge, and that their use or representation for the purposes of disseminating knowledge is fundamental.

The conflict between curators and conservators can also be seen as a power struggle within an organizational structure. Conflicts over how a museum directs its priorities and resources are becoming more prevalent as museum budgets shrink and museum philosophy changes (Clavir 1993).

It should be noted that disagreements also exist within the conservation profession, not just between the larger categories of conservators and curators. *Preserving What Is Valued* concerns itself with ethics and values, and it is to be expected that conservators will have differences of opinion based on their different personal philosophies and experiences as well as on the differences among the subdisciplines within which they work (Ashley-Smith 1986, 1995) and the cultures of their particular museums or other work situations. It is for this reason that I focus on those professional concepts and values that have general acceptance within the profession (e.g., the conservation codes of ethics).

The Public Mandate: Importance of People, Importance of Objects
In the conservation literature there are continual references to conservators being part of a team – a team that includes curators, scientists, and other professionals (e.g., Coremans 1969; Stolow 1972; Ward 1986; Ramsay-Jolicoeur 1993; Lawrence 1994; Ashley-Smith 1995). Conservation treatments and final appearance are determined through input from several parties. Conservators do not work in a vacuum; their work is circumscribed by institutional viewpoints. The work conservators do, however, is not usually held up directly for public scrutiny as part of the museum enterprise (except for work on well-known pieces, exhibitions specifically dealing with conservation, or treatment controversies [e.g., the Sistine Chapel]). Conservators work behind the scenes and, indeed, good conservation work is "hidden"; the object, not the conservation work, is brought to the forefront.

Requests from First Nations usually go first to the museum's director, or to a curatorial department, or to collections management; conservators are brought in secondarily and usually only if they would have been consulted in any case. This not only reinforces a traditional image of what is and what is not the appropriate work of conservators, but it may also serve to reinforce the conservators' view that their work concerns objects rather than people.

Importance to the Museum Institution
Conservation plays a significant role in constructing meanings. It not only

makes the objects in a collection look good, it makes the institution look good. Recognition for excellent work in conservation can take several forms. In Canada, for example, federal grants to museums from the Museums Assistance Program were recommended, in part, on the basis of whether the museum was seeking or able to provide "proper" care for its objects or objects on loan. Museum meanings are influenced by conservation, which takes a portion of the museum budget and spends it to reinforce the museum values previously noted. Conservation, by virtue of its impact on the preservation or restoration of certain objects and their appearance, can influence what constitutes evidence (Freed 1981; Pearce 1990; Mann 1994). Conservation can influence the construction of what is deemed to look good and why it is so deemed. In art galleries, conservation has been acknowledged as being instrumental in presenting a good image to the public. As Watkins (1989, 39) observes: "The impression of clear coatings and vividly painted surfaces, all in flat plane within their frames, clearly expresses to the public an image not only of great beauty, but also of an organization exercising proper stewardship over its objects."

Watkins has also pointed out that conservation represents a value that is increasingly evident in European-based twentieth-century mores: the desire to always appear young and to live a long life. The museum embodies the denial of death insofar as it is an institution that both preserves and presents "right before your eyes" objects from the distant past and, through periodic conservation, keeps them in good appearance (Watkins 1989). In addition, the museum keeps the conceptions people have of the past alive through its interpretations and through preserving "time frame settings" (e.g., for period furniture) or freezing First Nations objects in an "ethnographic present."

Science
The importance of scientific methodology to the field of conservation has already been noted. Discussions about the history of conservation outline how a scientific outlook became one of the principal features of conservation as it emerged as a field distinct from restoration. According to Ward (1986, 29): "The contribution of science to conservation has been pivotal. In bringing together materials research and the ancient craft of restoration, it precipitated the development of modern conservation." The preponderance of scientific analyses and related technical information in the conservation literature, and in what is accepted as thesis work in graduate level conservation training programs in North America, also supports the importance of an objective, scientific approach to problem solving. The importance of science as a meta-narrative of post-Enlightenment European thought has also been discussed, and this meta-narrative is summarized in the following comment: "In all of this there is a paramount belief in the essential

and absolute power of reason and in the physical evidence with which, as a matter of necessity, reason is informed" (Pearce 1995, 405). Scientific thought underlay, and profoundly influenced, the purpose of museums, especially museums of natural history and ethnography, and the way in which collections were made, organized, and displayed.

To situate conservation ethics, it is important to understand the relationship between ethical beliefs and scientific assertions. Scientific assertions can be tested using scientific methodology, whereas ethical beliefs cannot be so tested. Science is concerned with understanding what are seen to be laws governing the nature of the physical world. Ethics is concerned with understanding how people view the nature of "reality" and the underlying principles of value statements.

The beliefs listed below have a positive value in the scientific world. They are summarized here because they will be appearing in discussions later in this chapter.

1 There is a real world "out there" that operates according to natural laws that can be examined and understood. (Empiricism)
2 A causative agent produces a repeatable effect. (Determinism)
3 Problems have real causes and real solutions.
4 Solutions must be confirmed before being accepted: control groups, repeated experiments, and other methods are used to eliminate the possibility of results being caused by other factors.
5 Assumptions must be acknowledged and tested.
6 Vague statements are not acceptable. However, absolute precision is tempered by an acceptance of levels ranging above or below an average point.
7 The world should be explained according to scientific knowledge (i.e., one should rely on other scientists rather than relying on religious/spiritual ideas or what people say they know but cannot prove scientifically).
8 One should respect broad areas of knowledge that are already scientifically established. (Paradigms)
9 Theory must be proved to work in practice.
10 It is professionally acceptable to change one's opinion if a better model is discovered.
11 It is important to continually search for new knowledge, to fit the pieces of the puzzle together.
12 It is important to respect quantification and mathematical expression, including statistical probability, as the language of science.
13 It is important to have empathy for the value of human life and for humans as subjective beings.

Analysis for Conservation

Most of the above beliefs are found in the field of conservation. Conservation publications contain many examples of problem solving based on empiricism, determinism, the acceptance of paradigms, and the use of mathematical language. In a debate in the mid-1990s over environmental guidelines, assumptions were tested and new models emerged (Michalski 1994a; Erhardt et al. 1995; Schultz 1995; Real 1995; Lull 1995). If the positive value of science forms a meta-narrative in conservation, then it should not be surprising to find that conservation professionals have adopted the language and image of scientists. In a museum, the conservation workspace is usually referred to as a laboratory rather than a studio (at least in North America). Even a basic workspace, whether it is in a museum or not, contains such scientific equipment as microscopes as well as safety equipment relating to the use of chemicals. Conservators often choose to wear white lab coats. In other words, science is part of the culture of conservation in its values, in its norms of practice, and in its symbols.

Several of the scientific values summarized above have a particular impact on ethnographic conservation. For example, a belief in scientific rather than spiritual ways of understanding the world is one potential source of conflict between museums and First Nations.

If science is this important to conservation, then it should be expected that it would be referred to in the professional codes of ethics governing the field. Sections of eight codes are reprinted in Appendix B. Science is mentioned directly in three of these: that of the International Council of Museums (ICOM) (1984); that of the American Institute for Conservation (AIC) (1995); and in the "Basic Requirements for Education in Conservation/Restoration" section of the *Professional Guidelines* of the European Confederation of Conservator-Restorers' Organizations (ECCO) (1993). The latter document includes the ECCO code of ethics in a separate section.

The ICOM code states that "an intervention on an historic or artistic object must follow the sequence common to all *scientific methodology,*" which it then proceeds to describe (International Council of Museums 1984, sec. 3.6). It is not surprising that science is mentioned in a code drawn up by those who are concerned with differentiating conservation from the widespread European tradition of restoration. The 1995 AIC code mentions science and the liberal arts as being the components of the field of conservation. It also includes a section on "Examination and Scientific Investigation," which states that examination "forms the basis for all future actions by the conservation professional," and it goes on to state that the conservator should "follow accepted scientific standards and research protocols" in performing analytical investigations (American Institute for Conservation 1995, 26). This wording is also used in the 1999 Australian code of ethics (Australian

Institute for the Conservation of Cultural Materials 1999, 13). The impor-
tance of scientific methodology, both as an approach to problem solving
and as part of the subject matter of the field of conservation, is clearly illus-
trated. The AIC code antecedent to 1995 mentions science as an underpin-
ning of professional competence within the field of conservation (American
Institute for Conservation 1993, Part 2).

The eight codes of ethics, whether or not they mention science directly,
describe a systematic approach to conservation practice based on deductive
reasoning from evidence (in this case the physical object and its surround-
ings) and deductive and inductive reasoning based on a conservator's pro-
fessional expertise. In addition, there is the caveat that no conservation
professional should act beyond these limits.

As discussed previously, an important dimension of ethics is its moral
authority. Kuhn (1962, cited in Winter 1984, 43) proposed "that the ulti-
mate authority of science is not so much its rational methodology and
rules, but the consensus of the scientific community." Professional codes of
ethics, which will be discussed in the next section, represent the consensus
for appropriate rules for the conservation community as defined by that
community.

The ICOM document states that the object's significance lies (at least par-
tially) in "our ability to decipher the object's scientific message and thereby
contribute new knowledge" (ICOM 1984, sec. 3.6). As has been said, the
scientific aspect of conservation is crucial in the support of the curatorial
mandate. Science is important in conservation not just as a methodology,
but also as a goal. In other words, it is not just the preservation of objects
that is a product of conservation, but new scientific knowledge. Although it
is not stated explicitly, the ICOM document implies that this new knowl-
edge is both theoretical and applied.

Winter discusses various points of view concerning whether ethical sys-
tems are relativist or absolutist and how these relate to scientific theory and
methodology. He describes one dilemma in archaeology that pertains equally
to conservation: "Although there should be no question about the utility of
the scientific method as a means of effectively understanding cultures and
human behavior, there is also no question that much of what is called sci-
ence in archaeology ... is actually composed of value statements" (Winter
1984, 40). Referring to another author, he continues: "This mixing of re-
search imperatives, values, and theory with scientific methodology under-
lies much of contemporary American archaeology" (43). Winter concludes
his review by saying that the different points of view show that "value state-
ments (ethics) pervade all aspects of archaeology, from our rationale for
doing it, to the manner in which we survey, excavate, and analyze data, to
the goals, methodologies, and research imperatives that govern our research
and professional relations. Once we have recognized the presence of value

statements in archaeology, it should be possible to separate them from the scientific approach" (42). He suggests that the only way to distinguish science from value statements is to recognize that our goals and decisions are based on ethics and values and that science provides the means of achieving them. Science itself begins, after all, with "the value statement that it is worthwhile for one reason or another ... to study the meaning of reality" (43).

Although science is one of the basic meta-narratives of the field of conservation, it is not the only one. According to David Bomford (1994b, 4):

> There have been times in the history of conservation when empirical positivism seemed to be the only intellectual framework on offer, when everything was possible or provable if you had the right equipment, when objective truths were the only interesting ones ... At the very least, all conservators should have a basic appreciation of the historical or aesthetic context they are dealing with and appreciate the range of related questions that scholars, curators, owners and the general public might ask.

As early as 1976 Jedrzejewska (1976, 6) wrote: "The whole work of a conservator is a constant sequence of interpretations, as this is what guides his decisions and procedures." According to Keyser (1990, 378): "Conservation is more than a set of physical preservation techniques, it is also an interpretive activity which involves a complex of artistic, scientific, and historical ideas which influence the approach to treatment whether they are acknowledged or not." Weil (1984, 89) concurs: "Judgement and values are implicit in the practice of every conservator no matter how 'scientific' he may consider himself. In this sense one may indeed say that ultimately, the practice of conservation is interpretive, but one must add, interpretation based on a profound knowledge of objective, scientific fact and aesthetic/historical/ experiential (practical) understanding of the task at hand."

Rhyne cites several recent conservation authors and policies, particularly in relation to the preservation of sites and monuments, that have focused on accepting different cultural values, including the importance of the "nontangible" attributes of material heritage (Rhyne 1995). For example, he quotes Jukka Jokilehto, head of architectural conservation at ICOM in Rome, as stating, at a 1994 workshop in Bergen: "Conservation is not only keeping the material, but also recognizing this spirit, this 'non-physical' essence and authenticity of the heritage, and its relation with society" (5).

Meta-narratives found in the fine arts are also found in conservation. For example, it has already been pointed out that the prestigious position given to the fine arts in Western society has influenced the place accorded ethnographic objects in the museum/gallery hierarchy. As alluded to in Chapter 1, fine arts values the artist as a creative individualist, and art galleries value the created work. With regard to conservation, respect for the artist's intent

is one of its guiding principles, and copyright legislation has ensured respect for the artist.

Conservation, Subjectivity, and the Scientific Ideal of Objectivity

As mentioned, even though the conservation professional bases much of his or her decisions on scientific examination, knowledge of materials, and scientific reasoning, he/she also recognizes the importance of cultural knowledge. For example, the artist's intent and the object's social history are important foundations for making decisions regarding the object. Conservation work often adds to the information regarding both these phenomena. However, the conservator is expected to unearth this new information on the basis of expert observations of the physical object rather than on the basis of the traditional curatorial specializations of art and history. It is important to recognize that cultural information informs both the conservation decision-making process and conservation objectives. If the conservator is not completely conversant with the cultural aspects of the piece, then he or she is expected to consult museum and other professionals. The "shared responsibility" for conservation decisions and the importance of an interdisciplinary approach have been discussed previously.

In addition to cultural information, another area of non-science-based knowledge that enters into conservation decisions comes with the acknowledgment that subjective judgments are indeed present in conservation (see Etherington 1985; Renshaw-Beauchamp 1988; Michalski 1994b; Bomford 1994a; and Odegaard 1995). As science has become more predominant in the field, some have criticized conservation's neglect of the importance of intuition, the "feel" a practitioner develops for what is right, based on years of experience (Orlofsky and Trupin 1993). In paintings conservation this has also been noted and referred to as a "sympathetic attitude" (Talley 1983; Tomkins 1987). Tomkins (1987, 45) quotes the chief of conservation at the Metropolitan Museum of Art, John Brealey, as saying: "More damage has been done to paintings in this century than at any other period in history, simply because so many people are unwilling to make value judgements about complicated questions. They learn all sorts of technical expertise in their training and then they approach paintings as problems to be solved – how to glue down the flakes or clean that spot – when what they really need to do is get into the artist's mind."

It is also being recognized that value judgments play a part in how a culture determines the significance of objects as well as the best way to conserve them. Michalski (1994b, 242) writes about "two irrational judgements ... whose consideration has become taboo in the field of conservation: (a) artifacts vary enormously in value and (b) not all deterioration decreases artifact value, some even increases it." Wilsmore (1993b, 2) writes:

"the Burra Charter[1] avoids a temptation that much conservation has fallen into: to make out that its task is merely a practical one which can look mainly to scientific methodology for its clarification and avoid evaluation."

Within the field of conservation, there are indications of changes in attitude towards science. For example, for some conservators science is no longer the overriding consideration in determining actions; increasingly, social context is being publicly acknowledged. This can be seen in the publication *Durability and Change* (Krumbein, Brimblecombe et al. 1994) and in such publications on ethnographic conservation as *Critical Issues in Ethnographic Conservation* (Moses 1999). Another example of a change in attitude towards science can be found in the following remarks about deterioration.

Progress in knowledge of the deterioration of materials has always been defined as part of the purview of science. For example, Ward (1986, 14) argues that "preventive conservation is only possible because scientific research has given us a better understanding of some of the mechanisms of deterioration." Understanding deterioration is also one of the cornerstones upon which conservation decisions are built. "The conservator's duty is to take all possible precautions to prevent or minimize damage to collections and to oppose any situation, whether active or passive, that may cause or encourage any form of deterioration" (9). In *Durability and Change*, however, deterioration is described according to social and subjective criteria rather than objective criteria. According to Staniforth (1994, 218): "We describe deterioration as those changes that we regard [as] undesirable."

In 1990, Hodkinson (1990, 59) made the point that "not all changes must be regarded as damage, or deterioration, with automatic attempts at reversal or restoration." He goes on to say that the significance of paintings is changed "partly as a result of physical-chemical changes, but ... more by human perceptions ... Paintings are in a continual state of physical and metaphysical flux which changes their significance to the particular society that is interacting with them at any given moment in their history." And a group report on the topic of what constitutes durability in artifacts says: "Many members of the group were concerned to express a more global notion of durability that gave due weight to the cultural constitution of artifacts" (Orna 1992, 52).

On the other hand, one must recognize that a rationalist scientific approach remains a foundation of conservation and continues to be its defining paradigm. For example, in 1997 an editor for Studies in Conservation

1 The Burra Charter was written by the Australian group known as the International Council on Monuments and Sites (ICOMOS). It was written in 1979 in order to elaborate upon the Venice Charter of 1966, and it concerns professional work and ethics with regard to conserving monuments and sites.

commented as follows on a submission for publication: "The referee feels that the notion that conservation values are social constructs and subject to the influence of *Zeitgeist* is a minority view [albeit one] that is gaining ground and deserves to be published."

Professional Values

The third general area that informs conservation values is the area of professionalization. Chapter 1 described how conservation developed into a field distinct from restoration and gradually became a profession. Restoration was recognized as a highly skilled craft, while conservation defined itself as a new profession. As Wueste (1994, 17) says: "A Profession is more than a collection of persons with similar expertise and jurisdiction. It is a social institution. Acting within it, a professional has special prerogatives and vital responsibilities in promoting and sustaining certain values that, rightly or wrongly, are thought to be best served by those with the expertise." Features of professionalization exhibited by conservation but not restoration include:

1 Training in recognized schools (which are usually associated with universities) rather than through apprenticeship. Increasingly, this is becoming the standard for entry into conservation, although there are variations depending on country and discipline. University-level training signifies three important developments:
 (a) the establishment of recognized criteria for entry into the field,
 (b) the association of university-standard theory with the necessary manual craft skills, and
 (c) the establishment of broadly recognized standards of excellence.
2 Development of a code of ethics. This serves the membership by making public the standards of excellence regarding both rules of conduct and parameters of practice. The code of ethics supports and promotes viewing "professionalism" as an ideology (Vollmer and Mills 1966, viii).
3 Development of formal, national, occupational organizations that foster a collective group identity and professional culture. In addition, these organizations enforce the professional code of ethics, thus showing that the field is under collective control. Among other duties, the organizations facilitate communication among group members (e.g., through publications and conferences). Keeping "trade secrets," a feature of craft guild practice found in traditional restoration, is frowned upon. Some professional organizations also license members, adjudicate complaints against them, and protect them from unfair/outside accusations. According to Wueste (1994, 14), "professions are the products of the institutionalization of expertise."

Many authors and editors (e.g., Carr-Saunders and Wilson 1966a and 1966b; Flores 1988) have described the development of professions, the debates about what constitutes a professional, and the use of the words "professional" and "profession" to refer to areas outside of the three traditional professions of law, medicine, and the ministry. The following observations about professions apply to the development of the field of conservation:

- Rapid technological change is a factor in promoting professionalization.
- Professionalization is a dynamic process rather than an achieved end-state. The striving to be professional is both internalized by the participants and externalized by the work of the organizations.
- Professionals are dedicated to their work, and their permanent attachment is to their profession; this attachment is kept even if employment is transferred to another institution.
- Professionals organize their own work and make their own decisions, and their independence of judgment and manner is recognized even when they work as part of a team.
- A professional group is self-sufficient (i.e., self-appointed and self-regulated); its sphere of authority must be recognized by society in general and those whom it serves. The profession possesses epistemic authority and is seen as a source of expert advice.
- Professional groups experience a sense of obligation to the larger good of society. For example, while a business considers profit as a primary goal and pursues this with its own benefit in mind, professions purport to serve higher ideals. (This is also true of such institutions as non-profit museums and galleries, and it has been a source of conflict for some as, due to forced budget cuts, they find themselves embracing business values in an attempt to raise revenue.)

O'Neill (1992) discusses the reactions of professional curators to external challenges to their authority. This parallels the reactions of some conservators to First Nations ideas about the conservation of objects in museums. According to O'Neill: "The idea of a profession combines personal motivation and therefore personal satisfaction with contributing something of value to society. Changes in external relations – the contribution required by society – can be traumatic and a threat to curators' motivation and sense of professional identity and security" (34).

Professional Values: Whom Does Conservation Serve?
It may appear as a truism to say that professionals direct their work towards providing services to their clients, but this statement has important implications for conservation because its primary client has not been defined.

The "higher ideals" mentioned above, such as "curing the sick" or " achieving justice," benefit the clients of medicine and law. They also benefit society at large by contributing to the well-being of the community. Both the public and professionals see professions as protecting vulnerable interests (see *The Report of the Professional Organizations Committee, Ministry of the Attorney General of Ontario, 1980,* in Ramsay-Jolicoeur 1993).

Conservators have described themselves as "advocates for the artifact" (Phillips 1982; Ward 1986). The UK Institute for Conservation of Historic and Artistic Works' (1981) *Guidance for Conservation Practice* notes the conservator's responsibility to uphold the best interests of the object. In this sense the object is seen as the primary client of the profession. For example, according to Merrill (1990, 170): "Our loyalty is not owed to our institutions, organizations, or colleagues, but rather to the unique and irreplaceable objects that embody our history, culture and aspirations." It has also been argued that people are the primary clients of conservation (e.g., the people who attend public museums and, especially, future generations).

Conservation is, however, object-centred; this is the basis of the profession. Michalski (1994b, 257) considers a point of view not usually explicitly stated in conservation, one reflecting an acknowledgment of the cultural values of heritage preservation: "We must realize that to say we have a responsibility to the objects is only a parable. Our responsibility is to our biological inheritance as perceptive, active, emotional beings and our social inheritance as knowledgeable, cultured beings, as influenced by objects."

The literature on professions often defines responsibility as belonging to those interests in the project that are vulnerable. The *Report of the Professional Organizations Committee* referred to by Ramsay-Jolicoeur (1993) outlines three categories of interests, all of which are potentially vulnerable. First-party interests are those of the providers of the service (e.g., the conservators); second-party interests are those of the clients of the professional services (e.g., those who have purchased the service, such as museums or collectors); and third-party interests are those who have neither provided nor purchased the service but are likely to be affected by it (e.g., the general public). The vulnerability of second- and, especially, third-party interests have justified the regulation of professions such as architecture, engineering, law, and others.

Another way of configuring the question of vulnerability and determining the clients of conservation is to ask, "who will be harmed by bad conservation measures?" Damage to unique cultural property could result in irreparable loss. As with the issue of public safety, even monetary reparations can never repair permanent injury, or "death," of a unique object. This perspective alters the definitions given above for second- and third-party interests, and will be discussed later in arguments about the preservation of unique ecological features and non-renewable resources.

Other clients who could be harmed by bad conservation follow the conventional definition of second- and third-party interests (except for the last "client," which will be mentioned below). These are the owner of the work, the originator of the work (of special concern if poor conservation measures have destroyed or significantly altered an artist's unique creation), the public, and the collectivities who might suffer the loss of some aspect of their cultural material heritage. In addition, the institution housing the works might be harmed, both financially and in terms of credibility.

Again, it should be noted that many of the characteristics of the conservation profession are intertwined with conservation's association with museums and galleries. In the past, public museums have been defined as non-profit institutions contributing to the benefit of society at large. Their collections have often been thought of as embodying and making accessible higher ideals, such as "truth" and "beauty." With regard to both museums and conservation, the larger society has been defined as "the public" as well as "future generations"; however, "public" has usually meant the majority culture. Now, however, in Western society there is increasing recognition of diversity and of particular minority "stakeholders" whose special needs must also be served.

In discussing the relationship between conservation, science, and museums, it should be noted that there has been a long relationship between the general public and science. Writers in the history of science (e.g., R.C. Olby) have noted, for example, the contested ground that has occurred between the elitist, theoretical aspects of some avenues of science (e.g., mathematical science) and the lived experience and knowledge of even the highly educated public. Museums have played an important role in creating an interface between science and the public. Conservation, which has shown itself as a subject of interest to a wide audience, particularly when featured in articles and exhibitions, has also contributed to this interface. On the other hand, the popularization of science is fraught with pitfalls, such as those inherent in accurately translating scientific language into language that is accessible to the public (Olby, Cantor et al. 1990).

The status of conservators as professionals with a basis in science confers on them characteristics that could become contestatory in their relationships with First Nations peoples. Primarily, it endows conservators with "expert" status vis-à-vis the preservation of cultural heritage – a status recognized, if at times grudgingly, by the rest of the museum community as well as by a knowledgeable general public. Conservators are seen to have specialized knowledge, provable methods, non-controversial ethics and standards, and the right to assume authority in their area of specialization. They are also firmly in the mainstream of Western culture with regard to how the preservation of heritage resources should be approached. All of this validates how conservators define themselves and their field.

Inside Conservation: Codes of Ethics and Values
There is no universally accepted definition of conservation, but the codes
of ethics for conservators in different countries provide the clearest and
most agreed upon descriptions of this field. The common principles and
language stem, in part, from the fact that the conservation codes of ethics
originated in the IIC-American Group's Murray Pease report of 1963 and
in each country's examination of other national codes of ethics (Pease
1968). In this section I examine the role a code of ethics plays within a
profession in order to understand how accurately it defines the prin-
ciples of that profession. I then provide a number of examples of how
conservators define their profession. I continue with an analysis of several
values expressed in the principles of conservation that pertain particularly
to contemporary ethnographic conservation.

Underlying Assumptions
A principal assumption underlying conservation codes of ethics is that it is
worthwhile to preserve objects in museums. As Welsh says: "Art conserva-
tion was built on a belief in the preservation of art and other cultural mate-
rial, a mission that has seemed so fundamentally worthwhile and desirable
that it has not even been considered debatable" (Welsh, Sease, et al. 1992,
13). Not only do they have a strong belief in the value of preserving desig-
nated objects, but conservators also believe that conservation is fundamen-
tal to the museum. "*Preservation* is the most fundamental of [a museum's]
responsibilities, since without it, research and presentation are impossible
and collection is pointless" (Ward 1986, 1).

What Does an Idealized Code Reflect?
Some conservators do not believe that codes of ethics have real value be-
cause, for example, conservation encompasses too many different
subdisciplines, each having different antecedents and different norms of
practice. Ashley-Smith (1994) has pointed out the effect these differences
have had at the Victoria and Albert Museum. With regard to codes of ethics,
Oddy (1992, 12) argues: "Numerous attempts have been made to codify
these 'rules,' but all are doomed to failure because the approach to conser-
vation can never be generalised, and is very dependent on the aims of the
particular museum and curator." However, if conservation wishes to be seen
as having professional status, then the responsibility of the professional to
her/his clients and to the society at large needs to be overtly stated. A codi-
fied acknowledgment of professional ethics and conduct serves the primary
purpose of protecting the vulnerable parties in the relationship between
conservators and their clients. In addition, a code of ethics acknowledges
the profession's willingness to explicitly take collective responsibility for its

professional conduct (Newton 1988). Wueste (1994, 34) says that professional norms are the product of both official action by a group and customary norms that develop through public forums.

This is not to say that the difficulties pointed out by Oddy must be submerged in the interests of having a single code. According to Newton (1988, 50):

> It has been asked if a "code of ethics" is not, all by itself, a contradiction in terms; as a set of rules that to outward appearances are to be applied more or less mechanically, it can hardly be adequate to the infinite variety of individual situations that present us with ethical dilemmas ... And when the practice which the ethic is supposed to guide is changing rapidly to meet changing conditions, putting tremendous strain on individual practitioners and organizations alike, the maintenance of a coherent ethic may be an all but impossible task.

Newton concludes, however, that the dialogue created by these tensions (i.e., by the reactions of individual professionals who also have personal moral codes, attempting to apply general rules to particular situations as they serve a public trust) is fundamental. Conservators such as Ashley-Smith might agree (see Ashley-Smith 1982). It is the process, the practice and articulation of a collective ethic, not the finished code, that makes a profession a moral enterprise, often distinguishing it from other job categories and making it worthy of being entrusted with caring for cultural heritage. The code contains the collective ideals of the profession, which are a necessary element in the articulation of a professional ethic. Through a code of ethics "the practitioner, already initiated into the standard practices of the profession, is initiated into its ideals; through it also, these ideals are tested against the criterion of translatability into practical and enforceable rules" (Newton 1988, 53).

As we have seen, the values predominant in the fine arts and classical archaeology/antiquities have influenced how conservation was originally conceived and expressed in its codes of ethics. The emphasis on great aesthetic works reflects a different focus from that displayed in many museums. Whereas museologists have said that they are concerned with knowledge, and with the object as an embodiment of that knowledge, art gallery personnel are more concerned with the work itself, placing a high value on the importance of the original aesthetic object and its preservation. As one author has recently commented in a debate over the use of computer images in an art gallery: "If there's one thing a work of art is *not* about, it's information ... You're graphically shrinking the scope of the experience by having it almost completely eliminate the necessity of seeing the *thing*" (Freedman 1995, 51).

With regard to codes of ethics, ethnographic collections have benefited by the inclusion of what has been called the "single standard of care." This principle appears to have been included in order to ensure that *all* works coming to the conservator's attention, not just the most valued ones or the ones that have the most appeal to the conservator or curator, are given the same degree of respect and professional expertise and the same standard of treatment. Ideally, the single standard means that, for the conservator, ethnographic collections are equal to works of fine art and that pieces from Aboriginal cultures will receive the same respectful treatment as do European pieces. The single standard principle also supports the scientific meta-narrative: a belief in objectivity and the search for knowledge. However, not only have some writers questioned the premise that conservators do not make value judgments about pieces, but Aboriginal peoples are asking that certain collections (e.g., those having spiritual importance) be treated differently from other collections.

Conservation as Iterated by Its Practitioners

The following quotations provide a summary of the normative attitudes of conservators towards their field and their practice. They underline their understanding that their field is rooted in the physical aspects of objects and that their job is to prevent objects from physically deteriorating, stabilize deteriorated objects, repair damage, and appropriately restore the physical appearance of objects following codified ethics and guidelines.

> 1974: The restorer's responsibility is to stabilize and protect the subject; no more and no less. (Cains 1974, 164)

> 1984: [The task of] conservator-restorers ... is to comprehend the material aspect of objects of historic and artistic significance in order to prevent their decay. (ICOM 1984, sec. 2.2)

> 1986: *Conservation* is the technology by which preservation is achieved. (Ward 1986, 1)

> 1990: ... with our understanding of the physical needs of a particular work of art. (Barclay 1990, 24)

> 1990: Conservators ... are responsible for the physical care of works of art. (Ibid., 25)

> 1993: Conservators, correctly or not, occupy themselves primarily with the physical integrity of the pieces they are working on. They concentrate on

stabilizing the physical condition of the collections. (Hutchins, personal communication, 28 November 1993)

1994: Technically, conservation is the empirical science of stabilizing a work or preserving it from damage or destruction ... In the broadest sense then, an art conservator is a professional responsible for the physical preservation, repair, and maintenance of cultural property. (Giffords 1995, 18)

1994: The primary aim of conservation is to slow the processes of deterioration and make sure that instances of sudden damage are made less probable. (Ashley-Smith 1994, 3)

1998: When taken together, these two principles [i.e., respect for the integrity of the object and striving to achieve the highest standards in conservation work] guide the conservator to do what is in the best interest of the object without compromising its tangible as well as its nontangible aspects. (Sease 1998, 102)

1998: At the core of all conservation work lies the object, and respect for the integrity of the object is of paramount importance if it is to maintain its value as evidence of social or technical history, or even its own unique beauty. (Landi 1998, 4)

At the same time, as previously discussed, conservators recognize the complexity of their field: it is an integral part of conservation that conservators understand and incorporate values that go beyond those associated with the purely physical attributes of the objects.

In 1999 Whalen, a conservation administrator, offered the following anecdote:

I sat in an interesting meeting recently with five or six very distinguished people from the conservation profession, and if any disagreement arose, it had to do with the definition of conservation. It seemed to me that half the people at the table thought that conservation was literal intervention, probably on an object. The other half had, I think, a much broader view of conservation, one that relates to sites and cultural landscapes, open-ended theoretical research, and the constellation of professionals in between. (Whalen 1999, 13)

He later stated: "We [the Getty Conservation Institute] can't operate as a modern conservation institute if we aren't considering the broader philosophical and intellectual underpinnings of the field" (15).

Selected Conservation Values and Beliefs Particularly Relevant to Ethnographic Conservation

Integrity of the Object

The goal of conservation is to preserve material cultural heritage within an ethical framework that ensures that the intrinsic nature of the object is not altered. As Keene (1994, 19) writes: "At the foundation of the conservation ethic lies the precept 'thou shalt not change the nature of the object.'" The 1981 United Kingdom and New Zealand codes use the words "true nature of the object," and the CAC and the AIC (until 1995) use the word "integrity." Integrity is not defined in the codes, and comments in the *AIC News* discuss how difficult it is to define or explain it (American Institute for Conservation 1992a). According to Sease (1998, 102): "Integrity is a broad term that can be defined as being an unmarred, unimpaired, or uncorrupted condition. Accordingly it conveys a sense of something not having been violated. But the codes do not state explicitly what constitutes such violation or corruption, leaving the word open for interpretation among the [conservation] specialities." Integrity should not be interpreted as the equivalent of "pristine"; however, the integrity of a corroded archaeological object, for example, includes all that is currently extant of that object, even though it is no longer whole and unmarred. Likewise the integrity of an object might include signs of wear (historical integrity).

Most codes of ethics signify physical integrity, aesthetic integrity, and historical integrity. In 1989 the Canadian code went further and added the idea of "conceptual integrity." The 1999 Australian code uses the phrases "cultural integrity" and "conceptual characteristics" in its section on appropriate treatment (Australian Institute for the Conservation of Cultural Materials 1999, 7, 13). Again, while not explicitly defined, "conceptual integrity" includes properties "beyond the physical" (e.g., the cultural significance or religious significance of objects) (Hodkinson 1991). Among archivists the term "intrinsic value" has been used for many years in relation to materials whose value lies in their retaining their original form.

Since the codes of ethics use the terms "physical," "historic," "aesthetic," and "conceptual integrity" but do not define them, it can be difficult to distinguish the boundaries between each term. For example, with regard to a work of art, aesthetic integrity can be considered to be part of conceptual integrity. Furthermore, at a general level, conservators do consider all the "integrities" in their work so that, when one attempts to ascertain how they balance out preserving physical integrity with preserving conceptual integrity, we may appear to be dealing with a false dichotomy.

While the goal of conservation is to retain and restore the culturally significant qualities of the object, in the past "cultural significance" has not usually presented the kinds of conflicts that come from having to deal with

living people who want to see the objects to which they lay claim serve living purposes. These purposes and the power of the requesters are new to the traditional museum paradigm. In addition, determining "conceptual integrity" by consulting with the current generation of people who have the "conceptual" rights to the objects in question rather than by consulting only the literature or the curators, introduces a new area to conservation. And this, in turn, raises the question of how to adequately train conservators for this part of their work.

In part, preserving the essence of the object became a guiding principle in conservation in order to counteract past restoration practices that involved, for example, "see[ing] [the work of art] return to the workshops at least once every generation to be stripped and reconstituted in the name of the currently fashionable aesthetic principle. We know only too well that aesthetics vary greatly according to individuals, periods and regions" (Coremans 1969, 16). Scientific conservation, however, was intended to preserve the object according to a scientific meta-narrative that claimed to guarantee objectivity and to ensure that the object would be preserved in and of itself, regardless of the ever-changing tastes and politics of society.

It is not just scientific, but also museum meta-narratives that are represented by the conservator's desire to preserve the physical, aesthetic, and historic integrity of the object. For example, as mentioned previously, museums place a high value on authenticity, which is another way of constructing an idea about an object's "true nature." In general, conservation reasoning about integrity is based on supporting physical evidence present in or on the object as well as on documentation.

The importance of the concept of authenticity as a museum value has already been mentioned. Pearce (1992, 1995c) is one author who discusses why "the real thing" and "real facts" are so attractive in Western cultures, and why their representations are considered worthy of being housed in special institutions. Conserving the "true nature" of objects is an attempt to keep intact their evidentiary value and their connection to the past. In archives, the qualities determining intrinsic value may be physical or intellectual, giving the records evidential or informational value and making their retention in their original form the only acceptable way of preserving them (National Archives and Records Service 1982). It may also be that museums place a high value on the physical evidence found in and on objects because they recognize the idiosyncratic paths that lead some objects to be preserved in museums while others are not, as well as how much the objects in museums have been decontextualized, interpreted, and reinterpreted. The object is the tangible touchstone for a reality that exists despite such losses. As Pearce (1995c, 14) says: "Objects have a brutally physical existence ... This means that objects ... always retain an intrinsic link with

the original context from which they come because they are always stuff of its stuff no matter how much they may be repeatedly reinterpreted." Thus museums also value objects as discrete physical entities, displayed on walls or in cases, most often as aesthetic or historical objects. Some would say that museums essentialize the object. Integrity, then, represents the essence of the essence. In addition, one sees in the notions of "true nature" or "integrity" one of the modern meta-narratives of the art world: the artist is a unique individual with a unique vision, and the work of art is an individual creation that is significant in and of itself.

A relevant question is whether conservators believe that integrity is a matter of interpretation or a matter of attributes intrinsic to the object. If the latter, then, conservators would say that the object's attributes are preserved when the object is ethically conserved. Since this defines the field of conservation, it follows that conservators have assumed the authority to impose their conventions on museum objects as well as their beliefs as to the significance of these acts of preservation. Both of these areas have been contested by First Nations.

The idea that an object's attributes are intrinsic holds that these attributes are observable, objective facts. For conventional conservation in conventional museums, the role of conservation in preserving the physical, historic, and aesthetic integrity of pieces is not usually contested unless the physical or documentary evidence for an attribute is contested. In other words, if evidence is lacking for making a clear decision on some matter regarding one of the attributes, then there may be controversy; however, there is usually no controversy about the basic fact that the object should be conserved. The idea of intrinsic attributes strengthens the conservation ethic that attempts to preserve objects intact, holding them outside the passing influences of cultural and temporal events. The importance of intrinsic attributes is manifested in the conservation principle of minimum intervention. If, however, the importance of attributes recognized as objective facts (based on physical and documentary evidence) depends on how they are interpreted, then it must be recognized that it is impossible to preserve objects free of the influence of current cultural mores and that there will be different valid points of view regarding what is most important to preserve.

Pearce (1992), Ames (1993-4), Handler (1992), and Crew and Sims (1991), among others, all illustrate that it is interpretation, the socially constructed meanings of objects, that give them their intrinsic value. Handler, for instance, provides examples showing that proven facts such as date of attribution and the artist's name are not necessarily significant as they have no meaning unless interpreted. If meaning is a matter of interpretation, then cultural values are superimposed and then read as the truth. Conservators

who see integrity as intrinsic to the object may believe that the truth eluci-
dated through scientific investigation without seeing that even the param-
eters of "investigation" are determined by their own cultural values.
Conservators may also view one or several of the "integrities" as being more
socially constructed than the others, with physical integrity being perhaps
the least value-laden.

There is a contextual parallel here between the ethics of conservation and
the ethics of ecology. One belief of some ecologists is that natural phenom-
ena such as forests, animals, and marine life are valuable in and of them-
selves and should be preserved accordingly. In other words, they deserve
protection from destruction for the same reasons that apply to objects in
museums: they are unique and irreplaceable. In museums, the value placed
on authenticity, which is tied to a particular time, maker, and cultural con-
text, makes the object unique and irreplaceable. With natural phenomena,
uniqueness and irreplaceablilty devolve from the fact that their creation
and "integrity" are not the result of a human hand; therefore, human crea-
tions can never replace them. Of relevance here is the question of whether
something threatened by human actions can be considered valuable in and
of itself and therefore in need of human-instituted methods of protection.
Can phenomena have a kind of ultimate value outside of temporal and
cultural contexts or can the only value they have be determined by hu-
mans? Regarding archaeological and site-related cultural properties, Mes-
senger (1989, 19) discusses the related "Non-Renewable Resource Argument"
and its relation to the concept of stewardship rather than ownership.

Regarding "conceptual integrity," within the museum it can be said that,
in general, it is of the greatest importance to the curator: it is a realm of
knowledge that gives meaning to the object. As has been mentioned, many
conservators believe that meaning and context is the proper realm of the
curator or art historian, whereas physical preservation is the proper realm
of the conservator. This means that decisions involving preserving the physi-
cal versus preserving the conceptual may be based on institutional power
factors (i.e., the museum hierarchy and its personalities) as much as on
individual viewpoints concerning what it is important to preserve.

In museums, it is sometimes up to conservation treatment to reveal what
is considered the "true nature" of a deteriorated piece. Occasionally, deci-
sions involve striking a balance between physical and conceptual integrity.
For example, a leather shoe would originally have been flexible; if age has
made the leather harden, then is it necessary to restore flexibility? Or is it
only necessary to restore the appearance of flexibility? Conceptual integrity
may apply to the physical aspect of objects as well as to their cultural sig-
nificance, both of which influence conservators' decisions about treatment
(see Bomford 1994a and Podany 1994 for a discussion on the fine arts).

Concerning ethnographic objects, for example, for the exhibition at the American Museum of Natural History (AMNH) in New York (and other venues, including the Royal British Columbia Museum [RBCM] in Victoria) of the Kwakwaka'wakw potlatch, *Chiefly Feasts*, masks were renewed by the AMNH conservators on the advice of First Nations consultants. The original type of hair on some of these masks, however, was not available, and hair from Chinese goats (which has a similar appearance) was used instead (Ostrowitz 1993; Levinson and Nieuwenhuizen 1994). Note that in this case "integrity," ironically, involves a measure of falsification: the appearance is right, but the actual materials are of a different nature than those that appear in the original. In fine arts, this has been an accepted practice with regard to "in-painting" losses as a way of distinguishing the original from the restoration; what is under study here are the various interpretations of "integrity." A further question arises regarding ethnographic objects, which Appelbaum (1991, 219) has previously been quoted as saying are preserved in their "as-used" rather than in their "as-created" state: does this imply a balance in favour of one of the "integrities" – for example, historic versus conceptual? Or is conceptual integrity in this instance the better term for both?

Traditional conservation may be summarized as being centred on extending the physical life of the object. A more substantive definition of conservation states that its goal is to preserve the meaning of the works as well as their physical substance. Today, First Nations are reclaiming the right to define that meaning for objects from their heritage.

"Cultural Significance" and "Sacred"

As explained earlier, a key element in preserving the integrity of the object is, in short, the idea of preserving its cultural significance. Cultural significance has great potential to be defined in one way by Aboriginal authorities and in another way by museum authorities. The Canadian code of ethics for conservators states that preserving the culturally significant qualities of an object is the purpose of conservation. All codes define cultural property as material that has been declared to be culturally significant. The ICOM document (1984) refers to such objects as "significant expression[s]" of cultural attributes. Conservators are concerned with not altering the meaning of objects, and they rely on other professionals to work with them to ensure that this does not occur.

When it first appeared, the ICOMOS New Zealand Charter for the Conservation of Places of Cultural Heritage Value was the only conservation ethics policy that gave First Nations individuals and collectivities the right to guide conservation decisions regarding heritage monuments and sites of cultural significance to them, no matter who the legal owner. The context for this document is meaningful in that it postdates the initial versions of the

other codes of ethics and that it was developed in a country with a legally recognized policy of equality between indigenous and non-indigenous peoples. (See Chapter 6 for more information.) In its third revision (2000), the Canadian code of ethics has added certain phrases in an attempt to include First Nations viewpoints on material heritage (see Appendix B), and the Australian code of ethics was revised in 1999 to reflect more sensitivity towards Aboriginal peoples. For example, the AICCM code has a separate section on cultural issues, and indigenous concerns regarding sacred materials are mentioned in the sections on law and regulations, and disaster planning (Australian Institute for the Conservation of Cultural Material 1999: 8, 15). The ICOMOS New Zealand Charter, however, remains a landmark with regard to acknowledging indigenous decision making:

> The indigenous heritage of Maori and Moriori ... is inseparable from identity and well-being and has particular cultural meanings.
> The Treaty of Waitangi is the founding document of our nation and is the basis for indigenous guardianship. It recognizes the indigenous people as exercising responsibility for their treasures, monuments and sacred places. This interest extends beyond current legal ownership wherever such heritage exists. Particular knowledge of heritage values is entrusted to chosen guardians. The conservation of places of indigenous cultural heritage value is therefore conditional on decisions made in the indigenous community, and should proceed only in this context. Indigenous conservation precepts are fluid and take account of the continuity of life and the needs of the present as well as the responsibilities of guardianship and association with those who have gone before. In particular, protocols of access, authority and ritual are handled at a local level. General principles of ethics and social respect affirm that such protocols should be observed. (ICOMOS 1993, sec. 2)

Objects that have important cultural significance and have been created for ritual use or have ritual prescriptions attached to them are often considered to be "culturally sensitive." These objects may be considered "sacred" in that they are believed to contain an intrinsic quality of "holiness" or power, or they may be objects that make it possible to perform a traditional ritual commandment. In other words, not all ritual objects are considered "sacred" by their originators, but there may still be great cultural significance attached to them and the rituals surrounding them.

In the last fifteen years objects whose cultural significance lies in their being considered "sacred," "sensitive," or "potent" by their originating cultures have become a special issue for museums. Many different concepts of "sacred" are enunciated, and objects may be sacred in different ways. Some objects are not considered sacred according to the definition used in the US

Native American Graves Protection and Repatriation Act (NAGPRA),[2] for example, but there may still be important ritual protocols that First Nations peoples wish to see observed. It discusses objects that fall into the "sacred/ sensitive" category, or that can be called "potent" (Welsh 1992), only in relation to conservation practice and ethics. The following examples introduce this topic; more detailed discussions will be found in subsequent sections and chapters.

Power: Some contemporary practitioners believe that certain objects have power within them (e.g., certain pieces in the Pueblo traditions of the American Southwest or objects in New Zealand that have "taha wairua," or spiritual force). These objects have ritual protocols surrounding them and may be believed to have the potential to cause harm even to non-indigenous peoples. With regard to the concept of harm, Bernstein (1992, 27) asks: "While we physically preserve a sacred object in a museum, are we at the same time causing harm to the culture and the people it represents by holding an object out of context and away from the community responsible for its care and for the maintenance of the traditions it may represent?" Ames (1993, 5), on the other hand, discusses museums and "the empowered object" in the context of its social history and the meanings that it has accrued over the course of that history: "What is important for the scholar or curator, then, is not numinosity itself alone so much as the process by which it is continually constructed and reconstructed as a social object throughout its career as it moves, or is moved, from one context to the next."

Privacy: Some objects, images, and existing museum documentation are considered by the originating people to be "private," even if they have previously been accessible to either the public or to museum staff. This is especially true of older collections that were assembled under the mores of a different time period – collections that are now being informed by a contemporary ethical sensibility. "Private" may include the notion of something being accessible to some people but not others (e.g., to initiated members of a group but not to the uninitiated, or to men but not to women).

Politics: One of the arenas in which the concept of "sacred" is enunciated is that of politics and Aboriginal rights. In this context, the use of the word "sacred" has at times been judged to be politically-motivated and therefore less "authentic." This provides an interesting perspective on the whole discussion of authenticity in museums.

Rupture: One question I asked in the conversations with First Nations people is whether it is necessary to observe protocols and rituals for objects that

2 "For the purposes of this Act, the term ... 'sacred objects' ... shall mean specific ceremonial objects which are needed by traditional Native American religious leaders for the practice of traditional Native American religions by their present-day adherents (Native American Graves Protection and Repatriation Act 1990, sec. 2[c]).

have been in a museum for a lengthy period of time. Has the rupture from their originating culture and its practices had any effect on the objects as they exist today? This is asked in relation not just to ritual protocols, but also in relation to museum practices. For example, in storage and maintenance, what is the preference? To follow tradition or to follow contemporary museum practice?

Ritual Use Versus Preservation: The "use" versus "preservation" issue is particularly acute in the area of ritual. Unlike those few objects in museum collections such as clocks, where returning them to a functioning state may be accepted (discussed below), the "function" for First Nations objects is often linked to ceremonial purposes. In some countries, such as the United States (but not Canada) legislation enshrines Aboriginal religious practice (e.g., NAGPRA and the American Indian Religious Freedom Act [AIRFA]).

The ritual use question is by no means restricted to Aboriginal material. For example, in 1993 Aleksei the Second, Patriarch of Moscow and All the Russias, led prayers before an icon during a political event; the icon was an early twelfth-century piece to which miracles have been attributed, and it was borrowed for the event from Moscow's Tretyakov museum. The icon apparently deteriorated substantially because of the poor physical environment during the event and required extensive restoration.

Code of Ethics – Guidelines: Conservation practice regarding "potent" objects is not explicitly discussed in the codes of ethics and guidance under consideration, with the exception of the New Zealand ICOMOS document. This document is notable as a conservation policy because it states that spiritual values may take precedence over physical preservation: "In some circumstances, assessment may show that any [conservation/preservation] intervention is undesirable. In particular, undisturbed constancy of spiritual association may be more important than the physical aspect of some places of indigenous heritage value" (ICOMOS 1993, sec. 14).

Discussions Regarding Appearance and Treatment of Sacred Objects: The question of appearance and what it signifies, and whether it is appropriate to alter the appearance of a sacred object during conservation treatment, was raised in the conservation literature as early as the 1980s by A. Weersma (1987, 567): "Decay of sacred objects does not necessarily mean a loss of spiritual value ... Some religious objects on the other hand, are required or at least preferred to be as beautiful as possible. Conservation without 'cosmetic treatment' would make them unacceptable for devotional practice."

Mibach (1992, 1), in an introduction to the postprints of the 1991 American Institute of Conservation's discussion of the conservation of sacred objects, notes that "there may be times when we could solve a technical problem, but when that ability does not also give us the moral right to do so." Greene (1992) points out that some Jewish holy objects no longer in use may be repaired by a conservator but that others have an intrinsic attribute

of holiness; with regard to the latter, any work performed on them by a conservator would be inappropriate.

In the same AIC postprints Mellor (1992) notes that, for the African objects in the museums he is considering, it is not necessary for conservators to treat them with the same strict ritual protocols that they receive within their own cultural context. Mellor's conclusion, however, is based in part on the premise that first-hand information on these issues is difficult to obtain due to geographic distance. Subsequently, the NAGPRA legislation in the United States, the report from the Task Force on Museums and First Peoples in Canada, and individual conservators have raised the question of assumptions and practicalities regarding consultation. Mellor does, however, raise the undisputed fact that different cultures will express different points of view regarding the treatment of sacred objects. This is reinforced by Greene and others in the same journal.

Articles are beginning to appear in conservation literature that challenge the term "sacred" as well as the categorizations that non-Aboriginal people, both consciously and unconsciously, apply to sacred objects (Heikell, Whiting et al. 1995). For example, Vicki-Anne Heikell, a paper conservator of Maori descent and one of the people whom the reader will hear from later, points out that she has participated in many Maori ceremonies relating to works on paper that "may have been written by an ancestor, may depict an ancestor, may tell a story of an ancestor, or may relate a history of a tribal area" (Heikell, Whiting et al. 1995, 15). These ceremonies acknowledge the work as culturally significant to the Maori group and "involve the same commitment, and command the same respect by Maori people as they would when dealing with 'traditional' treasures such as carvings and cloaks" (ibid.).

John Moses (1995, 18), a trained conservator of Delaware/Mohawk descent who was also interviewed for this book, writes in the same forum that sacred objects may "continue to fulfill roles of spiritual focus and empowerment." He continues: "It might be argued that a museum is not necessarily the setting in which one can hope to experience or comprehend the significance of sacred objects, either from the viewpoint of those who created them, or from the viewpoint of those for whose benefit they were created and originally maintained" (ibid.). He insists that "well informed and carefully considered non-intervention" is an appropriate treatment option (ibid.).

The Relationship between Objects and Living People: One important issue raised by Moses, Bernstein, and others is the need to see sacred objects as "living" objects. Not only are sacred objects potentially different from other museum objects (due to their powerful intangible attributes), but they may also have particular non-museum procedures and rituals attached to them. They have a different relationship to living people than do most museum collections. Although one can argue the "museum-as-temple" and "art-as-

inspiring" perspective, which implies a certain symbolic parallel between awe-inspiring works and sacred objects, there is nonetheless a significant difference between (1) the ritual symbolism of a secular institution and the "icons" it houses and (2) "potent" objects that are at the core of one's cultural identity. The beliefs, ritual protocols, and traditions with which potent objects are associated are essential to maintaining the well-being of both the individual and her/his culture.

Artist's Intent

Respecting the intent of the artist has been one of the guiding principles of conservation. It has been considered primarily in the field of the conservation of works of art, but it also has implications for the conservation of ethnographic objects. Within conservation, respecting the intent of the originator has been mainly expressed as "intent of the artist"; however, as is seen in the Canadian code of ethics (CAC and CAPC 2000), the "original intention" is specifically referred to and conservators are asked, "when applicable," to consult with the originator (General Obligation no. 2). The care and treatment of a cultural property is also defined as being the shared responsibility of the owner, the conservation professional, and (when applicable) the originator (General Obligation no. 1). The originator is defined in the code not only as the creator of the object, but also as his/her representatives "by legal, moral, or spiritual right." This is standard procedure regarding, for example, copyright issues (legal), and it also recognizes the right of religious or ceremonial authorities (spiritual) and community or extended family interests (moral).

In ethnographic conservation, however, those traditionally consulted in order to gain a better understanding of the "intent of the originator" have not been the originators themselves or their descendants but, rather, other professionals (museum curators, art historians, anthropologists). In the current US code, "intent of the artist" has been replaced by "an informed respect for the cultural property ... and the people or person who created it." Respect, however, is not defined; and there are no guidelines regarding what constitutes showing appropriate respect. In the New Zealand code, the language used with regard to intent is strong, as may be seen in the description of responsibility to the owner.

The concerns faced by contemporary art conservators regarding the "intent of the artist" may mirror those faced by ethnographic conservators. Conservators of contemporary art sometimes find that their philosophy and practice conflict with the wishes of the artist (see, for example, Domergue, Lowinger et al. 1987; Merk 1987). One notable difference, however, is that the overriding context within fine arts is usually one of preserving the object while honouring the artist's intent, whereas in ethnographic conservation the intent of preservation itself may be challenged.

Use Versus Preservation

Certain objects in museum collections have been classified as "functional objects" and are used, or "run," rather than preserved according to the norms of standard museum practice. Use in itself can be said to be contrary to the usual purpose of museums. As Ferrell (1991, 44) has argued: "Artifacts enter museums when they cease to be useful." According to this definition, a museum artifact is one that de facto is no longer useful or is no longer fulfilling its original purpose. It has, however, acquired a museum-defined utility such as, for example, usefulness for research or education. Ashley-Smith (1995, 4), interpreting the Victoria and Albert Museum's mission statement, says that the use of an object is that it is capable of being enjoyed or adding to understanding. Rose (1988, 50) comments as follows regarding the parameters of ethnographic collections: "The conservation of an ethnographic object should be based upon a thorough understanding of the purpose in collecting and using that object within the museum community." That is, museum purposes must be recognized.

In general, "functional objects" are pieces that will be misunderstood or unappreciated unless they are restored to a functioning state. As Keene (1994, 19) points out, objects in museums are not just sources of information, but also vehicles for conveying information. When older objects are returned to a functioning state, however, there is a clear possibility that some of the elements that form part of their integrity will be lost. This may occur because: (1) the process of restoration sometimes necessitates alterations to, and possible removal of, both an object's physical and ephemeral aspects[3]; and (2) continual wear through ongoing use necessitates continual reconstruction.

Long-term preservation is, therefore, seen to be compromised when objects are allowed to be returned to a functioning state. Most objects considered in the category of "functional" are industrial vehicles such as locomotives, airplanes, or automobiles; decorative arts objects such as clocks; and machine-readable records such as sound recordings and computer data, which exist in a physical form but remain incomprehensible if they are not "played." Some excellent papers detailing the issues and ethics surrounding functional objects can be found in conservation and museum literature, and in the literature of avocational groups who restore industrially made vehicles. This literature has not, up to this point, considered ritual objects to be within the category of functional objects. The following points have

3 The "ephemeral" refers here to those aspects of an object's construction that are intentional parts of its craftmanship or design but that are either not represented materially (such as the spaces between physical elements) or are represented by materials that are deemed marginal or subordinate to the main object (for example pencil marks on the inside).

been made concerning the question of returning some objects in museum collections to a functioning state, so that they can be used or operated:

1 Technology plays a role of major significance in the construction of Western society, but the average person cannot comprehend its technical significance: operating machinery, for example, assists in the understanding of the artifact's intent; that is, "what the machine was used for and how it performed its tasks" (Bowditch 1991, 4).
2 "Motion is truly the soul and spirit of the machine," "Static displays of machinery might be likened to still photographs of dancers" (Bowditch 1991, 3, 5). The conceptual integrity of the artifact is not complete when the object is static.
3 Some objects, such as carriages, are restored to a functioning state even though they themselves are not mechanical objects. Strictly speaking, carriages do not need to be driven to be understood because the motion is provided by the horse and is not intrinsic to the vehicle. Due to technical obsolescence, however, carriages do belong to a class of objects that have undergone a transformation from "useful object," or even "aesthetic and useful object," to something that, in Ferrell's (1991, 44) words, "other than [through] nostalgic associations ... [has been] deleted from cultural memory." Ferrell documents the destruction of complex historic information due to the poor restoration of carriages and maintains that reproductions can satisfactorily accomplish the purpose of understanding the intent of the object.
4 Dick (1991) and Gray (1991) discuss ego satisfaction on the part of enthusiasts and/or museum personnel as a primary motivator for having objects restored to a functioning state. Operation becomes the definition of preservation: "Specimens ... are only fulfilled if they operate ... Our standard language deprives them of vitality if they aren't fired-up: ... 'live' steam, a cold engine is 'dead'" (Gray 1991, 15-6). As a writer for *TIGHAR Tracks* (the publication of the International Group for Historic Aircraft Recovery) perceptively suggests, however, "somewhere along the way our instinct to preserve got tangled up with our love of flying, and we started preserving airworthiness instead of airplanes" (Anon. 1991, 1).

It should be noted that the ethics of the "use-versus-preservation" debate regarding material heritage have been reconfigured in relation to architectural heritage. Buildings are usually, although not always, immovable, subject to the extremities of outdoor exposure, and expensive to maintain. Their continued preservation in the face of natural deterioration and urban development rests, in part, on finding uses that are both compatible to them and can help sustain them financially. Feilden (1981) states unreservedly

that the best way of preserving buildings is to keep them in use. Modern use, however, almost always necessitates alterations to the original physical structure (e.g., to bring the building up to fire code standards or to make it wheelchair accessible). The ethical compromises one sees in architectural restoration may be unacceptable in other areas of conservation.

Within a museum the preservation-versus-use debate is often situated within that institution's politics and power struggles. It is usually the curators or the educators who wish the object to be restored to a functioning state, and it is usually the conservators who are in the position of advocating for the artifact. Weil (1990, 28) expresses the differences between curators and conservators as follows: "Their [museums'] ultimate importance must lie not in their ability to acquire and care for objects – important as that may be – but in their ability to take such objects and put them to some worthwhile use." As the former director of the Museum of Anthropology at UBC has asked, "Preservation for what purpose?" Ames (personal communication 1991) points out that preservation, like use, has served particular interests: "Why, for example, can only the courier from the British Museum handle an object we borrow, when I can go to the BM stores and plough through the stuff on my own?" Later, he says: "The main point is ... museum rules serve the interests of those who make them, and not just the interests of the objects" (Ames, personal communication, 1997).

One question conservators would raise in response to Weil and Ames' concerns whether "museum use" necessitates physical use or whether its intention can be accomplished in a manner more compatible with preserving the physical object. Curators and educators may well be able to accomplish their goals in ways that do not involve risk to object but this situation is quite different from, for example, those of people concerned with sound recordings, which must be used at least once in order to be understood at all. As Keene (1994, 24) has noted with regard to computer records, "only by [restoring and running a historic computer] can software 'virtual' objects exist."

Conservators have most often taken the position that "the demands of long-term preservation must take precedence over short-term use" (Ward 1986, 9). However, the first statement in the Canadian Code of Ethics includes the word "use": "It is the responsibility of the conservation professional acting alone or with others, to strive constantly to maintain a balance between the need in society to use a cultural property, and to ensure the preservation of that cultural property" (CAC and CAPC 2000, 1). This raises the following questions: to which "society" is the document referring and what constitutes society's need to use designated historical objects? Is the toppling of statues during the post-Communist political upheaval in the Soviet Union an example of "need" (SOS! 1991)?

Conservators: Relationships and Responsibilities

The codes of ethics define a conservator's responsibility towards colleagues, the owner of the work, and the originator of the work. Regarding responsibility to the owner and responsibility to the originator, one can note that ownership falls within legal definitions and that there are strict protocols regarding appropriate professional behaviour. The responsibility to the originator is covered in less precise terms such as "respect." In many countries, however, if the object is a work of art, then responsibility to the originator is covered under copyright legislation. In Canada, for example, copyright law provides for the artist to retain both legal and moral rights to his or her creation.

The existence of copyright legislation, however, as well as related art gallery practice, means that conservators of contemporary art work with living artists to make conservation decisions. As has been noted, the question of First Nations legal rights is being determined largely outside of the museum sphere; however, the acknowledgment of moral rights is affecting the practice of many anthropology museums.

Conclusion

Chapter 2 explores the values and beliefs found in the field of conservation, with special reference to the conservation of Aboriginal material culture. It describes and situates the ethics and values of conservation vis-à-vis three major value systems: that of museums, that of science, and that of professions. It lays the groundwork for understanding how museums and museum conservators go about "preserving what is valued."

Chapter 2 illustrates that conservation, while having differences and disagreements with other museum sectors, is firmly enmeshed in and reflects most museum values. Conservation contributes significantly to the curatorial mandate and to determining the rendering of the object that will be seen and kept. Chapter 1 shows how science came to be one of the defining characteristics of the field of conservation, and Chapter 2 shows that its values are still strongly adhered to, although some conservators recognize that subjectivity plays a role even in conservation practices based on a scientific approach. Professionalization has contributed its own set of values to conservation, although some of its elements are still not clearly defined. For example, who are the clients of conservation? and to whom are conservators responsible? The answers to these questions have a bearing on how conservators construct their work in relation to First Nations.

Chapter 2 examines conservation by reviewing both its professional codes of ethics and how conservators themselves look at what they do. It highlights beliefs pertinent to First Nations perspectives: these include conservators' perspectives on what they are preserving, both in relation to "integrity

of the object" and "cultural significance"; opinions on use versus preservation; the responsibility of the conservator to the originator of the piece; and conservation practice in relation to material culture deemed sacred by its originators. The following chapters discuss First Nations perspectives on these issues.

Part 2
Preservation and First Nations

3
First Nations Perspectives on Preservation and Museums

The conservation of museum collections is not a frequent subject for First Nations writers, even within the small but growing Aboriginal-authored literature pertaining to museums and their collections. Repatriation and representation are the two most discussed areas in this literature. While both are beyond the specific focus of this book, they do reflect concerns about cultural authority and recognition, and these are also part of the museum/cultural preservation discourse. In addition, there is a growing Aboriginal-authored literature concerned with the protection of indigenous knowledge and creations. This literature extends through many fields, from pharmacy to archival studies.

Before proceeding with Part 2, it is important to consider whether separating museum perspectives and First Nations perspectives on preservation by relegating them to two separate chapters serves to create a structural paradigm of two distinct points of view, which could be misleading, generalizing, and falsely oppositional. Furthermore, does it serve to resurrect a professionally familiar but highly questionable "us"-and-"them" approach? Separate chapters can serve to lessen the acknowledgment of the fact that there is a reality of experiences and knowledge made up of both perspectives. For example, there are First Nations professionals in museums; there are First Nations cultural centres that have professional museum components; and many contemporary Aboriginal people, both urban and non-urban, work closely with museums. Finally, categorizing museum and First Nations perspectives separately, with the former being presented first, risks creating a power/knowledge imbalance in which Western perspectives take precedence over non-Western perspectives.

I raise these points so that the reader does not unconsciously absorb the structure of this book in a way in which it was never intended. Because this book examines areas in which established museum conservation practice and First Nations have potentially conflicting viewpoints, it is necessary to

consider each viewpoint separately to fully understand the meaning and context of preservation in differing value systems. Furthermore, considering "distinct viewpoints" is not merely a Western academic construct: contemporary First Nations are proud of their cultural traditions and place great significance on their "radically differing perceptions of reality and concepts of cultural retention" (Moses 1993, 2) *(Moses: Delaware/Mohawk)*. For example, Atleo (1990, 3) compares Euro-based rational positivism with the "interconnected, holistic, and relational view which reflects a First Nations perspective of reality" *(Atleo: Nuu-Chah-Nulth)*. With regard to museums, this dichotomy will be seen, for example, in the comparison between the traditional museum and the National Museum of the American Indian (NMAI).

Bearing all of this in mind, I now turn to First Nations perspectives. Chapter 3 examines written and other publicly articulated First Nations perspectives on preservation. Chapter 4 provides background on the First Nations of British Columbia for readers unfamiliar with this area. Chapters 5 and 6 report on interviews and conversations about preservation with First Nations individuals, first in British Columbia and then in New Zealand. Chapter 7 serves as a conclusion to Part 2.

Before beginning, though, I would like to alert the reader to one further consideration. In both the literature and the interviews/conversations, most of the First Nations speakers clearly state that they are representing their own personal views and are not official spokespeople for their respective communities or nations. As Claxton (1994b, 1) states: "I cannot speak for other Nations, this is protocol, that we respect what belongs to others and not place our opinion on objects we know nothing about" *(Claxton: Coast Salish)*. With regard to the citations presented in these chapters, the reader is encouraged to recognize the limitations of quotations, which represent only a portion of what has been stated by the writers and speakers. In addition, it is worth remembering that the First Nations individuals cited represent people of different cultures as well as different ages, experiences, genders, and so on.

Mithlo (2001, 4), whom the reader met on the first page of this book, follows anthropologist Edward Spicer (Spicer and Thompson, 1972) in regarding historical experience as having precedence over language, kinship, and customs as the primary factor in constructing social identity. She adds that, in her country, the United States, Native Americans are treated federally as a common group, regardless of distinctive cultural classifications observed by the tribes and clans themselves. "This control of native identity results in shared experiences of natives in regards not only to the loss of land and language noted by Spicer, but also in relationship to contemporary social experiences such as boarding school trauma, a high incidence of substance abuse, endemic poverty and continued racial discrimination ...

Not only then is there internal justification for utilizing the concept of a Native American identity (following Spicer's argument of shared historical experience), there also exists a legal precedent for consideration of the many tribes composing a pan-Indian constituency" (4,5). In this book, however, peoples' statements should be regarded as individual opinions. Likewise, the information gathered throughout Part 2 in the form of tables should not be read as generalizations but, rather, as summaries of main points.

It is important to note that, while conservators also represent a diversity of social factors and opinions, their voluntary adherence to similar professional codes of ethics enables certain generalizations to be made about their values and beliefs. The same cannot be said of First Nations values and beliefs.

This chapter addresses First Nations viewpoints on the meaning of preservation, the role objects play in cultural preservation, and the role and nature of museums. I present published or publicly articulated perspectives from Aboriginal people in Canada, the United States, New Zealand, and, in a few cases, other countries. I present them together to illustrate that, despite great cultural differences, there exist shared perspectives regarding the fundamental importance of preserving indigenous cultural beliefs and lifeways. In addition, these perspectives often differ from those of museums.

The reader should note that, as I explained in the Introduction, in *Preserving What Is Valued*, First Nations names are written without their diacritical marks. Not all sources include diacritical marks in their orthography, and, rather than use them for some names but not all, I decided to use the spellings that are most often seen in English. For example, Sto:lo and Kwakwaka'wakw would read Stó:lo and Kwakwaka'wakw in some First Nations sources; 'Namgis and Nisga'a would read 'Namgis and Nisga'a. I regret any inaccuracies the convention adopted for this book presents. I would also like the reader to note that a glossary of Maori words is included in Appendix C.

Meaning of Preservation

The following quotations illustrate the meaning of "preservation" for several indigenous organizations.

> The Keepers of the Treasures is a cultural council of American Indians, Alaska Natives and Native Hawaiians who preserve, affirm and celebrate their cultures through traditions and programs that maintain their native languages and lifeways. The Keepers protects and conserves places that are historic and sacred to indigenous peoples. (Keepers of the Treasures 1994, 9)

> [The seventeen Shuswap bands] declared their intentions to work *in unity* to *preserve, record, perpetuate and enhance the Shuswap language, history and culture.* It is with these principles in mind that the Shuswap people approach

the work of the Task Force [Task Force on Museums and First Peoples co-sponsored by the Assembly of First Nations and the Canadian Museums Association]. Any work or report which comes out of the meetings taking place between the museum and native communities must have at its heart the preservation, perpetuation and enhancement of native culture. These principles embody everything for which the Secwepemc [Cultural Education Society] strive[s]. (Secwepemc Cultural Education Society 1991, 1)

Michael Pratt *(Osage)*, sums up the meaning of preservation as follows: "We all possess one common goal. It is the retention and the preservation of the American Indian way of life" (cited in Parker 1990, 3).

The following quotations illustrate Aboriginal perspectives on the preservation of material culture:

Ed Ladd *(Ladd: Zuni)* asked, "what is the significance to preservation" when there are only objects left? (Ladd, cited in Clavir 1992, 2)

I called for a new approach to preservation that goes beyond the old concept of holding objects in the name of the public, and instead, sees the reconnection of objects to community as an essential step in cultural preservation. I said that museums are in a unique position to assist Indian communities in the revival and retention of their spiritual traditions ... The return of objects of cultural patrimony must take place while there are still tribal elders who remember their uses. If there is no one left who knows the stories, the songs, and the ways to properly handle the objects, how can their culture be preserved? (Hill 1993, 9) *(Hill: Mohawk)*

The unique feature of a distinctively traditional First Nations approach to the preservation of a specific cultural property is that the very act of preservation typically marks the point of intersection between the performance of a ritual observance or the fulfillment of a religious obligation, and the physical maintenance of the object itself. (Moses 1993, 3) *(Moses: Delaware/ Mohawk)*

Maori history is carried in material culture but also in spiritual and cultural mediums. They are all dependent on one another and important to sustaining Maori as a people. To conserve the material culture requires an understanding and participation in the culture itself to ensure the maintenance of all values and relationships significant to an object or structure. (Whiting 1995, 15) *(Whiting: Te Whanau-a-Apanui)*

At the Woodland Cultural Centre, we have Policies for Sacred and Sensitive Items as part of Collections Management which guide us in caring for

culturally significant items. The Woodland Museum was established as an integral element of the Woodland Cultural Centre, with a mandate to collect, preserve, research, exhibit and interpret a collection of archaeological material, historical material, arts, crafts, documents and archival photographs. (Harris 1993, 32) *(Harris: Iroquois/Six Nations)*

The oldest of our material cultural treasures are those of the Maori ... [They have been] ... fashioned into a great variety of objects of great beauty, many of which have a spiritual and cultural significance which, along with the objects themselves, must not be lost to us. (McKenzie 1987/8, 35) *(McKenzie: Rangitane)*

According to the people quoted above preservation means cultural preservation: the active maintenance of continuity with indigenous values and beliefs that are part of a community's identity. As Parker (1990, i) says: "In meetings and correspondence with the National Park Service, Indian tribes made clear their unique perspectives on historic preservation. Tribes seek to preserve their cultural heritage as a living part of contemporary life: in other words, preserving not only historic properties but languages, traditions, and lifeways."

This holistic view can be seen not only in individual opinions, but also in the practices of Canadian First Nations cultural education centres such as the Woodland Cultural Centre and the Secwepemc Cultural Education Society, both of which have professional museum components with conventional museum mandates but also espouse the "wider objectives of community-based cultural conservation" (Galla 1994, 1) *(Galla: indigenous/India)*.

Within First Nations writing, it is important to observe how often words denoting activity and life are linked to words denoting preservation. Words and phrases such as "revival" and "performance of ritual" will be found in many subsequent quotations. Many of the following First Nations comments concern the experience of and reasons for losses and changes in cultural traditions as well as a positive feeling about being identified as Aboriginal peoples. Over the last several hundred years, traditional cultural memory has been broken up and elements have been lost. In words such as "retain," "renew," and "regain" the emphasis is on the active prefix "re."

Importance of Identity for First Nations
First Nations peoples have expressed a strong link between cultural preservation and a positive identity as First Nations. Cultural identity is particularly important for First Nations within today's changing socio-political situation. As has been discussed in the Introduction, within the last two decades First Nations in Canada and the United States are seeing the recognition of Aboriginal rights in legal, political, economic, territorial, and cultural

spheres. In the 1990s this involved Aboriginal peoples regaining some measure of control over community and territorial matters. It is not surprising to see the link between assuming control and building a strong cultural identity, especially after generations of government-supported policies that actively repressed Aboriginal socio-cultural expression. In addition, Aboriginal communities are striving to retain their languages and other cultural elements (e.g., through recording cultural information from the diminishing numbers of elders who grew up with a strong base in traditional cultural knowledge) and transmitting them to younger generations.

The cultural and societal changes experienced by First Nations have meant that their cultural losses differ qualitatively from those experienced by the dominant cultures. For example, in an article about Robert Davidson, a renowned Haida artist who works primarily with traditional styles, Laurence (1993, 7) writes:

> Although he heard his grandparents speaking Haida and saw his father and grandfather carving miniature poles in argillite, Davidson grew up speaking English only ... Achieving self-awareness in a community largely separated from its artistic, linguistic and ritual inheritance, he had no sense of being Haida. "I didn't hear my first Haida song until I was 16," Davidson says. "That's how far removed we were from the culture."

Although many museums preserve the surviving fragments of Western historical material culture, in the eyes of First Nations, anthropology museums preserve the history of colonialism and the rapid and extensive changes that it brought, "Firstly, we have suffered from a loss of our traditions and secondly, we lack the resources to stop this runaway process of cultural deterioration" (Crowshoe 1994, 1) *(Crowshoe: Peigan)*. Museum collections stand as a symbol of the power relationships that led to that "cultural deterioration."

> In the process of the making of Canada, there has been an attempt to subsume aboriginal cultures under Canadian political authority. This has lead to the separation of contemporary Aboriginal communities from our own pasts. (Doxtator 1996, 62)

As will be seen in Chapter 4 ("First Nations of British Columbia"), government policies suppressed Aboriginal cultural expression as well as many other aspects of Aboriginal societies. The museum-related literature written by the First Nations of various countries shows the importance of the link between the loss of indigenous cultural heritage (as well as the current efforts to restore it), positive identity, and community strength. This

can be seen, for example, in the following comments regarding museum collections.

The social, economic and political climate makes life extremely difficult for many Maori people. Museums, through the cultural treasures they possess, thus become more important as places where self-worth, identity and self-determination can be regained and act as catalysts for growth. (Hakiwai 1995, 289)

Many First Nations now wish to access or regain control over their material and intellectual heritage stored and exhibited in non-Aboriginal museums. (Eastern Working Group 1991, 1)

Webster (1992a, 37) expresses the significance of regaining control over one's heritage as follows: "We are taking back, from many sources, information about our culture and our history, to help us rebuild our world which was almost shattered during the bad times" *(Webster: 'Namgis [Kwakwaka'wakw])*.

With regard to museums, First Nations want to regain control both in the area of collections and in the area of representation. McCormick was a spokesperson for the Native Council of Canada:

We are talking about taking control over our own lives, our cultures, and most importantly, the interpretation of our cultures, past and present. (McCormick 1988, 1) *(McCormick: Cree)*

Cultural autonomy signifies a right to cultural specificity, a right to one's origins and histories as told from within the culture and not as mediated from without. (Todd 1990, 24) *(Todd: Metis, Alberta)*

There is an emphasis on the importance of regaining both the tangible elements and the intangible elements of culture: "As bad as the losses were in terms of land, lives and culture, a greater loss was Indian pride. This essential source of strength, which kept them together as a people, was lost along with everything else. For people trying to contend with life and develop self-confidence it is essential that they have some control over their lives and their material culture. It is degrading to be forever at the whim of others" (Horse Capture 1991, 50) *(Horse Capture: Gros Ventre)*.

The importance of regaining the past by bringing it – in the form of knowledge, materials, and representation – back into one's culture and under one's control is evident in how crucial this is to First Nations identity. Recovering from the experience of colonization, First Nations have a positive attitude

towards their identity, especially those aspects of it that include intangible elements such as pride and strength. Having control over the tangible objects in museums plays a role in having control over the intangibles, as is seen in Hakiwai's comment. This also applies to the creation of contemporary Aboriginal art:

> It has been a life long dream of mine to help bring the art form of my ancestors to be recognized as great art, placed along side all the other great art of the world, to bring it beyond the curio attitude which it has suffered since contact ...
>
> I have always felt alien to art galleries until my showing here. In showing my work you have opened the door to many other artists who are working to validate their work as true art.
>
> Our art has helped us as a people to reconnect with our cultural past, helped us in regaining our own identity, giving us strength to reclaim our place in the world. (Davidson 1993)

Museum Values

Basic differences in emphasis between museum perspectives and First Nations perspectives can be represented schematically, as shown in Table 1.

I will now compare many of the museum values expressed in Chapters 1 and 2 with First Nations values (as expressed in their literature and/or public statements). It is necessary to reiterate that any tendency towards generalization must be tempered with the knowledge that there are hundreds of distinct Aboriginal cultures in North America alone – all having various histories, cultural differences, and contemporary outlooks, and all containing individuals with various perspectives.

The National Museum of the American Indian (NMAI), which is part of the Smithsonian Institution, is a largely Native American-managed and -staffed museum that hopes, in the words of its director, "to re-analyze,

Table 1

"Preservation": Museum and First Nations perspectives

Traditional museum	First Nations
Preservation of objects	Preservation of traditional cultural practice, Aboriginal values
Rationale: Loss of material culture, knowledge	*Rationale*: Loss of parts of culture, positive identity, control
Preservation of the past as a positive value: objects are witnesses to the past	Preservation is positive in the context of self-determination: renewal, living expression; objects are part of living cultures today

Table 2

The traditional museum and the National Museum of the American Indian (NMAI)

Traditional museum	NMAI
Preserves objects	Preserves culture
Conserves objects	Cares for objects
Displays objects	Uses objects
Object-based	People-based
Objects are out of their cultural context	Objects, people, and the environment are related to each other
Looks at the past	Integrates the past, the present, and the future
Objects are considered inert	Supports the Native American philosophy that objects are living and require air and natural light

Source: Swentzell 1991.

redirect and, in many cases, reformulate entirely the concepts and presentations of the past concerning Indian culture" (West 1991, 24)*(West: Cheyenne-Arapaho)*. NMAI has conducted numerous consultations with Aboriginal people across North America on many aspects of museum development, collections, and programming. Table 2 briefly summarizes some of their conclusions with regard to museums and objects.

Other museum and First Nations values and beliefs that appear to be in conflict with one another can be summarized in Table 3. Note that this table highlights areas of apparent contradiction between museums and First Nations; later discussions will expand on beliefs and values that appear less contradictory. Note also that this table represents conventional museum beliefs and that, as museums change, not all these statements will continue to hold true. The purpose of Table 3 is to set out and summarize key differences between the viewpoints of museums and those of First Nations. Beliefs pertaining specifically to conservation, such as object preservation versus use, and appropriate treatment of objects considered sacred or sensitive, are considered in more detail later in this chapter. I have included quotations in the table so that the reader can hear from individual First Nations members directly.

First Nations Perspectives on Museums

Museum and First Nations perspectives differ not only intellectually, but also emotionally. There is different emotional resonance implicit in many of the above statements. I now turn to some examples of differing perspectives and then to the positive and negative perceptions of museums held by First Nations people.

Table 3

Beliefs and values, museums and First Nations: Differences in perspective

Traditional museum	First Nations
Importance of heritage objects	"The objects themselves are not important; what matters is what the objects represent. They represent the right to own that thing, and that right remains even if the object decays or is otherwise lost" (Webster 1986, 77). "The [Kwakiutl] elders spoke of the importance for young people to know and touch their past [the repatriated objects] if they are to have an identity in the future" (Morrison 1993, 6). "What will they remember if we don't show them anything?" (Alicie Araqutak, Avataq Cultural Institute, quoted in Haagen 1990, 77).
Prevention of deterioration, preservation of culturally designated objects	Some objects meant to deteriorate and complete their natural cycle. "The emphasis on preserving the [Athapascan] Native elders' material culture was often contrary to their holistic belief that these goods should return to nature to nurture future generations" (Wright 1994, 1). "One person stated that there is not a single item in his culture which is used for religious or ceremonial purposes which is meant to be preserved in perpetuity. All are gifts to the Gods which are meant to disintegrate back into the earth to do their work" (Clavir 1992, 8). "It is also patronizing to assume that indigenous people necessarily believe that all their works should complete a natural cycle and be allowed to degrade and eventually return to the soil. Like other people, Maori wish to keep records of their achievements and history" (Heikell, Whiting, et al. 1995, 15).
Objects contain encoded knowledge.	Knowledge resides with the elders and is passed on generation to generation. "The attachment to material goods, however, did not ensure survival for these [Athapascan] people. It was the knowledge gained through oral narratives that provided necessary lessons in survival skills" (Wright 1994, 1).

▶

◄ *Table 3*

Traditional museum	First Nations
Objects very important; provide tangible evidence	Songs, oral history and genealogy, rights and privileges, and other "intangibles" highly important as evidence. "The objects themselves confirm the stories that have been heard by native people over the years" (Hill 1993, 10).
Loss of authenticity/ integrity in an object = loss of tangible link with past	Link with past is made tangible by participating in traditional lifeways.
Intangibles of culture are shown through animated museum environments (Macdonald 1992).	Intangibles are shown through rituals, community, and other cultural events. "A museum is not necessarily the setting in which one can hope to experience or comprehend the significance of sacred objects, either from the viewpoint of those who created them, or from the viewpoint of those for whose benefit they were created and originally maintained" (Moses 1995, 18).
Museums: a European tradition	Museums and similar institutions not part of indigenous cultures. Culturally significant objects used and cared for by religious societies, within families, etc., and displayed in appropriate cultural contexts. Objects beyond usefulness often ritually retired (e.g., some burned or buried).
Collecting and museums historically represent European "superiority," European roots.	"To Canadian nationalists, the necessity of belief in the superiority of Anglo-Canadian society doomed aboriginal peoples to extinction and assimilation" (Doxtator 1996, 61).
Ethnographic collections made to represent people who were believed to be disappearing	"My culture has survived, but as a refugee in my own land (McCormick 1988, 4). "We are not dead. We did no die out before the turn of the century and we're not a diluted form of the supposed 'real' and 'authentic' Maori" (Hakiwai 1995, 287).

►

◄ *Table 3*

Traditional museum	First Nations
	"All previous anthropological and social theorizations notwithstanding, and despite the best efforts of the combined European and western military, political and religious complexes, the Native peoples of North America have not become extinct over the course of these past five centuries, and traditional indigenous systems of religion and spirituality remain vibrant features of daily life in many First Nations communities" (Moses 1993, 7). See also Tamarapa (1996, 42).
Public museums represent secular, scientific values.	Traditional spiritual values at the heart of cultural renewal. Preference for explaining world on basis of spiritual beliefs. "Some [museum people] place science as the ultimate human endeavor, above the law, above the religious rights or human rights of Indians" (Hill 1993, 9). See also Harris (1993). "The distinction between science and mythology has to be rejected because both are equally ideological" (Bedard 1993, 7-8).
Public service mandate	"Museums were not founded to serve the needs of the Maori people but rather to entomb us and our material culture. We were to become the prize exhibits of the nineteenth century, now safely 'domesticated' in museums" (Mead, as quoted in Tamarapa 1996, 162). "With the state presenting itself as the impartial coordinator and arbitrator among seemingly troublesome and demanding ethnic groups. It sees itself working 'for the benefit of all'" (Doxtador 1996, 61).
First Nations societies subject of scholarly studies; studies transmitted to public (e.g., via museums)	Desire not to be subjects of studies, especially if no benefit returns to them. (See, e.g., Nason 1981; Eastern Working Group 1991; Hill 1988.) Prefer co-equal partnerships in urban museum enterprise and control of community heritage.

►

◄ *Table 3*

Traditional museum	First Nations
Importance of legal ownership by museum. In addition, frequent contemporary acknowledgment of "moral" rights of others.	Importance of First Nations Ownership of their cultural heritage. "The dominant society owns the concept of museology while the First Nations people own the heritage represented in the relevant collections" (Atleo 1990, 3). "Museums are to acknowledge that there is a living culture associated with these 'taonga,' and that Maori people are the spiritual and cultural custodians ... Museums are the caretakers of the 'taonga,' not the owners; the 'mana' of the taonga resides with the 'iwi' from which it originates" (Tamarapa 1996, 163). "The somewhat illogical situation arises whereby the Crown of Canada, in existence for 127 years, assumes it has a greater right, a greater interest and connection, to aboriginal material of twenty-thousand years ago than do the aboriginal peoples who have always inhabited North America" (Doxtator 1996, 62). "Question: I was wondering whether the material that has been returned to your museum has its title of ownership actually transferred to your museum, or are the pieces on long-term loan? Answer: I guess it depends on who you are asking" (Webster 1986, 79).
Museum displays often represent static moments in linear time.	Cyclical and other concepts of time. "To most of Canadian society, the past is very separate from the present and future. The past is measured precisely in years and days ... To Native societies, the past is not as distinctly separate from the present (p. 27). [In museums] to see change or European influence in the construction of an object was to see loss of culture (p. 26) ... The physical expressions of traditions change ... but the most basic principles that direct those traditions remain ... and are not dependent upon chronological time" (Doxtator 1988).

►

◀ *Table 3*

Traditional museum	First Nations
	In our way of thinking, everything is a significant event, and the past is as real as us being here right now. We are all connected to the things that happened at the beginning of our existence. And those things live on as they are handed down to us" (Parris Butler, Fort Mohave, as quoted in Parker 1990, 5).
Democratic principles for public museums	1) Restrictions (viewing, handling, storage, use) may apply to certain objects (see Moses 1993, 5). 2) Access for average First Nations person to museum collections has been problematic. The "public" has been privileged to the detriment of particular stakeholders such as First Nations.
Right to know, understand the entire world	"The separate legal status of First Nations creates a need to recognize that each one has its own national patrimony [not just Canadian or American patrimony]" (R. Hill 1988, 32). Some knowledge is private. "Does the public have a right to know all, to see that which another culture considers too sacred to show, to possess another's cultural/spiritual legacy" (R. Hill 1988, 33)? "For many Natives (within traditional cultures), knowing is a privilege, not an absolute right ... [A]ccess ... is granted only after a prolonged period of initiation or indoctrination ... Uncontrolled access ... in many instances is considered capable of producing catastrophic results" (Moses 1995, 18). "Everything about us – from our languages to our philosophies, from our stories to our dances – has become material in a quest for further discovery, for new treasures ... our difference – is reduced to playing bit parts in the West's dreams" (Todd 1992, 71).
"Proper care" defined by conservation guidelines and methods.	"Proper care" defined by cultural guidelines and methods.

▶

◀ *Table 3*

Traditional museum	First Nations
	"There are Elders and other members of our community who have never seen one of our religious objects deteriorate while being functional. Perhaps the love, respect, proper maintenance and usage of an object, carried out in accordance with custom and by persons with knowledge of the traditional ceremonial and religious rites, is in actual fact the only true 'conservation' of a sacred and sensitive artifact" (Harris 1993, 33).
Authority of museums, government, other sanctioned institutions of majority culture.	Authority of Creator, elders, hereditary and elected chiefs, religious and family authorities.
In museums, exclusionary power of those trained over those not trained. Authority of western perspective and established museum practice.	In most countries, few First Nations people trained as museum professionals, few First Nations museums. "It cannot be stressed enough ... how much the dialogue and the attempts at cooperative solutioning must start from a base where the Western thinker psychologically strips himself or herself of convictions and perceptions. It might be the only way of participating in cooperation on an egalitarian basis" (Branche 1996, 125).
Artist's intent key to meaning of object.	Cultural intent: original use of object key to meaning. "Museums may be able to preserve the 'artifacts,' but only the people who are directly dedicated to a culture can preserve and utilize the objects in question" (Harris 1993, 32).
Cultural significance of object from curatorial knowledge, catalogued by museum.	Cultural significance of object from elders, lived experience; "use" necessary to complete conceptual integrity. "Priority [at the Woodland Cultural Centre] will be given to [the artifact's] traditional ceremonial function as opposed to its museological significance" (Harris 1993, 33). Sacred/sensitive objects of most concern, but ordinary objects may have great cultural significance. (Phillips 1991, personal colmmunication; Morrison 1993).

▶

◀ *Table 3*

Traditional museum	First Nations
Museums are ethical (follow codes of ethics)	"How often have we heard museum directors and curators say, 'We're not responsible today for what was done in the past' or 'If we hadn't taken care of these artifacts all these years, they would have disappeared'? Such statements do not justify the holding by major museums of materials acquired in a dubious manner. My question to museums out there is, 'Why would you want to keep objects that you know, or even suspect, may have been stolen or otherwise illegally acquired.' If you can't answer that honestly, don't talk to me about your ethics" (Webster 1988, 44). See also Echo-Hawk 1993.
Value of authenticity	Both points of view represented: "I think we saved the remnants of some of the great images of the nineteenth century" (re: moving totem poles from Haida Gwaii to MOA). "Carve copies before they rot (and leave poles in place) and these poles will be around forever" (Wilson as quoted in Cernetig 1989, D7). See also Webster 1986.

Positive Perceptions of Museums

Some First Nations people have expressed an appreciation of museums and their work. For example, according to Tamarapa (1996, 67): "Many Maori are aware of the benefits that museums have as places of professional care and responsibility."

Horse Capture (1991, 50-1), a museum curator and consultant from the Gros Ventre nation, tempers Tamarapa's positive view with the following observations:

Native Americans, and perhaps other tribal peoples as well, have therefore a strange and special link with museums that has been described as a love/hate relationship. Many Indians appreciate the fact that for many reasons, the material that has survived is to be found in museums, where it is pre-served and researched. The hate aspect comes from the fact that these mu-seums are usually far away from Indian homes, and the materials are hence inaccessible to them. So the Indian people went to museums searching for ways to restore their culture. For the most part, they were viewed with sus-picion or outright hostility.

The same mixed feelings have also been expressed in New Zealand: "For the Maori people there has been a great degree of ambivalence towards museums. They are important and respected places because of the cultural wealth they possess but concurrently many Maori people feel anger and resentment in the way that museums have acted as 'experts' and managers of cultural heritage and knowledge systems" (Hakiwai 1995, 287).

The importance of museum training and of First Nations museum and other specialist professionals has been acknowledged. The Museums Association of the Caribbean held a workshop in 1993 that made the following recommendation: "Museums should provide education in techniques for care and preservation of artifacts for cultural groups" (Branche 1996, 126). In Canada, in a more politicized context, McCormick (1988, 3) suggested: "It will be our elders and specialists, our historians and anthropologists, our scientists, who from now on will be the interpreters of our Culture. That is what self-determination means and we will have no less."

First Nations museum professionals uphold museum values as well as their own cultural values, and they have expressed that this sometimes causes conflict for them.

> To ask ourselves to relinquish our senior museum positions to the seer of a "tribe" or to allow leaders to bang drums or spread salt on votive bowls from a museum collection is like wrenching our museological souls from our very beings. (Branche 1996, 121)

> I never thought I would say this, but in a way it was fortunate that the collection was returned in such terrible shape, because we were able to convince people that the objects were much too fragile to be used. (Webster 1986, 78) (See also Harris 1993)

Moses (1993, 7), a conservator, writes about the contradiction between the purpose of museum preservation and the purpose of cultural preservation: "The specific issue at hand is whether such objects are to be artificially maintained within the sterile environment of the Euro-North American-controlled museum, or whether they are to be returned to the heart of the living cultures from which they originate."

Negative Perceptions of Museums

Negative First Nations perceptions of museums have been given considerable voice. "As Gloria Cranmer-Webster stated at the concluding conference of the Task Force [Task Force, Museums and First Peoples, 1992]: 'We don't want museums.' The word 'museum' has a negative connotation signifying the place where dead things lie and where native people don't go" (Doxtator 1996, 64).

Moses (1995, 18) observes that museums "remain painful symbols and reminders of cultural loss and deprivation." Tamarapa (1996, 162) cites a Maori presenter at the national New Zealand museum conference in 1985: "The Museum represents a place of death, of bones, of plunder and relics and pillage." A Maori curator writes: "Museums are seen by many as a sad legacy of the past imbued with a continuing sense of paternalistic colonialism and monoculturalism" (Hakiwai 1995, 286).

Museums have housed the tangible symbols of fundamental aspects of the culture of many First Nations, and, in so doing, they have acquired a negative signification for many First Nations. Museums themselves have become the symbols of historic, repressive, and often racist dominance: "Museums remain to remind us of the horrors of our colonial past" (Atleo 1990, 13). Furthermore, the housing of these "signs" "placed the museum in the role of guardian of authentic symbols of 'Indianness'" (Doxtator 1988, 26). The museum developed a vested interest in presenting an image of First Nations as peoples of the past. Museums had been invested with the authority to speak about and display images of First Nations, while First Nations were excluded from any role in representing their own reality.

It is also offensive to many First Nations that museums often present a one-sided historical view of Aboriginal peoples. In 1994, for example, a resolution from the Commonwealth Association of Museums "support[ed] ... re-defining ... the idea of 'museum' from houses of indigenous peoples from the past (not as dead) and consider[ed] that museums house cultures and cultural meanings that reflect for indigenous people living culture" (Commonwealth Association of Museums 1994, 1).

The following poem by a Native American captures the resentment that many Aboriginal people feel towards museums and the majority culture.

Evolution[1]

Buffalo Bill opens a pawn shop on the reservation
right across the border from the liquor store
and he stays open 24 hours a day, 7 days a week

and the Indians come running in with jewelry
television sets, a VCR, a full-length beaded buckskin outfit
it took Inez Muse 12 years to finish. Buffalo Bill

takes everything the Indians have to offer, keeps it
all catalogued and filed in a storage room. The Indians
pawn their hands, saving the thumbs for the last, they pawn

1 Reprinted from *The Business of Fancydancing*, © 1992 by Sherman Alexie, by permission of Hanging Loose Press.

their skeletons, falling endlessly from the skin
and when the last Indian has pawned everything
but his heart, Buffalo Bill takes that for twenty bucks

closes up the pawn shop, paints a new sign over the old
calls his venture THE MUSEUM OF NATIVE AMERICAN CULTURES
charges the Indians five bucks a head to enter.

(Alexie 1992, 48)*(Alexie: Spokane/Coeur d'Alène)*

Negative Perceptions of Museum Practice

The museum process as well as the museum itself may carry a negative symbolic meaning for First Nations people. Moses (1993, 7) argues:

> Conservation issues quite aside, many Native peoples, on principle, take exception to the imposition of any such requirements, (such as requiring repatriated materials to be provided with certain prescribed standards of physical care in terms of security, environmental control, and so on) and consider them to be essentially a means by which the Euro-North American museum community attempts to force from the First Nations a tacit acknowledgment that the dominant society has the right to control and regulate the access of First Nations peoples to their own cultural patrimony.

A harsher view of museums and the museum process, which compares standard museum and conservation practice with prison practice, was manifested publicly in 1995 by two Shuswap (Interior Salish) men who went on a hunger strike outside the Royal British Columbia Museum (RBCM) in Victoria as a protest against the museum's refusal to return human remains. A newspaper reported that an unsigned statement, presumably from the protesters, described the human remains as "incarcerated ancestors – imprisoned in numbered cardboard boxes in a sterile cement room" (Crawley 1995, B1). (The RBCM said that it supports the return of human remains but that it requires First Nations community sanction of the request [e.g., having the request come from the band council].)

The word "collected," which usually has a positive value in Western society, has often been replaced in discussions by First Nations individuals with words such as "taken" and "stolen." Museums may also be particularly offensive to First Nations because they continue to house human remains.

A well-known First Nations artist writes negatively about museum practice and an exhibit shown at the UBC Museum of Anthropology:

> Desire. Is there desire in the museum? Oh no, desire would assume too many feelings: need, greed, jealousy, rapture. No, there is desire, but it is

hidden. In the not so distant yesterday desire was hidden by the guise of objectivity. Today, this modern architecture with many windows, architecture with hints of traditional long houses or teepees, or buildings with columns and dark corridors all hide the desire ... But back in the museum the act of desiring has many foils: collecting, cataloguing, preserving, maintaining, educating. (Todd 1993-4, 57)

Moses (1993) points out that many First Nations have traditional practices that enable them to preserve significant objects and that museums, which present themselves as institutions specialized in the preservation of valued material culture, have in fact allowed many pieces to deteriorate.

The discourse with which this book is concerned is occurring within a highly politicized and emotionally charged atmosphere. In some countries, the values of conservation and museums are being challenged to work within a framework that supports both museum and First Nations perspectives. Rethinking their concept and purpose is what Branche (1996, 131), Director of Museums in the Department of Museums in Belize, had in mind for museums when she concluded: "All the words come together to describe this type of change – challenging, uncomfortable, fearful, emotional, and yes, even unscientific. It is in the best interests of all that we consciously come to grips with this issue and make deliberate moves in this great transformation."

First Nations Perspectives on Selected Conservation Beliefs
The following sections give First Nations perspectives on key concepts seen in museum conservation.

Integrity
While preserving the integrity of the object is of primary concern to conservation, preserving the integrity of the indigenous culture and the cultural attributes of the objects within it is a primary concern of First Nations. This speaks to the holistic relationship of living people to their material culture and their desire that museums reflect this. "The most important fact that *Te Maori* taught the world is that Maoridom is a living culture and that our *taonga* express us as a people with a past, a present, and a future. As a result, museums were to admit they had not respected or acknowledged these intrinsic values" (Tamarapa 1996, 162).

Concerning heritage objects themselves, First Nations opinions reflect several ideas pertaining to the conservation model of "integrity." The first, as may be seen in the following quotations, is the view that First Nations cultural perspectives, not museological perspectives, should determine the parameters of the "integrity of the object."

Culturally significant Maori works should be decided by Maori people. This seems to be a reasonable and logical view to take. However in our colonial past acknowledged "experts" have often determined what is important about Maori people from historical (colonial) and aesthetic (colonial) considerations. (Heikell, Whiting et al. 1995, 15)

The artifact was initially made for a specific purpose, to perform a specific cultural function, and ... the natural deterioration of the artifact is therefore part of its actuality. (Harris 1993, 32)

Preserving "conceptual integrity" (as conservators would think of it) is extremely important, and this is emphasized in many First Nations statements, as will be seen in the section on cultural significance and sacred/sensitive objects. Consider, however, an interesting comparative example related by Welsh in Clavir (1992). Welsh, at the time a senior curator at the Heard Museum in Phoenix, Arizona, said that Navaho consultants objected to a particular basket being displayed because it closely resembled sacred/sensitive material. The basket was a known reproduction and had never been used ritually. In addition, certain elements of it were evidently physically different from those of the "original" basket. Although the basket was not "sacred," it had sufficient conceptual authenticity for the consultants to believe that it should not be displayed, and it was withdrawn from the exhibit.

Cultural Significance and Sacred/Sensitive Objects

Some First Nations people have stressed several issues pertaining to sacred/sensitive objects, the primary one being the overriding importance of respecting spiritual and ceremonial values. "Aboriginal people do believe in a grand narrative. We believe in the laws of the Creator. Laws are anathema to the postmodern. Some even call our Relationship to the Creator a covenant, a sacred agreement to protect the earth and the life it sustains" (Todd 1993-4, 60). This comment emphasizes the point that the cultural significance of certain objects, especially of sacred/sensitive objects, is far more important to the First Nations community than it is to the museum community. "There is a sense of balance that goes hand in hand with the restoration of the ritual associated with sacred objects ... The sacred duty has been performed. The people are fulfilled in a way that can only be experienced, not fully explained" (Hill 1993, 10). The importance of the cultural significance of objects to their originating culture includes:

1 Recognition of their fundamental necessity to the First Nation:

 In the traditional ceremony, the principal participants are the bundles/ ceremonialists, the hosts [and others] ... Creator's authority is recognized

in the bundles, thereby making the objects within them sacred ... At the signing of Treaty 7 in 1877, the Peigan Nitsitapi community was guided by 16 bundles/ceremonialists and 5 societies. (Crowshoe 1994, 6)

Most traditional materials are to some degree sacred in nature ... The most sacred items are communal and hence vitally important – meaning their repatriation could greatly benefit a living Indian community or group ...

An essential part of these Indian beliefs is the material itself. This could include sacred material or material of cultural patrimony. Both give direction, hope, pride, strength, and all the other essentials to survival. (Horse Capture 1991, 51)

2 The importance of the restoration/performance of ritual. "The [repatriated] objects stimulate the restoration of the ceremony. The ceremony, in turn, revitalizes the community" (Hill 1993, 10).

3 The continuing role in Aboriginal communities for sacred/sensitive objects that have been/are being housed in museums:

When you get to the level of sacred objects, they shouldn't even be in collections with a curator. They should be back among the people who handle and care for them. They were given to us, each one of them was given to us by our Creator and they are for us. They are not for the general public. (Pete Jemison, *Seneca,* in Parker 1990, 37)

We are asking for things back which have been with us for thousands of years. (Tallbull, in Clavir 1992, 31)

Other concerns are:

Privacy: Many authors referred to respecting privacy protocols pertaining to certain sacred/sensitive objects. "The fact remains that uninitiated individuals, female or male, non-Native or Native, should not have access to sacred or secret materials" (Moses 1993, 8).

Power: This is considered an inherent quality of certain objects. An analogy might be found in the comparison between a sample of granite and a sample of uranium in a natural history collection: both have a physical integrity that can be described by standard procedures, but the uranium has a powerful, invisible, intrinsic attribute. Those who know how to use it can do so for good or for evil purposes. Those who ignore it can be damaged by it. Thus there are strict protocols for handling it and using it (Phillips 1996). "Traditionally [western Plains] bundles are not the only objects which can be imbued with medicine or power. Certain types of shields and shield

covers, head-dresses, pipes, drums, and various articles of clothing and personal adornment, can also function as physical manifestations of this concept of medicine" (Moses 1993, 5).

Although objects in museums may have been separated from their originating community for a period of time, this rupture has not necessarily diminished their importance or their "power."

I know that respected elders from the Iroquois community in Oshwegan, called Six Nations, go there [Canadian Museum of Civilization] either annually or every two years to feed the false-face masks and that's needed. (Barnes 1993, 2) *(Barnes: Mohawk.)*

She [Linda Poolaw, of Delaware and Kiowa ancestry] would not touch it [an eagle feather fan] because it was a ceremonial object, but she said museum staff could handle it for her. (Kaminitz 1993, 6)

Spiritual items such as pipes, medicine bags or bundles can be documented for their educational or research value, and then returned to the people in the native community who are qualified to handle this material. (Secwepemc Cultural Education Society 1991, 2)

This last quotation as well as the following also highlight the point made by First Nations that they too, not only museums, are able to look after heritage objects: "[After repatriation] many communities hold public meetings, rituals, and councils to teach each other about the care of the restored objects. People of all ages learn of the significance, intended use, stories and rituals associated with each object ... The entire community feels responsible for the welfare of the object" (Hill 1993, 10).

Use Versus Preservation

There is a strong First Nations belief in the necessity to use heritage objects:

We know what conservators do or try to do; that is, preserve objects for as long as possible. But, diametrically opposed to this is the general Indian view as I know it, which is that objects are created to be used and when those objects are damaged or worn out, they are thrown away and new ones are made. (Webster 1986, 77)

A lifetime of constant use is the artifact's only purpose. Since these objects were meant to deteriorate through functional use, they must remain crucial focal points of our traditional functions, available for use by the people to whom they belong. (Harris 1993, 32)

For some people, the parameters of use for utilitarian objects are related to the condition of the object. (Other parameters will be seen in the personal conversations reported in subsequent chapters, and they include who has the right to use the object.) For example, the late Elizabeth Harry (Keekus), an elder and basket maker from the Sliammon Band in British Columbia, said that older baskets would traditionally be repaired in her culture, and, when they could no longer be used, they would be thrown out. They were useful objects, made to be used (Harry, personal communication, 1994).

On the other hand, Allison Nyce, from the Nisga'a and Tsimshian Nations, has commented that, when objects were sold to early anthropologists such as Boas, there were many more people who had "grown up with the culture," and therefore had the skills and the knowledge to continue to make the traditional objects in question. She noted that this is different from today's situation (Nyce, personal communication, 1995). Nyce might take further steps to preserve old baskets than would Keekus.

For ritual objects, however, use is continuous. A Salish spiritual leader, speaking at the Keepers of the Treasures Conference in 1992, talked about traditional cultural matters being put in the background rather than disappearing. He said that his culture had not gone away, it was just quiet, nobody was using it, and he was pleased to see that it was coming back strongly (from notes in Clavir 1992, 7). If objects in museum collections were to receive ritual caretaking, then this might well involve their being handled in non-museum ways. For example, Hill (personal communication, 1994) notes that ritual caretaking includes stroking, caressing (e.g., during ritual feeding, using sunflower oil) and the ritual burning of tobacco. "My grandad died in 1913 in Washington as part of a delegation petitioning the government ... Three years ago his pipe came back. The family now has an annual sundance. The pipe is kept in a frame building without environmental controls – I don't call it a Museum – It's still alive" (Native Americans consultant, cited in Kaminitz 1993, 12). The living culture is continually emphasized in First Nations statements about heritage objects. They highlight the sense of continuity and the objects' importance in contemporary life, and they make the point that the cultural function of these objects does not and has not deteriorated. This stands in sharp contrast to the cultural function of many objects from Western material culture found in museum collections.

Again, for First Nations the emphasis is placed on cultural preservation. It includes the need to use and maintain objects ritually, and it often includes the need for them to be seen by community members and guests. It is also important that the histories of the objects be told and that the traditions associated with making them be passed on. In other words, the objects need to be part of the community's identity. The irony is that these objects left First Nations communities due, in part, to the activities of people (i.e., museum

collectors) who, subscribing to the erroneous nineteenth-century belief that Aboriginal cultures would disappear, believed they were preserving cultural heritage.

> At a Kwakiutl feast in 1900 anthropologist Franz Boas experienced the eerie irony of his own collecting work and remarked that although the speeches were still the same as he had heard in the past, "the bowls [were] no longer here. They are in the museums in New York and Berlin." (Doxtator 1996, 60, quoting Franz Boas as reported in Cole 1996, 276)

> In contrast, Canadian museums have traditionally approached treasured material heritage by removing it from customary use and protecting, conserving and interpreting it in an institutional setting and in the name of the people of the country or region. (Eastern Working Group 1991, 1)

First Nations wish to use objects from museum collections not only for the purposes of traditional ritual use, but also for the types of use normally found in museums: education and research. "Clearly the preservation of ethnographic collections is very important. But of equal importance in this country is the access to those collections by native people, particularly the carvers, for study purposes and, in special cases, for loans of material for ceremonial occasions" (Webster 1986, 78). In addition, one can note that the importance of cultural use to First Nations is often emphasized in the choice of certain words: for example, "to bring this generation back *in touch* with the power that used to be our birthright" (Hill 1993, 10). It is interesting to note how often words that museums associate with conservation are the same words that First Nations associate with cultural preservation: for example, "sacred knowledge is *fragile*" (9); "If it had taken any longer for the sacred objects to be *restored,* even those elders might not have survived" (10); "I had been wondering where negative stereotyping and imagery about the Native Indian was being *conserved*" (Watts 1988, 1); "The need to '*balance*' is what created the Peigan world view" (Crowshoe 1994, 3). (The last citation is analogous to the first principle of ethical behaviour for conservators in the Canadian code of ethics.) (All emphasis mine.)

Culturally Modified Practice in Museums

There are a growing number of examples of how Aboriginal cultural concerns are modifying museum practice. During a presentation in 1994, for example, Tamarapa (1996, 165) noted policy changes at the Museum of New Zealand *Te Papa Tongarewa*, where restrictions were placed on food being brought near any *taonga* (because food is believed to neutralize the life force of particularly sacred items), and where water bowls were placed near the door leading from *taonga* in storage so that people could spiritually cleanse

themselves. Objects related to food and everyday functions were stored separately from sacred objects (166), and *nga toi moko* and *koiwi tangata*, which are "the most sacred objects of our collection," were kept in special sacred storage and referred to with Maori terms of respect (166). Tamarapa also stated that *karakia*, or prayers, were usually spoken when a new *taonga* either comes into the museum or is moved. She also noted that the museum had been restructured in 1991 and that this involved the creation of a Department of Maori Art and History that employed senior Maori staff knowledgeable in Maori protocol.

Another example of indigenous cultural concerns modifying museum practice was evident during the Te Maori exhibition. O'Biso (1987) has written that Maori ritual required that the welcoming museum have a ceremony at dawn, during which the doors of the museum were left unlocked and no guards or other museum personnel were permitted to be left inside; rather, they had to enter the museum in a ritually prescribed fashion. Regarding objects from the American Southwest, the ritual use of corn pollen and meal to feed masks was of concern to conservators at one museum because of the risk of insect infestation. A compromise was reached with the religious leaders whereby the food was ritually given to and left with the masks but was allowed to be frozen beforehand, thus eliminating the possibility that insect eggs would be brought into the museum (Welsh, Sease et al. 1992). Clavir (1994, 54) reported on changes being planned in 1992 for a storage room at the Museum of New Mexico (MNM) in order to address concerns from the pueblos:

The room for culturally sensitive objects at the Museum of New Mexico needs to be set apart from the rest of the collections. Features of this room include:

1 A design similar to a traditional pueblo storage room in that
 • the person who enters crosses a threshold into another area.
 • the shelves are open.
 • the room has access to a room with fresh air. The objects are considered living and have a need to breathe like all living things.
2 The blinds pull down over the shelves or there are dust covers so people do not have to see all the objects at once, as the objects in the room may come from different cultures. This is the MNM's addition to try to avoid offending Pueblo people seeing other objects. It is a compromise in order to use a single room for all material.
3 The objects are arranged by culture. Within this, the objects are arranged in a certain order, and sometimes piled, on the advice of the consultants. The consultants also advised interleaving piled objects with paper or cloth bags, like they do at home.

4 The room is sealed off from the rest of the collections, so objects can be fed (cf. #1 re living objects) or smudged (exposed to smoke, [in many Native American cultures this is done using] smouldering sage, tobacco or sweetgrass), as required.

At the Six Nations Woodland Cultural Centre in Ontario, rituals are not performed in the museum; however, "the Woodland Museum has had the opportunity to 'loan' the Medicine Masks in our collection to the traditional community for ceremonial purposes. In these ceremonies, the Masks are 'renewed,' meaning that they are cleaned and conserved according to customary procedures. These procedures are what preserves the Masks" (Harris 1993, 33). It is emphasized that ritual care is as necessary as scientific care. "Among the First Nations, traditions of proper care and handling and appropriate use, are well and long established, and have served to ensure the continued physical and spiritual well-being of a variety of ritual and sacred objects over the span of many generations" (Moses 1993, 6).

The experts who provide this kind of care are those who are considered appropriate by the First Nations community. Moses makes the point that these specialists should be regarded as part of the circle of professional advisors with whom a conservator normally consults. "Euro-North American museum workers should look upon Native elders and recognized spiritual leaders as a *professional* resource in their efforts to obtain a more complete understanding of the Native materials they come in contact with" (Moses 1993, 8).

First Nations Perspectives: A Summary
The overwhelming impression given by First Nations statements about the preservation of material culture is that preservation of objects is connected to regaining identity, respect, and cultural well-being through practising traditions and redressing historic power imbalances. Preservation of objects is defined as integral to maintaining the life of the community. In addition, objects housed in urban museums may remain in the museum or may be repatriated; however, in both cases the objects should be contextualized in such a way that First Nations are able to make decisions about them.

If this place [NMAI] does nothing else but be a living entity that transmits human respect and sensitivity, then all the work we do and will do will be a success. (First Nations consultant, cited in Kaminitz 1993, 10)

There needs to be an equal partnership which involves mutual respect and appreciation of the First Nations' culture and history. (Barnes 1993, 3)

Ecotourism, equal partnership and empowerment seem to be the way of the future. (Branche 1996, 131)

Writers such as Moses (1995) have acknowledged that objects change their meaning as they progress through their life histories and that they are interpreted in different ways by different people. The original purpose for which an object was created is not necessarily the only purpose it will serve. Furthermore, Doxtator (1996) and Hakiwai (1995) comment that it is in fact museums that have not recognized the dynamism and changes in First Nations communities, tending to place Aboriginal peoples firmly in the past. Many Aboriginal authors do, however, confirm that the contemporary needs of First Nations communities are served by using sacred/sensitive objects from museum collections in accordance with their original purpose and that these needs take precedence over museological needs. It is also recognized that sacred/sensitive objects (depending on the point of view) may represent only a small proportion of existing museum collections.

Conclusion

The tables in this chapter show that there are often significant differences between First Nations and museum perspectives. Some of these differences, such as those pertaining to ownership, represent issues that have far-reaching implications and that are being influenced by decision-making processes situated within a broader socio-political and legal context. Other issues, such as the appropriate care of objects in museums, fall more within the individual museum's sphere of responsibility. In summary, while there may be significant differences in the points of view of some museums and First Nations, certain issues, depending on their scale, are potentially easier to resolve satisfactorily in discussions between the two groups.

The museum remains a charged negative symbol for many Aboriginal people; however, at the same time, they make use of its positive aspects. Seen as both positive and negative, museums occupy an ambiguous place, a place of decontextualization and of (often negative) recontextualization. Moreover, they both preserve against future loss, through conservation, and contribute to past loss: "A lot of cultural material has been lost, mostly to museums" (Webster 1986, 78).

In research on Aboriginal artists and their self-definitions (e.g., are they artists first or Aboriginal artists first), Mithlo (1994) states that, in times of change, when the boundaries people have set up for themselves are also changing, there exists a liminal zone, a state of ambiguity. In this zone people can be "both" as well as "either/or." "The maintenance of boundaries, or the manipulation of 'separateness' thus serves the interests of the disempowered" (Mithlo 1994, 1). Following Mithlo, in understanding why it is important for First Nations to maintain their "separateness," one can also understand why some individuals have defined themselves and their work as "both museums and First Nations" while others have posited First Nations concerns as being in opposition to those of museums.

This schema applies to the definition of preservation as well. For example, with regard to the use/preservation issue, in some cases use is regarded as the direct opposite of preservation (i.e., when the latter is defined as museum conservation), while in others use is seen as a form of preservation (i.e., when the latter is defined as the care of an object through ritual use).

First Nations believe strongly that they own their heritage, even if the museums own their objects. Within this atmosphere, how does one make decisions regarding the appropriate care of objects housed in urban museums? Do the contrasting viewpoints produce clear conflicts? Or is there a tendency to expand the conventional models of both conservation/ museum practice and First Nations viewpoints so that the "and/both" model referred to by Mithlo can transform the either/or conflictual situation? The personal conversations presented in Chapter 5 address these questions.

4
First Nations of British Columbia

It would be impossible here to adequately introduce the reader to all the First Nations of British Columbia, but some introduction may be helpful to those who are unfamiliar with this area, its history, and its current demographics.

The First Nations of British Columbia are diverse and wish to be recognized as such. For example, in one of their publications, the Sto:lo (who live in the Fraser River Valley just east of Vancouver) express this diversity in the following way:

> Two aspects of *Stó:lo* society – the specific status based on social structures and unique relationships with the Spirit world – clearly distinguish and set it apart from many other Aboriginal communities. Recognizing this cultural distinctiveness is extremely important if one wishes to truly appreciate *Stó:lo* people and *Stó:lo* history. *Stó:lo* society is as distinct from other North American Aboriginal societies as Spanish culture is from different European cultures. Just as you would never try to learn about Spain by studying Swedish or Ukrainian society, you would not try to learn about the *Stó:lo* by studying the Iroquois or the Cree. And yet, government policy towards Aboriginal people in Canada has never appreciated these cultural and geographic differences. Indeed, one of the few things shared by all Canadian Aboriginal peoples is the experience of colonization. (Carlson 1997, 88)

In 2000, statistics showed that 16.4 percent of Canada's registered Aboriginal population lived in British Columbia, representing a little more than 1.7 percent of the population of the province (DIAND 2001). Status Indians, Aboriginal people who are registered under the federal Indian Act and have rights and benefits specified by that act, numbered approximately 110,500 in 2000 (DIAND 2001). There is, in addition, a significant population of non-status Aboriginal people and Métis in the province. In 2000,

just over half of British Columbia's status Indians lived on reserves (DIAND 2001).

In Canada, some Aboriginal people still refer to themselves as Indians, the term used in such official titles as the Indian Act and numerous band names. The increasingly preferred terms however, are "Aboriginal" and "First Nations." "First Peoples" is also used as a collective term. Many Aboriginal people wish to be recognized for the specific band or First Nation to which they belong. A First Nation may refer to a single band or to a group of bands affiliated with a tribal council or cultural group. (When used on their own, the individual words "nation" and "band" may or may not be capitalized.) A band has been defined as "a group of people that holds reserve land or has funds held for it by the federal government, or has been declared a band by the Governor-in-Council. Its definition is provided in the *Indian Act*" (BC Hydro 1995b, 8). Anderson (1995, 553) writes that there are close to 200 bands in British Columbia, many with a membership of under 500 persons. Tribal councils are groupings of different bands and may represent traditional alliances with a common language and culture or modern associations formed to deal with administrative, political, and land-use issues (BC Hydro 1995b, 9).

In naming individuals or groups, however, it is most important to give recognition to the name or affiliation by which those people wish to be known. The significance of being acknowledged by one's own terms rather than through those of others is underscored, for example, in the following description of chieftainship:

> I was chief of the Lillooet band for a number of years ... Our community had decided it was time for a change so we split the chieftainship ... I am not *the* tribal chief of the Stl'atl'imx Nation, I am just one ... It is important that I am not an elected chief under the Indian Act; I am elected strictly by the people within Tl'stl'kit, which is called the Lillooet Indian band in English. Tl'stl'kit is the Stl'atl'imx term for our community.

> What we are doing is re-identifying with ourselves, because in order to get our message across to the people here so that you start to understand who we are, we have to re-identify with our roots. That is going to be a tough job for our people. It is going to be an internal struggle because of the emotional, spiritual, and physical assimilation that has gone on in our communities ... When we have done this, we will be telling you who we are in terms of being Stl'atl'imx.

> We use the other term, "Nation," because that is a term that non-Native people can use to identify that we are a people with a language, a culture, a

tradition – a people who have adopted your culture and your traditions, in some ways. (Leach 1992, 23)

A map of names of the First Nations of British Columbia current at the time of this publication is reproduced here. One of the people interviewed in this book is Pam Brown, from the Heiltsuk nation and a curator at the UBC Museum of Anthropology (MOA). She wrote the accompanying text, which states:

Peoples of the First Nations have always recognized themselves by names in their own language. These names denote their identities: village, house, clan or tribe. Following European contact 200 years ago, the majority of tribal groups in British Columbia were given arbitrary English names or identified under generic terms created by early explorers and ethnographers. The inevitable mis-identifications have created serious concerns for First Nations, as well as confusion in much of the published texts. Today, as First Nations take control of their own destiny and strive for self-determination, they have asked the non-Native public to recognize them by the names they prefer. We are striving to present these names on this map. To recognize our [MOA's] First Nations neighbours with whom we share the Georgia Straits region, we have focused on distinctive local names. (Brown 1994)

Throughout this book I have emphasized that one cannot speak of First Nations perspectives as representing a homogeneous collectivity. The historic and present profound diversity of First Nations in British Columbia, as shown by this map alone, underlines this.

Many books and articles have been written on the history and politics of First Nations/non-First Nations relations in British Columbia. The legal and other questions surrounding Aboriginal title and ownership are large and complex, and they differ for each area. They are, however, pertinent to any discussion of cultural heritage. I offer a brief summary of the situation in British Columbia to help the reader better understand why First Nations-museum relationships differ from all other community-museum relationships.

British Columbia is the only province in Canada where, for the vast majority of its territory, treaties were never negotiated. Today, Canadian law holds that Aboriginal title and Aboriginal rights have not been extinguished, although their definitions are still being clarified in the courts. (In 1991 the Supreme Court of British Columbia ruled that Aboriginal rights in British Columbia were extinguished by pre-Confederation (pre-1867) legislation; however, the BC Court of Appeals overturned this decision in 1993, stating that undefined Aboriginal rights continue to exist [BC Hydro 1995c, 6].

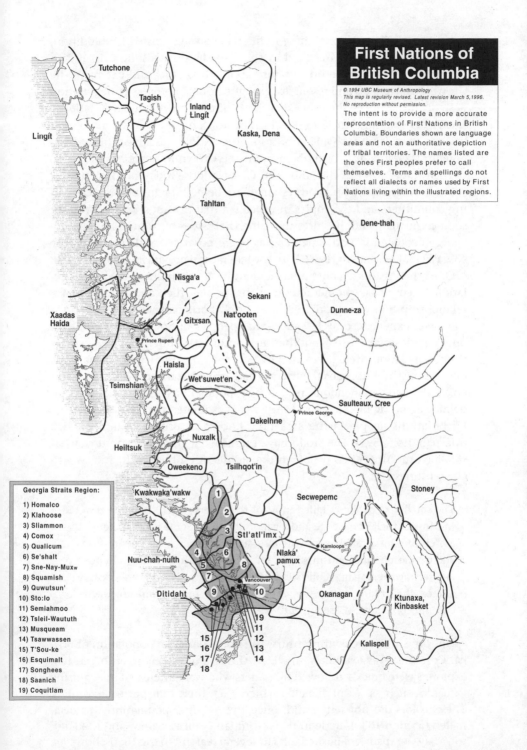

First Nations of British Columbia

© 1994 UBC Museum of Anthropology
This map is regularly revised. Latest revision March 5, 1996.
No reproduction without permission.

The intent is to provide a more accurate representation of First Nations in British Columbia. Boundaries shown are language areas and not an authoritative depiction of tribal territories. The names listed are the ones First peoples prefer to call themselves. Terms and spellings do not reflect all dialects or names used by First Nations living within the illustrated regions.

Tutchone

Tagish

Inland Lingít

Lingít

Kaska, Dena

Tahltan

Dene-thah

Nisga'a

Sekani

Nat'ooten

Dunne-za

Xaadas
Haida

Gitxsan

Prince Rupert

Haisla

Wet'suwet'en

Tsimshian

Saulteaux, Cree

Dakelhne

Prince George

Heiltsuk

Nuxalk

Oweekeno

Tsilhqot'in

'Kwakwaka'wakw

Secwepemc

Stoney

Georgia Straits Region:

1) Homalco
2) Klahoose
3) Sliammon
4) Comox
5) Qualicum
6) Se'shalt
7) Sne-Nay-Muxw
8) Squamish
9) Quwutsun'
10) Sto:lo
11) Semiahmoo
12) Tsleil-Waututh
13) Musqueam
14) Tsawwassen
15) T'Sou-ke
16) Esquimalt
17) Songhees
18) Saanich
19) Coquitlam

Stl'atl'imx

Nlaka'
pamux

Kamloops

Nuu-chah-nulth

Vancouver

Ditidaht

Okanagan

Ktunaxa,
Kinbasket

Kalispell

According to First Nations, these rights have always existed.) In addition, Aboriginal rights are entrenched in the Canadian constitution. In British Columbia, "there can be no certainty about the nature and extent of the Crown's title to land and resources, except through a process of negotiation designed to reconcile the respective rights of the Crown and First Nations" (BC Treaty Commission 1996, 17). First Nations, however, might hold that, because there is no treaty, First Nations title and interests have never been bought; therefore, it is incumbent upon the Crown to negotiate the terms of their duties towards the land with First Nations. Today fundamental issues of ownership of land and resources are being brought before negotiating committees and the courts in processes that, for most bands, will not soon come to an end. It is not surprising that issues of cultural heritage are being negotiated in both small arenas (e.g., museums) and large (e.g., the Nisga'a Final Agreement [1999] with the federal and provincial governments).

One other historical contextual element in Aboriginal/non-Aboriginal relations needs to be commented on at this point – the nature of the power relationship between Aboriginals and non-Aboriginals, and the extent of the losses experienced by BC Aboriginal peoples during colonization. Not only were losses extensive, but they also occurred within only a few generations. Populations were decimated by European diseases (such as smallpox) even before the Europeans themselves had arrived (Carlson 1997, 28). These epidemics had a tremendous influence on populations; in the smallpox epidemic beginning in 1862, for example, it is estimated that one-third of the First Nations people in the area now known as British Columbia died (Macnair 1995, 594). The Sto:lo have published a graphic account of what smallpox meant to their people in the eighteenth, nineteenth, and twentieth centuries:

> The smallpox epidemics killed most of the Elders which therefore resulted in a loss of their knowledge and a gap in learning. Some people refer to this as "culture loss." *Stó:lo* survivors also suffered from severe depression. In addition, economic hardships were encountered, which resulted in poverty and feelings of despair. While some aspects of *Stó:lo* society were necessarily altered, the striking feature was not the changes, but the amazing degree of cultural continuity. (Carlson 1997, 39)

Until the mid-nineteenth century, the non-Aboriginal population of British Columbia was extremely small. At the end of the eighteenth century, explorers were quickly followed by traders who were interested in acquiring valuables such as sea otter pelts, which they then transported to China. These sailors did not settle, and, once the sea otter population was decimated (around 1830), trade in pelts from land animals grew, and the Hudson's Bay Company established forts in several regions. In the 1850s, however,

gold rush fever brought an overwhelming number of settlers into certain areas of the province. Many First Nations communities were profoundly affected by these and other developments resulting from Euro-Canadian and -American colonization. For example, in the nineteenth and early twentieth centuries First Nations experienced the following: the arrival of missionaries and the devaluing of First Nations traditional beliefs; the relocation of some communities (so that they could be near trading centres), sometimes resulting in rival chiefs moving to the same village; and pressure on the traditional system of cultural status and ritual prerogatives resulting from location changes and gaps in the social hierarchy (due to deaths from various introduced diseases). In addition, European material culture began to displace some of the First Nations material culture. Other aspects of traditional material culture changed as some Aboriginal groups acquired wealth through trade; and with new wealth came new economic rivalries. As the settler population increased, pressure to control land became enormous. Although British Columbia has many First Nations reserves, they are generally quite small and were created unilaterally. Due to their small size, they do not represent a viable economic base (Anderson 1995).

Tennant (1992, 9) emphasizes that, despite the extensive disruption of Aboriginal populations and societies, the continuity of the larger tribal groups or nations was maintained: "The great majority of communities that were present at that time did survive and still exist today." As can be seen, the non-Aboriginal history of British Columbia is very recent. For First Nations in British Columbia (which joined Confederation in 1871), most of this period has been spent under various "Indian Laws" or the federal Indian Act. These laws or acts have been used to:

outlaw traditional governing systems and replace them with elected band councils; limit the aboriginal land base to small reserves (which presently accounts for 0.36 percent of BC's total land mass); annihilate the aboriginal economic base by prohibiting Indians to sell land, agricultural goods or farm animals; prohibit aboriginal people from investing moneys earned by their communities; prevent aboriginal people from voting provincially or federally (this was lifted in 1945 [actually, it was 1947] and 1960, respectively); limit the ability of aboriginal people to leave the reserve (special permission from the Minister of Indian Affairs was required); prohibit aboriginal people from retaining a lawyer or to raise funds with the intention of hiring a lawyer (changed in 1951); forcibly remove aboriginal children from their homes and families to attend distant boarding schools (ended in 1983); and eradicate aboriginal identity by creating arbitrary categories of "Indianness" – i.e. status, non-status, Metis. (BC Hydro 1995a, 14)

With these restrictions, the obstacles of, say, the Nisga'a Nation become evident. The Nisga'a began to pursue their land claim in 1887, and it was

only in 1998 that they were able to sign a final agreement. In addition to the above stipulations in the Indian Act, of particular relevance to cultural heritage is the 1884 amendment prohibiting the potlatch and the sundance. This amendment was never officially rescinded, but it was dropped from the act when it was rewritten in 1951 and, therefore, ceased to be law.

Social and Cultural History

First Nations oral histories record that they have lived in British Columbia since time immemorial. For archaeologists, there is evidence that First Nations inhabited southern British Columbia 9,000 years ago; dates further up the coast may be even older. The glaciers retreated from British Columbia approximately 12,000 years ago, and for hundreds of years after, the land continued to change its configuration, rising as a result of the pressure of the ice mass lifting and changing river courses; what early sites there may have been, therefore, are considered mainly unrecoverable (McMillan 1988, 171).

The phrase Northwest Coast can cause certain misunderstandings when used to describe the First Nations cultures of British Columbia. In the first place, it implies a non-existent homogeneity among coastal peoples; in the second place, it leaves out Interior peoples altogether.

The Interior of British Columbia is geographically different from the Coast. Areas of the plains and plateaus between the mountains may have a semi-arid climate. Distinctive First Nations material as well as social cultures are present in this area, which extends both north and south of the Canada-US border. One notable difference in the material culture of the Coast and the material culture of the Interior is that the latter does not include totem poles. It should be noted that totem poles in the round do not exist in *all* areas of the Coast. It is interesting that cultures with large, complex material objects such as totem poles are often prominently featured in many Western museums, while cultures with complex social and linguistic patterns, but with a less prominent material culture, are often relegated to a minor position. On the Coast, the southern, Salish-speaking peoples display both differences from and similarities to the more northerly groups.

As "potlatch" is a familiar term and appears many times in the personal narratives that follow, it is useful to clarify its past and continuing role in Northwest Coast societies.

The complex economic system governing the ranking system and relating to ownership of ceremonial privileges was the potlatch, an institution that characterized all Northwest Coast societies. The potlatch *was* society; it was all-inclusive, encompassing things economic, political, social, religious, ritualistic and ceremonial. Simply stated, a potlatch involved a payment of goods and food to assembled guests gathered to witness a host's claim to

ancestral rights or hereditary position ... [B]y accepting gifts [the guests] validated the claims of the host and confirmed his status. (Macnair 1995, 596)

Conclusion

To connect the information in this chapter more closely with the personal conversations in the next, I include selected extracts in which several people describe what it was like to grow up as a First Nations person in British Columbia. These narratives were recorded in 1995, and they are told from each narrator's personal perspective. See the list of participants in Appendix A for more information about each person.

[Alfred Scow:] I was born in the village of Alert Bay, upcoast from Vancouver about 180 miles on the inside passage between Vancouver Island and the mainland. Alert Bay is on Cormorant Island, an island that is divided into two. The non-Indian population live on one part and the 'Namgis plus a mixture of other tribal groups live on the other part of the island. So I spent my growing-up years partly in Alert Bay, partly at Gwayasdums on Gilford Island (Kwicksutaineuk), and partly at Kingcome Village (Tsawataineuk). And my father was the chief of our tribe, the Kwicksutaineuk, and my first language was Kwakwala which I spoke, my parents spoke, and everybody in the village spoke in those days. I was born in 1927, so that our language was still the primary communication between different occupants of the villages in which we lived. Except, of course, in Alert Bay, most of the stores were located with the non-Indian sections. And in our dealings with the fishing companies and stores, English was required so we had to learn English as part of the process of growing up. My parents had both attended a residential school. In those days, before it was called the residential school, it was an industrial school. And my mother graduated in Grade 8 and my father was removed from the school by his father when he attained the equivalent of Grade 3 or 4, I'm not certain which one. It was because my grandfather, on my father's side, apparently needed my father to record the transactions of the potlatches. And so he moved out of the residential school and they lived part of the time in Kingcome, which was the home of his uncle's, my father's uncle and other relatives as well.

My father and mother developed a belief that in order for their children to survive in the new society we would have to be educated. For the first three years of my normal schooling period, from six to nine, I would spend about a month in the Alert Bay day school for instruction and then we would move to Gilford Island, Gwayasdums Village, where there was no school. So I had no schooling for several months a year, and then in the spring we would go to Kingcome village, where my parents participated in harvesting oolichans and processing oolichan oil. So there was a school

there, so I had one month in Kingcome; so in three years I must have had a total of six months of schooling.

But my parents in the interim wanted me to learn how to read, so I carried all the books that we had with us so that when we were at Gilford Island they would sometimes have me read to them. So, you know, gradually I became familiar with the books and textbooks. When I was nine they decided that I needed a more thorough form of education, so they believed that the residential school was the closest thing, and probably the most available thing, and probably the most suitable thing for me to get this more adequate schooling. So I was enrolled in the St. Michael's Indian Residential School [in Alert Bay] which was run by the Anglican Church. So I did my elementary school, from primary grade to Grade 8.

What happened when school started was all these students were sorted out, they started me in primary grade, and everybody in the primary grade was given a passage to read from a book. And I read from the book as did all the others, and the teacher said to me, "You don't belong here, get over to Grade 1." So I went to another building, to Grade 1. And then at Christmas time in Grade 1, I was at the head of the class, so the teacher bumped me to Grade 2. And I was at the head of the class in Grade 2 at the end of the year.

Alfred J. Scow being invested with the Order of Canada by Her Excellency the Governor General of Canada, Adrienne Clarkson, 28 February 2001. (Sgt. Julien Dupuis)

And this was notwithstanding the fact that we had half a day in school in the classroom, half a day on the grounds, working, doing our share to keep up the buildings and the grounds. Later as we grew older we started working a half day on the farm to provide our own potatoes and carrots and turnips and that kind of thing, cabbage. And we had milking cows, so we provided our own milk; we learned how to milk the cows, which was totally foreign to the coastal way of life.

[Alfred Scow:] Practically all of my growing up years, the potlatches were outlawed, they were illegal, according to the Indian Act.

[Miriam Clavir:] Had your father's regalia been seized from your family at the Cranmer Potlatch in 1921?

[Alfred Scow:] Not my father's. I'm not sure of the details of who all was arrested in that Cranmer potlatch, but I do know from family stories that my grandparents, both sides of my family, spent time in jail because of participation in potlatches. Kingcome Village, for instance, became a centre for the underground potlatches that went on regardless of the laws. And of course they were caught from time to time. But Kingcome had the advantage of being upriver from the inlet, the navigable waters stopped at the mouth of the river, except for canoes. So when a potlatch was going someone would be designated to keep an eye on who was coming and then the message would go out to the village. I had some exposure to the potlatch ceremonies when I was growing up, but, of course, I didn't know what they were all about. They took place at night, too, and the fire burning in the middle of the floor of the Big House. The events were – parts that I can recall – were quite eerie in the sense that there was only light from the fire [against which] you could witness what was happening. Smoke and fire and the dancer and the masks make these people so big; you know, when you're five years old, everybody looks big. And the singing, I can't recall too much about the singing, but in later years, when I was older, I heard singing and I have vague recollections of practically the same sounds from the older people in those days who knew all the family songs and what they represented for each family. But eventually they gave up the practice because the enforcers became a little more aggressive and more people went to jail, so they had fewer and fewer potlatches. Of course, some of the older people died off, of course, including my grandfather, who had many ... he was a canoe builder and he gave many potlatches and from all accounts he was a power broker, I think, in our society. [He continues describing marriages and the children of his grandfather. He also describes acquiring some songs and crests through marriage.]

But anyway, the format of potlatches was changed. During my grandfather's time, the person who gave the potlatch was the organizer of the family. He got the other family members to participate in the gathering of wealth to be distributed at the potlatches. My grandfather was a canoe builder

so he built many canoes that were given away at potlatches, and other members of the family did different things, so that those were the properties that were given away during the potlatches. Now, even during my grandfather's time, it started to change. They started using flour and blankets and dishes and other foreign goods, and money at potlatches. Now it's basically, substantially, all money. A very few token gifts, you know, and now almost anybody can throw one. You have some kind of remote connection through some former chief. It used to be only the chief's families that could afford to throw potlatches because they were the ones that organized the family to contribute to the gifts. Anyway, of course what happened, as you know from your involvement with the museums, what happened ... many of the prosecutions ...

[Dena Klashinsky:] I am both Musqueam and Mamalilikulla. I consider myself to be from both communities, but I am actually registered as a band member at Musqueam. My grandfather was originally from Musqueam, and my grandmother was Mamalilikulla, which is Kwagiulth, or Kwakwaka'wakw, from Village Island.

When my grandmother was still with us, I tried to spend as much time with her as I could. She passed away in January 1995. I tried to travel to

Dena Klashinsky, 1994. (Bill McLennan)

Alert Bay as often as possible, to visit with her, my great aunt and other relatives as often as possible. In my mid-teens, I started to realize just how much they had to share. They possess so much knowledge and family history. With my grandmother's passing I fully realized what an impact she had on my life. I felt a tremendous sense of loss, and I was glad that I had spent time with her.

I've been involved with the Museum of Anthropology since 1988. I started in something called the Native Youth Programme (NYP), which is an employment program for First Nations secondary students. The program helped me to explore my culture and identity as a First Nations person. For one thing, I became more connected with Native students from many different nations. I also gained a tremendous amount from the artists, elders and other community members who contributed to the program. I grew up in a suburb of Vancouver, and there I didn't have opportunities to connect with many other Native people (with the exception of family members) prior to the NYP. I later coordinated the NYP and continued working in other areas of the Museum of Anthropology. Over the years, I have worked in a number of other museums with Northwest Coast collections or exhibitions. I've also been involved with different First Nations organizations and, like other urban Native people, I participate in social activities here in the city and in my home communities.

If I am asked where my "home" community is, I have no simple answer. I have lived in or just outside of Vancouver all my life, but I have extended family and other close ties in a number of First Nations communities. My grandmother lived in Alert Bay for over twenty-five years, and that's the community where I've spent the most time. I was a member of the Mamalilikulla until last year. Their traditional territory is on Village Island and in the surrounding area, but we haven't occupied out own reserve since the mid-sixties. The fact that we are scattered about has really affected our community, and the situation makes it difficult to feel like you are informed or involved as a community member. Because my grandmother lived in Alert Bay all of my life, it has always felt like the closest thing to a "home" community to me.

On the other hand, I am also of Musqueam descent. I've been able to spend more time in the community recently, more than I ever have before. My immediate family and I are now all Musqueam band members. So, I feel like I am becoming more connected to the community. It feels great to recognize more and more faces at Musqueam and to participate in community activities. I am grateful for the opportunity to actually become involved.

[Miriam Clavir:] And so if I ask what is your nation then, you know, would you say your nation was Coast Salish or Kwakwaka'wakw? Or would you identify more with the band?

[Dena Klashinsky:] Well, my response would depend on the context. For someone who doesn't know Kwakwaka'wakw, they wouldn't recognize the different villages that are a part of the larger nation. So, I might not bother saying I'm Mamalilikulla, or Musqueam. Musqueam is my band affiliation, but it was Mamalilikulla until recently. My mom was reinstated under Bill C31, which gave women who had lost their Indian status under earlier federal law by marrying a non-Native the right to regain that status. She had to make a choice on where to apply for band membership as she was entitled to be a member of both. At the time, my mom chose to go with Mamalilikulla because it's smaller and my grandmother was still alive and was a force to be reckoned with! So among people who are familiar with First Nations and the Northwest Coast, I do say I'm Musqueam or Mamalilikulla. In general, I'd probably say Coast Salish or Kwakwaka'wakw, perhaps explaining the previous name (Kwakiutl) used to identify the nation.

[Miriam Clavir:] Dena, can I ask how old you are?

[Dena Klashinsky:] Twenty-two. I'm ancient.

[Pam Brown:] I'm from the Heiltsuk Nation but I'm also part Kitasoo, which is southern Tsimshian, and part Nuxalk. I'm Kitasoo on my mother's side and Nuxalk on my father's side. Bella Bella is on the central coast of BC. It's about 300 miles up the coast. You can hardly get in there by, by boat or plane ... there's a ferry there once a week. The population is about 1,200 with about 800 off-reserve people. My family moved down here [Vancouver] almost forty years ago. So, I've been living down here for a long time. Most of my family – immediate family – live in the Vancouver area. But we have a trade network of foods and things like that, so, I never lose real touch with my family.

My Mum has brought us up in a Tsimshian way and so I've mainly followed her path, which is, to me, I think, a pretty traditional one. We grew up using all the traditional herbs and medicines and foods and we still use them down here today. We still practise it all the time, and when there are marriages or deaths or things like that in the community, when we go up North or even down here, we still follow a lot of the old practices, but a lot of new things are starting to be incorporated.

[Rita Barnes:] I was born in Rivers Inlet, which is not my home area. My parents were up there, my father fishing, my mother working in a cannery, and I was born July 3, 1934, during the fishing season, and spent my very early years in Kingcome where my father was from. He was from the Tsawataineuk tribe of the Kwakwaka'wakw.

And we spent a bit of time in Gilford Island because that is where my maternal grandfather was from. My maternal grandmother was from a little

Pam Brown with nieces Janelle Brown-Walkus and
Faren Brown-Walkus at the opening of the exhibition
Kaxlaya Gvilas, "the ones who uphold the laws of our
ancestors," 21 June 2000, Royal Ontario Museum,
Toronto. The voices of the contemporary Heiltsuk
community were celebrated alongside important
heritage collections in this first museum exhibit of
Heiltsuk art and culture. (Bessie Brown)

village, from Fort Rupert, and they were the Kwagiulth tribe, the people
from Fort Rupert. They were the Quatsino of the Kwakwaka'wakw house as
well. The Kwakwaka'wakw and the Tsawataineuk of Kingcome and two other
tribal groups called themselves the Musgamagw, because they were four
tribes which cooperated, they supported each other, and through every-
thing. And so that's my background.

When people started leaving Kingcome, I think they were encouraged by the Indian agent to relocate to Gilford Island, some of them stubbornly stayed on at Kingcome, my father's family being one of them – my grandfather, my uncles and my father, and a couple of other families. And because of people moving away gradually and just a few families left up there, and very few children, the little mission school there closed down and my father was supposed to put us into the residential school. Mind you, we were not accepted right away. There seems to have been some reluctance on the Indian agent's part to accept us, and because I was very little, I don't really know for sure what his reasons were, but my father seemed to have problems to get us into the residential school, and I felt I was waiting and waiting, hearing all about the kids going to school and still at home, seven years old, quite ready for school. Eventually I was accepted ... well, all of us were, my two sisters and my brother were in the residential school. My father supplied the school with salmon twice a year to feed the whole school – 200 kids, about thirty staff members, thirty or forty, and also oolichans once a year to feed the whole school.

I was very fortunate, because St. Michael's School, the residential school I attended, was located in Alert Bay where I had a lot of relatives, and on weekends my sisters and I could go to homes of my relatives, grand uncles, my great grandmother, uncles, cousins. And I think, too, as a result of that, being able to go home to relatives every weekend, we still speak quite a bit of Kwakwala.

As for my time in the residential school I hear stories, horror stories from other people today, some of them that I grew up with in the residential schools, some I didn't, who I've just recently met. I didn't really have any horror stories. I think the most horrible experience I ever had was being strapped for not memorizing the Nicene Creed in the time allotted. As the Bible, the Prayer Book, was part of our curriculum. It was our textbook ... when we were in Grade 3. And I have some depressing memories about the church. For years and years, even after I left the school, I attended church faithfully and one day I just thought, what am I doing here? I walk out of this place, I just end up feeling so depressed. I discovered that my dislike of daffodils and tulips was connected with the church. So I walked out of that church in Burnaby, and I never went back. And I've never regretted it. And end of periods of depression on a Sunday. And I don't know whether I can use the term "rediscovered," but I think I rediscovered potlatches, you know, and what it did for me ...

We moved into the urban area and we had to make a place for ourselves ... That had to take priority over something [potlatches] that was such a big part of me. And then all of a sudden it just came back so strong, and now there's potlatches every year and it's wonderful.

I guess my memories of potlatch are like being in a potlatch ... cuddling up with my grandmother under her shawl, her big sort of blanket-like shawl, and keeping warm in the fall. And being told to be still and be quiet because she had no money, and because if you did things that weren't considered proper manners in a potlatch your family paid a penalty, and at that time ... they had to pay everybody in the Big House a quarter. You know? So we were always told to "Be still, be quiet. We have no money." And that's how children were kept, you know, they were made to behave.

5
First Nations, Preservation, and Conservation: Personal Perspectives

All the potlatch stuff that you're given is special because it's from a potlatch, so that means you should use it more. But the English and Danish side of the family, if something's special, then you take care of it better. You put it aside. It makes it more special when you use it less. This is a generalization, of course.

– Kim Lawson

We don't really conserve – in the same sense as storage at the Museum of Anthropology – we renew. It's a continuity, like a lineage.

– Ken Harris

As will be seen from the personal narratives quoted in this chapter, there are many differences between what First Nations and what museum conservators mean by "preservation." The quotations in this chapter are taken from conversations and interviews I held in 1994-5 with First Nations people, mainly in British Columbia, who are connected to museums and cultural centres or to cultural affairs (in the area of heritage). The people I talked to were chosen from various constituents of the First Nations population and represent a broad range of opinions, although it is also true that many people and nations were left out. This chapter does not present a comprehensive coverage of First Nations opinions concerning heritage preservation but, rather, detailed perspectives from a number of different First Nations individuals. I spoke with both men and women, with people ranging in age from their early twenties to their mid-eighties, with people who had different band affiliations, with people who grew up and/or who now live in urban centres, and with people who live on reserves. Several people were of mixed parentage (Aboriginal and non-Aboriginal), and several have been, or are, married to non-Aboriginal spouses. The individuals interviewed defy stereotyping. They represent different life experiences, different museum experiences, different

ties to traditionalism, different ties to the reserve, and different status within their communities as well as within the larger BC society.

In most cases those selected made it clear that they are not to be thought of as representatives of their communities. It was often reiterated that people were not speaking for their nation but only for themselves. While, in one sense, being privy to only individual opinions may leave the reader feeling somewhat frustrated, since, as has already been discussed, one cannot extrapolate from the quotations to say that there is "one First Nations perspective," or even "one Kwakwaka'wakw perspective," I would like to underline how valuable I believe these conversations to be. One could read this book solely for these citations. They are meant to provide a straightforward way for the reader to hear directly what First Nations people have to say about preservation. Furthermore, there is a general consensus of opinion among the speakers regarding such key matters as the need to use objects and the importance of cultural preservation.

Preservation: "Tangible" and "Intangible"

Returning to the quotations with which this chapter began, Pearce (1995a) presents a metaphor that can be used as an analogy to clarify differences in perspective between museums and First Nations people. She compares the collections in a museum to an iceberg: the small proportion of a collection usually on public view is the iceberg's small visible portion. I have extended this analogy to the individual objects themselves. It is their visible attributes (e.g., condition, aesthetics) to which museums generally pay the most attention and that are captured by museum practice (e.g., photography, measurements, exhibition). However, the collection and its individual objects are, like the iceberg, composed of a large component that often remains invisible (e.g., how the collection was formed, the memories evoked by an individual piece), but is nonetheless highly significant.

Figure 1

Attributes of collections and objects: The iceberg analogy

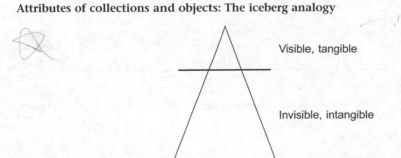

Conservation provides one of the best examples of an area of museum practice devoted largely to the visible, material attributes of objects. Furthermore, these are the attributes that are amenable to being worked with in a scientific manner.

As distinct from conservators, the First Nations people I talked to emphasized the "invisible" attributes of the object: at the level of cultural metanarrative, at the more specific level of cultural preservation, and at the level of the attributes of the objects themselves. Many First Nations people, even those, like Salish weaver and carver Debra Sparrow, who believe strongly in the importance of the "visible" aspects of the object, also emphasize its "invisible" aspects: "What the blankets do is they reflect the strength of the people. And when you see these blankets show up in different areas of life, whether it be a women's conference, the signing of the Treaty Commission, or an educational conference on Aboriginal people, or other people; it says that there are a people that existed that have values and strengths, and there's nothing more beautiful than something pleasing to the eye. And if you see that, somehow or another, it validates those people" (Debra Sparrow).

The emphasis on the visible or the invisible can also, at times, reflect a differential emphasis on the nature of boundaries. Traditionally, museums and conservation tended to perceive discrete although overlapping boundaries, which could lead to struggles, for example, between the conservation and the curatorial perspectives (or worlds) to determine which should govern collections. In a culturally holistic perspective, the boundaries are often more permeable and the objects may exist in several worlds at once (e.g., an object may be kept in museum-quality storage but used in ceremonial activities) (see Figure 3).

Of course, the terms "visible" and "invisible" are not really adequate to describe attributes of material culture, including that of First Nations. As

Figure 2

Perspectives on preservation: "Visible" and "invisible" attributes

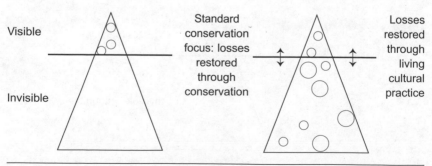

Figure 3

Material culture/collections: Different worlds, different boundaries

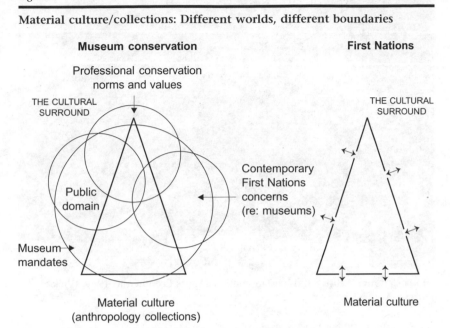

expressed in the conversations iwht First Nations people, the visible, rather than existing as a quality in its own right, is often linked to the invisible. For example, the value of the object lies in the act of using it within the community, so that the invisible (the non-tangible) – rights, lineage, loss, and redress – is made manifest and witnessed. In one sense this illustrates a holistic viewpoint (and note that it is I, not the people to whom I talked, who suggested looking at the visible as separate from the invisible): the whole of the iceberg is important, including the top, the submerged portion, the interior, and the surface. Even the words "tangible" and "intangible" are not quite adequate, since, in Western positivistic terms, the "tangible" is held to have more reality than the "intangible." Oral traditions, for example, are often given less credence than written ones. According to Haagen (1990, 41): "Heritage, for the dominant society, refers only to the productions of the past; Native people, when they refer to heritage, do so in the broadest sense of a culture (and a tenure on the land) that has been transmitted over time and that constitutes a concrete reality in the present."

In *Preserving What Is Valued* I use the words "tangible" and "intangible" to refer to the visible/invisible aspects of an object. None of these words is quite adequate; "material" and "social" in some instances would better describe these object attributes from First Nations viewpoints. For example, a historic landmark building that is still being used as a school might serve as

Gloria Cranmer Webster and her late mother, Agnes Cranmer, in 1999. (Vickie Jensen)

an illustration of the "material" versus the "social." Architectural conservators would be most concerned with saving and maintaining the physical, historic, and aesthetic (i.e., the material) integrity of the building, making what they might consider compromises to enable its continued use. For First Nations people, on the other hand, a school building might well be perceived as a shell unless life is brought to it by the students and staff using it, and the transmission of knowledge, values, and attitudes (i.e., the social) that take place there. The building and what goes on inside symbolize both past (missionary schools) and current (e.g., First Nations' growing control of education) relationships, and it may evoke strong emotions. These aspects of the "invisible," or the "social," hold the meaning of the "object": the school, the building alone, would not.

> I'd rather you showed one mask and told people about it – that connected it with human beings: who made them, who used them and who suffered for them. They go: "Oh, it's such a wonderful building – Erickson's building! [MOA was designed by architect Arthur Erickson.] What a wonderful museum!" It may be a wonderful building but it's a lousy museum. It's a great warehouse but it's a lousy museum. Blasphemy! (Gloria Cranmer Webster)

> [Dolly Watts:] It's up to the owner to do whatever he wants with the old one [mask]. Sometimes they'll just give it as a souvenir to somebody just to

keep it in the family or give it away as a gift. So it keeps on being replaced, you know, replicated and so forth. But the way it happens today quite often is the museum will step in and give money to a person to replicate it. The museum will take the old one. And it's not the same. It just loses the whole meaning.

[Miriam Clavir:] Because of the money?

[Dolly Watts:] Because of the cycle, the cycle of – 'cause then gradually, if that keeps on [the museum stepping in and buying the old mask], like the feasting and gathering that goes with the mask disappears. It just loses the same meaning, you know?

At whatever level, the tangible evidence that objects provide is important, but the meaning of the objects lies even more so in the intangible aspects of the culture they symbolize and the cultural knowledge and norms they represent. In the following statement, the use of the word "lived," and even the word "more," represents a depth of meaning and connection not covered by the possession of the objects alone. "But when I took my youngest daughter through the Museum of Anthropology, she was very quiet. I said, 'Is something wrong?' She said, 'Did you really have all these things?' I said, 'We had more. We had more because we lived it'" (Ken Harris).

In the area of sacred/sensitive material culture, the importance of the social as well as the material attributes of an object are apparent. Subsequent sections will show that this is important even in discussions related directly to conservation concerns, such as what is considered damage to an object.

Every First Nations person I talked to supported the view that the preservation of the intangible cultural aspects of an object is very significant – that it is as essential as is the preservation of the tangible object itself.

I think it's important to preserve objects because of the dances that they go with, the songs that go with them. The dances and songs still belong to people; they're still part of people's rights and privileges. Maybe those people don't know that right now, but some day they will, and they'll go back to the objects. I think if they can see it in a physical sense, it seems more real to them. If they see the mask that goes with the dance or song, then they're more excited about it, and want to learn more. In general, I think people really like objects ... people really want to work with objects and they want to come to museums to see the pieces, they don't want to see a picture of it. (Juanita Pasco)

A few years ago, I interviewed an elder from Katzie about the "From Under the Delta" exhibit at MOA. The exhibit was about materials recovered from archaeological wetsites, and I asked her why she thought the objects are

Juanita Pasco, Collections Manager at the U'mista Cultural Centre, checks a dance apron (UCC-94.09.023) against its documentation. (Bob Waldon)

important. She said they are important because every object tells a story; they tell stories of our people. They illustrate our histories. Sometimes, those objects offer the only opportunity for young First Nations people to see a visual representation of those stories and to be introduced to our histories. The objects may even initiate further conversation. If elders have passed on and are no longer available to answer questions (for example, when I mentioned losing my grandmother) then those objects can help to tell some of our stories. They can help to maintain some of that knowledge in the community. As I understood, she was reminding me that the objects are tangible evidence of those who came before us. They are markers of our history. Our communities have persevered through a great deal of oppression and devastation; often the objects form a crucial link to our histories, our traditions, and our culture. (Dena Klashinsky)

I think that for traditional First Nations people, there is a different kind of link, perhaps stronger, between people and objects – like when you make something, it has part of you in it. Gifts that you give, food that you cook, should all be done with good feelings and good intent, because those intangible things become part of the object. This kind of thing is the explanation or reason that I've been told for the things that people should stop doing after they have lost someone close to them – like other people should cook for the family who is grieving and for the settlement feast – because any strong feelings or your grief, the intangible stuff, becomes part of the food, and that's dangerous for people. (Kim Lawson)

Haagen (1990, 36, 37) sums up the different emphasis that First Nations and non-First Nations place on the material and social attributes of objects:

> When referring to culture, Native people talk about values, beliefs, and prac-
> tices, and non-Native people talk about discrete cultural productions and
> cultural industries ... The Western, or "modern post industrial" society deals
> with culture in this way; as a commodity or a production, as something
> that can be separated from daily life, cultivated and appreciated at a dis-
> tance. It is also generally understood as something visible, or accessible in a
> sensory or concrete way ... In contrast, Native thoughts about culture reveal
> an active emphasis on culture as an accessible unifying force, as a common
> set of values that link all aspects of life into a whole.

In the subsequent sections it will become evident that Haagen's analy-
sis, which is implicit in the earlier analogy of the empty/active school, is
accurate.

Worldviews and the Meaning of Loss and Preservation

The Western positivist meta-narrative is linear, scientific, isolates the parts
to gain an understanding of the whole, and contends that the world ben-
efits from universal access to knowledge. All four of these characteristics
contradict First Nations narratives, and all have been described by those
cited in this chapter as having implications for the preservation of cultural
heritage.

For First Nations, one important reason for preserving material culture
relates to the link it provides to the past. The relationship between this
apparently linear perspective and a holistic view is explained as follows:

> People talk about cyclical and time together. People talk about circles and
> symbolism in lots of contexts, through philosophy and things. But, for time,
> and for history, it seems to me the emphasis is more on generation and
> succession rather than cause and effect. I haven't heard any traditional cul-
> tural leaders compare Western and indigenous ways of keeping history, but
> I hear ideas about cause and effect being important for people's relation-
> ships to the environment. There's also a lot more concern for cycles of re-
> birth and proper naming and succession and passing along, and bringing
> the things from the past with you. (Kim Lawson)

> I guess what it comes down to is there are two worldviews, you know? Two
> worldviews that sort of collide within the museum. You have the museum
> point of view, that these objects should be maintained, that these objects
> should be protected, that these objects should not be thought [of] in terms
> of ten years down the road but more like one hundred years down the road.

Don Bain mapping the trail for the Traditional Use Study on Lheidli T'enneh territory. (Gordon Corvallis)

But it's like the traditional Native belief structure is that these objects were made for one purpose, and that's to be used within the community. And these objects are alive in that sense that they do have a fixed period of life, and when they go, they go. You may replace that object with another object but that object takes on, is born, forms its own identity.

But in time that object will go. And you can use the knowledge of the original object as the basis for the new object. But it doesn't necessarily transfer the significance or the history of that object to this object ... I guess I see the museum perspective as very linear. And what you're trying to do is cheat the end; you want to elongate the life of that object. Whereas the Native view is circular, it all comes back. The knowledge that is contained within the object is important, but that knowledge can be transferred to another object. (Don Bain)

And I think that society, in breaking down their own humanness, they find that everything is compartmentalized, and that we have psychology, we have sciences, we have academics, we have artists. But in our world, I think we know and understand that all of those go together. And they are not individual. And that without one we cannot understand the other. But what we do here in 1996 is that we make it very isolated. And I think that we as Aboriginal people at one time understood that everything goes together. And that, that is balance. (Debra Sparrow)

Several people concurred with Don Bain that prolonging the existence of an object is not natural and does not necessarily prolong its life. This will be discussed further in the section on damage and deterioration. In addition, the importance of "life" and "living" as it pertains to objects and their cultural role is emphasized. It is not just certain sacred/sensitive objects that are considered to have life. In a larger sense, the importance of life derives from the importance for First Nations of an object's intangible social attributes.

At the same time, it must be remembered that emphasizing social attributes does not necessarily mean de-emphasizing material attributes: "I keep on thinking, you know, the dagger is a tangible object, or a tangible representation of the past. And if I were to hold that dagger, I would be so proud" (Don Bain). Several commented on how important it is for people to be able to see the actual objects that carry personal, historical, and cultural meanings:

[There is a] need to preserve some things that we have so we have tangible evidence of our history. (Dena Klashinsky)

They're old and they came from time, and I think they just verified existence; they verified what was so that we understand what is, so we can go forward with what will be. (Debra Sparrow)

Debra Sparrow's earlier remark about society breaking down its own humanness, about its compartmentalization, was discussed in a different way by Kim Lawson, who commented on First Nations resentment of the dominant Western notion of universalism and science:

The idea that heritage should be preserved because it is of value to the entire world is better than the philosophy that believes in or advocates assimilation and "cultural evolution," but I think it's still ethnocentric, because it can be what someone decides everybody else should value, and is often disrespectful. It often leads to the idea of an international "ownership" of all cultures and seems to be used to justify attempts to utilize or exploit the cultures and knowledge, and often works to minimize the community's link to the knowledge or "profits" from it. It has been used as a justification to take things away from communities or colonized nations and relates to imperial points of view. I think that one of the implications of that kind of statement is that: "It's of value to the entire world. It's right now sitting in a little community, who doesn't place the same value on protecting it" or "They're in the middle of a war" or "They don't have their act together for whatever reasons, therefore we're justified in taking it away for the greater good of (meaning for) other people." In these cases, the

"greater good" of humanity in general is put ahead of whatever this little community feels, and that's remarkably arrogant. And it's very divisive, often the value of some thing or place to the local community is very different than it would be to the whole world. The "world heritage" approach seems to assume that they would be the same, or at least that what you do to "protect" or commemorate it would be.

Like traditionally, parks are considered a good thing in that it prohibits development, so First Nations should support the creation of parks and should be happy to see parks set up camps and let people tramp through the area and see how beautiful it is and what it protects – that's seen as a "greater good" but that doesn't take into account First Nations perspectives. First Nations people hunt, and they take care of the place so that the deer have food and there's been a lot of things that people do to take care of the deer over the last thousand years besides just hunt but the assumption is "People hunt, period." Hunting is bad, parks are good. (Kim Lawson)

Kim Lawson, who, at the time of her comments, was working in the field of archaeology, spoke about the conflicts between the science of archaeology and First Nations perspectives.

Archaeology is both science and social science, and its vocabulary and its jargon really distances it ... from Aboriginal people. The questions that it tries to answer are really driven by the discipline, not much by questions that the community which is being studied may have. Also, studying culture tends to "objectify" it, tends to make it sound inanimate or stuck in the past or "dead," which is very different than talking about one's own culture, and a dynamic living culture. The hard science vocabulary of archaeology, such as deposits or matrix, or "proving" or being evidence for something, gives the impression that oral history or traditional knowledge is less believable – that it's unproven or perhaps unproveable. That really starts closing doors on dialogue. (Kim Lawson)

Lawson also addresses the social implications of the Western scientific, universalistic perspective, emphasizing the effect it is having on First Nations/non-First Nations relationships.

In the dichotomy between science and traditional knowledge there's a dialogue problem. All of the baggage First Nations people have from the past with the words, and with the idea of working with outside consultants, and because it's reflected in so many areas of life – there's the expert on economic development, there's the consultant that comes in and tells you how to build houses and there's somebody that comes in and says what you've got

to do to have a good education, plus a history of many of these projects going wrong and of good intentions leading to worse situations – people have just such strong, emotive reactions to any notion of expert in general that it's actually going to be difficult to have relationships on a profession-to-community and a profession-to-profession relationship just because ... there's such overwhelming baggage right now and trust really has to be hard-earned. (Kim Lawson)

People were asked whether they felt modern scientific materials were appropriate to use in repairing or restoring heritage objects. Three of the four people who voiced an opinion on this had directed or managed collections in First Nations cultural centres.

[Miriam Clavir:] Some people don't like the fact that objects from First Nations are being preserved by Western scientific methods. They don't feel that's appropriate. What do you think about that?
[Gloria Cranmer Webster:] Well, I think that some of the people who are saying that are carvers who use power tools. We're living in the nineties. Museums are part of our world now and the kinds of things museums are able to do are also part of our world and I think if those objects are owned by those museums, I think those museums have a responsibility to preserve those objects in whatever way works. However, if the people who make this kind of criticism prefer not to preserve their own treasures with Western means, that's fine.

[speaking about the use of twentieth-century chemicals to preserve old pieces:] Some people might say it's not appropriate. But I think some people also might say, "Well it's that or lose it forever" ... but I think some people might object ... it's old and that's not the way we do it. (Juanita Pasco)

Another person who had worked for many years in conjunction with museums stated that she considered that any methods, including Western scientific methods, that successfully preserved objects were worthwhile. She said that many of the pieces she had seen in people's homes were not well cared for. Several others commented on hazards, such as theft and fire, that are a constant worry when one has something valuable at home.

The above comments on science reveal a general acceptance, particularly by people who have been responsible for collections, of its use in the preservation of material culture. However, it is interesting that other people had no opinion on this matter. In fact, their hesitation in answering showed that this issue was new to them. The impression that questions about the preservation of objects was not a topic of much concern to several of the

people with whom I talked was reinforced in some of the other conversations. It is not surprising that the issues of interest to conservators are not widely shared; the profession of conservator and the details with which it is concerned represent a small circumscribed world. Although all of the First Nations people to whom I spoke were involved in cultural or educational areas, the preservation of objects was not necessarily something they had to concern themselves with, and museum-style conservation of collections was even less important. In addition, there were occasional instances in the conversations when an underlying difference in perspective, or a lack of immediate familiarity with a museum or cultural concern, produced a simple miscommunication, such as the one illustrated below between myself and Leona M. Sparrow, the Musqueam cultural liaison with MOA.

> [Miriam Clavir:] If we have a minor earthquake what happens in terms of the care? Do you recommend that we call you and say look, the masks have fallen, this is the damage that's been done, or do we ... ?
> [Leona M. Sparrow:] Before that happens, I would hope that you've got some kind of plan that's ...
> [Miriam Clavir:] Mmhm. So do we. Boy, let me tell you. [meaning Emergency Contingency Plan].
> [Leona M. Sparrow:] But there isn't one, is there?
> [Miriam Clavir:] We are, at the moment – an actual plan?
> [Leona M. Sparrow:] Well, the museum doesn't at this point, have an operating agreement with the community to understand any part of an interrelationship ...

Haagen (1990, 41) notes that Western and Aboriginal conceptualizations of the relationship between the past and the present can be very different: "Where the western world separates itself from the past, Native people express a continuity between the past and the present that does not make a distinction between heritage and contemporary culture." She says that heritage, for the dominant culture, is most often expressed through things that both have a relationship to the past and that are objective entities, such as an artifact or a museum exhibit. Access to heritage is usually mediated by organizations or institutions, is separated from daily life, and is obtained through a relatively passive act (such as observing a cultural production) rather than through doing or participating. Heritage can be appreciated at a distance, and this appreciation can be intellectually cultivated. For First Nations, heritage is "continuous and accessible through acknowledgment and practise" (40), and it is preserved through active use: "The act of recording a language alone is not considered an act of preservation; only the act of speaking the language ensures its survival and thus its preservation" (39). Haagen points out that these different viewpoints have a certain legacy in

the historical differences between tribal societies and industrial societies: "This is not to say that the cultural experience is thus diminished, but it is an experience of a different order than that of the immediate experience of participating and creating" (38).

Continuity with the past and active participation in and respect for traditional cultural forms and beliefs is what First Nations highlight as the basis of the meaning of preservation. Heritage objects play a role in this; however, in representing continuity and in being used in ceremonies they represent the present as much as the past. They represent a First Nations identity.

[Do museums have any value?] Yes, according to Sandy Jones, an elder. He would like a museum in his community and he would go and see what he used to wear, and show it to his grandson. His grandson will learn his culture from the longhouse, though, from his own participation in traditional spiritual life – from participating rather than seeing objects in a museum.

I keep telling myself, I have to tell him [her nephew, Beau Dick, a carver] that maybe he should replicate it so that it can be preserved for as long as possible. So when I was telling my brother this, he said, "Well, for what purpose? You know, it will just stay in the museum forever." And I said, "I hope so." And he said, "But why? When can it be used?" I said, "Sure it can be used," I said, "Beau can make another one exactly like it." And he said, "You're probably right, but you see it's never ... " My brother is quite a bit older than I am, and he said, "It just doesn't make sense to me to have these things in a museum when they can be utilized for the things that we do today." And that was a literal translation for how we refer to having potlatches.

"[Speaks in x̲an's 'wigilasex̲]," they always said. And it just simply means, "For what we do." (Rita Barnes)

At the museum, there was a whole bunch of young people who came in. They didn't speak the Kwakwala language, but what they really wanted to know from Mrs. Cranmer was "Who was my family?" What were the names of my family? What were the crests, what can I use when I'm making my own dance regalia? For these young people, it was really important to them to know who they were, and where they come from. It hadn't been before. Now they wanted to know. For their self-esteem, they need to know. (Peggy Svanvik)

And my first thought was to think, man, this blanket's over a hundred years old. A hundred years ago grandpa was born, the blanket was being worn. And so the significance to all of that gives me more strength as a connection to that. Now, for once, I can say, well, this is where we come from. This is our history; this is a part of it that can be seen and can be seen as a good

Agnes Cranmer encourages Christie Taylor in the Madam, 1981. Agnes Cranmer taught native dancing to Alert Bay school children in the former St. Michael's residential school. Seen here (left to right) are Tara Ambers, Christie Taylor, Andrea Alfred, Agnes Cranmer, Sherry Alfred, and Mildred Child. (Vickie Jensen)

thing. You know, it's not about how I felt for those years that I'm sure the people fifty years before me felt we did not have a part, and we felt inadequate and useless, and ... because that's what we were told, and we believed what we were told. And now we can say, no, no, that's not what it's about. And, you know, we can take our place in history now. And that's exciting. It really is. (Debra Sparrow)

For First Nations, especially in British Columbia, which, as previously mentioned, received no significant Euro-based settlement until the mid-nineteenth century, continuity with traditions is not necessarily based in a recovery of long-lost practices but, rather, on a connection with elders, remembered and alive, with languages remembered or still spoken by some community members, and with the traditional practices and cultural protocols. This, of course, varies from community to community and individual to individual. Alfred Scow sums up a situation common to many:

Throughout all this time my father became very knowledgeable about our practices, customs, traditions, whatever. Unfortunately in some respects he

did not pass that knowledge on to his children, because he could see the ending of that phase of our lives by what had happened through the enforcement of prohibition of potlatches.

So he thought it would be better, I guess, if we didn't know. If he were here today I would kick him in the behind. Because I think that so much of our family history got lost in that way. We have some recordings of family songs, and we have certain songs that everybody acknowledges belong to our family, and I'm trying to think, in 1951 the prohibition was dropped against the ceremonials and they gradually started, slowly, they started coming back. Of course, the sad part about the revival of the potlatch was that the old people who were totally familiar with the history of all the families, the practises, the customs, the traditions, that went into the potlatches, most of them had died. (Alfred Scow)

An emphasis in the meta-narrative of continuity acknowledges the immense disruption that occurred in Aboriginal societies with European contact. Loss and recovery from loss are major themes within the preservation narrative.

You see, I think they did have potlatches. My mother would disappear, but nobody would tell us where she went, because it [holding potlatches] was against the law.

I never saw Indian dancing until the fifties, the late fifties, when they were allowed to do it again. I was like the tourists, just anxiously awaiting to see them dance. (Peggy Svanvik)

Peggy Svanvik at the Campbell River
Elders' Conference, 2000. (Lisa Peterson)

Because the cultural loss experienced by First Nations was the result of deliberate policy on the part of a dominant culture, the feelings that surround it are particularly emotionally charged. Although "loss" is a catalyst for "preservation," the losses and breakage that museum conservators repair and prevent are vastly different from the cultural losses and disruption from which First Nations peoples are recovering. Conservators analyze and treat the remains of material culture after loss through accidents, neglect, and so on. First Nations *feel* their loss. Loss for First Nations especially in places like British Columbia, is personal, recent, and emotional:

> My grandparents were among those people who were jailed for participating in the potlatch. And I'm still outraged to think that my grandmother was stripped, standing naked with her people, when she didn't want us to show our arms and she wanted us to have our dresses cover our knees – we weren't to show our knees. And for her to be treated like that and she had this ranking, she could be the Queen Mother in our society. And to be treated that way – I mean, I remember my grandmother and I think "How could they do that to her?" It still outrages me. (Peggy Svanvik)

> The residential school era affected the First Nations in a profound manner. There were the effects of cultural losses in self esteem and self worth, not to mention the loss of language, and everything to do with cultural heritage was stripped from us.
> The phrase "I didn't know that I didn't know" has a lot of meaning to a person like myself. (Claxton 1994a, 5)

As has been mentioned, museums and the objects in them play both negative and positive roles with regard to First Nations identity.

> [Miriam Clavir:] So what motivated you to get involved in the museum?
> [Dolly Watts:] I wanted to piece together our culture, our history. So much was missing, you know – when I left home, everything was erased from my mind. The boarding school experience, you know, that was mainly what they tried to do was erase past knowledge. A whole way of life. We had to forget about that and start something new.

> You don't just see an object, you see a whole people and what they must have been about. (Debra Sparrow)

The nature of cultural loss and its expression in the meta-narrative of preservation affects how people determine what is important to regain or recover. It is significant, although not surprising, that First Nations mention

the importance of regaining intangibles. Gloria Cranmer Webster, in speaking about the exhibit entitled *Chiefly Feasts*, said that collaboration with museums returns to the First Nations "the ability to influence what other people say about us." *Chiefly Feasts*, she stated, respected the wishes of the old people. The museum didn't have the last word. This "gave back to the old people the dignity and respect their knowledge deserves" (Webster, cited in Clavir 1992).

The following comments apply to both the intangibles implicit in "save and retrieve," and the tangibles implicit in "preserve":

> When you think back on how much we lost in such a short period, and then feeling even back then that we didn't have a choice, that it was taken away from us. But eventually I guess my feeling was that it was just a matter of time that Kingcome would no longer be doing what they had been doing when other villages had stopped.
>
> As the new generation came, and lost interest, and hearing kids saying things like, "My God, she still speaks Kwakwala!" you know, as something that was out – what's the word for it? It's like saying that someone has never grown out of the fifties. You know, that sort of thing ... [you're a square].
>
> And I think, you know, when you think in terms of how much we lost in such a short period, and we now see that we can save and maybe retrieve, then of course we should try to preserve as much as we can. (Rita Barnes)

The following description shows "regain," in this case control over cultural interpretation:

> In 1989, there was a filming of a children's show at the Museum of Anthropology. I was one of two students acting as guides for the group of kids. The host of the show asked me to explain our tradition of feasting on the Northwest Coast, the potlatch. She very emphatically asked me to "keep it simple" because the show had a very young audience." Otherwise, she was concerned that I would confuse the children. She suggested, "with the potlatch, just let them know that it's like a birthday party with lots of presents." I was just fifteen at the time, but I was feeling more than a little frustrated. I informed her that I wasn't comfortable with such an over-simplified description and that I felt I could explain the potlatch in a couple of sentences without disrespecting our traditions. I just walked away and started talking to the kids. The cameras started rolling. I said something like:
>
> "When someone gets married, when a baby is born, or when someone passes away, you know how people, your families for instance, gather together to celebrate or honour the occasion? For special events, it's important for your family to come together, right? Sometimes what happened

that day is written down on paper. At a wedding, there is a marriage licence that's signed. For a new baby, sometimes an announcement is made in the newspaper. Well, in the past, we couldn't do that. Our language wasn't written; it was only spoken. So, we had to pass things on strictly by talking about them.

"The potlatch was a way for us to get together and celebrate special events. At potlatches, things that are very important to a family may also be passed on from an older generation to those who are younger. Those things might include an object like a mask, a song, a story or a privilege that is connected to that mask. When the event happens or those special things are passed on, everyone is there to see what takes place. They are witnesses.

"At a potlatch, gifts are also given to all the guests. By accepting the gifts, the guests show that they agree with what took place; it was meant to happen. When they leave, everyone remembers what took place, and the gifts are reminders of that event. The potlatch was so important because our languages didn't include writing in the past. Even today, potlatches are still really important. That's just the way we do things, and how we celebrate special occasions."

I explained it in basic terms and the children easily understood. In my experience, children often have less difficulty understanding ideas or traditions that are different than their own. They are so open to things outside of their own experience. Unlike many adults, they have few preconceived ideas about First Nations people or our traditions. They accept such concepts as just a way of doing things that they haven't heard about yet! (Dena Klashinsky)

Figure 4 illustrates the nature of loss and how it is expressed in the meta-narrative concerning what is important to regain or recover. The title of this figure is taken from Rita Barnes.

It is interesting to note that conservation codes of ethics refer to objects using broad terms such as "historic and artistic works" and "cultural property." The all-encompassing, idealized nature of codes of ethics promotes the use of simple, universal statements. Conservators seek to apply these same principles to each individual object upon which they work. To First Nations, however, differences in objects, even between objects of one type, are significant because they represent social and cultural differences. For example:

Well, look at the context. Some pieces, like I said, shouldn't be touched by certain people, and ... that's a difficult one, I mean, it's a very general question. You can't give one answer for everything. It depends on whose weaving it is, who made it, if someone actually owns it, like a family, or if it's an unknown. Does the person who the museum wants to do this repair work,

Figure 4

Parallel paths: "For what we do, for who we are"

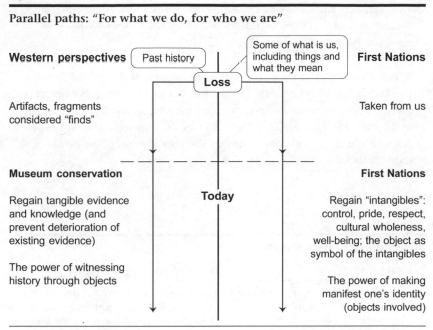

is that person recommended by the band to do the work? ... Or does the band concur with the decision? There are many variables on that; no one answer. (Leona M. Sparrow)

Just as there are differences among First Nations communities and differences in the viewpoints of individuals, so there are differences between museums and cultural centres. For instance, a later section addresses why a collection of whistles from Alert Bay housed at MOA remained on public display at least as late as 1999, whereas outwardly similar whistles at U'mista in Alert Bay had been removed.

The importance to First Nations of social context is nowhere more in evidence than in the use-versus-preservation debate. Consider the following comments:

My son has a mask in the museum that's been used three times in potlatches, and it's become more valuable. It has more value now. Each time it's used it becomes more valuable. (Peggy Svanvik)

Wear and tear through use on the mask? I don't have any experience of that but to me at least the family can make use of it. I think what you get out of it is just the use by different family members, like the children – well, it's

continuing your tradition to be able to use it and [have] that family wear it – I mean it could always be copied again. It's not the same thing but, I mean, if you let it sit there and sit there, it's not what they were meant to be made for. (Pam Brown)

By using the object you're continuing the evolution of the cultural identity. You know, that object is really in the past, but they're using that object to continue the present and future. Whereas versus non-use, the object is still in the past, but it's stagnated. It doesn't evolve as much. It won't evolve unless it's in use. It's always rooted in the past, it's not being carried forward. (Don Bain)

Table 4

Preservation of material culture

Museum conservation	First Nations
The objects themselves are important to preserve. This is the role of conservation.	The cultural life of which the objects are a part is what is important to preserve (first and foremost for and by First Nations).
Preservation requires that objects not be used and that professional conservation guidelines be followed.	Culture is preserved through use of the objects, through participating in the traditions.
Controlling access to collections mitigates further loss.	Access to collections mitigates loss.
Relationship with collections: emotions involved are usually associated with professional satisfaction, aesthetic appreciation, wonder.	Relationship with collections: personal. Emotional responses to objects are associated with ownership, identity, one's own history (personal and collective).
Objects are sources of information.	People, then objects, are sources of information.
Objects are validated even if they are decontextualized.	Objects are most validated in connection to their original context.
Reclaiming heritage is synonymous with reclaiming objects.	Reclaiming heritage is synonymous with reclaiming traditions, pride, well-being.
General principles apply to all objects in deciding preservation questions.	Specifics of nation, clan, family, and type of object are important in deciding preservation questions.

This approach to "use" applies even to objects with a more personal cultural significance. "I look at those things [bracelets] and I think, what a waste. Sitting in a glass case when it could be adorning someone. When somebody could be enjoying them. And I think the reason why I can feel this way is because some of the jewellery wasn't really a part of our past history, it is something very new. And they just ... to me they should be worn" (Rita Barnes).

Major differences in outlook between First Nations and museum conservators with regard to the meaning of preservation are summarized in Table 4. The next section will look at these differences in more detail.

Preservation versus Use

In the following comment, note that the intangible social factor – the relationship between the two women – is as prominent in the narrative as are the logistics of preserving the baskets, which is what conservators would consider to be the main topic.

A great friend of mine who I had the privilege of taking the Aboriginal Museum Internship Program with in 93/94 was a great basket weaver. She not only made baskets, she made woven figurines from cedar bark, hats et cetera. She also worked with hides. She made baskets from bark that she gathered and prepared herself. Last winter at UBC we had a chance to clean several old baskets. She asked the instructor why they were trying to preserve these poor, thoroughly deteriorated baskets. She said that the basket had already served its purpose and needed to die. I can still hear Keekus and all her stories, truly a talented elder who I will miss forever. (Claxton 1994b, 1)

Another person, being told about these comments, responded:

I can see the value in Keekus' point, particularly if an object is no longer usable and it doesn't have an important history associated with it, or if its history is unknown. It may be possible to have another object created, one that serves the same function. The new object might even function better than the old one! Under those conditions, a new, fully functioning object would have more value than an old one that can't be used. It seems crazy to spend your energy on preserving an object that, like she said, is lifeless. (Dena Klashinsky)

So, regarding the question of what attributes of an object must be preserved, First Nations clearly place a high value on usability. There are a number of reasons for this, one being that use reflects what the originators intended for the objects.

John Moses examining a replica wampum belt of the Six Nations Confederacy, in his role as Native History Researcher at the Canadian Museum of Civilization. Replicas such as this one are commissioned for research and display purposes. (Canadian Museum of Civilization)

How would my grandfather have felt? I think my grandfather's feeling was "when it's there, it should be used." (Rita Barnes)

Without meaning to sound superficial or trite, I would say that nothing lasts forever, and that certain objects are not fulfilling their intended functions within the culture (i.e., *Native* culture) unless they are made use of in their ritual or ceremonial context. They may be fulfilling their functions perfectly well within non-Native culture by being artificially maintained within the sterile environment of a museum, but obviously this is not their intended function within their originating culture. (John Moses)

The importance of the originator's intention regarding the function of an object can be seen in the emphasis on cultural continuity: "But those pieces that have traditional or spiritual values I don't think should be purchased and displayed by a museum, so long as it's still being practised. Today, it's still thriving. It's still being practised" (Howard Grant). Use is especially important with regard to ritual objects: "In terms of a ritual piece, the cultural significance of an object can be preserved by facilitating or enabling its appropriate use by appropriate community members" (John Moses).

If a family is actively participating in their cultural ceremonies, the use of a ritual object can be a matter of necessity rather than choice: "The same kind of rights are not associated with pieces of jewellery. You treasure a gold bracelet your grandmother gave you. You don't ever have to wear it like we have to once in a while wear a mask that's been passed down to us" (Gloria Cranmer Webster). Use is also seen as crucial to the transmission of the culture.

Like I said, it's good for the kids to use them ... it's really teaching them. They're feeling the texture, the artwork, you know, and what better way to keep the culture alive? (Dolly Watts)

The fact of the objects being used, I think, that's important. And understanding the use of it. Taking my granddaughter to the potlatches. (Rita Barnes)

I suppose for kids in the city the business of touching may be more important. Potlatches are so much a part of kids' lives here in Alert Bay. (Gloria Cranmer Webster)

Even with regard to archaeological objects, where the question of current use does not come up, knowing about how they were used is still important in transmitting culture. Transmitting culture means passing on a positive cultural identity: "And now the artefacts that have come back, the new art forms that are being developed, are, I'm sure, a contributor to the growing revival of the culture, the arts. And the building of self-esteem is gradually taking place. I think there is a growing pride in who we are and where we came from. You know, even though in some circles today, that's not considered to be such a great thing, but we think it is" (Alfred Scow).

Use is also indicative of rights and privileges, as, for example, in the case of cultural prerogatives being displayed and witnessed at a potlatch or other ceremonial occasion.

The Native people didn't have a writing system. A way for them to pass that down was to invite people to be witnesses for different events, like marriages, when a boy became a man, a young girl when she became a woman. And so you would never just privately hand these things down, you would have to gather people to be witnesses so they would say, "Oh, yes, well, I remember that was handed down from his grandfather." And you couldn't just use whatever you liked, just because you liked it. (Anonymous)

Within my blood line, I was very privileged to be born into the family line that contained, I guess, the ranking. I wouldn't want to call it ranks, but

we'll use that word for now. I was born into a family that had the right, or the privilege, to wear a mask. And this mask was handed down from generation, to generation, to generation. (Howard Grant)

Right now I have a family mask that's present in the Vancouver Museum. Yes, we'd love to have it in the family again. Yes, these kinds of masks are to be worn on ceremonial occasions, but I would be a crazy person to say "I want to keep this in my house." But again, there are special occasions that I think I should be allowed to wear it if it was possible, recognizing that after use I would return it. (Howard Grant)

Finally, use is indicative not just of family or lineage identity, but of cultural identity. The following illustrates a parallel between the use of cultural resources and the use of natural resources: "I think my band definitely sees a real value in my academic training and museum experiences in anthropology and archaeology. The discipline can help our communities increase our capacity to assert our rights – in terms of land claims, use of resources, and gaining recognition of the value of our cultural traditions" (Dena Klashinsky).

It is "use" that can establish rights in the complicated arena of Aboriginal land claims. In the following examples, use is what gives value to an object:

There's a difference between what an artist carves, and sells: a mask to a family to use for ceremonial purposes, [or] he may carve a very similar mask and sell it to a gift shop. But once this mask has been used by the family in a ceremonial context, it takes on a cultural significance. Whereas this mask that got sold in the gift shop is more viewed as an object of art. (Don Bain)

I know there are a lot of things that are brought out only on special occasions that are danced or whatever, even if they are a bit frail, but people just take more care – but the only way to validate it or for people to see it is in a potlatch. (Pam Brown)

One person did challenge the precedence First Nations give to the cultural need to use objects. This respondent noted that many First Nations people feel they have the right to the use of the items but that they do not think of the wear and tear on them or about how to take care of them. She remarked that these people "get touchy" if this issue is raised. This – the contemporary politicized arena that provides the larger context for museum/First Nations relationships – was discussed directly by several others and will appear later in this chapter.

In *Preserving What Is Valued* I employ the word "use" in the same way as do conservators – to cover a general category that can bring physical risk to

an object. First Nations people, however, often distinguish between types of use/types of objects used and weigh the risk to the physical object against what would be gained by using it. This is seen in the previous quotation from Pam Brown and in Adelynne Claxton's comment: "Baskets are work things, but some could have a different use in an educational collection, and some are worth preserving."

To further underline the First Nations perception of "use," it should be noted that certain kinds of wear are mitigated by the passing on of cultural values. In other words, there exists a traditional cultural connection between the use of objects and the proper care of these objects. Values such as these can be found in Western as well as indigenous societies. For example, Western musicians take great physical care of the old musical instruments that they use because they respect them and because their sound, (i.e., their inherent meaning) depends on their condition.

And I think that sometimes it's very important to touch. But I mean, if they're going to be rough and stuff, then of course, they mustn't be allowed to do it. But, well, learning self-discipline and respect is part of what they should learn too. (Peggy Svanvik)

In the dance program, the children have little masks and other gear that they're allowed to touch and learn how to take care of. But it's not so much a matter of just "touching." It's "using." (Gloria Cranmer Webster)

I think if you have or if you borrow a blanket or if you lend it to people, there's always an expectation that they'll look after it. You don't have to really say that, you know. When I used to go to some ceremonial feasts and I never had a blanket ... people would lend [one] to me and they'd never say "Be careful!" You know, they wouldn't say that – you don't do that – and people are always willing to lend their material, and they know that you'll look after it. (Pam Brown)

The Collections Manager at the U'mista Cultural Centre commented: "When I'm working in the back room they'll come in and they'll kind of pick a piece up, and no washing the hands, no nothing, just, you know. And I have to tell them that's not how you pick that up. But usually I don't worry about it, they're used to handling it, it's maybe not pieces of gold, but it is the same regalia they use for a potlatch" (Juanita Pasco). The preceding quotation illustrates one interface between museum conservation and community or cultural centre ideas of proper handling. "Handling" will be discussed in more detail later on.

Some of the answers to the question of whether or not a particular object needed to be used were based on practical considerations rather than on

political or cultural correctness (what "should" be done): "Would he use his paddle shirt today if he had it back? Sandy Jones pointed out that it is fifty years old, and probably would 'have had it' [would not be in a usable condition]." Use was not spoken about only in terms of its original use. For example, objects were passed down from generation to generation, and even if they were not in good enough condition, say, to be danced at a potlatch, they could still serve an important cultural purpose. "But we don't put a price on it. We don't think of it in dollars, you know, like it's priceless or anything. As long as someone's using it. Like, if I'm giving it to my grandson and he's going to practise using it, that's OK. And then eventually it just goes out of sight, and then there is the new one" (Dolly Watts).

When masks are too fragile to be danced, but it is important to use them at a potlatch, acceptable compromises have been found: "And they displayed the regalia. They didn't use them to dance them but they brought them out to show everybody that had come" (Juanita Pasco). In the preceding case, the use of the objects at the potlatch was facilitated by staff at the U'mista Cultural Centre, where the family had chosen to house the objects. As museum-like storage in Alert Bay was the family's choice, and as the family was concerned about the objects' well-being, in this instance standard conservation practice integrated well with First Nations' need for use of the object at a potlatch. In fact, one could say that following standard conservation practice validated the importance of these older pieces for their family of origin because it signified that the family took good care of the pieces. The collections manager at U'mista brought the objects over to the Big House for the potlatch: "I brought them in, and told them how to handle things, just a little: 'This is how you do it, you know, you use two hands. Don't hold two objects' – and just went over the basics with them. They were all excited. They wanted to use the little white gloves but – but I didn't have any!" (Juanita Pasco).

In conservation there is a tendency to look at "use" in terms of original use and to view the museum's role as that of protecting the object from use. "Museum use," however, also involves the risk of wear or damage. This is most obvious if objects are used in interactive educational programs, but wear is potentially a part of every museum process involving objects. The U'mista Cultural Centre, whose main collection of older material was repatriated to them in the late 1970s on the condition that they build a museum and follow standard museum procedures (including not using the pieces), has purchased contemporary objects specifically to loan them to families who have the rights to certain dances but do not have the appropriate regalia. A related "museum use" common to places having Northwest Coast collections is described by a staffperson at a cultural centre: "With the masks in the museum here, they were given back to the museum on the condition that they'd stay in the museum; none of the masks ever leave the museum

to go back to the families, if they have the right to use it, but that family can make a copy of that mask. So it doesn't leave here" (Anonymous).

In museum cataloguing, any use an object was put to between the time it served its original purpose and the time it entered the museum is often

Doug Cranmer adzing the Wakas replica pole at Stanley Park, Vancouver, 1987. Nels Powell looks on. The original pole is on the left, covered with a net that serves as a grid. (Vickie Jensen)

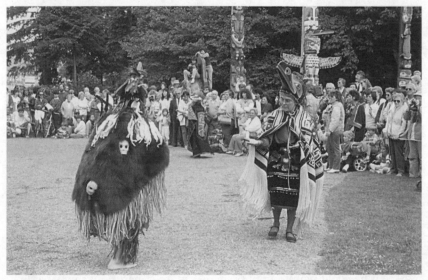

In the ceremony celebrating the new Wakas replica pole at Stanley Park, Gloria Cranmer Webster dances as a hiligaxste', leading the hamat'sa (her brother, William T. Cranmer). (Vickie Jensen)

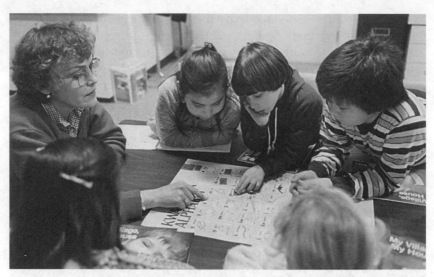

Gloria Cranmer Webster reviews the Kwakwala alphabet with Alert Bay school children at language classes in the New U'mista Cultural Centre, 1981. (Vickie Jensen)

unknown or considered of secondary importance. Several people mentioned having ceremonial objects at home that no longer served their original purpose either because of the condition of the piece or because of the devaluation of the cultural practice. However, these pieces were still useful.

> My sister has a bentwood box that's even older than what I have, and her sisters used it as a toy box for years and years and it came from my great-great-grandmother, so I don't know, I can't begin to think how many years back that might have been.
>
> [I have] a fairly old piece, and I had it, mind you, years ago when my children were small, when it came into my possession from my Dad, I used to allow my children to take it for show and tell. And I raised five kids and they all at one time or another took this piece, ... sometimes carefully and in a plastic bag, but in the case of my son just having it around his waist and parading down Rumble Street never thinking that someone might recognize it as something very valuable and [it] could have been snatched out of their hands just like that.
>
> But eventually I was to realize the value of this thing, after my father died, and so I decided to store it in the museum. But I find that a lot of people have a right to this thing. Just very recently my nephew phoned and asked if he could sign it out of the museum for Calvin Hunt's potlatch in Fort Rupert, and I myself personally feel that I can't refuse them. (Rita Barnes)

Gloria Cranmer Webster, Director of the U'mista Cultural Centre, and Andrea Laforet, later to become the Chief of the Canadian Ethnology Service at the Canadian Museum of Civilization (CMC), unpack a dants'ikw or power board upon its return to U'mista from the National Museum of Man, now the CMC, in 1980. (Vickie Jensen)

Another person commented on the role a museum can play when an object is no longer considered usable:

As an example, I know a person here who has a mask that is 200 years old. I'm sure its deteriorating. I'm sure that someone in the next generation, the generation after, will come to a decision point of: "I can't use this in our sacred ceremonies anymore, because it's just too far gone." So one of two things is going to happen. One, they're going to put it away and leave it in the corner, which will rapidly deteriorate it, or, two, they'll sell it. Maybe, because they might lose the significance, or they might just say: "It's taking up too much space in my house." So if there was that strong communication link between your museum and this community, they could say, well, hey, there is the ability to store it there, to keep it there, for eternity. (Howard Grant)

Immediately after the return of the potlatch collection, the Kwakwaka'wakw treasures were unpacked and put on view for local families. Elders, such as Jack Peters seen here, were invited to view them and share stories. In earlier times, when a person was taken in war and ransomed back, they were said to have U'mista. This word appropriately became the name of the cultural society and centre, housing the artifacts that were confiscated and finally returned. (Vickie Jensen)

Access and Use

The need for both preservation and access is as much a dilemma for Howard Grant as it is for museum staff. In the previous quotation, Grant views museums the way conservators do, as places that can preserve objects. Housing objects in a museum is not, however, entirely satisfactory, even in the above situation, as standard museum practice is designed neither for easy access nor to answer personal needs.

And I forgot to tell my uncle that if they ever need it, it's there [relative's house], because if they can ever use it, that's good. But I don't want to preserve it, I don't want it to go to a museum. I want it to be there when they

want it; when they need it. I don't want to go through signing papers, and shipment and putting it in crates and everything. I just want to say, sure, go ahead, take it, it's at Nancy's house. It should be available. (Dolly Watts)

At the same time, in more than one cultural centre, staff emphasized that excellent collections management practice is essential if the centre has objects that are borrowed for use. One person made the point that, if objects are going in and out of the museum, then written agreements are necessary so that new staff know the procedures and know who can borrow what.

The failure of museums to fulfil personal needs is discussed at more length in a later section (in relation to the bentwood toybox mentioned above). It is important to remember that personal needs, including borrowing for use, are significant factors when it comes to defining preservation from a "continuity of-culture-through-living-it" perspective. It should be noted that people may make distinctions between cultural centres and museums in this context, as is illustrated by the examples of the family that placed its regalia at U'mista and Rita Barnes' sister's bentbox.

With regard to physical risk to the object, the preservation-versus-use dilemma has been mitigated, when culturally appropriate, by such things as using newly-made regalia. As this can be expensive for individuals, cultural centres like U'mista have purchased contemporary work for ceremonial use. In British Columbia, this has also been done at the Royal British Columbia Museum. In addition, some urban museums and, especially, cultural centres situated in First Nations communities, have offered to keep privately owned regalia in storerooms. In other words, the facility acts as steward of these collections, providing a safe environment and facilitating easy access.

It should be emphasized that "easy access" refers to lessening bureaucracy, not to allowing public access. Here the issue is very different from the access mandate of most contemporary public museums. Everyone is concerned that proper cultural protocols be observed and that only those who have the rights to the ceremonial gear be allowed to borrow them.

The documentation [which came back with the repatriated pieces] was so bad and we had to wait for so long, no one really knew who owned what and we certainly weren't about to do something that might create a lot of problems by allowing someone to use this mask who didn't really have the right to. So, we just said no. They're symbolic, I guess. (Gloria Cranmer Webster)

I couldn't tell him [what he was allowed to use in his potlatch] because I didn't know his family lineage or what was handed down to his family. And the potlatching system, you couldn't just use whatever you liked, you had to have the right to use it. So you couldn't just pick and choose, you know, what you'd like to use; you had to have the right. (Anonymous)

Another major role that First Nations people believe museums should take on is to assist them in gaining access not only to objects, but also to curatorial and archival information. In the past, lack of access has been a major First Nations criticism of museums.

> I did forewarn the Museum of Anthropology some twenty years ago that there were people within this community who knew there were objects within the museum holdings that were part of traditional use and that certain families had indicated they might like to access those particular pieces for family functions, or public functions. The museum just did not know how to respond. Had absolutely no idea, other than going into severe shock, of what to do. (Leona M. Sparrow)

It is particularly interesting to investigate how cultural centres have resolved the preservation-versus-access dilemma, as they have to serve both professional museum and community concerns. As has been mentioned, centres such as U'mista have resolved this dilemma by having a contemporary collection for use, housing personal regalia still in use, and allowing no use of the older, repatriated collection. U'mista provides both cultural reasons for denying use (e.g., not being sure who originally owned some of the older material) as well as standard museum reasons (e.g., the fragile condition of the material). I asked whether, when the collection was first repatriated, the elders believed that now they would be able to use the pieces again. How did the elders accept the standard museum rationale mentioned above as well as the fact that these pieces had been repatriated on the condition that they be kept under museum conditions? Gloria Cranmer Webster, who was the driving force behind accomplishing the repatriation and creating U'mista, who was its first director, and who is the daughter of Dan Cranmer (at whose 1921 potlatch this regalia had been seized), provides some insight into this:

> [Miriam Clavir:] And when they first came back, then, did people want to use them?
> [Gloria Cranmer Webster:] Oh, no. No. They were in pretty bad shape, some of the pieces, and it was pretty obvious that they couldn't be used.

She continued with comments on the impossibility of, in many cases, knowing to whom the pieces originally belonged. This being the case, any use would have been inappropriate.

Dora Sewid Cook, cultural director of the Kwagiulth Museum and Cultural Centre on Quadra Island (which was created at the same time as U'mista and whose purpose was to receive the repatriated objects on behalf of the area's families), said in response to the same question:

There was only one person that I know of that wanted to take it home, and he was a young man, but he's no longer with us. And the other old people, with the help of my dad, wanted to leave it in here to preserve it for the generations to come. We belong to so many different families. In my family alone, the Alfred side, there's great-great-great-grandchildren now. How would we do it? Cut up our things and give it individually to different members? It's better that it's in here. I mean, it's theirs. They still own it. But it's being cared for. (Dora Sewid Cook)

Juanita Pasco, the current collections manager at U'mista, commented:

I think they were happy to see the pieces come home. I think they all pretty much understood that you shouldn't be using them because they are so fragile. But at the same time, they probably thought, "Well, we've been told the pieces belong to us, why can't we use them?" I think we've changed quite a bit regarding access to the pieces. I wasn't there for the opening ceremonies, but I know with the stuff we had transferred from Cape Mudge, it was displayed at a potlatch."

The changes to which Juanita Pasco refers reflect the continuing changes in museum practice in British Columbia: the acceptance of compromises allows the needs of both museum and First Nations to be met.

As has been discussed, museums categorize certain objects, such as vehicles, as "functional" and debate whether or not they should be restored to a functioning state. With this issue in mind, we can pose the following question: Would First Nations ceremonial objects be included under the "functional" category? John Moses, who was trained as a conservator, responds as follows: "I feel Native American ethnographic objects occupy an entirely different area of concern, and their use by the cultures which created them involves a fundamentally different set of issues." He goes on to say:

It would seem to me that if we are discussing the actual use and operation of technological or scientific artifacts in museums of science and technology, or perhaps agriculture or industry, etc., then we are discussing the use of mechanical objects in purely didactic terms; that is, they are presumably being made to operate in situations open to the general public, specifically so that the method of their construction and/or operation might be made known to as many people as possible; i.e. school groups, family groups, etc.

I am assuming that if we next discuss the use of ethnographic objects, we are talking about their use by their originating culture or contemporary descendant population. I suppose in answering your question [i.e., Would First Nations ceremonial objects be included under the "functional" category?], I automatically thought in terms of either a ceremonial rite, or

perhaps an object of traditional art or craftwork being made available for examination by contemporary Native craftspeople or artisans. In either instance I would think it unlikely that such a gathering would be open to the general public. That is, knowledge of the object would not be made available for public consumption.

It is interesting to note that in many museums technological objects which are accessioned pieces from the collection are frequently made use of for instructional purposes or for other reasons like public relations or fundraising. Situations which immediately come to my mind are things like the printing press at the National Museum of Science and Technology in Ottawa, and certain aircraft in the collection of the National Aviation Museum, also in Ottawa. On the other hand, many museum professionals, whether curators or conservators, shudder at the thought of, or reject outright, the notion that perhaps selected ethnographic artifacts might be made available for use or examination by their originating or descendant populations.

I feel that in such situations a number of larger issues immediately become involved, including for example (in the case of religious objects) the right of Native peoples to practice their traditional religions in a free and unhindered manner, inasmuch as some Native groups believe that until certain of their sacred objects are released from museum collections, they cannot practice their true religions in their originally intended form. In other words, sacred objects are not interchangeable, and "replacements" or "stand-ins" for objects held by museums are not appropriate. (Moses, letter to Clavir, 1995, 1-2)

It should be noted that, while John Moses' comment about "replacements" certainly applies to cultures such as the Zuni, it is less applicable to cultures such as the Kwakwaka'wakw, where objects illustrating family rights and prerogatives might be either old or new.

Table 5 summarizes the similarities and differences between First Nations and museum perspectives on use.

Table 5

Museum conservation and First Nations perspectives on use

Museum conservation	First Nations (FN)
Objects entered the museum when they ceased to be useful.	Older objects entered the museum because FN under pressure from dominant Western culture. Today traditional ritual use of objects being renewed; "use" helps build positive identity and community well-being.

▶

◄ *Table 5*

Museum conservation	First Nations (FN)
Museum uses recognized: enjoyment, increased understanding.	All uses related to passing on the culture and observing cultural protocols important (e.g., ceremonial use, teaching children, artists learning).
Use recognized as a necessity? No, if it involves risk to a valuable object.	Use recognized as a necessity? Yes, if not using objects involves risk to cultural continuity, spirituality, rights. Not always necessary to use older objects.
One-time use may be necessary (e.g., if original information is in a medium that is incomprehensible if not "played" or "run").	Cultural protocols, rather than protection of physical object, govern use.
Principal argument against use is that it causes physical damage to object's integrity through alteration and wear.	Traditional use adds value to the object: wear and alteration are part of this.
Risk of damage from museum use mitigated by use of replicas or reproductions, by handling rules, etc.	Sometimes cultural norms can work with museum norms (e.g., when appropriate, use new pieces; treat regalia with respect). This upholds value of passing on the traditional culture.

Avocational groups (e.g., car enthusiasts) /some museums	First Nations (FN)
Use is what objects were intended for.	Use is what objects were intended for.
Use establishes technical understanding.	Use establishes cultural understanding within the culture.
Use is fun: for participants and museum visitors.	Many emotions evoked through use of traditional objects.
Motion is "the soul of the machine." Preserving physical integrity alone does not necessarily preserve meaning: according to some, meaning of the objects established only when they are used.	Use is one element involved in preserving the culture within which the objects have meaning.

Damage

Since the conservator's major objection to use is the risk it poses to the physical fabric of the object, I asked people about their opinions on what effect physical damage has on the cultural integrity of an object. Their ideas about damage contrast strongly with the traditional conservation perspective.

> Now, again, I'm talking explicitly here, about our community's masks that are art objects in the museum. If we were to utilize a mask and it somehow got damaged, and if I were to want to use it again, first of all, yes, I would like it repaired, because I want to use it again. And if I had enough respect for that work, I would ensure, first of all, that it didn't get damaged. (Howard Grant)

> I never see "wear," anyway. It "ages" and what not. Let it go that way. (Doug Cranmer)

> No. They just fix it. (Dolly Watts)

> If it's important for an object to be used, and if, in that use, the family or community gains lasting value through increased knowledge or further understanding of themselves and their history, then you just have to accept the minor changes that may result. (Dena Klashinsky)

I should note that it is perhaps unfair to compare First Nations opinions regarding the preservation of objects – opinions which derive as much from daily living as from museum or cultural centre experience – with the opinions of a particular profession whose central ethos is to preserve physical objects. It would, perhaps, be fairer to compare these First Nations opinions with those of a museum's visiting public, or with an avocational group whose interest is in, for example, heritage cars or steam locomotives. In discussing what constitutes "damage" to valued objects, it is, however, interesting to compare the opinions of First Nations people who have little or no responsibility for collections (represented in the quotations above) with the perspectives of First Nations people, such as John Moses and Gloria Cranmer Webster, who have had such responsibility.

> Oh well, a Hamat'sa mask – if there's a scratch on it, it's part of being used. If it were damaged to the point where the beak wouldn't open or close, well, THAT'S damage! I think that anything that impairs the function – if the eyes won't open and close any more. Yes. But I think things like a little scratch or a feather coming loose or whatever is part of normal use. (Gloria Cranmer Webster)

John Moses gave a more conservation-oriented definition of damage than did Gloria Cranmer Webster, although he also recognized the importance of use:

> On a very practical level, damage to me would include tears, rips, split seams, pieces completely detached or missing altogether. It does not include flaking paint or shedding fur, worn fabric surfaces, creases, or use/wear marks in and of themselves.
>
> Damage is to be avoided in the first place, as far as is reasonably possible, and within the limits of an object's intended use within its originating community. (John Moses)

Both Webster and Moses acknowledge, as do the First Nations people who do not work closely with collections, that damage to the object is to be expected within the context of its social function. Deterioration is accepted as part of a natural process, and the object is considered damaged when its function, not its material, is impaired.

The degree of seriousness of damage was also defined in social terms:

> [Miriam Clavir:] And I guess if something happened during the dance [e.g., a piece falling off], I guess that would be very serious.
> [Peggy Svanvik:] That would be very serious, especially for the dancer. And the dancer's family.

In other words, the damage done to the mask was secondary to the damage done to the honour of the family. "The family giving the potlatch would have to give more money away to wipe away the shame of the accident" (Gloria Cranmer Webster). First Nations people also emphasized the importance of the social aspect in discussions about the appearance of objects. "I kind of like the marks of time, but I think that's me. I know the elders, if something's in really bad shape, they don't show it at a potlatch like that" (Juanita Pasco).

Damage was also defined socially, rather than strictly in terms of the deterioration of physical materials, by one person who emphasized the importance of not only the decision but also the decision makers. He said that, in matters of preservation, he would ask the elders how they would choose to preserve the objects. Adelynne Claxton wrote an essay in which she remarked: "I can appreciate the work of museum staff on their respect of handling our objects and we are thankful for that. It would be even better if our own First Nations elders can be a part of that" (Claxton 1994c, 4).

Dena Klashinsky illustrates how different groups of people can mitigate damage while still allowing use by sharing information:

Hopefully, the owners and those who are involved in an object's preservation are all aware of any issues or concerns about its preservation and they make informed decisions about its care and handling. For example, ideally the owners of a mask are fully informed of any potential conservation issues that may arise from using the mask in a potlatch. They may weigh those concerns against the value of dancing that mask. They may decide that while dancing with it may cause some minor wear and tear, the mask will be used as it was meant to be used. It is alive within the community. That's their decision.

There is no need for objects to be placed in needless jeopardy. What I mean is, everyone should be provided opportunity to be fully informed about the potential consequences of using or handling an object. For example, say a mask was used in a potlatch. The owners felt that it was important for the mask to be danced. As always, the mask was respectfully handled, but while it was lifted off the head of a dancer, minor paint flakes came off, or a feather was dislodged. That's relatively minor. The family was aware of the risks, and they were willing to take them. I am suggesting that we should certainly make full use of modern preservation techniques and practise "preventive conservation," but we should continue to use masks and other regalia as they need to be used, however our community members see fit. (Dena Klashinsky)

People also expressed the view that damage can be mitigated by traditional care.

[Miriam Clavir:] Do these pieces ever come back with cracks or any kind of damage?

[Juanita Pasco:] That hasn't happened yet. Probably because, once they're used, they're put back right away and then they're brought back to the centre soon after, like maybe a day after or sometimes two days after the potlatch.

[Miriam Clavir:] So, do you tell people, "Because it's been used, you have to put it back in its box right away." Or do you ... ?

[Juanita Pasco:] No, no. That's just the way things have always been done. We were told that originally potlatch pieces weren't even on display, and so when people used the regalia, they put it away, as soon as they were done with it. Like, personal blankets, they don't display them in their homes. They have them folded up and put away and bring them out and they put them right back away. It's just the way they've always done it.

It is interesting to note that, in the experience of staff at the cultural centres, there has not been much damage through use. At U'mista, there has been much more serious damage to the collections, namely complete

loss, through the actions of non-community members: two objects on display were stolen by visitors.

"Complete Its Natural Cycle"

For conservators, often the ultimate expression of First Nations views on damage presents itself in the question of whether certain objects, such as totem poles, should be allowed to deteriorate for ritual or other cultural purposes. The following present some First Nations perspectives:

> [Speaking about the memorial poles at the Alert Bay graveyard]. We often get comments like – I have a niece who worked in the tourist bureau [and she] has said that the tourists have come and said, "You people ought to be ashamed of yourselves for not keeping up these poles." So I said, maybe you need to tell those people that those poles aren't there as tourist attractions. They weren't put up there for tourists, they were put up there as memorial poles; that those memorial poles will stand there until they crumble, and when they crumble then gone are the memories.
>
> The old people say that they're not supposed to be maintained. (Peggy Svanvik)

> When a totem pole is erected in the village, there is a significance, a cultural significance attached to that pole. If the pole, in time, erodes or decays, and perhaps falls over, it's the choice of the family, or the individual who owns that pole to perhaps repair and re-erect that pole. And that would take a potlatch, and it's a choice of economics, I suppose. But the pole, when it's lying on the ground, doesn't lose its cultural significance. In time that pole starts returning back to the earth, and that pole may provide what's now known as a nurse log, that little seedlings grow from the pole, that insects and small animals use the pole as refuge, but in time that pole goes back to the earth. It's a cycle. (Don Bain)

> You hear stories that a mask could be used four times and then it had to be burned. Its life was over. But this didn't seem to be any kind of general rule that I know of. (Gloria Cranmer Webster)

According to one person, even objects such as baskets should be allowed to disintegrate: "To see our baskets or swoqualth blankets on the verge of 'total destruction' should be given the 'right to die.' They have served their purpose, new ones would have to be made if our ancestors had so desired" (Claxton 1994b, 1).

Breakage as well as complete destruction was sometimes the result of certain cultural practices. This type of knowledge might have an impact on

conservation decisions, for example, when deciding whether to reassemble an object that is no longer intact.

> One of the elders of Saanich mentioned that when an object has gone through its lifecycle, its owners usually buried it. This is why several stone bowls have been unearthed by construction or roadways going in. The owner sometimes broke the bowl and then buried it. It has gone through its cycle. It was the choice of the owner to have it buried. It saddens me to see these objects now being sold for thousands and thousands of dollars. Some of these stone bowls have reached museums, a dedicated space for them in museums would be ideal. (Claxton 1994c, 4)

Some First Nations people, however, expressed mixed feelings about letting objects deteriorate even though it might be according to custom.

> After his grandmother's funeral, his mother burned her mother's regalia. Sandy Jones feels now that this was a loss, although it was a traditional practice. (notes taken 3 November 1995; see Appendix A.)

> For sentimental reasons I would keep a particular mask but in the olden days they wouldn't. We used to burn our dead. And we also have a burning ceremony of these things once we've renewed them. (Ken Harris)

> Well, you know, I can understand them saying it [i.e., some objects shouldn't be allowed to deteriorate], but I also don't agree to the extent that some things, as we said before, need to be validated. But if we can have a pole that came from a century or two ago that still exists, there's strength in that deterioration as it happens. And whether we've slowed that process down, I mean, heavens, we're looking to slowing down our own deterioration every day! You know, we're putting on face cream, we're trying special remedies and potions to keep us younger, but when we meet an elder, you know, what do we feel in that? That we ... hope we're as graceful as that when we're that age. And I think that that's just something that my boy needs to see, the old carvings. He needs to see [them] ... he loves the museum. (Debra Sparrow)

At one cultural centre a staffperson stated that she felt that today people would prefer to see the poles preserved, and she noted several old poles that had been restored and given to local museums. Unlike the poles in the graveyard at Alert Bay, however, none of these was a memorial pole currently in use. The Haisla Nation, at the time of writing, is in the process of repatriating a pole from Sweden. The Haisla are being asked to house the old pole in a building that has environmental controls. They have decided, therefore, to have their artist carve two new poles: one to go back as part of

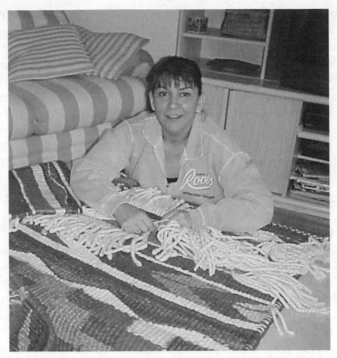

Debra Sparrow puts the final touches on a weaving she made
with her sister, Robyn Sparrow, 1999. The weaving is on
permanent display at the UBC Museum of Anthropology.
(Jill Baird)

this exchange, and one to be erected in Haisla territory where the original
pole once stood. The latter will be allowed to deteriorate over time.

Two First Nations people, both senior experienced museum staff mem-
bers, noted the influence of cultural change and the influence of museums
on First Nations ideas about preservation, and they both emphasized the
influence of the socio-cultural context on preservation. One person stated
that, while she agreed that Zuni *Ahayu:da*, or "War Gods," should be al-
lowed to deteriorate because this was part of ongoing ceremonial practice,
old Haida poles should not be allowed to deteriorate because they are not
currently fulfilling that function. She felt that it would be a disgrace to
allow them to rot and that this attitude, that objects should be allowed to
complete "their natural cycle," was part of the highly politicized nature of
the relationship between First Nations and museums (and, in particular, of
repatriation).

I asked Gloria Cranmer Webster whether she felt there were "any objects
that ... shouldn't be preserved – that should instead be allowed to complete
a cycle?"

Not only for me but, I think, for a lot of Native people – we had to change [our ideas with regard to] the way that objects are used. You know, that traditionally when something wore out, somebody replaced it. When a pole fell down, that was the end of it. You didn't replace it. It had served its purpose. But I think that because of contact with museums and conservators and people like that, everyone began to look at things in a different way. You know, there's a totem pole by Willie Seaweed. We know there's never going to be another one by Willie Seaweed – and maybe for us it's not right - that we allow it to fall down and rot away. And I think people have developed a different way of looking at those objects and, as I said, I think it has to do with the way that we now know something about museums and conservation. And history. (Gloria Cranmer Webster)

This theme, that First Nations and museum views on preservation are coming closer together, or are at least becoming more mutually understandable as a result of increasing contact between the two groups, will recur. Leona M. Sparrow made the point that First Nations might agree with some of the museum's reasoning regarding preservation but that this was not to be read as having the same point of view: "I think it's relative to how many similar objects are around, circumstance, how old the piece is, and some of the same criteria you might use, we might balance as well. It doesn't mean we put the same weight on each one."

The First Nations people cited in this book resolved the question of physical damage through use by pointing out the cultural necessity of using objects in culturally appropriate ways and by working to mitigate potential damage. People recognized that museums have a role to play in this, but they also insisted that socio-cultural protocols must be a crucial part of the preservation process. Museums and cultural centres could facilitate both use and preservation.

If you could, somehow, foresee that possible damage – and prevent it in some way but still use it the way that you'd hoped to and that would be, in a perfect world, that would be what you'd hope for. (Dena Klashinsky)

I think part of finding bridges between museums and First Nations and finding balance for preservation and use is that traditionally things did fall apart and there are traditional ways of getting successors to objects just as there is a proper way for people to inherit names and positions. So part of the revitalization and empowerment should be reviving the traditional way of succeeding the objects – whether the proper "death" for an object is to be hidden away somewhere and disintegrate or whether there's a way that you can release the spirit of the object somehow and transfer it to the new object and let the old one deteriorate much more slowly in a museum. Whether

that would be acceptable or not I don't know. But I think that the whole question of revitalizing Native culture and empowering communities to take over all the traditional roles and whatever traditional spirituality the community is going to carry forth, I think that's a question that has to be put to those people who take on the spiritual role. (Kim Lawson)

Integrity of the Object

Another conservation principle challenged by First Nations perspectives concerns the integrity of the object. This section describes responses to the question of what, in the eyes of First Nations people I talked to, would constitute integrity in an object. It also looks at which of the four forms of integrity listed in the Canadian conservators' code of ethics is considered most important to preserve: physical, historic, aesthetic, or conceptual integrity. Most of the First Nations people agreed with Juanita Pasco: "I would think that what the objects mean would seem to take precedence." For her, meaning rested in the cultural intangibles symbolized by the objects. She went on to say: "You can always carve another piece, but it's those songs that it is important to preserve." Likewise, Gloria Cranmer Webster commented: "I don't know whether the people who made those things or used them thought in terms of aesthetics, or integrities, because it was a symbol of something that was old and valued and it was that aspect of it that was important – not so much what it looked like, I think ... I guess that's a Western thing." Other people chose to emphasize lineage and cultural continuity:

When you think of historical, I am thinking in terms of – that it's a part of the family history. (Rita Barnes)

That's really hard [deciding which type of "integrity" is most important] ... I think number one would be the cultural aspect of it. Because that's where the whole history gets carried through, is through the cultural aspect of the Native people.

 You can't pass it on unless you're having the cultural part of it, the potlatches, so it would be the main number one, certainly, cultural – passed on, continue to be talked about. (Anonymous)

The holistic nature of integrity was often pointed out: "I think that [cultural significance] would be the most important, in terms of family and – the history is to me the most important and – you know, it's all rolled in together, you can't really separate it. Everything is interrelated" (Pam Brown). Some thought "conceptual integrity," best represented these intangibles, some thought "historical integrity," and some thought you needed all of them; however, it was clear that any difficulty lay in deciding on the wording

(choosing from phrases that even conservators had not well defined) rather than on what was important to preserve.

In emphasizing the intangibles, however, it bears mentioning again that the First Nations people cited here did not negate the importance of preserving the physical objects symbolizing those intangibles. Gloria Cranmer Webster and Peggy Svanvik observed:

> Well, if you don't have the physical, you don't have anything else, do you? So, I guess that's the most important thing. (Gloria Cranmer Webster)

> It's more important to keep the mask, and hopefully use it. If the mask is destroyed, then they will have nothing. (Peggy Svanvik)

Another person supported a traditional conservation point of view, stating that objects have value in and of themselves and should, therefore, be preserved. Such objects are a part of someone's culture and may well not be being made anymore.

A fundamental goal of conservation is to preserve the cultural significance of objects. Conservators do this by respecting the historic, aesthetic, physical, and conceptual integrity of the object. One could make the semantic distinction between what First Nations want to "keep" and what they want to "preserve," which is determined by the strictness with which museum conservation norms are applied. This is illustrated in the following example. An urban museum conflates the meanings of "keeping" and "preserving," but at the U'mista Cultural Centre it was important to preserve the old collection of repatriated pieces and to keep a contemporary collection for ceremonial *use*. In addition, U'mista, which is both a community cultural centre and a museum, is also a preserver and a keeper of knowledge – not only of family rights, but also of associated "intangibles." If people want to know how to organize a dance, they can ask the U'mista for the appropriate information.

As well as preserving history, preserving heritage objects assists in preserving knowledge and practices that are culturally significant to the contemporary community.

> I can't explain it except as a question of identity ... as a symbol or a representation of the difficult journey that First Nations cultures have been carried through. (Kim Lawson)

> The objects will always be the connection to the past. They'll always be representative of the past. I think that more and more these objects are becoming important in terms of the cultural identity of different communities

and that these objects, you know, they may reside in mainstream museums. MOA [the Museum of Anthropology] may return ... some objects to the community, or there may be some kind of partnership, perhaps, and these objects will perhaps remain in MOA under community control, but the community has contributed some of its knowledge to that object, some context to that object. (Don Bain)

But, you know, it [weaving] wasn't about a job for me, and some of the ladies, it was about life, it was about really connecting unanswered questions from the past and finding out what the answers were here, and using those for sort of building blocks for reestablishing, I think, who we were as Native people in our community. Because, I think you know, we lived on an everyday basis, knowing that we had to assimilate, and we assimilated pretty good, but there was something always missing, you know? And we weren't quite sure what it was. Even though we had the Winter Ceremony, it was something that could only be done in winter. And what I sort of see as lacking in our community were some things, in that people usually have to see to believe, and we had nothing to see exactly, that reflected any kind of positive reflection from our past. (Debra Sparrow)

The objects symbolize both continuity and change, as do the cultural practices, including the making of original art and reproductions or replicas.

The men are now doing replicas for the show called *Written in the Earth*. And they're duplicating those pieces. Those men that are out there right now have never identified with anything. And when they saw those pieces, those guys out there, I think they were really moved as well. And they're very geared up. They're feeling very connected. They're there, and they're working and working and working. I would be the only woman, besides Susan, involved with it. And I think that that's somewhat important, that there is that change that's also ... happened – that it's not just the men carving or engraving anymore. (Debra Sparrow)

John Moses emphasized the importance of preserving conceptual integrity by preserving knowledge in the originating community:

Preserving cultural significance is, to me, the most important aspect to preserve. Cultural significance means that knowledge of the original function or use of objects is maintained within the originating community or its descendants. The least important is the preservation of any marks that might indicate the object's history. Objects can end up bearing various marks and abrasions from a variety of causes, including neglect or poor

treatment received while languishing in a museum storage vault. They are indeed indicators of its history, but not necessarily ones that community members might want to preserve.

Pam Brown responded to the question, "how is the cultural significance of objects preserved?" by talking about the "intangibles:" "I think by people knowing the stories behind it and whose family it was from and whose name and the crest or clan and when it should be used and how it should be used and who has the right to use it and how it was passed down ... the names that were given or how it was used in dances" (Pam Brown).

This brings up the question of whether "conceptual integrity," or "cultural significance," can ever be preserved in or by a museum or whether it can only be preserved in or by the cultural knowledge and traditional practices of the community of origin. In general, people gave answers similar to the following: "The cultural significance of objects is usually preserved by families who pass their knowledge down through the generations, not by museums" (Adelynne Claxton). However, most agreed that museums had a role to play: "Museum resources can help people know their ancestors, their family" (Peggy Svanvik).

Two of those who work in cultural centres noted the centres' role in preserving cultural significance. They both mentioned housing the old collections, but their responses focused mainly on preserving cultural significance through using the centre as a resource that offers language and dance classes, for example (Juanita Pasco; Anonymous). In other words, the phrases "conceptual integrity" and "preserving cultural significance" brought to mind cultural intangibles. Rita Barnes noted the centre's role in preserving cultural significance by storing regalia for individuals, and one person noted U'mista's role in the revitalization and re-emergence of traditional cultural practice, "pulling it above ground rather than underground" (CL).

Gloria Cranmer Webster focused on a particular "intangible," symbolism, as an important element of cultural significance that is preserved at U'mista. She also suggested that this symbolism derives its meaning from the collection as a whole. In this case the intangible attribute pertains to a collectivity, rather than an individual object.

I think the way that it [conceptual integrity] is preserved here is different because the history of the collection is different – the way it returned, what it symbolizes for us – and the pieces, the objects in MOA's collection, don't have that kind of thing. But I don't know that you can think about objects there in the same way that you think about objects here. One of the things that I was criticized for when I was at the centre was that there were no individual labels. That didn't seem really important to me because it was the whole collection that was meaningful, not individual ones. And I don't

even think about MOA's collection in the same way because ... pieces were acquired in different ways. (Gloria Cranmer Webster)

Conservators usually treat each object individually, and, indeed, the codes of ethics do base the importance of preservation, in part, on the uniqueness of each piece. Conservators may treat art using the artist's body of work as a reference, but rarely do treatment decisions rest on the intangibles inherent within the collection as a whole. (A museum example might be: Why did the collector acquire these particular pieces?)

A First Nations point of view on the difference between museums and cultural centres, and their attempts to preserve what is culturally signifi- cant, is succinctly summarized in the following:

Well I don't know if museum people should really be talking about preser- vation or maintenance of culture because all you've got are things and those things – those objects really, oh, really don't mean much by themselves, sitting on shelves. They only come to life when they are really used. So, I guess, your job is to preserve those "things." It's our job to preserve the culture that those "things" have meaning in. Yeah. I think that, sometimes, people expect too much of museums; they expect even too much of the cultural centres. I think it's true of MOA or anywhere else that people should not think just because things are carefully taken care of there that people in the villages, like Alert Bay, don't have to worry. We have our own stuff to do. (Gloria Cranmer Webster)

In my mind, I see museums as sort of the introductory for a mainstream society. That people can go to different museums and get an introduction to different communities. But that they know that there are other cultural centres, that there are other people within the community that live that culture. (Don Bain)

Museums may preserve "things," but the significance of these "things" can only be preserved if the cultural practices that gave rise to them are preserved.

Further differences were underlined between cultural centres and museums:

This was in the days when the middle workroom [at the U'mista Cultural Centre] was used to make hundreds of sandwiches for potlatches. Anyway, the visiting conservators were just appalled that we were allowing all this kind of thing to happen in a museum. They forgot we weren't a "museum": we were a cultural centre where this kind of stuff was supposed to happen! (Gloria Cranmer Webster)

But in the terms of a cultural centre, I think cultural centres can act as an intermediary between the general public and the community. The community doesn't have to more or less deal with these individuals, that there's some sense of control through the cultural centre. (Don Bain)

Cultural centres serve the community by preserving, showcasing, and facilitating both tangible and intangible aspects of culture. "First Nations are reclaiming their heritage and cultural centres are one of the approaches we have chosen" (Claxton 1994a, 4). CL noted that a community facility gives a sense of pride and that, with repatriation, it would give something tangible as well.

One person noted the role of the cultural centre in educating not only visitors, but also the community's children. The creation of the Secwepemc Cultural Education Society and its museum component resulted in introducing Shuswap culture to the area's primary school curriculum, which had previously highlighted only the well-known Plains cultures on the one side and the Northwest Coast cultures on the other side of Shuswap territory.

Conservation Practice and Guidelines

Conservators' practice revolves around the parameters for preserving the physical object. How do First Nations regard these parameters and the museum practice associated with them if the importance of preserving the physical objects is in relation to cultural meaning and practice? In answer to this question, people pointed out that the physical elements of an object are important with regard to what they signify and that restoration work should focus on whether or not the social meaning of the object would be changed or whether or not the work was necessary for the object's use.

I would prefer, personally, if things were damaged, that the original pieces, if they're strong enough, would be used for replacement. My second choice would be the same material but new, e.g., if it's cedar bark and you went and got new cedar bark to replace it with. Thirdly only under extreme conditions would you actually replace it with something much more modern. Because in my culture, every piece that was attached to it would have had significance. (Howard Grant)

They were never shown in bad shape. But I kind of like them that way better. But if they are for potlatches then they try to make them look good. (Juanita Pasco)

This last quotation is interesting because the custom of making objects look good for the potlatch was the basis of the conservation work done for

the exhibition *Chiefly Feasts*. The conservators at AMNH refurbished (i.e., added missing pieces as well as cleaned and stabilized) the masks according to conservation principles such as reversibility, and they supported their methods and materials by reference to professional conservation standards (Ostrowitz 1993). The decision to refurbish had also, for cultural reasons, been emphasized by a First Nations consultant to the exhibition. Gloria Cranmer Webster was a guest curator for that exhibit, and at one point in our conversation, she expressed her opinion of restoration: "Well, don't conservators say the less you do the better? It seems to me that still applies. These pieces aren't going to be used. They're simply going to be exhibited so there shouldn't be a problem of any rapid deterioration or chance of damage." This appears to go against the work that was performed for *Chiefly Feasts*. When asked about this exhibit, she replied: "I think the thing with *Chiefly Feasts* was that they only asked one person to advise them to refurbish or whatever, but I think what happened, soon after that, people at the American Museum realized that they should talk to more than one person, that not one person spoke for everyone. Yeah, because I think if they had asked other people, they wouldn't have had the same masks."

In the conversations I had with them, First Nations people never disparaged the attempt to physically preserve heritage objects, even if they held different opinions about it.

> You know, I may choose to alter an object because that change is necessary in order to make full use of it. An experienced and culturally sensitive conservator will respect that decision, realizing that his/her job is to ensure that the owners have all the information possible. It's up to the owners, and the owners only, to make decisions about the life or use of an object. Someone with a background in conservation can definitely facilitate an informed decision-making process, but only the individual or family owners who are intimately connected with the object can determine the best course of action. (Dena Klashinsky)

> Because if the museum didn't do the study that they do to look at ways of preserving it, and helping to maintain the usefulness of the objects, they wouldn't be there. (Debra Sparrow)

Some also noted a general lack of familiarity and understanding in their communities regarding museum practices and their rationales.

Everyone I spoke with viewed physical preservation as part of a whole. Objects, even in a museum, are important as tangible cultural materials that are linked to intangibles; they can be especially significant in an era within which the process of recovery from cultural loss is only a few decades old.

The clients of conservation, in the eyes of those to whom I talked, are the First Nations and their material culture, not the material culture of First Nations.

> Yes [clients of conservation are First Nations, not the objects themselves]. Because the objects that you speak for are the "property" of the First Nations. They belong to the First Nations community. So there has to be connections between the conservator and the community. (Leona M. Sparrow)

> But the fact of life is that we're still micro-micro in the sense of the world, we're still micro in the sense of the only preservation that we see is our own. (Howard Grant)

Restoration

In balancing preservation and access, how does one balance repair or restoration for use with normal conservation parameters? How far does restoration for use proceed, and what is acceptable in the views of the First Nations people represented here, especially regarding an object that is the property of an institution rather than an individual?

Two people whose work was not in collections management nonetheless concurred with the conservation viewpoint, which favours minimal intervention.

> [Pam Brown:] For myself, I would always rather not do that [alter an old piece by, for example, adding more buttons or feathers], if I didn't know how or we didn't have the original or something that matched it. I think it just depends on the person because some people would but I don't think I would feel comfortable about that.
> [Miriam Clavir:] Say it was a mask and the paint was peeling a bit. Would you rather keep that old paint showing or would you rather have it renewed by an artist?
> [Pam Brown:] Well, I'd probably just leave it, but if there was an artist I knew and knew his work, then I would do that. But otherwise I think I would rather just leave it.
> [Miriam Clavir:] Why?
> [Pam Brown:] That's how it was meant to be ... because if you change it, it changes the whole piece. It's like sometimes I think about my Mum's baskets. I feel really bad that they're falling apart but, if you change it, sometimes it just changes the whole – it changes the meaning sometimes, I think. It depends – maybe for a blanket it's different. I don't know ... Sometimes, I'd rather listen to elders and see what they would think, you know, because they had definite opinions.

I'd certainly be upset about Beau [Dick, her nephew, an artist], about any-one altering something that belonged to me, something like the sisiutl, but then I think it would be up to me to caution them: "I don't want it changed in any way. Don't try to improve it ... " Mind you, he did do that. He did do that without my permission.

I think it was important that it be whole. And yeah, he probably knew me well enough [to know] that I would have said "No." But he also has enough faith in himself that I could be very pleased with what he did. Because I couldn't see where he did it. I really don't know how he did it. It was his paint job, and you know, the paint job didn't look new. Whatever he did, he was very good at it. (Rita Barnes)

In both the above cases, the limits put on restoration are individual deci-sions. Both people are speaking from their own personal experience and point of view, and both are hesitant about drawing generalized conclusions. They emphasize the socio-cultural aspects of the situation (e.g., not want-ing to alter the meaning of the object, asking elders).

In response to the questions pertaining to intervention, many explicitly stated that they were giving their own point of view and that others might feel differently. Most concurred that minimal intervention is best, some for reasons that appear technical but that may also have a cultural foundation, and others for reasons that echo such conservation principles as respect for integrity.

If a mask has flaking or faded paint, leave it. (Sandy Jones)

We might use the wrong paint. (Adelynne Claxton)

Personally, I feel that if an object is connected to an incredible history, it's important to maintain that history. I realize that if I were to paint it, that would also become a part of its history. However, as a result of my actions, I may irreparably destroy the physical, tangible evidence of all of its previ-ous history. I doubt that I personally would make the choice to paint it, but I think that other people have the right to make whatever choice is right for them. (Dena Klashinsky)

I just think that if things have been kept for historical reasons, I think they should just be left in that state. (Rita Barnes)

I'd like it to be left the way it is. I don't want to play with someone else's property from that time period. My first instinct in connection to it, is it belongs to my people. I don't tamper with something that I respect, and I

wouldn't insult my people by guessing that that's what it looked like. (Debra Sparrow)

Two people, one of whom was an accomplished artist and the other of whom had done some carving, replied that they would opt for restoration:

I mean, if you're not going to keep it up [the physical object], you're not going to be able to dance with it, are you? (Doug Cranmer)

I would be inclined myself, to repair and refurbish. As long as that repairing or refurbishing does not change the form of the original. If you wanted to preserve the state it's in now, you photograph it. (Alfred Scow)

When asked about refurbishing his own pieces, however, the artist Doug Cranmer shook his head and replied with the tongue-in-cheek statement, "You have to do a new one once in a while!"

To elicit opinions on the limits of restoration, people were asked whether it was acceptable to alter the cloth rigging that holds the mask onto a dancer's head. This is a question that has come up when museums have been asked to lend material for ceremonial use: in conventional museum practice, to alter the rigging would be to alter part of the integrity of the original mask.

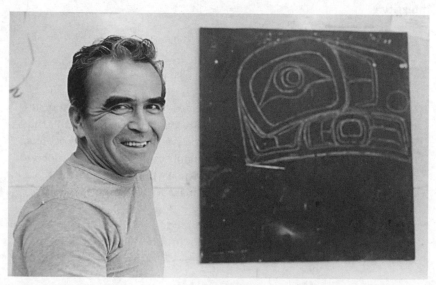

Building on his own instruction from Mungo Martin, Doug Cranmer has taught Kwakwaka'wakw design and carving to two generations of artists in Alert Bay. (Vickie Jensen, 1981)

In their responses to this question, people underlined the pragmatics of use (which they had also brought up with regard to the question of wear and tear on the object). "No, no – it wouldn't really matter. There's an awful lot of altering of rigging. I mean, you know, people have different size heads" (Doug Cranmer). Two individuals who were directly responsible for collections answered:

Well, I guess if you're never going to loan it out then it's important to keep it exactly as it was. But, if you're going to loan pieces for use and the rigging doesn't work and you say you can't change a knot or anything, it really doesn't make a whole lot of sense. I think I'd be terribly upset if I worked in your museum and loaned a piece for use in a potlatch up here and someone decided: "Ah, this thing looks just so dog-eared and grubby. Why don't we wash it and repaint it?" Yeah, that'd be pretty awful. But I think the rigging is – if you're never going to loan it out, then I think it is important to keep exactly the same kind of knots, the same order. (Gloria Cranmer Webster)

I think they're pretty good about altering things. They work around what's there and they'll make their own rigging and attach it and then take it off after. But they wouldn't drill holes, or anything. They understand that if pieces are old you can't treat them roughly, because they're not going to stand up to everything. You can't change it just because it doesn't work for you. So they're really good at adapting things. (Juanita Pasco)

However, for many the limit of restoration is reached when the meaning of the object is altered. "Repaint it? Personally, no. Because the various ways and means that they painted a mask is very important. To change it, I think is disrespectful" (Howard Grant). With regard to the cases both directly above and directly below, social meaning rests both in the object as signifier and in the culturally valued relationship to that signifier.

[Ken Harris:] It [a Dog Salmon pole belonging to Chief Nii 'Ta'm, in Kitwanga, that had begun to rot] was restored in fiberglass. Our people wouldn't accept it. I was willing to accept it, but the old people weren't willing to accept it ... It is alien because it's fibreglass, it's not wood.
[Miriam Clavir:] So even though it looks the same ...
[Ken Harris:] It looks the same; you couldn't tell the difference.
[Miriam Clavir:] Even though it represents the same ...
[Ken Harris:] It looks the same. You couldn't tell the difference. But it's fibreglass, you see. So it's still laying on the ground. Nobody put it up. So I think the answer to your question [whether the same materials should be used in restoration as were used in the original] is if they used another

Ken B. Harris (centre), Hagbegwatxw, in front of St. Augustine's Catholic Church, Vancouver, during Aboriginal Day Celebration. Also present, from left to right, are Reverend John Brioux, Margaret Harris ('Ludiisxw), Brenda Westley (Hiiswiildugiitxa), and Donna Roach (Beiladxw). (Dominique Wong)

species of wood and get somebody to carve it, it would be OK, because the ritual of bringing people together, honouring the past, and resurrecting the past in this new creation is the important thing.

With regard to decisions pertaining to a pole, it would be important to involve the community from the beginning.

Doug Cranmer, the artist, believes that restoration can assist in maintaining not only the aesthetics of a piece but also its social meaning:

[Miriam Clavir:] And what if they decide to add more cedar bark or feathers to a mask to be danced?
[Doug Cranmer:] Yeah, it always helps. It really doesn't matter as long as you haven't altered the *mask* as it is, you know.

Likewise, if a valued social meaning can no longer be realized, for example, if the piece is in such bad condition that it can no longer be used, then the object is not worth restoring. The example of Keekus' perspective on baskets in bad condition has already been given. The following illustrates this further: "There were a couple of pieces that we knew, from photographs, had not been well cared for ... particularly a frontlet that was complete with

the ermine train, sea-lion whiskers, the whole thing. And what came back was nothing but the frontlet. Nothing else. And people said: 'It's too bad, then. It will have to be thrown away'"(Gloria Cranmer Webster).

Dena Klashinsky felt that, while some alteration is acceptable and to be expected, the limit for restoration is reached when it is overdone and the original object is "lost" or its preservation truly jeopardized. Others, especially those who had worked in museums, made similar statements.

As individuals, we are constantly changing, growing and adapting. It's the same with masks. In some cases, I think a mask may serve a much different role or function than it did three, or even twenty years previous. For example, my family may be presenting a mask at a potlatch, as an object that is of great value to us. An elder in the family or the dancer may feel that it's important for the mask to look, you know, as outstanding as it was intended to look. They may decide that it needs repainting. The rigging may need to be adjusted to fit the dancer. Cedar bark may need to be replaced. All of those adaptations are fine, if they are intentional. However, if a potential alteration suits a present need but jeopardizes the long-term preservation of an object, or if a change will dramatically alter it forever, I think you'd have to factor those costs into your decision. (Dena Klashinsky)

You know what? I think he's already done some doctoring on that. And I looked at it, and Miriam, I couldn't find where it had been fixed.

When I went to see Beau later, and said, "You fixed my sisiutl, didn't you?" And he said, "Oh, you noticed." and I said, "Which side was it on?" and he said, "Why would I tell you if you can't see it? Pretty good job, hey, aunty?" he says to me. So I guess ... I'm really not concerned that there's any paint or anything. I don't think it's been repainted or anything like that. (Rita Barnes)

Rita Barnes' comments again illustrate the importance of social relationships. She is not concerned that her nephew will go overboard and repaint her piece, as she trusts his judgment and skill. It also illustrates one classic objection conservators have had to artists or other non-conservators repairing heritage pieces: the work may approach a state of "falsification" if the physical integrity of the original object has been altered and the alterations cannot be detected.

What do First Nations people think of other conservation parameters pertaining to the restoration of heritage objects? Rita Barnes' remarks were in response to the conservation principle pertaining to differentiating the original materials from materials used in restoration (discussed in more detail on p. 173). Others would have agreed with Dena Klashinsky:

To be able to distinguish between original materials and later additions wouldn't necessarily be one of my primary concerns. While I don't think a physical distinction is necessary, I do think it's important to keep a history of those adaptations. That history could be maintained by those who are caring for the object or within the family who are connected to it. It would be nice to have the knowledge that "so and so" altered the mask last year, or made some other kind of changes. As I mentioned, there's a value in that. Everywhere, history is created on a daily basis. Such changes only add to the depth and the history of the mask.

The use of different materials may affect the value of an object. In saying that, I am not really referring to a financial value, though that too could be a factor. I am talking about cultural values. For example, a new material might be more effective in terms of the preservation of a mask, but maybe cedar bark is what has always been used. If a new technique or material is in conflict with what is considered culturally valuable or acceptable, then I would choose the traditional material. However, if a new material is compatible with the overall cultural and physical integrity of an object, and it does not diminish those values, then I would certainly consider using it. (Dena Klashinsky)

She also observed that change to what conservators would refer to as the integrity of the object does not necessarily mean "damage." Change can be good, signifying cultural continuity and "life." "If it's all within one family, like the grandson has made alterations to his grandfather's mask, then I think that's pretty wonderful. The idea of such continuity is wonderful. I guess continuity is most important. If there are slight changes made but a sense of continuity is maintained, then they only increase the value of the object" (Dena Klashinsky).

Dena Klashinsky compared change to physical objects with cultural change; she saw it as part of a normal evolution, noting the contrast between traditional museum practice (which freezes objects in the past) and living culture practice (which involves objects in a dynamic process of change). Here again we have two different constructions of the meaning of preservation: (1) the museum meaning, which, through physical and intellectual means, focuses upon keeping fragments from the past from disappearing, and (2) the First Nations meaning, which focuses upon continuing and renewing past traditions and the material culture associated with them. This means preserving the past by bringing it into the present and ensuring that it has a living future.

I think it would be important to maintain the knowledge that the object has been altered or added to, but change itself is not always a bad thing. In fact, I think that such change and the accompanying history enrich an

object. It's not as if objects need to be static or stagnant to be of value! I especially don't believe that change, just because it's recent, diminishes an object. Tradition and continuity exist in the context, in how those objects are used and what stories they tell. That's what's important to maintain.

I get really frustrated when some people suggest that it's inappropriate or even "inauthentic" for someone to use chainsaws to create a large pole, or something of the sort. First of all, our people have always used whatever tools and techniques necessary to do the job. We have always adapted and worked with new tools or ideas. Secondly, when you get down to the fine lines of carving, no chainsaw can ever come close to what a sharp knife in the hands of a skilled artist can do. It would also be ludicrous to suggest that a mask is inauthentic or loses value because it has Velcro atttached. That Velcro keeps it secure on a dancer's head, and makes it function better. It makes the mask easier to use, or maybe it will even help it last longer. That's what is important. If some change is necessary for the mask to serve its original purpose to be danced, I don't think it's an issue. (Dena Klashinsky)

In answering the question of who does the repair work, and who is the appropriate person to preserve the object, people distinguished between objects still in the family and those in the museum's care. Even for those in a museum, however, many answers were similar to the following: "If there's a family or a community directly associated with an object, I think it's important that those people be involved with any changes made to the object" (Dena Klashinsky).

Many of the people I spoke with mentioned artists in their family or community who were considered highly skilled; they would ask these people to work on their personal pieces and would certainly ask them to refurbish pieces these artists originally created. Doug Cranmer, however, preferred not to repair his older pieces. He felt that the responsibility for this was that of the present owners; he himself preferred to create new pieces. In museums and cultural centres in British Columbia, it has become standard practice to ask artists from the community to do the restoration work on totem poles when this involves recarving or repainting.

If an older piece belonging to their families were to be damaged, several people said they would just leave it. In part, this reflects their belief that objects simply reach the end of their usable lives. In part, however, economic and cultural reasons were also potential factors in their responses. (This is especially true if the "object" – and I asked the question using this generalized word – is a totem pole, as is seen in Dolly Watts' response below. The decisions regarding who does the actual repair work and whether or not repairs should be undertaken are situated within a large social context. "They do maintenance, and there's a feast involved. It's just another way of keeping our culture alive" (Dolly Watts).

Three people said that, if a piece were damaged when it was in the hands of a museum, then it was up to the museum to repair it and bear the associated costs. Cultural centre staff said that they might do very small repairs themselves and that conservation questions would be addressed to an institution such as the Canadian Conservation Institute or to local conservators. Howard Grant, not a museum staff person, noted the difference between restorers and craftspeople: "My grandmother made a million baskets. Half of them are in Vancouver still, not all of them. From a personal point of view, yes, I'd like to see them maintained. It reminds me of my grandmother. But at the same time, the people who would refurbish it would not have the same skills that they had, you know, and the same care. Because a refurbisher only does it for the aesthetics."

The people with whom I spoke did not interpret the question of who should repair an object as involving a conflict between artists and conservators. Several who were associated with museums mentioned that there was value in the work of both conservators and community artists. The role of conservators was to inform and work with the family or community, share their knowledge of conservation concerns and methods, and help artists to repair or create new work. Their role also involved performing restoration work if the museum damaged an object or was responsible for it.

Some people also stated that there were cultural limits to the work a conservator should do, especially with sacred/sensitive objects or other objects requiring private ceremonial maintenance. Adelynne Claxton, who is Salish, noted that it was not appropriate for a conservator to wrap up spiritual objects; rather, the conservator should approach elders who would arrange for the appropriate person to wrap the object. Leona Sparrow made the following comments:

> [Leona M. Sparrow:] I wouldn't try to suggest to you in that statement that people aren't interested in conservation, but it's how the conservation is done that they're most concerned about. It may not be appropriate to put two different types of rattles in the same cage. OK? That's like putting two different species of animals together ... They may not interact.
> [Miriam Clavir:] What about the appropriateness of putting them in cases? Or cages, as you said. At all.
> [Leona M. Sparrow:] It may not be. Some of them might be better off in bundles. Wrapped up. It may be more appropriate in a side room, rather than in visible storage.

In order to take "proper care" of ethnographic collections, the conservator needs to seek expertise from the First Nations community and to share his/her expertise with it.

Importance of the Difference between the Original and the Repair
As discussed previously, it is a principle of conservation that materials used in repair and restoration should be distinguishable from the original materials. This distinction is made in order to avoid the possibility of the restorer's work being taken for the artist's work and to ensure that falsifications perpetrated in the past by some restorers are not repeated. This principle involves two components: (1) the materials themselves and (2) how the work is done – the "brush strokes," as it were.

All the First Nations people with whom I spoke about restoration materials stated that it was preferable to use the same type of material as was used in the original. The reason usually given for this had to do with favouring what was traditional. Some, however, felt that it was acceptable to use modern materials if this was what was most practical. "I don't think it really matters today. I mean, there's so much plastic. Nobody uses leather hinges on transformation masks any more. You know, they're shiny, brand new hinges with stainless steel screws or whatever. People are not even trying to hide it any more, you know? I guess today – whatever works" (Doug Cranmer).

Juanita Pasco responded to this question by noting that some artists like to try to make their own paints and that she thought it was fine to use these different materials. Another comment came from a conservation perspective: "Where the stability of the object allows, I would prefer that the same materials and methods be used in its treatment. As a conservator, however, I of course realize that this is seldom possible, and is contrary to certain ethical constraints by which we are supposed to abide" (John Moses).

I asked the question about acceptable materials as a theoretical "which-would-you-prefer" type of question. It was not part of a discussion focused on a particular object, as might occur within a museum situation. In a museum, with particular objects brought out for discussion, the participants could be more concretely informed about, for example, the options conservators have with regard to distinguishing restoration materials from original materials. They would then have a better idea of the final appearance of the object. It is possible that a situation such as this might have produced different responses. And it is precisely this sort of discussion that several people noted was necessary in First Nations-conservator relationships.

When asked if it was important to be able to tell the difference between the original object and the restoration work, one person replied: "I don't think people would really worry too much about that sort of thing. I think mainly what they worry about is that they can have access to it and maybe use it" (Pam Brown). Two people who had been responsible for the pieces in a cultural centre gave responses based on museum practice. Juanita Pasco felt that, for practical reasons, it was important to be able to tell the difference

between the original piece and the newer piece. Her experience had shown her that some restorations are done extremely well and that museum documentation, which is sometimes not as complete as it should be, does not always provide a back-up system that enables one to tell the difference between the original materials and the restoration. Gloria Cranmer Webster said that, while she did not consider it important to be able to tell the difference between the original and the restored object, if modern materials were used in the restoration (e.g., plastic broom bristles on a mask instead of the traditional and now much harder to obtain sea-lion whiskers), then one was obliged to state this, in the exhibit labels, for example. Others who had worked in museums also voiced opinions that could be said to be based in a cultural-museum middle ground, recognizing the importance of both social attributes and standard conservation values:

> I think it's kind of a dichotomy. Because if the object resides in the community, that's fine. It doesn't necessarily need to have to distinguish different parts of the mask that have been repaired more recently. That's the life of the mask, that's the history of the mask.
>
> For repair work done in the museum, the conservation dialogue still applies. That you have to be able to reverse what you've done to the mask. If it's done with the blessing of the community, the family, that would be different. (Don Bain)

For Don Bain, the conservation dialogue applies if the object is in a museum, but he leaves the issue open-ended by adding that the wishes of the family must also be considered. John Moses, the conservator, asks who the restorer is: "I personally would want to be able to tell the difference between the work of the originator and the work of a museum conservator. If you're talking about restoration or repair done by a traditional craftsperson from within the community, I feel that becomes a different issue" (John Moses).

Handling

Museum handling rules come within an area of conservation practice where museum concerns for object safety can be seen to be challenged by First Nations wishes for direct access to and control over their own heritage. Handling objects with gloves is a museum practice, not a First Nations practice: "Well, I don't want to say this, but I did chuckle a little bit when I was sitting in class and everyone was using white gloves. I thought to myself, well I wonder how many of our people would use white gloves when they handled things. What they really do is get into grease [oolichan oil] and put grease all over it. [Today some carvers use linseed oil]" (Ken Harris).

Pam Brown, a curator at MOA, expressed ambivalence about following or enforcing handling rules:

> Sometimes I think it's good and sometimes I think, "They wouldn't have done that." I mean, that thing that was in my grandmother's was used as a doorstop. There's things in people's houses that are just – out. They don't worry about it. Sometimes, I think the cultural centre idea will probably be growing to something that would be really museum orientated, you know, in terms of storage and that sort of thing. But it would be nice, in the ideal situation, to do it without even thinking about it being in a museum.

The differences in the power issues between those who control access and those who want access are not the same in a First Nations community cultural centre as they are in a large urban museum. It can be hypothesized that rules pertaining to handling would be less contentious, at least symbolically, in a cultural centre than in an urban museum. One remembers Juanita Pasco describing family members who wanted to use white gloves as a sign of respect for and care of objects that were being displayed at a potlatch.

One person who was viewing ancient archaeological pieces in MOA felt that not touching them at all was what was respectful.

> He had all the objects on the table, and he said, "Well, Debra, if you want to pick any of them up, you have to use the gloves." And I said, "Why would I want to pick any of them up?" And he looked at me, and he said, "Well, to look at them." And I said, "I don't want to. I can see with my eyes, I don't need to touch them. And I wouldn't want to." Why? ... Because they lived in a different time frame, that I very much respect. They lived beneath this earth for many, many thousands of years some of them. I don't have to go and touch them and feel them [to] know that they exist. I can see that they do. And even in making them [doing re-creations], I'll use pictures, and seeing them here, I'll keep that picture with me. But I don't want to touch them. I don't feel it's necessary for that. (Debra Sparrow)

Traditional Care and Respectful Care

In order to ensure that the social meaning of particular objects is not lost, First Nations people may request that a museum integrate traditional care with conservation-type care. This has certainly been the case regarding the ritual maintenance of objects housed in museums in different parts of North America. The following section examines issues relating to both respectful and traditional care as seen by the people with whom I spoke, and it looks at how this relates to current museum practice.

Many people mentioned that, traditionally, regalia was kept wrapped up. A museum storage system such as MOA's Visible Storage would not, therefore, be culturally appropriate; however, "non-display" storage within the visible storage system could be provided by using another custom – storing regalia in bentwood cedar boxes. Boxed storage could, with consultation about its appropriateness, be harmonized with conservation methods, including insect control. Similarly, a Kwakwaka'wakw elder's advice to keep the upper and lower beaks of the potlatch masks clasped together when they are not being danced is easily integrated into museum practice. One person mentioned that, as far as she knows, details of the best way to look after things, according to custom, had been lost in her community. Another person supported the comments made earlier by Leona M. Sparrow concerning not keeping certain objects in close proximity to each other. This person, even though she was from a different nation than Leona, mentioned that she had heard that in her culture some masks should not be displayed next to each other. She said that she did not know enough about it but that there were others in her community who did. Several people mentioned that regalia was kept hidden between use (one recalled it being wrapped and hidden under the floorboards of her house) for ceremonial as well as "secular" reasons (e.g., keeping it in good condition, keeping it away from children, etc.). Someone said that, in his culture, there were certain taboos about women handling hunting implements, but he felt that, in a museum, as these tools were no longer being used for their original purposes, it would not be necessary to observe these restrictions. On the other hand, the Makah Cultural Center in the State of Washington does not allow women to handle or research men's whaling equipment. One respondent did mention that, in her culture, no one is allowed to touch anything belonging to the members of a particular society (as these people have "extraordinary powers") or to touch medicine bags. The latter, she felt, would still have power even if they had been in a museum for many years.

As mentioned, cultural proscriptions pertaining to culturally sensitive objects can affect such areas of conservation concern as storage, and these restrictions may also affect if and how items are exhibited. In addition, in the following example, conservation issues such as whether functional objects should be restored to a functioning state, which involve determining where the meaning of the object lies, are also part of the decision-making process. At U'mista whistles were taken off display, following the advice of elders, because they had all been used in potlatches – Alert Bay is a community that potlatches – and the potlatch is the only place they should appear. With whistles meaning lies in the sounds produced, not in what the object looks like: "They should only be heard, not seen" (Gloria Cranmer Webster). At one time MOA's Visible Storage system classified whistles as

"musical instruments," whereas, as Gloria Cranmer Webster asserts, they should not be so categorized since one cannot play a tune on them. If whistles are catalogued as ceremonial objects, however, then museum staff are sensitized to the possibility that cultural restrictions might apply. Through Juanita Pasco, MOA sought advice from U'mista about whether the whistles should be removed from Visible Storage, and the answer was negative: "I asked Gloria about the whistles at MOA, and she said that for those ones it was OK, because those families had sold those ones. And some of them may not have been used in potlatches" (Juanita Pasco).

The cultural centre at Cape Mudge had also initially decided not to take its whistles off display, as they had already been shown for a long time.

[Dora Sewid Cook:] Another thing that was never shown, *ever*, at any time was the whistles. Now you see all kinds of whistles we've got in the cases. We're up against our people's beliefs and that.

[Miriam Clavir:] Has that been a problem?

[Dora Sewid Cook:] One or two have come to speak to me about it, because they're traditional. And I understand what they mean. This is where the museum and my people clash. I've accepted both. We had a very understanding father. He taught us to have one leg in each society.

It must be recognized, however, that perspectives change over time, and, by 1999, the question of whether or not MOA should display whistles was being revisited. Two points regarding the display of Kwakwaka'wakw whistles at these three locations need to be emphasized: (1) the necessity of recognizing cultural, community, and family differences, and (2) the fact that museum practice, albeit inadvertently, may not recognize these differences. Two people had a parallel complaint about Visible Storage and the categories used in organizing the collection at MOA: "I did research on Chief Harry Mountain's objects. When the objects arrived [at the museum], they were put into categories, and they're lost to his family. They're all in categories, like all masks ... So when the family member comes there they can't even [find] them [because what belonged to Chief Mountain is organized by category, not by family name]" (Dolly Watts).

Regarding the whistles and Chief Mountain's regalia, these speakers felt that the standard museum practice was disrespectful to, and diminished the cultural significance of, the objects. The MOA collections manager, however, works within a pre-existing system, which classifies objects by culture of origin. And, as is well known, Northwest Coast objects from one nation have frequently ended up owned by the family of another nation (as is the case with some of Chief Mountain's regalia) through trade, gifts, purchase, marriage, and/or potlatch.

People also emphasize that it is important for museums to respect cultur-ally significant objects and to consult with First Nations regarding how museum methods can show this respect.

> So my recommendation for objects that have reached museums/art galler-ies for some reason is that they should be treated with respect, have tribal elders present to see that they are stored properly and stored only with other objects that pertain to that object. This being masks, stored separately from the winter spiritual objects such as rattles, wool garments, spinners, hoof articles, paddle shirts and drums. They should not be displayed, as in their natural life with their owners they did not hang as trophies but were wrapped and stored until it was needed. We have unwritten laws on the care and handling of these cultural spiritual objects that are practiced in the home. The same rule should apply in the "new storage facility" (museum/ art galleries). (Claxton 1994c, 3-4)

Sacred/Sensitive Objects

In considering sacred/sensitive or private objects in British Columbia, we find significant differences between various First Nations. This is also true regarding what some consider to be the most sensitive of collections that museums may house – human remains. Most First Nations are actively seek-ing control over decisions regarding the remains of their ancestors stored in museums, with many seeking their repatriation for reburial. But as Gloria Cranmer Webster points out,

> museums really have to be careful *not* to overdo political correctness in dealing with repatriation requests or demands from Aboriginal groups. I'm thinking about human remains as an example. At every conference I've ever attended that has to do with repatriation, there are always references, sometimes very emotional, to human remains and the need to return those. What museums, treaty negotiators, or whoever need to remember is that there is no one aboriginal way of looking at human remains. Here on the Northwest Coast, the dead were placed in kerfed boxes and put in trees. Over time, the bones fell apart, the human remains fell to the ground and were simply left there. (Gloria Cranmer Webster)

Returning to the question of sacred/sensitive or private objects housed in museums, according to Claxton (1994c, 3): "Masks owned by the Coast Salish have a very spiritual place in our lives. Masks should never be han-dled by women, they too should be wrapped in a special blanket and placed only with the objects that are used in the mask dance ceremonies. Masks are handled only by the owners or the members of the immediate family who belong to the mask dance society."

Today, many Salish masks and dances are not only restricted according to cultural norms pertaining to individuals, but they are also meant to be private. Masks are seen and used only within a community ritual context:

> Now, within the Coast Salish Hunqu'minum [Halkomelem] culture this is still a very private ceremony. We have not danced for money. And this is not for public display, because it's for your own personal strength. It [regalia used in this ceremony] was not for something to be viewed by the general public. They sold it because they wanted to acquire monetary gain to purchase other things. So, the museums around the world, I would presume, have a number of these masks which hold a lot more meaning and a lot more value than money could really buy. (Howard Grant)

Several others emphasized that the spirituality associated with the object remains with it even in a museum: "No matter what happens, the significance of the mask will manifest itself later on back at its home" (CL).

In Kwakwaka'wakw culture, however, the objects are considered to have life, as the culture has life, but not inherent power:

> As for masks ... I don't know if you can ever make an exhibit really real because, I mean they're – when they're sitting on a shelf, they have no life. And it's interesting. In English, you say you "put on" the mask but the term in the Kwakwala language is "to be inside." You are inside the mask. The mask isn't "on" you; you are inside. (Gloria Cranmer Webster)

> I guess what was different about our repatriation – you read a lot of stuff about other Native groups demanding the return of their objects because those are needed in their ceremonial rites. The difference for us was we didn't need any of this because people had continued carving masks, people had kept masks and other gear. The demand for the repatriation of the potlatch collection was based on other things – the idea that they belong here, that they were wrongfully placed in museums. (Gloria Cranmer Webster)

Repatriated ceremonial regalia is the heart of the display area at U'mista. The following example shows a Salish cultural point of view. Howard Grant noted that certain objects, such as house posts or blanket pins that were worn daily, could be either appropriately displayed in a public museum or held in its storage. Other objects, such as those used only on ceremonial occasions, were considered private, and only members of the family had access to them.

Sometimes sensitivity towards spiritual objects extends to the accompanying documentation. One community asked MOA to remove descriptions of ceremonial practices recorded by early anthropologists from the

documentation in Visible Storage so that it would be less immediately accessible to the general public.

The question of how a museum accommodates traditional First Nations practices not only involves balancing First Nations and Western perspectives, but also balancing the past with the present. Some people strongly supported the traditional, while others commented on how, in their own personal lives, they had been faced with balancing the traditional with the modern: "Well, I guess what was really bothering me was that there were so many supernatural beings in our culture. The transformations. I didn't quite know how that happened, you know. So it was important for me to go find out. And when I studied at the Museum of Anthropology, I was able to sort it out in my mind. I can live with it. I believe both sides" (Dolly Watts).

Many people, whatever their relationship to a museum, mentioned the need for museums and First Nations to be mutually respectful and communicative regarding culturally sensitive objects: "So, certain things I believe should be acquired by museums in order to show the rest of the world a thriving culture existed, but also I firmly believe museum individuals should understand the culture of a community first and say what can and cannot be displayed. What should and shouldn't be purchased. So there's again that reality sense that should be conveyed to the students that are being taught" (Howard Grant).

One young woman commented on acknowledging culture change:

I get frustrated with people sometimes thinking that cultural continuity can only be maintained through stagnancy, or even that everything has to fit a pre-determined mould. Some people actually believe that there are only certain tools or ways of making and preserving something that are truly "authentic." Somehow, if you go beyond these set restrictions, then it's no longer traditional. Some people even attempt to apply that mentality to First Nations people, as if Natives living in an urban centre are not the "real thing." The fact that I grew up in Vancouver doesn't make me any less Kwagiulth, or any less Musqueam. I have always had close ties with my relatives, and with my culture. There are cultural values that I maintain no matter where I live. (Dena Klashinsky)

With regard to sacred/sensitive objects, and following traditional cultural practices pertaining to objects now in museums, she observed:

I guess certain masks aren't considered to be as private as others are. It's kind of hard, because I find potlatches are a lot more public nowadays than I think they may have been in the past. Today, many masks could be public. There are very strong feelings about Sxwaixwe masks in the Coast Salish community. Most people feel that the masks should never have been seen

outside a ceremonial context. Yet, there are other views. Someone who applied for the Native Youth Programme wrote an essay on a Sxwaixwe from his community that he saw in the museum. In his essay, he said that a few years ago, he would come in here and find that it angered him to see a mask on display. Now he doesn't necessarily feel the same anger, because he feels that it is an opportunity for him to see a mask that he might not otherwise be able to see. That presents a very complex situation, and it raises issues that can only be resolved within the community. Outside of the Sxwaixwe, there are other masks that are more clearly appropriate to have publicly accessible. It depends on the community, how they feel, whether it should be seen publicly or not. (Dena Klashinsky)

Gloria Cranmer Webster commented: "I think 'sacred' and 'spiritual' are the two most overworked words in Indian vocabulary. There aren't terms in Kwakwala that are the equivalent of 'sacred' and 'spiritual.' We talk about things not being ordinary, which is closer to 'not natural,' maybe 'super- natural.' but I don't know if I ever heard old people talk about 'sacred' or 'spiritual.' It's part of this whole invention – the invention of culture."

She also commented: "When I first came home, I often asked different old people: 'Why, why is this done? Why this mask?' 'Because that's the way it's always done.' 'Well, when did it start?' 'I don't know. It was always done that way.'" As I understand her comments, Gloria Cranmer Webster is saying that, within her community's traditions, ceremonies are not obliga- tory because they were ordained by a higher power (or higher powers) but, rather, because cultural continuity and tradition demand them.

As cultures change, material culture changes as well. I asked whether new objects had the same significance as older ones. Museums traditionally place a high value on antiquity, although the mandate of many art galleries and certain ethnographic museums includes highlighting the vibrancy of con- temporary culture. Gloria Cranmer Webster emphasizes that the age of ob- jects may be important because it has personal meaning but that it is permissible in Kwakwaka'wakw culture for a new (similar) mask to replace an old one.

[Miriam Clavir:] So, then, is there any special value to an older object over a newer object, a cultural value?

[Gloria Cranmer Webster:] Yeah, I guess there is. I guess you'd be able to say, "this is the mask my grandfather wore when he first became this kind of dancer." But if that particular mask is gone altogether it's not the end of the world. You can still carve a similar mask. I suppose the value of something old generally for our people is the same as the value of some- thing old for everybody, you know – your great-grandmother's wedding ring or something.

As she says, "There's lots of times that the object itself is not as important as the right to own that object, and the object may be stolen or sold or lost, but the right remains with the owner, and you can always have a copy or another mask made."

In considering whether older objects are as significant as newer ones, two people commented on the relationship between "antiquity" and the present within a holistic First Nations perspective:

> I think that chronological age does have some impact upon the way certain objects are perceived within the community. On a very practical level, I know of potters, for example, who are always very much interested in surveying museum collections for examples of early Iroquoian or Eastern Woodlands pottery, because as craftspeople they are interested in replicating as closely as possible early manufacturing techniques. On a different level, community members appreciate the age of the Confederacy wampum belts, for example, because they realize that some of the belts date from the very formation of the League, and they are a way of connecting the generations across time. That is, they consider the belts in the same way an American, for example, might consider the original copy of the Declaration of Independence or the US Constitution. In terms of contemporary fine art and craft, there are many Six Nations artists working today who have created what are considered to be modern masterpieces, in a variety of media. (John Moses)

> These are the only things left from a very difficult time when traditional religion, ways of life and so much else were under attack, when everything else tangible was taken away and a lot of people died, so the historic moment symbolism of this is one of the little fragments that's left and there's so little left that we've got to protect it all. (Kim Lawson)

Juanita Pasco said that, in Kwakwaka'wakw culture, a copy may not have the same significance because it has not been danced before but that, otherwise, it has the same significance in that it can be used as a material symbol of the same rights and privileges: "Some of the pieces that are for sale in the gift shop, one of them which has been used in a potlatch is worth more than it would have been if it hadn't. And that's because it has more history. But I think what's more important are the rights that go along with it. The piece can always be replaced."

Rita Barnes stated that the sameness of the objects is an important cultural value because it represents continuity and that, traditionally, older pieces were replaced after a period of time; this information can also be found in comments by others regarding totem poles and certain ritual regalia. Howard Grant commented on sameness and continuity in relation to repair: "Ceremonial objects have a lot of significance. They were constructed,

created for specific events. To recreate new objects to signify that particular event – no problem. But to refurbish, to reconstruct that original object takes away what may have been in that story. So I would oppose taking the older object and revamping it." He emphasizes that public community objects seen on a daily basis are different from private ceremonial objects.

Regarding ceremonial use, one Salish elder noted that his daughter will be sewing a new ceremonial paddle shirt and that it will have power: "New and old, it is the same thing in the Longhouse" (Sandy Jones). Likewise, in his opinion it is acceptable to use new materials when repairing or replicating objects. Dena Klashinsky noted that, while an older mask represents a certain period of time, if a contemporary mask were made with the same intention and served in the same tradition, then it would be just as valuable as the old one. Pam Brown noted the importance of newer objects with regard to continuing a living culture: "I think they're equal ... I mean, there are so many beautiful [Heiltsuk] things, like at the Royal Ontario Museum but there's also, with the canoe revival – you know, they're making canoes and things that are just as important and they're teaching the young people to carve in their family traditions and to me that's just beautiful."

Debra Sparrow echoed these sentiments and expanded upon them to include the importance of the connection between contemporary cultural endeavours and self-sufficiency: "Because it's not about owning anything, for me. It's about other people being able to see these pieces, especially in museums where I know a lot of people come and view what they're going to see as history, but as history in the making for now. So that we can see a connection between the old blankets and the new ones. And that they exist again. If we can become self-sufficient based on who we are, and not hope on what somebody says we have to be, then I'll be happy."

Is the Western practice of placing more value on the works of certain artists a First Nations value as well? Are older objects from the past valued more highly because they were made by a particular master? Is a replica of a Mungo Martin (a widely respected Kwakwaka'wakw carver) mask valued as highly as the original? It could be hypothesized that, if cultural continuity is what is important, then it is less important to know who did the work (unless this was a factor related to lineage). Several people noted that First Nations are well aware of the gallery and museum value of "quality" and that they appreciate the difference between certain old pieces and certain new pieces. However, as Pam Brown's remarks show, a new piece that is beautifully made may be just as appreciated as an old piece. In addition, a piece does not have to be beautifully made to have significance: "Some of the masks I still have today were very quickly made for the potlatches. When I was given the tribal house, I found them, and it is so important. I could get a carver to fix them up really nice, but the importance is that they represent a period of time when we weren't allowed to dance. A lot of these things

can be important because of all the circumstances surrounding them"
(Ken Harris).

An anthropology museum would agree that an object does not have to be
beautiful to have significance. No one I spoke with said that a piece by a
famous artist was more significant than an equally fine piece by someone
else. Peggy Svanvik, however, said that a reproduction of a Mungo Martin
mask would have to be made by one of his descendants. In other words, for
her the importance was not a matter of whether the physical Mungo Martin
mask was valued, but whether lineage was valued and protocols observed.

Doug Cranmer added his personal view on the role and importance of
the artist. Although he is well known for his art, he says that he is just
someone who has painted and carved to make a living:

> Some of them [secondary school children] ask, "What's it like to do carv-
> ing?" I have nothing to say other than that it feeds me. As simple as that.
>
> In the Renaissance and beyond, the people were architects, sculptors and
> painters and that's what they did for a living. They painted. And after the
> Renaissance, all of a sudden we have this word "Art"! Why save these things
> if the work was done by Mungo [Martin]? Because Mungo *did* an awful lot
> of things.

Kim Lawson proposes that the questions surrounding the cultural signifi-
cance of old as opposed to new objects and materials be looked at in terms
of whether the latter can be viewed as appropriate successors to the former
or simply as reproductions. This provides insight into the meaning of cul-
tural significance, and it also affects what is considered to be the best place
to house both old and new objects. Kim believes that, if the objects are
successors, then it follows that the community is the appropriate repository
for them. If, however, the new objects are replicas, then they may belong
just as well in a museum.

> I know it [is an] analogy, people saying that what's important is that the
> traditions live on and that things should have their proper place just as
> people should be in their proper place. I know that there were some com-
> munities and some masks where the appropriate thing to do was to carve a
> mask for a dance season and then burn it, and you were to make another
> one the next year. That was the appropriate line of succession and, for
> others, the appropriate line was to make a new one and then when it was
> the right occasion you can dance it as many years as the dance is required
> but then, on a really special occasion like the successor to a name, that's
> when another brand new mask was made ... I don't know what happens
> to the old mask. It's something that I've only seen little glimpses of, but

"succession" sounds like a really important concept and one that would really affect the question of whether the old ones belong in the museum to protect the physical – or whether the old ones belong in the community. Because if it's a successor, the new ones belong in the community but, if it's a replica, the new one belongs in the museum, according to First Nations values. So, I think there's a lot of room there for dialogue and discussion, but it would be very particular to, perhaps, even each family, even more than each community, and that would be a difficult one ... to be prescriptive about. (Kim Lawson)

Respect

A word that often surfaces in these discussions is "respect." Although "respect" is not actually defined in their codes of ethics, conservators believe that this value underlies their work. In response to the question, "For you in your work, what does respect mean?" four non-First Nations ethnographic conservators (two from British Columbia and two from US museums that, in the last decade, have highlighted contemporary Native Americans in their permanent and temporary exhibitions) gave the following answers:

Respect for an object involves having a deferential regard or esteem for it physically, conceptually, historically, aesthetically as well as all it represents. It involves treating the object with consideration, avoiding any activities that might degrade, insult, offend, or injure it. This consideration should guide all treatment, handling, use, and exhibition of the object. (Sease, personal communication, 1994)

I think of respect as genuine recognition, consideration and concern for the entire context of the object. (Odegaard, personal communication, 1995)

I guess it means putting the object before myself, deciding that just because I would like to do this treatment because it would be an interesting treatment to do, is not enough. It has to be because it's something that the object needs as opposed to it's a challenge or interesting and that it would be fun, or whatever. (Brynjolfson, personal communication, 1996)

Well, I think respect means to look at the object in its entirety and from how to handle it, the proper way of handling it, the proper way of mounting it, displaying it caring for it, treating it, storing it and if you can give the object that kind of treatment from all different aspects, like you're not exposing it to any part of its case that will cause further deterioration, then I think that you have given it respect. (Thorp, personal communication, 1994)

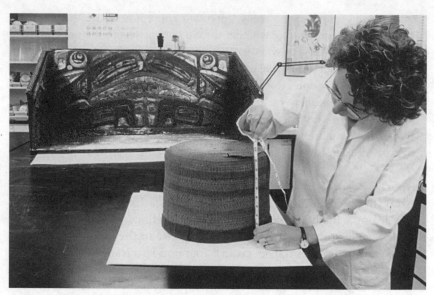

Val Thorp examines the extent of deterioration of a spruce root twined basket (cat. #19639). A Haida chief's seat carved by Charles Edenshaw can be seen in the background (cat. #1296). (Royal BC Museum)

The conservators understandably answered the question as "respect for the object." While their wording did not exclude people, it furthered illustrated that the object is the focus of the profession and its code of ethics.

In contrast to the foregoing, the First Nations people with whom I spoke discussed "respect" in terms of the objects' cultural life and their relationship with people:

> You know, to have an understanding of the community, its values, concerns and needs. Then, actions that you take are in response to, or respectful of, those needs. (Dena Klashinsky)

> Part of respectful treatment is remembering that the objects have life and treating them accordingly. This life-force is important for people. (Sandy Jones)

> If an object in the museum is from, for example, his family, not everyone could touch it; others would not know how to treat it with respect. (Sandy Jones)

> I must say that in working with the museum, they have been the most respectful of believing in what they don't see [e.g., in commissioning work]. They have trusted me and Robyn, they have respected us, and we respect

them back. And that's why I don't have a bad feeling about museums, because I've worked with you, out there. (Debra Sparrow)

Leona M. Sparrow reiterated the need for respecting the social and cultural differences symbolized by objects: "There are different items with different purposes for different people. So you can't put the same balances and checks in place for conserving them."

Howard Grant noted the "respect" that goes into the making of objects. "Now, if you went to someone's home, and if it was, say for example, the family crest, you would always see that crest in the family's household. Probably of three times the quality of the stuff that they are selling to the general public. So there is a difference in respect in what you have acquired, you and the museum, and I'm sure you'd be able to tell, taking two similar objects, saying 'Yes, you know this one had a lot of respect.'"

One person clearly distinguished "cultural respect" from "museum respect," making the point that the latter was not sufficient. "It is a great concern to our people to see objects mistreated. By the term mistreated, I do not mean that the person does not handle it with the greatest of care, I know personally that they are handled with respect, but what I am stressing here is how the artifact may lay on a shelf unwrapped beside something of entirely different background" (Claxton 1994c, 2-3):

Conservation: the Field

The previous sections discuss aspects of conservation practice and beliefs, comparing First Nations and museum perspectives. Some people also commented directly on the overall practice of conservation in museums. Several comments showed support, although not necessarily unqualified support, for museum conservation. Gloria Cranmer Webster's comment, for example, is worth repeating in this context:

We're living in the nineties. Museums are part of our world now and the kinds of things museums are able to do are also part of our world and I think if those objects are owned by those museums, I think those museums have a responsibility to preserve those objects in whatever way works. (Gloria Cranmer Webster)

You do have a prerogative, as a conservator, and I have a lot of respect for that, and I hope my killer whale mask will be handled with white gloves too. (Ken Harris)

In a paper for a course related to conservation (and taught by the former head of conservation at a major museum), Adelynne Claxton (1994b, 1) wrote: "I realize the mandate of a museum is to save everything or slow

down the process of deterioration on objects. I respect that theory, but if it is a lost cause to try and save something, let it die peacefully, there are probably 'twin' objects out there that can be saved. Museum practices are doing wonders in preserving objects that are in good condition for study purposes, to this I refer to First Nations objects, this my people are grateful for."

Other differences between First Nations and conservation perspectives were noted:

I suppose respect [i.e., conservators' respect for objects] means finding out where that particular object originally came from and working either with it, or with the people that it will come from, or stem from. You see, you can only do the best job that you know how. Let's face it, it's in a particular building, and you've gone to a particular school to learn how to look after this particular object. (Debra Sparrow)

If the philosophy is 100 percent preservation, then you're going to end up with different methods than you're going to have in an institution that says indigenous access first, conservation second. (Leona M. Sparrow)

The earlier discussion of handling rules shows that some people consider the conservation approach excessive or unnecessary. The following comments by Dena Klashinsky add to this:

My uncle is an artist. I have heard him say: "When a pole falls over, it falls over because it's meant to fall over. When it starts to rot and deteriorate, that's simply part of its life process." His comments capture a cultural philosophy, and they raise the issue of preservation versus use. In an ideal context, when a pole starts to deteriorate, there is an active artistic tradition in the community. A new one replaces the former pole. There is a constant process of renewal, in the sense that new poles are being raised in that community. Consequently, my uncle will sometimes shrug his shoulders and laugh when he hears talk about humidity controlled environments and stuff like that.

Doug Cranmer, like the boy in the children's story who declares the Emperor has no clothes, notes aspects of conservation that are underplayed by conservators, perhaps because they do not reflect how the profession wishes to present itself.

When we were over at Ottawa, we went through the CCI [Canadian Conservation Institute] and went to see what they were doing. They were picking off little bits of grass and mud and stuff – And I said "How long have

you been doing this for?" She'd been at this thing for something like two months! Hardly started!

When I walk into the conservation lab, you're either on the phone [laughter] or making something and the rest of the group are on the computer. Another computer!

Gloria Cranmer Webster sees conservation not in terms of universal principles but, rather, as embedded within the museum context: "We've not done anything [about the frontlet with the ermine train that was in such bad condition]. We never did anything about bringing it back to the condition it was when it left. There was the problem of money, and the other thing, I guess, was that the National Museum of Man should have taken care of that. It needed work before they returned it to us. If we'd insisted on that, we might still have been waiting!"

Conservation work on the frontlet depended upon who had caused the damage and who had the resources to pay for it, not on overarching principles concerning aesthetics or the integrity of the object. We see here again the importance of social intangible attributes as distinct from the conservator's focus on the material. Gloria Cranmer Webster later went on to explain more explicitly her feelings about refurbishing old material: "I would say the conservator's approach is appropriate for these objects because of the history of that collection. It seems to me that amateurs shouldn't mess around with any of that and I still feel that, because most of the damage was caused while it was in the care of supposed professionals, those professionals – I think it's their responsibility to take care of whatever needs to be done."

Leona M. Sparrow also views conservation as inseparable from the museums within which it is practised and their social meaning to First Nations.

[Miriam Clavir:] Would [you] agree that the standards are appropriate for the old fragile material such as the basketry?

[Leona M. Sparrow:] I don't know if they are or they aren't appropriate because I don't have a lot of access to information about other facilities. OK?

We have placed our trust in the museum, and the museum has almost usurped that trust. It's taken it over. And it's as if you are the authorities. And we are going to look after these pieces the way we think they should be looked after. But the trustee also has a responsibility to communicate back to the First Nations. (Leona M. Sparrow)

Dena Klashinsky emphasized how conservation might change in the future, but this would involve recognizing and respecting the social attributes of the objects: "Consultation – really listen to communities, respect their

values, and honour their intentions. Offer them all the information available about the preservation of an object."

Preservation Where?

If different individuals expressed a range of opinions and emotions regarding museums and cultural centres, then where is the appropriate place, in their eyes, to preserve heritage objects? Do these objects constitute family heritage first or community heritage (or clan heritage, which is customary among northern nations in British Columbia)?

Everyone acknowledged that some objects are important to individuals and families and that they should be kept by those people and handed down from generation to generation. This is, of course, a practice prevalent in most societies, including Western cultures: "I believe they should be within the family. Because it's very important for family memory to see them every day. To talk about them, to fix them, to use them. And if they're absent there's nothing for us" (Dolly Watts).

The value of these objects to the family may lie, for example, in their sentimental, personal meanings; in the cultural right to certain regalia (in some communities this regalia is considered private and personal); or in the fact that these objects are reminders of cultural identity.

Jewellery as well as objects made by family members were often mentioned as examples of personal items that people would prefer to pass down in the family.

> I think my first intention would probably be to keep a bracelet, and to pass it on to a younger member of my family. I guess it also depends on whether the object has value outside our family. If it represents an important part of the heritage of our community, if there is a particular educational value or cultural value outside of my immediate family or extended family, then my decision might be different. There might be more value in having the whole community have access to it, rather than restricting or limiting access to just the family. (Dena Klashinsky)

Regalia, except pieces such as masks made for sale, was passed down according to custom. Whether regalia or jewellery, however, and whether made for use in the family/community or for sale, these objects are found in the collections of both cultural centres and museums. Older regalia housed in urban museums may have been used in the community, while older carvings of argillite were originally made for sale outside the community. In the case of regalia stored at cultural centres, it may be there, for example, due to the repatriation of older collections. Or, as mentioned earlier, regalia may be stored without being owned by the facility. Individuals or families may choose to house their property in the facility for safekeeping, and, indeed,

this is one of the services cultural centres see themselves as providing. Regalia that comes under this category is not usually displayed and is only available with the individual's or family's permission. In storing it, the traditional museum mandate of preserving objects considered of value to the culture is being continued, while, at the same time, the value First Nations societies place on family lineage is also being recognized. The cultural centre has maximized its mandates to serve the community and to provide both preservation and access to objects of cultural (and here, especially, lineage) significance. However, problems of limited storage space and resources can make this arrangement less practical than it could be.

Would First Nations people choose to keep family objects at a cultural centre or museum rather than with the family? The answer to this question depended on the type of object, whether it was already in a museum's or cultural centre's collection, and its legal ownership status. It also depended on the location of the cultural centre in relation to where the family was now living and the relationship between the latter and the former. One person mentioned making a storage decision upon the advice of the band council. Many did not answer this question in the abstract but, rather, in relation to the realities of a particular cultural centre or museum (e.g., whether the objects it housed were currently on display or in storage and, of course, the quality of that storage). Most mentioned that their decision would be linked to the centre's acknowledgment of the importance of family access to the objects.

Several people mentioned that there was value in having objects from their heritage stored and displayed in large urban museums. At the same time, however, they stated the need for appropriate access as well as the need for collections to be housed in their home communities. Storage at an urban museum or community cultural centre was not presented as an either/or situation; rather, it was presented as a "both/and" situation. People acknowledged that urban museums can serve urban First Nations as well as a larger audience; that urban museums have conservation resources not available to smaller facilities (e.g., the specialized equipment and knowledge needed to preserve ancient waterlogged basketry); and that urban museums already exist, along with their museum-designed facilities and professional staff. However, there was a strong emphasis on the need for more community and family input into these museums. In addition, issues of ownership and "keeping in trust" needed to be acknowledged and worked through. First Nations cultural centres are situated within First Nations communities, are controlled by a board made up of community members, and provide financial revenue for community members through employment and sales in their gift shops.

I also asked whether young people were interested in working in museums or cultural centres or becoming conservators. Most stated that this was

not yet a priority for the young people they knew. The reality of obtaining jobs, especially in urban museums, was slight in comparison with obtaining jobs in other fields (such as education, law, or social services). Although it was not stated directly, it appeared that the nature of the work involved in museums was not particularly attractive and did not have high status compared to other areas. Dena Klashinsky and Don Bain began working in museums as young people because that was where they found jobs, not because it was their chosen field.

Are the objects family heritage first or community heritage first? (As no Tlingit or Tsimshian people, for example, were among those with whom I spoke at length, clan ownership was not discussed.) People answered this question by providing specific details. These answers considered how the objects left the family, whether there were any family members alive, and whether promoting the community's link with the objects would help in repatriation. The complexity involved in sorting out which family members could currently prove direct lineage links to older pieces housed in museums was also mentioned; without this evidence, the objects would be given "community" status. Archaeological objects, to which family lineage could not be ascribed, were also considered to be community objects. The First Nations conservator who is not from British Columbia but from the Six Nations in Ontario used the example of his area's wampum belts, which were always considered to be communal property. This is the situation in numerous indigenous cultures. Conversely, all the BC First Nations people emphasized the rights of the family (if known), rather than the community, to their "personal property." These rights include deciding the disposition of these pieces and who has access to them: "They are part of the family, they're personal property, and they should be handed out to whoever I want, and if I want people outside the family to have access, then that should be allowed. But if I want to restrict the access, there should be means of accommodating that too" (Leona M. Sparrow). However, Leona M. Sparrow also stated:

> Well, that's very difficult to separate the family from the community, because the community's all interrelated.
> There's ways to identify specific items that belong to certain families – even when they are in the community. Some things it doesn't matter. Some things there is no known owner ... or you can identify that it came from a certain house.
> But not one individual owned the house. They were extended families.

Don Bain expressed the link between family and community with regard to the preservation of heritage objects: "I think that ultimately a family or individual owns those pieces. And if that can be proven then it's the right of

that family or individual to do whatever they want with it. But I think people are becoming more and more conscious of their cultural history; there would be pressure within the community if these families sold pieces. It's sort of like a cultural responsibility. It's no longer socially acceptable to sell objects for profit, traditional objects."

Many would probably agree with Peggy Svanvik, who said, "I'd like to think they're family, and then community." One person also noted that the family or community issue was also being examined within other contexts, including that of intellectual property rights and the legality of attempting to will land individually owned but situated on reserves to a non-status family member (i.e., to someone who is not legally defined as an Aboriginal person).

Almost everyone made it clear that they and the people making up their communities have a primary and continuing interest in First Nations objects housed in museums. They raised such issues as how the objects left the families, and they talked about the complexity of the factors involved. One speaker mentioned knowing that something that had been sold a long time ago was no longer yours but, at the same time, knowing that the person who sold the object did not have the right to sell it. Other comments included the opinion that objects were sold because of pressures to assimilate and that the situation is different today. The value of the objects to the identity of the home community is now widely acknowledged, and people questioned whether museums were sensitive to this. In addition, if a family no longer legally owns the pieces, then do they have any rights that, in Canadian law, would be parallel to a copyright? Alfred Scow, a retired judge in the BC court system, commented: "I think that applying different concepts to different societies is difficult. To my way of thinking, artifacts that belong to Indian families, ownership should be interpreted, preservation should be interpreted according to the customs and the traditions of the Indian people. And if you try to adapt a modern concept like copyright ..."

In discussing objects in museums, Gloria Cranmer Webster commented: "Well, if they're legitimately yours then I think you have the right to make whatever conditions." Clearly, the parameters of the word "legitimately" are both extensive and contested.

Preservation and Museums
Regardless of who, legally or morally, owns cultural property, decisions about its preservation are being made daily in museums. I asked the following questions: whose responsibility is it to make decisions concerning heritage objects housed in a museum or cultural centre? and how does one balance daily professional conservation work with family/community consultation? Many people responded that, with regard to objects housed in the museum, it was the job of the conservator to make sure they were not damaged and

that they were maintained so that they would not disintegrate further. They agreed with the views of First Nations conservator John Moses: "I think that most Native people would recognize that if we're talking about an object that is maintained in a museum's collection, then that museum will have its own staff conservator do any necessary treatment. I would add, however, that in the case of a ritual or ceremonial object in a museum collection, many groups would resent the direct intervention of a conservator."

Museum responsibilities were also seen to extend to loan conditions; however, in this case most people emphasized social concerns rather than the usual museum registration and transportation concerns. One person said that she would be worried if museums loaned objects to those who did not have lineage rights to those pieces. Just as declarations of lineage are made at a potlatch when a mask is danced, so a museum should ask for verbal proof of lineage rights when someone wishes to claim an object: "I guess what's important at a potlatch is that the speaker is able to say at the end of the dance: 'This comes from our host's grandfather down from his mother's side and it came from' – a bit of the history is given. It seems to me that if someone requests a loan of a mask, then they ought to be able to tell you stuff like that. 'This Eagle mask belonged to my grandmother, who used it to dance at a potlatch given by her husband'" (Gloria Cranmer Webster).

As has been the case with the Royal British Columbia Museum and MOA, a loaning institution in an urban centre should include, as part of its professional responsibilities, working with indigenous communities to ensure the safety and preservation of objects on loan and to verify cultural information regarding access. Working with a community cultural centre, if there is one, facilitates this process enormously. Likewise, as mentioned previously, conservation treatment decisions (such as whether an object should be treated in order to be preserved or whether it should be allowed to deteriorate) can also be made in consultation with appropriate community members.

Although the First Nations people I interviewed did not expect every conservation decision to be made in consultation with the community, they did expect a better relationship between museums and communities than has generally been the case. Leona M. Sparrow described her feelings about the previous relationship between First Nations communities and museums as follows:

[Miriam Clavir:] How do you make decisions about whether something is too old to be used?
[Leona M. Sparrow:] I don't know. We don't have that opportunity with museums.

Howard Grant describes what he would like to see in terms of collaborative relationships and museum decision making:

Almost all of my responses have been in respect to museums that are lo-
cated locally – i.e., the Museum of Anthropology, the Vancouver Museum.
But when you're talking about Perth, Scotland, or whatever else, first and
foremost I think that the collections that are around the world that are of a
family category should be returned to a local museum, local to the First
Nation. And replicas to take their place. If the museums around the world
want that type of display. And once that is done, then ... I can respond to a
number of these questions, to say that OK, [you asked ...]can we refurbish
pieces that are deteriorating. Then it gives you a stronger communication
link, by where you're not offending the family et cetera and taking the time
to do certain things. If we were able to bring all objects to the local area, then
I would believe that the curators, and the people who are staff at those muse-
ums, will have a good background working knowledge of the people that
have the ownership. I think the answer would be much more easily clarified
that way. You would almost know when and when not to contact the board.

Some people commented directly on the current politicized atmosphere
within which questions of ownership and the relationship between muse-
ums and First Nations are being worked out.

So communication is a very important thing, that we all tend to ignore.
That we take for granted. Like you have to work with the aggressive nega-
tives of people who purchased art work and have now since donated them
to museums. I mean, you gladly accept these things, but how they were
acquired still has bad taste in the mouth ... and the communication that
you're getting is, "Give me those damned pieces back, you thief, you thieves!"
and whatever else. You know? And it makes it tough for people like you to
do your job. (Howard Grant)

If the person who, whether they own the right to reproduce the mask or
physically own the mask or whose grandfather owned the mask at the time
that the government took it away, or the time that it disappeared from his
basement, for example, – if the person who has that kind of a claim on
ownership is willing, then I think there's a very clear role for the museum
to take responsibility; specifically for the physical protection of it, and that
if there's anything such as smoking it or smudging it or feeding it, that the
traditional owner would have done, that those are different kinds of roles
that can be accommodated. With so many objects, that's such a time-
consuming thing and that becomes quite a bit on trust, but I think it's not
only feasible but it's very positive. (Kim Lawson)

An important point here is that, within today's context, museum ques-
tions may have broad implications. Museum conservation and First Nations

perspectives on museum issues, however important to the future of anthro-
pology museum practice, may be subsumed within a larger context centred
on land claims or other treaty negotiations.

If First Nations people attach meanings to the preservation of material
culture that centre on living traditions and continuity in their communi-
ties, then what are their personal feelings and thoughts concerning off-
reserve museums and museum practice? Leona M. Sparrow emphasized the
importance of the social attributes associated with museums and commented
on their storage conditions (earlier, she had mentioned her unhappiness
with the storage of archaeological pieces from her area).

> It's difficult for the First Nations communities – I'm not talking about me
> personally – it's difficult enough for First Nations communities to figure out
> how they have a relationship with a museum. And then once you open the
> door and you're inside the museum, it's even more difficult to define how
> you have a relationship with the objects in the way they're displayed and
> the context in that, and the person who within the museum is responsible
> for the caretaking. That's a whole new relationship that has to be developed.

Previous sections have shown that First Nations people are both support-
ive and critical of museums, and this holds true for this section. All of them,
however, had perspectives that differed from that of the conventional mu-
seum conservators, and all had personal ideas regarding the "use-versus-
preservation" dilemma. Some of the people who worked in museums and
cultural centres commented directly on how their thinking had been
changed, perhaps compromised, by their museum work.

> I guess the way we were brought up is, I didn't have to worry about that. I
> mean, we had that frog bowl in our family for years and it would always be
> there. We touched it. And we had a talking stick, and that killer whale and
> things like that and we had all these berry baskets. There are some very old
> baskets that are sitting there that we were allowed to – I mean, we got ber-
> ries and they were dripping with, you know – and then today, when I look
> at it ... I always think it's so fragile and I'm afraid to touch it. Before, we
> never used to ... It was just something that we used. (Pam Brown)

Conservation was always viewed within its social (museum) context:

> The way I connected with my culture was through this museum. It was the
> place where I first started to explore my identity. For that reason, I recognize
> the value of institutions like the museum, and now increasingly there are
> more cultural centres. From my perspective, there is a need to hold onto and
> preserve some of our special objects, to provide for places where we can

cherish, celebrate and share our cultural heritage as First Nations people. Those objects provide tangible evidence of our history. In museums and cultural centres, I think it's possible to create a balance between preservation and use, and to provide both community and public access to our cultural objects while respecting cultural values. (Dena Klashinsky)

Museums see their role as the saviors, they seem to think that if it was not for them everything would be lost forever. (Claxton 1994, 3)

I don't think it has anything to do with colonialism. I think it has to do with people who have the insight to preserve. (Ken Harris)

Some emphasized that, for First Nations peoples, the museum stands as a negative symbol.

They're [museums are] symbols of colonialism. (Leona M. Sparrow)

I didn't really like it, the museum. Because these things were taken away from my people and that bothered me. (Dora Sewid Cook)

There's still a lot of fear, you know, about what museums mean. Up till now it's been quite negative. You know, they have our stuff and they don't want to let us near it and they don't want to call us the right name and that sort of thing. But ... I mean it's changing. (Pam Brown)

Several people complained about the "gatekeeper" attitude they associate with museums, and that they believe prevents them from gaining easy access to their own heritage. One person mentioned this not only in relation to access to collections, but also to an always-looking-over-your-shoulder attitude on the part of museum staff. In addition, the very fact that urban museums may be located far from the communities whose objects they house precludes ready access for community members: "I guess it comes down to what you define as access. You know, if objects are residing, for example, here in Vancouver, from my area in Prince George, it would mean that people would have to make a twelve-hour trip by car, ten to twelve hours, by road, and they would have to, you know, make an appointment and organize" (Don Bain).

However, one person, who wished to remain anonymous, said: "I place a strong value in having these things in museums and I don't personally have a problem with them not being in the community because I feel that they are quite accessible to me, intellectually as well as physically. I don't see any real barriers to me going to look at them if I wanted to research them or just to see them."

Some people resented the fact that museums act as experts on First Nations cultures and on preservation. This feeling was also directed towards archaeologists and may be seen in Leona M. Sparrow's comment about museums usurping trust. CL and Adelynne Claxton concur with Sparrow:

We have lived here since time immemorial. We don't need archaeologists to tell us this from the bones. (CL)

Mentioning this to the "museum experts," we always got a "what-do-you-know" look. I suppose we were not to be the experts of our own traditional objects. (Claxton 1994a, 3)

Dolly Watts underlined the First Nations perception that museums are meant for "them, not us": "There's a lot of celebration that accompanies the major exhibits and our people can't really go see them, they can't afford to see them. You know ... they're meant for the people who can afford it. The middle class or the educated people, not for us. It's not for our benefit."

These perceptions devalue the role of museums in First Nations eyes: "The way I see it, the objects are preserved for a society that can afford to go see them, and not for us." (Dolly Watts)

Some people were emphatic regarding their distrust of museums: "Museums aren't trustworthy. In the eyes of many communities, not just a community, but many communities" (Leona M. Sparrow). Dena Klashinsky, however, said that, based on her experience, she did trust museums:

Places like the Museum of Anthropology can contribute to an understanding of First Nations cultural traditions and histories. If they are doing their job well, they can be effective facilitators between First Nations people and the larger public. That's why I work hard to explain to other First Nations people that I have trust in this institution and the relationships that we can build by working together. It takes a lot of work, but equally satisfying collaborations can happen. With the changing political, social and cultural landscape, they are happening more and more.

Pam Brown explains what she believes museums have done well and what they have done badly: "[What I think they did wrong?] I think that ... the story was not told in consultation with First Nations. They just assumed that they were saving us and didn't really care how we were presented. The lack of respect in not listening. What I think they did right? At least we have a lot of the material that otherwise wouldn't have been here. That museums are – some museums – are doing right, I think. They're trying to work with First Nations today."

Regarding her involvement with the Cape Mudge Museum and Cultural Centre, Dora Sewid Cook states: "This is the reason why I got involved with this museum. So I can tell our side of it, the history of my people. And I hope that's what the universities and museums in the big cities are doing, using our young people in the museums to do what we're doing here. Because it has to be us that's going to be able to tell the public. But one thing I can say is I sure [would] like to see some of those blankets and masks in UBC come back again."

Three other elders spoke positively about museums:

Well some of it – quite a bit of it went. We found different things in different museums that were sold by other people who had no authority to sell them.

And I talked to my father. "Shall we try and get these back?" "Well, no," he says, "they're alright where they are, as long as they identify them as belonging to our family." (Alfred Scow)

This is where I think the [UBC] Museum of Anthropology and others like it are so important as a repository for these things, if they are properly catalogued and the history of how we came about is reported, because this is what anthropology museums are all about. (Ken Harris)

I guess we wouldn't know a lot about history if we didn't have museums. (Peggy Svanvik)

Dena Klashinsky has worked at MOA, the Vancouver Art Gallery, and the Canadian Museum of Civilization as, among other things, an exhibit interpreter and a supervisor of MOA's Native Youth Program, and she has organized public programs of First Nations performances at MOA. Consequently, she has been put in the potentially awkward position of having to justify to other First Nations people her attitude towards museums:

I think it was valuable for people who were in the museum that day to hear of his [coordinator of a ceremonial drum group's] response, to hear him say he had difficulty being in here ("I've been here once before and I had no intention of ever returning."). When other First Nations people raise questions or express feelings like that, I think it's a really good place to initiate a dialogue. I think that by sharing their feelings, they are expressing a willingness to resolve some of those outstanding issues. I realize that, sometimes, our most sacred objects and traditions are basically just tossed out there for anyone's consumption. It can be really difficult to deal with such disrespect. I don't agree with institutions ignoring the cultural values of a community or First Nation. However, there are other circumstances where

there is a real value in having some of our objects on display. Of course, there is much room for improvement, but I honestly believe that there is real potential for useful dialogue, and for increasingly fruitful partnerships between museums and First Nations.

With other First Nations people, I often talk about my own experience working in the Museum of Anthropology. I try to give an honest appraisal of reality, sharing both the positive and negative experiences that I have had. Overall, I am really optimistic. Otherwise, I wouldn't continue to work in this area. When I freely share my thoughts and experiences, I think they're really grateful. It relaxes them when they see that I do not hesitate to talk about problems, challenges, or frustrations.

I also try to encourage other First Nations people to take advantage of the museum as a resource. I think it's important to ensure that First Nations people receive that kind of invitation. I want them to know that those of us working in museums strive to recognize and honour the significance of particular objects to certain communities. Those objects of value to you should be made accessible to you. For some people struggling to reconnect with their culture, the museum provides a valuable opportunity to appreciate the work of their ancestors and increase their understanding of their cultural traditions. They can look at objects and also read the information provided with them. They can ask for more information or for a closer look at a special piece. I mean, one person may come in here saying: "I don't know anything about my culture." Another person may have a special object or community that they want to track down. Artists should feel free to make an appointment to view a piece up close. Parents should feel like they have a place to share their knowledge and heritage with their children. (Dena Klashinsky)

In her answer to another question, Klashinsky discusses her experience and what she believes museums have to offer First Nations:

I've expressed to other First Nations people that the Museum of Anthropology is a place that can provide a more "neutral" ground. It can be a place where non-Native people can explore and increase their understanding of our cultural traditions, our histories, and get a sense of the diversity among First Nations. Meanwhile, this exploration can happen outside of our own communities, in a place where non-Native people are comfortable and where we don't need to feel our privacy is infringed upon.

Klashinsky advises the museum as follows:

You have to respond to those needs, to be facilitators in that respect. You can't just house objects. You have to respect the cultural values that go with

those objects. You have to honour the people who are associated with those objects, whether they are the makers or descendants of the original makers. The connection to those objects can be just as strong. It's just as important to maintain a dialogue, a connection, with the makers or their descendants.

Other First Nations people were also appreciative of the roles played (or which could be played) by contemporary museums:

I guess this is how we learned [you never question why] ... but the only [problem] with that ... when you learn things that way, [is that] you just accept it as such, and you don't say "why." The reason I bring this up is because at the museum people are always asking, "Well, why?" So now I've had to go home and ask a lot of questions about why is that, and why do they do this, and have learned so much because the museum made me question things. (Rita Barnes)

Museums are important institutions for Native people, whether they realize it a lot or not. I think of parts of this Coast where people lost much more than we did, and, if they're really serious about rebuilding, then they need the kind of resources that are in museums and archives in order to do it properly – not to invent. (Gloria Cranmer Webster)

Well, yes, museums can have a big role in that by telling us there's only one tablecloth of this design known to exist in the world. That imparts present knowledge to the indigenous community. (Leona M. Sparrow)

But I think once they're back and community controlled, or, you know, the communities know these objects, it may be that the community may choose, or the family may choose, or the individual may choose to have these objects ... remain in the museum and that these objects would more or less reside in the museum for the rest of their life. (Don Bain)

Training is another role that First Nations people saw as appropriate for museums; that is, they believed that museums should not only communicate back to the communities by collaborating with band governance, individuals, and families who have objects in the museum's collections, but that they should also share their information in training situations pertaining to jobs for young people and internships, for example. Several people noted that museum training had helped them with regard to their own cultural knowledge and their appreciation of their heritage. For example, Ken Harris observed that this was true for his daughter: "I know the interest developed the time we walked through the Museum of Anthropology. And she [Margaret Ann Harris, his daughter] saw all these things that, you know, our young

people couldn't even imagine that ever existed." CL emphasized that it was not just "teaching" that museums could offer, but also "practical help."

All of the above statements concerning roles apply (resources permitting) to cultural centres as well as to museums. People made the point, despite some residual negative feelings towards museums, that urban anthropology museums have an appropriate role to play. This said, however, many people, as mentioned earlier, made significant distinctions between the relevance of both museums to First Nations and of cultural centres to First Nations: "It was the band council that I worked with. They were fairly clear that we were not building a museum because Indians don't go to museums. We were to build a place where things can happen" (Gloria Cranmer Webster).

Dena Klashinsky pointed out that one must recognize the significant differences between urban museums themselves:

Working at the Canadian Museum of Civilization was a real learning experience for me. In all honesty, my brief experience there helped me to recognize that the Museum of Anthropology is a really great place to work. Maybe I felt a difference because the museum is part of a university. Maybe it is because the museum is situated right here on the Northwest Coast and they have had no choice but to establish working relationships with First Nations. I just felt like the two institutions had different motivations, mandates, or philosophies. I felt more comfortable at the Museum of Anthropology. I also recognized a difference in the public that came through each institution. Here at MOA, while visitors may or may not be more informed about First Nations (especially those on the Northwest Coast), they seem to be more interested in being informed. In the east, I felt like the museum was one of six "attractions" that tourists stopped at in a day. It provided a backdrop for lovely photographs. To be fair, tourists are anxious to take photos just about anywhere! For me, the difference was how the institution created exhibits and programming, sometimes in responding to the public pressure for "interactivity" and "exciting" exhibitions. At the CMC, I felt there was more emphasis placed on responding or catering to those perceived needs. From my perspective, their exhibitions reflected a lack of understanding [of] – or lack of willingness to understand ... First Nations cultures and protocols. For example, in the Kwakwaka'wakw bighouse in the Grand Hall, they were continually screening a video about the potlatch, one that was quite slick and dramatic. I thought that it made the potlatch seem mystical and quite, quite far off from this world. In reality, the potlatch is political, social, and cultural. It is a means through which we govern ourselves as First Nations people.

During my short time there, I also recall feeling pressure to make our program's presentations shorter and snappier, more "interactive." Quite

simply, I felt that community beliefs and values may have been respected on an intellectual level, but those values were lost in the pressure to bring in numbers and satisfy the curiosity of the masses. Overall, I think that there were big differences in how the two institutions approached the idea of informing the public about First Nations, and about supporting First Nations youth as cultural interpreters. I recognize that my experience at the CMC was limited and that my relationship with the Museum of Anthropology is much longer and more varied. However, that experience had a large impact on my perceptions of both institutions.

The above statements represent not only what First Nations people think about museums, but also what they feel when visiting them and being inside them. Their emotions become part of a museum's intangible attributes, and their comments show the range of these feelings:

That was a real big adventure. That was the first time I ever went to a museum. For me it was fascinating – because I've always been nosy! – to see things, and to learn about my family and others. (Peggy Svanvik)

[Joan Scow, wife of Alfred Scow, talking about her father-in-law] He looked around [MOA] and he was in awe, and he said, "I never thought I'd live to see this." He was totally in awe. And he grew up in a time when these things were not treasured. I don't know if you've heard me say this, Alf, but it was very moving.

I'm happy to discover a mask that my uncle made in the museum's collections. I'm proud to take a look at it and realize it's my uncle's mask. (Dena Klashinsky)

Well, for one thing, [in an urban museum] it's mainly non-Natives taking care of it. And I feel really bad that our own people aren't there, because they're ... I know there's a few, but they go in and out, they're gone ... they're not there permanently. It's very, very difficult for us to go in. I know. I really feel bad, I really do. Because not everybody knows what they're talking about. They don't understand why we feast. (Dolly Watts)

And anytime I go out there [to MOA], I feel like a, almost an alien, because there's nowhere for me to be, I'm constantly pointing fingers to fix this, and what about that. There's no space for me to sit down and really look at anything comfortably. (Leona M. Sparrow)

Well, no. I didn't really go through the anger parts because I think I sort of went through that before I came to this. I think that in not knowing even

who I was, or even what I was a part of, I think I was already angry, or went through the anger, before that. So when I got to the museum, and go to different museums, I feel sad. I feel a real certain sadness about the fact that there was this whole hundred years of silence that no one was connected to these objects and that they sat there all that time, unrelated to us, again. And when you go in there and view those objects and see the reflection of them yourself, then it stirs in you the emotions that you will have to deal with the rest of your life. Which are positive. You don't just see an object, you see a whole people and what they must have been about. (Debra Sparrow)

Both positive and negative emotions are triggered by what is tangibly there – for example, the objects or the building. The tangible elements evoke emotions because they symbolize intangible elements: cultural loss and misunderstanding, esteem and validation. Sometimes the trigger is the realization of what is not there.

But I do remember the first time I ever saw the stuff that we use in our potlatches and things ... having a big lump in my throat, and, you know, I can't even remember what museum that would be.

You know, I think it was sadness, because potlatches weren't ... there were practically no potlatches going on. I know up at Kingcome they had potlatches, I remember potlatches when I was a little girl; but to me there was that in-between time. And I know when I was a little girl I used to go to these big potlatches with all the dancing and everything, that seemed to go on for days when I was a little girl, [even though this] was at a time that potlatching was banned. But then there seemed to be a big gap, and that could even have been in the time I was in the residential school that there was no potlatches, although I remember a couple of times that my sisters and I would be taken home because of a potlatch ...

We moved into the urban area and we had to make a place for ourselves, and this society, and struggling with it. That had to take priority over something that was such a big part of me. And then all of a sudden it just came back so strong, and now there's potlatches every year and it's wonderful.

I think it was sadness when I first saw objects used in potlatches, in a museum. I think it must have been in a period of life when I was not going back or anything like that. And feeling that ... remembering that feeling that it gave you sitting in the Big House, the smell, and the atmosphere, everything that goes on in a potlatch, I think just sort of whelmed up, and yeah, it did get emotional, and you know, suddenly the drumming, the drum log with his sticks, and all of a sudden wanting to hear something, something so familiar like the potlatch songs. (Rita Barnes)

Cultural centres and their collections also evoke emotion:

I think [U'mista] itself is a source of pride, and ... I think it's a reminder too, of past days. I know – I can only speak for myself – I have a feeling of pride [for] that museum. The work that went into it, and I was there at the opening, when this old man was asked to speak and he was from Fort Rupert, and he was standing there, and I was standing here, almost directly in front of him, and he was asked to speak, and he started to speak, and he couldn't, and the tears, and it was a really dry day, the ground, the dirt was dry, and the tears, seeing the wet on the ground from his tears and him saying to this old lady next to him, "You speak. I can't." Because he was just so emotional. And so she spoke. She spoke for him. And the way she spoke, she spoke of those things, it was almost like they were people coming back. That, you know, our people have come back. (Rita Barnes)

The emotions people felt when personally involved in a traditional cultural event were always positive.

[Regarding Sandy Jones' regalia:] The objects have power, have life, and some release is needed from the storage box every so often. This release also has the effect of making Sandy Jones feel good. (Sandy Jones)

Well, attending potlatches, because we would go to as many as we can, and I'd come back to the city and I would just have this feeling, so good, and feeling that nothing and nobody could hurt me. I just feel so good, and I just want everyone to feel good. Mind you, it doesn't last, and then I need another potlatch. (Rita Barnes)

And I used to hear this singing, and you have to be one of us to understand that it's a wonderful feeling to hear the singing. (Dora Sewid Cook)

Some spoke directly about their emotions regarding a museum experience that had had particular personal meaning. The following description illustrates how, for a First Nations person, it is easy for museums to become sources of loss even in the act of preserving.

The bentwood box would be very old, and my niece and my nephew used to use it as a toy box. It sat displayed in the living room in a corner for the toys that were living-room toys, and then after I put my sisiutl in the museum at Alert Bay and I was telling my sister – she also has another mask in the museum, which would be about the same age as my sisiutl – and I said to her, you know, your bentwood box, it's so old, and it's so fragile, you should really take it to the museum. And she said, "Well, you know, the museum up at Alert Bay is so new and you notice that most of the things you can touch them, you know, they're right in the open, they're not in

cases, so I was thinking maybe I should just have it stored in a museum in Vancouver." And I said, "Why don't you store it out at the Museum of Anthropology?" So I phoned Dr. Ames, and her and I – I drove her to the museum – Dr. Ames took one look at it and called somebody and said, "Come and look at this." And they seemed to have marvelled, a bunch of them sitting around, standing around this thing marvelling at it, and I don't know if it ever got – whether anybody ever – how would they find out such a thing? Like how old it is?

[Miriam Clavir:] I think they would just compare it with every box that they know about.

[Rita Barnes:] Well, when we left the museum, my sister said, "Now it's in the museum, they'll put it away somewhere and I won't even be able to see it. It's been part of me since I was just ... " – because she had it when she was a little girl because my great-grandmother gave it to her. "And it will be just hidden away in that museum and the only thing that I have of it is a memory that's in my head that this thing is mine, and it's hidden away. I may in time even forget the design on it."

So she said, "This thing that was passed on to me, I'm no longer going to get anything out of it, it'll be in my will that it goes to my daughter, but it will just sit in the museum." And she looked at me, she said, "So now what?" You know. And I didn't have any answers for her. All I knew is that it shouldn't sit in her apartment any more, she's now moved into an apartment, and I said there's also too the chance of theft ...

And I said, "You said lots of people had broken into this apartment block already. There's also a chance of you losing it. And then you will never see it again. At least you know it's in the museum." And she said, "But to me it just doesn't make any sense, one day I'm going to die, it'll go to Geraldine, and what's Geraldine going to get out of owning this thing"?

And I said, "Well, you could always sell it to the museum, they'll display it. She can go up there any time she wanted to look at this thing, but you'll have the money in her hands." And she'd go, "As if I would do such a thing." So you tell me what really makes sense here.

But she's put it in there so that nobody could touch it so that it wouldn't deteriorate any more than it's deteriorated already.

We left and she was so sad, and I felt so guilty talking her into this.

[MOA notation: The box's status is that it is on a renewable loan for safe-keeping, and the loan can be cancelled by the family at any time.]

The following account concerns a group of Salish women from Musqueam, who have revived the art of traditional weaving, and their visit to see old Musqueam weavings housed in major US museums. The Musqueam Band's lands form part of what is now Vancouver.

[Debra Sparrow:] And, you know, we took a trip to New York. The group of women [weavers] did.

[Miriam Clavir:] Yes. Tell me about that.

[Debra Sparrow:] It was really the most moving thing that had ever happened to that group. I wasn't involved with the first group, but I went with them. And some of the women had never been on a plane before, so here we go off to, you know, the other side of the country. I don't think they really knew what they were in for. Half of them hardly go downtown. Or, in fact, I hardly go downtown!

So, we flew off, we went to New York – and I don't really think that they knew what they were in for – we go flying into, you know, Midtown, down in Manhattan, and get to our hotel room, and we were way up in the, I don't know what floor, and everybody's, like, in shock. And I never knew what culture shock was until that happened. And it was really amazing for the women. Some of them didn't come out for a few days. But then we had to go off to a couple of museums; we went to the Museum of the American Indian. And then later on that week we got a train and went down to Washington, and went into the Smithsonian and viewed the collection they had on Musqueam. And as we were heading to that section, we passed the Northwest Coast section, and the feeling that we had, as we walked through that museum, was so moving, because here were pieces that we knew lived here in Musqueam. Way over there, in this building and they belonged to someone else, and yet they were part of who we were.

So I think, you know, we as people view those objects so terribly different than museums or other cultures. And I don't want to focus on one particular culture, but we really do recognize that, and yet it is a controversy and it is a Catch-22 because we know that that has to be. And I think people are torn between, you know, Aboriginal people are torn about their feelings. And I think their first feelings, as you will see when you get to know different people in different communities, their first reaction is anger because, you know, in the process of healing, and coming to know what your healing is, you will feel anger. And I felt anger when I was younger. And then I went through another process of trying to understand why everything is the way it is, and you have to look at the larger picture now. In balancing you understand ... what was and what is.

And so it really does set your mind and your spirit in motion. And as you go in motion, you realize you have to balance both of these. And it's a real challenge to stay balanced.

The depth of the many emotions the women experienced on their visit to New York is evident from this account. Still reacting to being in a huge metropolis, the women were balancing their sense of loss regarding their

material heritage with the fact that at least it was being protected and surviving in this far-off city. As with the example of the bentwood box, so with the weavings: these women experienced very mixed emotions upon seeing their material culture preserved in an urban museum.

Feelings of uncertainty associated with unresolved issues, unclear answers to questions, and unsettled outcomes permeated many of the discussions I had with First Nations people. As previously mentioned, some of this was due to their unfamiliarity with professional conservation concerns; not having thought about these concerns, they hesitated over many of their answers. Some of the feeling of uncertainty, however, was simply a part of their considered response to my questions. Relationships between museums and First Nations remain, of course, incompletely resolved. As for objects in the museum, there are also many uncertainties:

> When these pieces came to the museums, they were sold to the museum by families, sold to collectors who in turn donated it, or sold it to the museums. Some pieces were stolen out from graves or families, individuals, but when they came to the museum does that mean that in the grand scheme of things, that's where they were meant to be? You know, that their perceived end is at a museum? Or is that just part of their life? I don't know. I think that objects within the museum are still, well, they're unsettled, and that the communities, for the most part, they don't know exactly what's out there yet. The issues are unsettled, and the status of the objects are yet to be determined. (Don Bain)

Debra Sparrow, however, spoke of the future not as unsettled but, rather, as excitingly open. She also connected the future to a past before museums, and she acknowledged that museums have a positive role in the present: "So there's much to learn yet ... I mean, I think it's just beginning. I really do. And part of that is that in educating ourselves we have to go back in time, we have to go into history, and where is history for us but in museums? And yet in those museums we see our history doesn't just go back to museums it goes back ... hundred[s] and thousands of years."

Unknown paths, uncertainties, and unresolved issues do, however, allow room for change. Many people, whether their feelings regarding museums were positive, negative, or both, believed that these institutions were in the process of change vis-à-vis their relationship to First Nations.

> I think we are really excited to know that the museum is there, and the changes with museums in being more open, in opening their doors. Also to know that these particular people whose objects are housed in the museum are a functioning people. They're not people whose past only lives in a museum, they're still here in the future. (Debra Sparrow)

Museums have come a long way in this day and age, they are now more lenient, they will loan out to the community a sacred object to be used for special ceremonies. I think it is about time. (Claxton 1994a, 3)

They've changed somewhat. But the attitude is still there, although the actions are not always the same. The attitude is attempt to control – attempt control of the objects, rather than look at the museum as being a facility for protecting the object so that people can access and use it, OK. It's protect at all costs rather than protect for use. (Leona M. Sparrow)

I think that there are a lot of changes happening in museums. A lot of museums are acquiring the kind of humility they should have had a long time ago. I think it finally got to people that there was this attitude in museums: "These things belong to us. We know everything and we don't have to ask anybody." That's changing now. Native people's attitudes towards museums are changing as well. There are more Native people working in museums. That makes a difference. (Gloria Cranmer Webster)

Recommendations to Museums

The responses from the people with whom I spoke illustrate both support for the preservation of objects and a critique of standard museum and conservation values. Doxtator's concept of parallel paths (see Introduction) is supported by these responses, although, strictly speaking, the paths have too many complexities and unprecedented or unresolved questions to be completely parallel to one another. In addition, there are, in some museums, connections that bring the two paths together – a "product" or a process that helps to meet the different needs of both sides. How successful these are to either party depends upon the particularities of each case and involve issues such as power relationships and whether or not an agreed-upon protocol has been worked out. Figure 5 illustrates the parallel paths and some of their links.

What were peoples' views on how museums and conservation could change to better meet the needs of indigenous peoples? The major point regarding the future, already seen in many of the quotations, is the need for more communication between museums and First Nations. "Developing the communication lines, OK? Coming to a community, working with a community, rather than the community having to go bang on the door" (Leona M. Sparrow).

Regarding conservators, several people noted the value of conservation training and thought that this knowledge would be beneficial to the community.

For example, my Mom or another community member might be able to observe larger changes on the surface of a mask. She'd quickly recognize

Figure 5

Parallel paths: Finding common ground

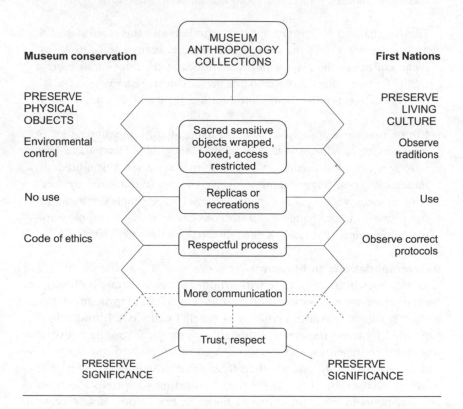

when the beak of a Hamsaml is falling apart or is falling off, but there may be subtler deterioration that she cannot detect. It's amazing what you are aware of if you have experience in conservation techniques. If you have some training in the area, then you may be better able to detect weaknesses, potential damages, or areas of concern. I think someone like Juanita Pasco [collections manager at U'mista, who took some of her training at MOA] could play an important role in bringing those issues to the attention of an owner or family. By sharing her technical knowledge with them, she may enable them to make more informed decisions. In the end, only the owner(s) can make the final decision, but Juanita can provide them with the best information. With that information, the owner or family can make the most valid decision, based on what is important to them. I think the decision is up to the individual or family who (physically or intellectually) own a piece. Ideally, they are provided with information from someone skilled

in conservation, and they can benefit from that technical advice, making the most informed decisions possible. (Dena Klashinsky)

And that's what I'm willing to do. I'm willing to look at what we can do now you and me. I know what went wrong. I know what was. But I just want to work ... about always being positive, about how we can work together now. (Debra Sparrow)

And if the museum can't adapt to the needs of the communities surrounding it – and I'm talking about the First Nations communities – then the museum itself can become redundant and defunct, because the communities will find a way to get their own facilities. (Leona M. Sparrow)

Adelynne Claxton can see both sides of the preservation/use dilemma and said it was hard to choose between them. She suggested one solution: have the objects in a museum in the community, and put both technology and the people's ways to work.

Conservators should have an awareness of community values. Sometimes, cultural values may be in conflict with what action you have to take. However, it's important to at least recognize, to acknowledge, those cultural values and community concerns. At times, you may have to make different or difficult decisions, but I think such acknowledgment is important. I think people appreciate that, even if the steps taken are not as they would have originally hoped. At least there's an awareness of their values and concerns, an acknowledgment of them. If that kind of dialogue takes place, and there is a real connection and mutual respect, then a community may be willing to trust in the process. (Dena Klashinsky)

In the next quotation, Dolly Watts uses the word "cooperation." Words carry different meanings for different people, and whether the word is "cooperation" or "collaboration" or "partnership," it is meant to acknowledge that the needs of each are equally valid: "What I would like to see is cooperation with the people. If they're not coming forward, go out and tell them what's there and that repatriation is possible. Just bring the people up to date. They don't know. And that's so important, just to inform us. After all, we have a stake in the objects in the museum" (Dolly Watts).

Don Bain noted the trend in Canada towards collections being supported in several locations – larger urban museums and small community museums or cultural centres – and that this involved partnerships between the institutions. In other words, "end product" was important but so was "process"; in this case a continuing process of developing relationships

had been started, was proving viable, and was seen as a pathway to the future.

At the same time, Don Bain noted the First Nations trend towards more community control. He said that one result of this would be that, if you wanted to learn about a territory and the people in it, then you would have to go to that territory rather than to an urban museum or academic institution. Others argued as follows:

> Stronger communication. I would say to any museum or to any institute that as part of the curriculum they should visit First Nations communities, to talk, as you are doing right now ... and to maintain posts, linkages, in respect to communicating with the public that someone owns the art pieces. Because too often we make academic decisions that are very logical and very real and albeit the right one, but people get offended. Almost all the right decisions are so debatable and so controversial, you know? And my thoughts are, this should have been done twenty years ago and not for a thesis paper but just general care of the object. (Howard Grant)

> And I'm not saying that the First Nations communities know everything, OK? I'm saying there is a spectrum of knowledge that each party has that has to be shared, and it has to be received in the right manner, and the educators have to realize that they don't know everything and respect that someone else may have knowledge that would be helpful. (Leona M. Sparrow)

Conclusion: Perspectives on Preservation

> Your job is to preserve those "things." It's our job to preserve the culture that those "things" have meaning in.
>
> – Gloria Cranmer Webster

In these two sentences Gloria Cranmer Webster succinctly summarizes the nature of the meaning of "preservation" for many First Nations vis-à-vis its meaning in museum conservation. Tables 6 to 9 summarize the major differences between conservation perspectives articulated by conventional museums and those articulated by the First Nations people cited in this chapter.

Table 6

Museum and First Nations perspectives

Museums	First Nations (FN)
Use generalizing language (e.g., "the Haida," "objects").	Specifics are crucial: which objects, which families.
In museums, most objects are considered and kept non-functional.	"Functional" is not the appropriate word but "access" and "use" (following cultural protocols) have very high priority.
Objects themselves are preserved.	Objects are preserved mainly as embodiments of cultural knowledge; preserving the intangibles for most (not all) speakers came before preserving the objects.
Antiquity is valued.	New objects may serve the same purpose as old ones for many FN of BC.
Creator of objects: a "name."	Name of artist important re: lineage not "star quality."
Sacred/sensitive objects; some museums changing (e.g., special storage and access, loans and repatriation, NAGPRA in USA).	Museums should not have sacred/sensitive objects at all unless FN have decided to keep them there; decisions about sacred/sensitive are entirely up to FN.
Can find some cynicism re: construction of "sacred."	Can find some cynicism re: construction of "sacred."
Museums are secular institutions: only "sacred" in symbolic sense of "museums as temples."	Sacred/sensitive attributes can remain with objects even in a museum.
Museum owns objects or has stewardship role. "Moral rights" of FN to their heritage objects are acknowledged in BC museums.	"Our heritage first, not yours."
Fiduciary trust: hold collections in perpetuity for people of the nation.	Museum holdings are necessary to fulfil FN striving for self-determination and social well-being.

Table 7

Conservation and First Nations perspectives

Conservation	First Nations (FN)
Public heritage.	Ceremonial objects in BC: family first, then community heritage. Clan heritage also, in north. Some ceremonial objects are also considered private, individual.
Objects are treated as if unique and irreplaceable.	Replacing objects is part of passing on the culture.
Assumes object has reached end of its "history": "integrity," or "true nature," freezes object in time.	"History" connects to FN in the present: object has continuing history.
Codes see conservation ethics as universal, beyond time and place.	See conservation as embedded in museum context.
Use lessens value.	Use heightens value.
Four "integrities" valued, but physical the bottom line.	Most important to FN people in BC is maintaining family connection. Cultural centres also see importance of maintaining physical integrity.
Damage is anything that affects the integrity of the object.	An object is damaged when its use is affected. The rest is from wear or "age," and is fixed.
Change to "integrities" represents damage.	Change to object may represent cultural continuity and "life."
Damage has physical implications.	Damage has social implications.
Conservation and museum ethics, values, and mandates govern most conservation decisions.	FN social and cultural protocols govern most preservation decisions.
Restoration should not falsify.	Restoration fine, as long as cultural meaning of object is not changed.
Distinguish original work from restoration materials.	Similar materials to original preferable in restoration; but, for cultural centre, important to know which is which.
Respect is for objects – more abstractly, for their cultural context.	Cultural respect, respect for people. "Museum respect" not sufficient.
Clients are collections, public, institution, owner.	"Clients" are us (FN).

Table 8

Conservation and cultural centres

Conservation concerns	Cultural centres' solution
Use versus preservation.	Contemporary collections for use. Provide secure housing for individuals' regalia. Advice re: fragile pieces. Facilitate access but manage collections.
Respect for objects, including originators (usually in abstract).	Facilitate respect for people's rights to use objects and careful use of objects.
Preserving cultural significance (purpose of work on objects).	Cultural significance preserved within the culture. The centre's role is to: • facilitate the passing on of what is of most cultural significance: the intangibles, cultural continuity, • house significant collections in the originating community, • show significance to culture through display, interpretation, from FN perspectives.

Table 9

Continuing and future role for museums, as seen by First Nations participants

Build relationships with communities through respectful communication.

Facilitate access for First Nations to objects from their heritage within the museum, nationally and internationally.

Facilitate access to curatorial and archival information.

Take initiative to communicate information related to a community's heritage back to that community.

Seek, listen to, respect community members' opinions. "Honour their intentions."

Share museum disciplines' knowledge and skills with community members.

Ensure cultural protocols followed re: storage, display of and access to collections, and return of objects.

Train and employ First Nations people.

Serve the urban First Nations communities.

Serve as a facility to present First Nations voices to the larger public, in partnership with the First Nation concerned, following above principles.

Provide excellent quality, secure storage to community members for safekeeping of fragile and/or important objects.

Maintain high professional museum standards in collections management, conservation: this facilitates access of many generations of First Nations to their heritage.

Bear the costs of specialized functions possible only in a large facility (e.g., environmental controls, certain scientific and conservation laboratory equipment).

6
New Zealand: A Comparative Study

If, as may be seen in the preceding chapters, museum conservators and First Nations people have often expressed distinct differences in their philosophies on what is most valued in heritage preservation and on how it is best accomplished, then is it possible to balance preserving the physical integrity of collections with preserving their conceptual integrity? In New Zealand I asked this question of conservators of Maori heritage to find out how they have reconciled their scientific conservation training with Maori cultural concerns. The discussion in this chapter is expanded by contributions from other New Zealand museum personnel – both Maori and non-Maori. I am indebted to all of those with whom I was able to speak.

I conducted the interviews/conversations in this chapter in 1994, and the people to whom I spoke, in reviewing the material in 2000, told me that there have been significant changes in the New Zealand museum world since then. As one example, the new building and exhibits for the Museum of New Zealand *Te Papa Tongarewa* in Wellington were in preparation in 1994; now they are open. Since 1994 the Auckland Museum *Te Papa Whakahiku* has produced new Maori exhibits, staff positions, research, and publications. Obviously, the quotations in this chapter reflect the time period in which they were made. They continue, however, to be relevant to illuminating the conservation dilemma of preserving both physical and conceptual integrity. For the readers' information, Appendix C provides a short glossary of Maori terms.

Despite obvious cultural and geographical differences, there are sufficient parallels between New Zealand and British Columbia to make a comparison between museum conservation perspectives and indigenous perspectives worthwhile. As will be seen in this chapter, Maori values with regard to heritage preservation in general agree with other indigenous viewpoints. With regard to the professional field of conservation, there are always cross-border parallels; the museum conservators' code of ethics in New Zealand is similar to that in other areas. In New Zealand, the ethical code of the

International Council on Monuments and Sites (ICOMOS) acknowledges indigenous cultural concerns more than do many of the conservation codes of ethics regarding moveable cultural property, but it is quite similar to other recent codes pertaining to sites and architecture. New Zealand's conservation treatments, and the values underlying that work, are in keeping with the broad international parameters of the profession. Although conservation values in New Zealand have been both imported from and influenced by the profession overseas, the country has a specific context that influences the preservation of indigenous ethnographic collections. This is a vast subject, and all I will discuss are a few points emphasized by those with whom I spoke: five conservators of Maori heritage, two non-Maori conservators who work on Maori material, and other museum personnel (see Appendix A for list of conservators).

New Zealand (*Aotearoa*) is now an officially bicultural (Maori/*Pakeha* [people of European descent]) country, with government acknowledgment of the partnership implicit within the 1840 Treaty of Waitangi. By 1994 national museums and other publicly funded cultural bodies were developing policies to make their institutions more bicultural, and they were able to obtain government funding for implementing some of these policies. Actions ranged from hiring Maori staff and enlarging programs concerned with Maori heritage to instituting names and signage in Maori as well as in English. The five Maori conservators with whom I spoke were able to attend the master's degree conservation program in Australia thanks to funding provided by the *Roopu Manaaki I Taonga Tuku Iho* (the Cultural Conservation Advisory Council). At the time I visited, the nature of the relationships between the indigenous and non-indigenous population was highlighted by an emphasis on achieving equal partnership. One of the non-Maori conservators commented: "I think New Zealand is very concerned with the whole issue of cultural sensitivity in all areas of life and that museums are just one of them" (Julia Gresson).

With regard to her museum, the second largest in New Zealand, she said:

I think we take a much greater sense of responsibility to Maori objects here than any others, and that's just a lot to do with commitment to biculturalism. The bottom line is that the Maori collection here is incredibly strong, that it's got all these ties to the living world that a lot of the other objects don't have, and that there's a lot of accountability to those people, too, who own them, or used to own them. And so I do think they will always be treated differently, and so they should be.

By comparison, Canada's policy of official bilingualism does not include Aboriginal cultures; rather, it recognizes the status of the French- and English-speaking populations who were considered the founders of the country.

As noted earlier, there are many different First Nations in British Columbia and Canada. In New Zealand, while the Maori (and the smaller population of Moriori) are considered to be the indigenous peoples, they should not be considered to be one people having unified opinions. The *iwi*, or "tribal/national" groups; the *hapu* ("subtribal") designations within these; and the lineage of an individual are extremely significant: "But there is an intertribal thing. There's not a Maori thing. There's no such thing as a 'Maori' person. They are all tribal (though we don't use 'tribal' any more), but you can go from one end of the country to the other and see 100 different ways of doing the same thing" (Nick Tupara).

Regarding indigenous collections now housed in museums in New Zealand, many of these have a different legal status than do those in British Columbia. Objects, and, in some cases, buildings were loaned or put "on deposit" in the museums by their Maori owners; therefore, they are not legally owned by the museums. Nick Tupara gives the following example:

> If you look in the record book, a lot of the collections have been given by Maori communities or custodians, and there's all sorts of reasons why and a lot of it ties back culturally. The strength or the inner essence that an artifact has can affect the well-being of a community or an individual so, to combat that, rather than destroy that ["bad"] object or dispose of it in a traditional sense, they'll give it to a museum, and a lot of them would suggest that the ills in a museum are because they have all these things that cause ill to the community. My own family, for example – a sickness befell my family and the priest there came in to deal with it (this is really cosmic-y) – so to deal with it [he] suggested that it was coming from these carvings. So, the carvings should be burnt; but the undeniable need to preserve these things is handed down to them by their ancestors. There is a strong sense of preservation amongst Maori communities. They gave them to the museum to take that burden and make the museum sick and by putting a bit of space, a bit of distance, between them, they were happy with that arrangement ... When a museum says: "We should be giving you back your treasures." "Oh, no, no, no, no! That's all right. You keep that one!"

The Maori sense of cultural ownership extends to objects housed far away and will be discussed shortly. Although land or objects may have been sold, the *mana* (power) that is a part of them was never sold. Connecting with those pieces, "keep[ing] them warm in some way" (McKenzie 1990, 172), rather than repatriation is, for some, a satisfactory acknowledgment of cultural ownership and a fulfillment of what is culturally necessary.

There's a meeting house, *Ruatepupuke,* in Chicago in the Field Museum where the local *iwi* went over there to help with the conservation and

preservation, and it was enough for them to re-establish that connection. I think it was beneficial for the museum to see that, the history, or the lack of history, was embellished greatly by having these people there, and some of these conceptual-type things you talked about became far more apparent to them. So, again, the doors [of the museum] were open. The glass case was open. People came in. It meant the objects stayed in Chicago. In fact, it meant the objects benefited from their being there from both points of view. Those people came back to New Zealand quite happy with that. (Nick Tupara)

Whether the objects are to remain in a museum or whether they are to be returned to the *iwi* is, in some cases, under dispute; and in some cases this dispute has been successfully negotiated. These cases emphasize, however, that negotiation with the appropriate indigenous representatives was, even in 1994, a part of accepted museum procedure. In interviews and conversations, those I spoke with provided a number of examples showing that the museum often negotiated with Maori community members:

If I could use an example of, say, *Te Hau Ki Turanga,* which is our meeting house here [at the Museum of New Zealand *Te Papa Tongarewa* in Wellington] and *Rongowhakaata* people. Initially, it had to be negotiated, to be retained in the museum. So you have to go through the process of acquisition: how we acquired it and was that acceptable that it is in the Wellington area and how is it going to be displayed and used? We negotiated over that, plus that it would be able to be used as a functional house by *Rongowhakaata* but by no one else. So, we would have in the new museum a pan-tribal *whare* that everyone else could use. But people other than the *Rongowhakaata* could not use *Te Hau Ki Turanga* in the traditional manner. (Rose Evans)

Significantly, the question of who makes decisions about the care and treatment of First Nations objects in museums, and the parameters of conservation work, are decided within the context of Maori legal ownership of many of the objects in New Zealand's major museums.

A portion of the older Maori material cultural heritage, both communally owned (as with carvings in *whare* in Maori communities) and individually owned (as with stone *Hei tiki* or cloaks of plant fibre and feathers), remains in the possession of their indigenous owners, either in their houses or on the *marae*. An important part of the institutionally supported work of several of the Maori conservators was to provide conservation advice, training, and treatment work to communities, especially concerning preserving the communally owned *whare*, or meeting houses, and the ancestor portraits, carvings, and/or photographs located within them. In 1994 New Zealand did not have a strong equivalent to the type of BC First Nations cultural

centres that have a museum component, although one person did mention a movement towards establishing *iwi* cultural centres and museums and the possibility of repatriating collections to them.

Museums, Collections, and Maori Perspectives
Pakeha perspectives are, not surprisingly, the foundation underlying the Euro-based cultural institutions in New Zealand. Those with whom I spoke indicated some of the differences between *Pakeha* and Maori perspectives with regard to the following aspects of their work.

Cataloguing a collection:

> When I look at a drawing or print, I see the meeting house and then the lake. A *Pakeha* colleague might see the lake and then there's a house and it's a whole different view. That's all about access. Maori people are less likely to access that drawing and print of their home area because it doesn't actually mention their meeting house – or if it does, as an aside ... Or things like manuscripts. A lot of our people don't know they're in here because the access points says: "Maori Song." Now, if a Maori person was doing that they would say: "*Waiata* from Te Whanau-a-Apanui by ..." Now the Maori person would say: "Oh, wow, it's from my area. I'll get that." Often, they say that we had access but we didn't really. We don't come from the same place. (Vicki-Anne Heikell)

The collections themselves:

> After all, a museum is its collection and it has to realize that. Its collection, in Maori terms, is not just the collection; it's also the Maori viewpoint. They're not just collections; they're ancestors. (Rose Evans)

Use of replicas:

> From the community viewpoint, I don't think they can allow that. They won't allow that because you can have a facsimile cloak but that cloak won't have been worn by Te Rauparaha. I feel there's an enormous amount of transferral of the person – their *mana* – to the collections they had because they would instil that *mana* in them. (Rose Evans)

Interpreting a historic site:

> They built this new meeting house on a very old *pa* site there – a site that was important to the people down there so they were re-using the whole place as it once was. They were re-occupying it. So the project was seen as

their way of interpreting the place and making the history come alive again, I guess in the same way that plaques and notice boards are in a European sense. (Dean Whiting)

People also noted that Maori used *Pakeha* cultural institutions differently than did other New Zealanders:

It was significant that half the staff at the library when I was a child were Maori, so we were actually encouraged. Because, when I went, you used to have to sit at a desk by yourself in a library but the Maori staff in the Maori area used to put all the desks together so you'd come in with all your friends and make lots of noise. I mean, that's significant: they embraced us rather than told us to be quiet or get out. (Vicki-Anne Heikell)

For instance, at an art gallery when I was there with a Maori group, a lot of people hadn't been to a gallery and a lot of the time they were going up to the lovely oil paintings and touching [them] because they hadn't the prior knowledge about galleries. So, I see that as part of my job, too – to go out and teach our people that's not an appropriate thing in a gallery, or touching our *tukutuku* panels [panels made of dyed, woven plant material, often on the inner walls of a meeting house] that we have here in the [National] Library, because they're so used to going up and touching and feeling. We've got one downstairs with feathers, and you see all the little Maori kids often when they come in, touching and playing with the feathers because that's what they do in the *whare* and they're often encouraged to do that – touch carvings and things – but it's just trying to teach them what's appropriate. Or, maybe, it's teaching us what's appropriate. (Vicki-Anne Heikell)

The people with whom I spoke noted that indigenous people in New Zealand harbour mixed feelings about museums. They expressed this both on behalf of Maori visitors to their institutions and in relation to the organizational structures and priorities within which they worked.

The following two descriptions concern Maori visitors to museums:

Maori communities don't feel that their needs are being met by this museum. In one of our exhibitions there was a mourning cap made of seaweed. There was a certain amount of information but there was no information as to how it was made, what it was made for. Maori communities really want to know how things are made and what they're made from because a lot of that information has been lost. A lot of it has been lost – not all of it. And that's why people want to come into our storage areas. They want to know the old styles of carving – the changes and divergences and styles of carving, the paint that was used and the decorative elements. And

they really want to know. I know that because, when I've done these nego-
tiations, they say to me: "Well, why do you think it had a different paint?
Why do you think it had a different colour?" I feel the Maori community
isn't being aided. I also think it isn't being aided because it doesn't have
input into the curatorial aspect – being able to come in and tell their stories.
(Rose Evans)

They don't want them [portraits or photographs of ancestors] to leave the
whare, meeting house. If they let them leave the meeting house, they're
certainly not going to let them leave the district. So it's a bit of a problem
[performing conservation treatments]. It's all to do with the past. Often
people from big institutions have come in and taken a look and said, yes,
and they've either used that material or it hasn't been returned. So there's
all that suspicion that you have to break down, coming from a major insti-
tution, particularly a library, where we collect information. That's what they
think we're out there for – to see what they've got so we can take it away.
(Vicki-Anne Heikell)

With regard to the role of heritage objects, there are many similarities
between the views expressed by the First Nations people in British Colum-
bia and the Maori conservators and others I talked to in New Zealand. For
example, there is a strong element of Maori culture that acknowledges the
importance of the intangible, spiritual aspects associated with material cul-
ture and that pays respect to ancestors:

Look at the forms of the art. They all have names. They all have lineage;
people have lineage to them, therefore they have a spirit about them. They
are a living thing. They are treated like people! People talk to them and
people sleep with them. They hug them and all that sort of stuff. There's a
sense of community – they want to be next to them and, when they're not
next to them – there's a thing called *ahi-ka,* or the home fires, and if you're
away too long, your home fire is going to go out and so there's a dire need
to want to go back and be back with your people. (Nick Tupara)

Touching is part of the keeping of the carvings warm. Keeping them and
touching them is linking with them. And most people who do that are
linked to those carvings. (Rose Evans)

The above comments reinforce the important role that material cultural
heritage plays with regard to Maori identity (a role that, as we have seen, it
also plays with regard to First Nations identity). The way Rose Evans links
this identity to cultural continuity echoes what happens with First Nations
in British Columbia: "That issue of respect comes from the status of the

carvings and it's an in-built thing and I can't really even explain it. It's something that you're brought up with, that you have – it's really hard for me to put it into words. Maybe it's an awe (not necessarily a fear) 'cause you have a knowledge that your lineage is through to this person somehow, and I feel that anybody of any Maori descent would feel that."

In New Zealand museums one might see a visitor greeting a carving of an ancestor by touching noses with it. In some museums there are bowls of water for cleansing one's hands near the doorways of galleries or storerooms holding objects with *mana*; green leaves are often placed directly on or near objects, signifying remembrance and life. As Vicki-Anne Heikell says, "It is more than an object to me":

> A significant Maori document was returned to New Zealand, and the things that I did, not only as a conservator but as a Maori person, before we did any conservation work – we had a *tapu* [taboo] lifting and I had water in here and those were things that were hard to explain to other people. If I'm conserving Maori material, I like to follow through on all those things because it's more than an object to me. Even works on paper are more than just works on paper, and most of my colleagues are fine about that – so we sang and we had the *tapu* lifting, we had the water and we had the green leaves and things around the object which we wouldn't normally happen to have in the Conservation Laboratory, but I felt that was important to its return and to its actual conservation, in a way – it was its return home so the conservation was more than just the physical aspect. It was the whole spiritual thing to bring it back to life. If you had been sitting in another country for 150 years ... (Vicki-Anne Heikell)

The *mana* of the object may exist even in a museum and even after many years, and it must be accorded respect: "The meeting house – there's that area in the front which is called *marae*. Now, they'll create a *marae* situation wherever they are and, if it's the display hall of a museum, they'll create it by locating, positioning themselves relative to a treasured item like that and undergo ceremonies" (Nick Tupara).

As with the First Nations in British Columbia, the meaning of the object for the Maori lies very much in its non-empirical significance – in its "intangible" and "social" aspects:

> And people do touch them, lean on them, break them, abrade them ... fondle them, whatever they do. In a spiritual sense, I suppose, they fondle the community. It's retaining that, that is most important. (Nick Tupara)

> I guess it would be its spiritual integrity [that it is most important to preserve] because, without that, it doesn't mean anything. Why have a piece

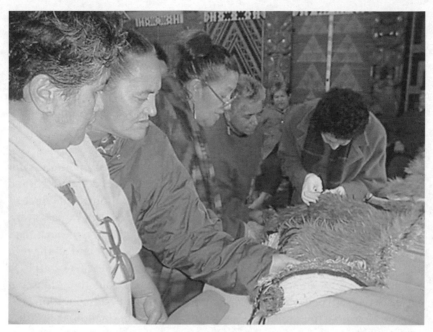

Participants at a National Preservation Office/National Services preservation workshop presented by Vicki-Anne Heilkell and Rangi Te Kanawa at Huria marae, 2000. (Courtesy of Huria marae)

of paper with a lot of script on it if it doesn't have any *mana?* (Vicki-Anne Heikell)

The idea that preservation means cultural preservation, which involves living cultural continuity and practices, is seen in New Zealand as it is in British Columbia. Preserving the objects is one means of achieving cultural preservation; speaking the language is another. As will be seen in various quotations in this chapter, for Maori people heritage objects and buildings need to be used in order to preserve the living Maori culture and be kept, if appropriate, to give evidence of the past to contemporary and future generations. In some cases, though, it is appropriate for the objects to complete their cycle and to cease to exist along with their owners.

Preservation is not actually part of Maori custom, so far as I understand. Once something is dead or has no life about it, then it must be returned to *Papatuanuku.* That's the land. We don't see any great loss with that because our affinity to the land and sea and the sun is what we are about. So, we're not actually completely losing it. My mother and my grandmother are traditional Maori weavers and they continue to weave traditionally and, in

doing so, they are actually keeping part of the culture alive. So, when they see a cloak that is past it or stained or damaged, then they would say: "Just wrap it up, and bury it and I'll make another one." So, that's their way of preserving a culture, which is totally opposite to what I'm doing because I will keep the dead alive, however, and they are accepting of that but that is a Western thing, isn't it? I have never had to make that decision about when to put a *taonga* that is absolutely beyond repair to the ground to return it to *Papatuanukua*. (Rangi Te Kanawa)

At the same time, one non-Maori conservator made the important point that there are *Pakeha* objects in her museum that protocol demands should be allowed to "die": "Some people do talk about a *mauri,* or the life force of an object, and that some objects should be allowed to die or just pass away. I guess it's paralleled a bit too with things like the military colours, flags that are traditionally supposed to fall apart and dust to dust and all the rest, and yet in the museum context [they] are kept intact" (Julia Gresson).

One conservator indicated that the issue was analogous to a "museum cycle," which involves letting objects that are in such bad condition that they cannot serve museum purposes be deaccessioned, or allowed to "die." With regard to a cloak that was extremely deteriorated and whose lineage was known, Rangi Te Kanawa commented: "I think we would go back to the *iwi* and discuss the issue with them. It'll never be exhibited so it's not going to be seen, whichever hands it goes to."

Julia Gresson made the following comment on allowing objects to "die," or "complete their natural cycle": "I do think it is important that they do last, the objects, and sometimes that might be in philosophical conflict with the person who made it. But then, the person who made it, I guess, also wasn't aware that maybe it might be one of the last ones there ever was going to be, and maybe they wouldn't have cared and maybe they would have."

Conservation Work and Related Perspectives

Maori conservators see their Maori-related work, even in urban institutions or heritage organizations, as: preserving Maori collections in a way acceptable to the Maori people; giving advice on preservation to Maori communities (both on objects within the community and those housed in museums); and, ideally, letting Maori owners contribute significantly to the final decisions (including, in appropriate cases, determining those decisions). It would be fair to say that non-Maori conservators working on Maori objects view their role in a similar way, even if they may not be working as directly on the *marae.*

[Re: who decides on the care of the object in a collection?] If the community doesn't yet know about it, that it exists, then it is my responsibility. If

the community takes an active part in looking after these things, then I think it's a partnership issue. But most of the time our people, if they see another Maori person there working, they'll take your advice and say: "Well, you're the expert there, then you'll know what to do." And they usually follow your advice. But, if they said they wanted something done with which I disagreed, I would, in a Maori forum, be able to express my opinion and say, "I don't think you should do this." (Vicki-Anne Heikell)

That the final decisions are made by appropriate Maori community or lineage members is certainly the case when the objects are located on the *marae,* and it is the goal when objects are on deposit in museums. When the objects are part of a museum's collection, some issues related to preservation (such as loaning out for use) may be considered to be curatorial decisions. However, in these cases museum staff often negotiate with the Maori community in an effort to reach an acceptable decision. It was important to all the conservators that the Maori community be given detailed information so that it could make informed decisions about preservation.

What I can do is that I can actually explain. I can sit down and I can explain that "if we're not going to do this now, then we won't have this with us next year or the year after. That's your decision." (Rangi Te Kanawa)

We adhere to the NZPCG [New Zealand Professional Conservators Group] Code of Ethics, and there's also the Charter [ICOMOS New Zealand Charter for the Conservation of Places of Cultural Heritage Value] – working for indigenous people and their things. For works on paper, it's a bit different. It's actually a bit harder to convince Maori people to do things about their paper things than about their carvings ... they see that as important. But if they want to let it go and they don't want to keep it, then there's nothing I can do. So, there's sort of that wanting to show them my preservation techniques to look after it but, if they don't want to, then I have to let go – but so long as I give them all the options then they, ultimately, have to decide. (Vicki-Anne Heikell)

Dean Whiting, a conservator of Maori heritage, noted that, for example, giving meeting houses a new coat of paint can be considered a part of historic preservation; however, if the community wants, for example, to replace carvings with something different, then the role of conservators (in his case, the Historic Places Trust) is to help the community find the right artists and/or artisans and the sources of funding needed to accomplish this. Maori conservators see themselves as contributing to the Maori people by offering them their training and their knowledge of the many aspects of material heritage preservation.

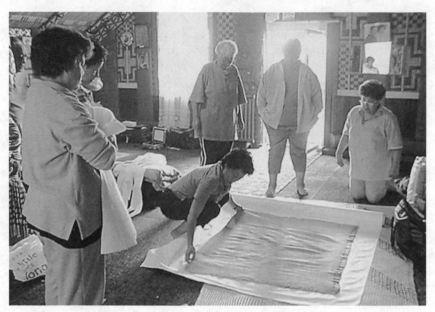

Participants at a National Preservation Office/National Services preservation
workshop presented by Vicki-Anne Heikell and Rangi Te Kanawa at Papakai marae,
2000. (Courtesy of Papakai marae)

Some of the Maori conservators had mixed feelings regarding museums
and their relationship to the Maori people. These feelings were not so much
the result of contradictions between different cultural meta-narratives as
they were of conservators' work being situated within the practices and
viewpoints of a *Pakeha*-controlled institution that did not always serve the
Maori people. Sometimes they felt that the institutions were opportunistic
and that they used bicultural opportunities for their own agenda rather
than as a means to forming equal partnerships with the Maori people.

Sometimes they [non-Maori personnel] acknowledge that you need to do
those things [Maori rituals] but they don't actually understand. They think,
oh, you know, that she's just doing her thing so let her do her thing. And
they also find it strange that, because I'm a professional, as a conservator
that I would still be upset about those things [not following Maori
protocol] ... but they certainly use it – all the publicity shots in the end
were all the Maori people coming in to view it and all the bigwigs
(dignitaries, politicians, etc.). (Vicki-Anne Heikell)

Even when you ring them up, they can never remember what their Maori
name is, but it's all part of our apparent bicultural swing around the nation.
A new era of biculturalism. (Nick Tupara)

Dean Whiting, who works with historic sites and monuments, noted contradictions between the *Pakeha*-oriented perspective inherent in his institution's regulatory guidelines and Maori viewpoints. For example, registering historic places or classifying buildings does not necessarily reflect the perspectives of Maori communities.

In a lot of ways, it has little relevance to Maori people if the place is registered or not. They don't seek status [for] it because it has its own status; and, the other thing is, they feel it is another control that is being applied to it, when it's registered. The other thing that was resisted before this new act came in was the classification of buildings. Generally, Maori structures weren't classified, because they represent ancestral people; you can't apply a ranking system to people. That was quite inappropriate. So, the [Historic Places] Trust was good in enabling *marae* to exist outside their classification. (Dean Whiting)

One non-Maori conservator also commented on the difficulties she had with some museum policies and procedures. These did not concern intercultural relationships but, rather, reflected the same conflicts described in Chapter 2 (e.g., these involved new directions in museology, budgetary restraints, and internal situations that, in conservators' eyes, put objects at physical risk) that created difficulties between conservation and the institutional modus operandi.

Well, I think a lot of the challenges simply come from the direction museums are taking and that the less money there is and the less time there is, and the more people want to develop galleries very quickly and develop buildings really quickly, the less conservators are able to impose or even recommend standards that they're more familiar with. And, while some of that, I think is negotiable – and it's particularly negotiable in terms of people wanting access to their objects – there are some things that aren't negotiable and that, one example is simply – people doing construction work and damaging objects. An electrician was working in the Pacific Hall and basically he broke a very precious object, and that could easily have been avoided. (Julia Gresson)

In other words, in her eyes it was not the Maori/non-Maori concerns and viewpoints surrounding collections that presented the principal challenge to ethnographic conservation; rather, it was the internal, conventional museum power relationships and differences in perspective. Both she and Valerie Carson strongly emphasized that working with Maori concerns had been a positive rather than a negative experience: "An enriching experience – no question about it. I know that I'm a better person for having had this

contact and having experienced so much from Maori people. I feel very fortunate" (Valerie Carson).

The differences between Maori and *Pakeha* cultural meta-narratives were experienced on a personal level by the Maori conservators, but they were not necessarily experienced as terribly conflicting: "I would not do that [rub a carving] in my profession. But, being a Maori, I might even do that myself and, in fact, I think I have done. It's a personal thing and, because I'm of Maori descent, I have no problem with it. I can actually come in and out of these worlds when I feel like, when it's appropriate, when it's suitable. It's actually the same amount of respect for both" (Rangi Te Kanawa). Nick Tupara did note a conflict he had experienced:

Certainly, when we were studying in Australia, I had great difficulty with the codes of ethics. From a Maori perspective, I thought that there would be conflict here immediately to the point where I felt it necessary to talk to the head of our department about codes of ethics. I suggested to him that this would be impossible for me to implement, to put down on my people who already had cultural ethics of their own that go over many thousands of generations and you're asking me to impose another ethic and I think we will find it extremely difficult to move amongst our people if we were too strong with these ethics.

It is significant, however, that this occurred while the conservator was in training. All the conservators noted that, in their work, they are able to address and, in fact, are committed to addressing these differences in perspective and making these Euro-based structures serve Maori people. Nick Tupara continued his discussion of the problems he had with the conservation code of ethics as follows:

We had some input into the ICOMOS New Zealand Charter. I think that's a good first step towards ethics for Maori things. The artifacts that we work with, we have no power over. We have no determination as to why they're there or what their use will be, but that's determined by the communities that live around them. And we try to acquaint ourselves with their ethics and utilize our knowledge to assist them to progress around these artifacts, to keep them going, and that may cut across a lot of codes of ethics but there is an undeniable desire to preserve and carry these things forward. There's a great deal of respect and honest responsibility with regard to the protection of these things, so we encourage that through. The way we encourage that through may be slightly different from the way they may have done it traditionally but, under analysis, it is very much the same. The techniques are more modern but the same passion is still there.

In other words, conflicts between the Maori and *Pakeha* perspectives do not necessarily remain conflicts within the conservator's work. Nick Tupara worked to resolve his conflict with conservation ethics by contributing to a professional ethical charter on the one hand and working to integrate Maori perspectives into his daily work on the other. Rose Evans, also of Maori heritage, settlled a conflict by following ethical conservation procedure on the one hand and by acknowledging the community's right to make the final decision on the other: "Now, if, for instance, a community then said: 'Well, we don't care.' Then I would say: 'Right, I've done everything I can. I will document it to cover myself, ethically'" (Rose Evans).

Another Maori conservator commented on her work in relation to differing perspectives:

> We have to educate our people and, in the same respect, the museum world has to be educated. The community out there, the people believe that their carving or their cloak is inside that museum and no one's ever going to see it. No one's ever going to touch it or be around it. It's never going to be worn. It's like it's never ever going to be loved in their eyes. And yet, in our world, it's comfortable, it's lying flat, there's no dust on it. We're all together at the start, we both care a lot for our *taonga*, and now we just need to compromise. (Rangi Te Kanawa)

Both the scientific aspect of the Western meta-narrative and traditional indigenous viewpoints, which, outwardly, might appear to be in conflict have been integrated into the conservators' perspectives:

> I do find I have that aspect [scientific] in me too. I don't actually find it a very hard river to cross really. I've had to do quite a few lectures on Maori and science. I found that science was such a creative area that I don't feel that it's a cold clinical viewpoint. Science is not just fact. Because, as we all know, in science fact is only a proven theory and theories change, and I suppose something that helped me move in that area was when I did anthropology. [I learned] that science was a paradigm, that various scientific views were paradigms within a belief system.
>
> So, I don't really see it as such a disparity with what I do now, which is in conservation and working with Maori communities and with Maori *taonga*. I just do not find myself in a dilemma there at all. When we were putting forward a proposal for the natural history resource centre with the Maori element of it, they put me on the area of developing the scientific angle. A lot of people thought, oh, it just wouldn't work because Maori science is different from Western science, and I said: "I don't see why we can't link them." Because you can link, for instance, the carvings, the sciences, the

material sciences behind carvings, the wood technology, the science be-
hind wood deterioration (the insects that eat into wood) and why, for
instance, trees were cut down at a specific time and why they were water-
logged, why they were put in rivers [because the sap would be reduced and
you would not have an insect attack]. All those things that are actually
intriguing to Maori communities. I don't think that science was even taught
properly in Maori communities. (Rose Evans)

Nick Tupara used analogies from his professional conservation training
to describe Maori perspectives. In one instance, he drew a parallel between
Maori perspectives and the conservation concept of integrity, at another
time between Maori perspectives and the principle of non-falsification.

From a conservation point of view, conservators seem to have a more inti-
mate view of objects and, in the past, I've only maybe seen it from a visi-
tor's point of view because a conservator likes to look inside. What molecular
structure is it made out of? What sort of inner character does it have apart
from the aesthetic or the exterior views – the interior thing – which was a
sort of a spiritual dimension for me, from a Maori perspective, working
with these old artifacts and it sort of touched me.

If you have an object in a community, that's the setting where it was
created. The meaning why it was created is in there and, in fact, you're
removing it from that and turning it into another object somewhere else
and, in a sense, falsifying it. So, in a way, you're destroying that object.
What we're saying is that the object is dynamic with the community which
is ever evolving and that's what we're preserving. That is, it's too narrow to
conceive that you're preserving just the material but it's a living, breathing
object. Sounds really terrible but its soul is with the community; what you're
preserving as a museum is actually falsifying a lot of that.

The fact that the conservators' work included negotiating with commu-
nities and working with the *kaumatua* (elders knowledgable in Maori
protocols and culture) attached to museums, and the fact that their work
often focused on traditional Maori material heritage, meant that many times
the conservators were working within the framework of traditional Maori
social perspectives. Again, these perspectives emphasized the importance of
acknowledging the "intangible," or "social," elements of the objects with
which they worked. For example, when advising or conserving objects or
structures belonging to private individuals or communities, issues of gender,
age, and status were added to the significance of lineage relationships: "What
I'm eventually hoping to do is to be able to do it as a group because Nick
and Dean get to work together often and being men also helps them. Being
a woman who goes by herself, somewhere, is a lot harder ... and often in

your own communities harder still. Because they have more of a right to ask you who you are, where you're from, and all those sorts of questions to sort of set you up and that's quite hard" (Vicki-Anne Heikell).[1]

When Rangi Te Kanawa was asked about whether she would express conservation concerns to a person of high stature, she responded: "You have to [express conservation concerns even to someone of high stature] as it would be very unprofessional of me if that advice wasn't given" (Rangi Te Kanawa).

Conservation Work: The Tangible and the Intangible

Although, as we have seen, two general meta-narratives, Maori and *Pakeha*, exist in New Zealand regarding the preservation of indigenous cultural heritage, they do not necessarily spell conflict for the Maori conservators either in their personal value systems or in their professional conservation work. Some parts of the meta-narratives do not, in fact, conflict. This has been seen in a previous quotation concerning the importance of the preservation of material culture to Maori people and is seen again in the following:

We often see things in black and white. We see that communities want their *taonga* back and the museum is a big, bad wolf that won't give them back – the community will be all right, but often the community has issued concerns, especially old people, that they cannot look after them. They would rather have their collections held in acceptable conditions and be there for their grandchildren and great-grandchildren to see, especially in areas like this where people are from different tribal groups. (Rose Evans)

I do say to them not to touch and I explain the reason why – they're very accepting of it. It is an education and they're becoming very interested in the care and preservation of *taonga* and what's involved. (Rangi Te Kanawa)

In cases where the meta-narratives do conflict, the conservators have often been able to bring the two points of view together, expressing the possibility of having a "both/and" rather than an "either/or" viewpoint. How to balance preserving the tangible physical integrity of a work with preserving its less tangible conceptual integrity did not involve a conflict for any of the people with whom I spoke.

When I'm treating a carving, I'm not treating it as a piece of wood. So, that's the first issue – that I'm treating an ancestor – so that's quite a different thing. And I often find myself chatting away. So, there's no real problem that I have with it. (Rose Evans)

1 By 2000, Vicki-Anne Heikell and Rangi Te Kanawa had been able to work together many times to provide preservation workshops on marae to both *iwi* and *hapu*.

I do feel, because of my ethnic origin, I have no real problem dealing with that spirituality in conservation. (Rangi Te Kanawa)

Because the conservators believe in the importance of both the tangible and intangible aspects of the object, they alter the conventional conservation approach to accommodate both preservation of the physical object and preservation of its cultural life. Their work shows respect for both Maori and *Pakeha* viewpoints.

I worked in the front of *Te Hau Ki Turanga* and we had a ceremony before it went up, to lift the *tapu*. I did ask if it was necessary before it was worked on and they said that I didn't have to. But I'm always aware of that because, from my angle, I don't want to get into any trouble as well. But I'm quite aware of the power of the carvings. (Rose Evans)

What I tend to do is, I do a treatment and then, after it has had its physical being restored and conserved, then I can get somebody in to say something. (Vicki-Anne Heikell)

The work of the non-Maori conservators also shows respect for both Maori and *Pakeha* perspectives: "You have to accept that, yes, these things will be used, will be borrowed, but they're not borrowed lightly. They will be borrowed for a *tangi*, that is a funeral, and that's right and proper" (Valerie Carson).

The highlighting of respect for both the tangible and intangible elements pertaining to collections was accepted by both Maori and non-Maori conservators who worked on Maori objects: "There are certain things that most people know about like not treating carvings when you're menstruating, not using saliva on objects, not eating or drinking near objects – so there's that level of your personal behaviour, in a way" (Julia Gresson).

The conceptual integrity of not just the object but also the display area is important, as is seen in the following example. This is reminiscent of Gloria Cranmer Webster's comment that conceptual integrity was expressed not just by the individual objects at U'mista (the cultural centre in Alert Bay, BC), but by the whole collection. Cultural significance lies in the "whole," and it is made up of both the tangible and the intangible.

For an annual high-profile ceramics exhibition the central Maori Court [in the old museum] was used for the opening ceremony, and it was used inappropriately. The conceptual integrity was totally ignored, for the sake of more space. This is not only insensitive to the space, but places those objects at great physical risk – which it did, because they had various sorts of

equipment trailing over the objects. The inappropriate use? That was just because it had nothing to do with the objects in that gallery. It was using them as props, as a backdrop. An "exotic" backdrop, in a way. (Julia Gresson)

The non-Maori conservators were very conscious of their position and of doing their work appropriately:

Here, anyway, we're fairly conscious of not alienating the public by using methods and materials which reinforce the scientific or slightly cynical view of treatment or storage of museum objects. I am very concerned with the idea of making it comfortable for people to come in and look at objects. And, on a very practical level, that might involve using, for instance, grey Jiffy [Ethafoam] foam instead of white. (Julia Gresson)

Very early on I came in contact with a very powerful Maori woman and this issue of cultural conservation, of a *Pakeha* woman actually handling Maori material, was right up front. I was in trepidation of meeting this woman. We sat down at the table and she came across very strong. I was very daunted. She threw down the gauntlet and said: "You're not going to be handling our material." ... I realized then I had to establish where I was at, lay my cards on the table and stress to her how I felt about handling Maori material and about how important and precious it all was. I had to establish my base, and that took quite a long time. It wasn't just talking, it was the actual physical handling of the material and letting them see that I was serious and that I was caring and careful. (Valerie Carson)

Some of the Maori conservators commented that the *Pakeha* conservators were in a different position vis-à-vis the Maori communities than were they themselves:

Being Maori, that helps. I mean, if a *Pakeha* had gone in and said that, they ... probably would have been ticked off. (Vicki-Anne Heikell)

It's a power thing and you need the *tangata whenua* [first people of the land] to educate their own people rather than someone else because ... people back home wouldn't perhaps appreciate a *Pakeha* person telling them, "Hey, you shouldn't be rubbing the carvings" when they come to museums, or putting leaves on them like they do because the leaves signify life. But if I said to them, maybe you could put the leaves on but, hold off – you know: "Everyone's rubbing them, there won't be anything left", or something, they may be more likely to say, "Okay, then, we won't." Maybe a way of determining standard of care is to provide appropriate training to First

Nations people and increase their understanding of what the profession is about, and why you're doing it. (Vicki-Anne Heikell)

In addition, while Maori conservators expected all *Pakeha* staff to be respectful of Maori heritage and perspectives, two people commented that they did not expect them to perform ceremonies.

[Miriam Clavir:] What about in terms of any rituals? Are there things that you need to do or someone has to come in and do either before you work on a piece or before a piece goes on exhibit?
[Rangi Te Kanawa:] Not that I know of, no. I haven't had anyone come into the lab yet and do anything. That's my thing. I take care of that myself, even if it's only a little prayer or something. That's not before every cloak but there's a certain amount of silence that I give the cloak beforehand.
[Miriam Clavir:] If it's a *Pakeha* conservator – should that person, do you think, find an appropriate person to do something before treating it?
[Rangi Te Kanawa:] I don't really think so. I still think it's a personal thing. I think each to his own. I don't have a problem with doing my little bit and I don't have a problem with anybody else not doing their bit. I don't expect Valerie to have that sort of contact with it, but she does have respect. It's respect.

[Question: Do you expect *Pakeha* conservators to get someone in after a treatment to say a *karakia?*]
[Vicki-Anne Heikell:]Well, I don't know. I think they would be prepared to do that but we deal with such a lot of Maori material, too, it would be hard to judge them. And, at the moment, we have an informal policy where if the piece is really significant it is blessed.

Although the Maori conservators did not question the need for appropriately preserving both the tangible and intangible aspects of an object, this does not mean that they never experienced inner conflict regarding this issue:

[Miriam Clavir:] As both a conservator and a Maori person, do you think it's okay to put objects at physical risk if it means preserving their conceptual integrity, their cultural meaning?
[Rangi Te Kanawa:] Well, I have two hats that I have to wear here. I'm not sure which one I'm going to speak for, whether it's my Maori cap or it's my conservator's cap. The answers will contradict each other. With my conservator's cap on, if an object is in poor condition, then I would advise against it being lent out. If the people are adamant that this *taonga* should go out,

then I would agree to it with certain conditions [Rangi continues with an explanation of the conditions].

The whole issue of letting something go that I might think is important but the people who own it don't – that's a problem for me, it's a struggle for me and sometimes ... I keep having to say: "Why am I in this profession?" And I'm always having that struggle. (Vicki-Anne Heikell)

Achieving Balance

The following examples of conservation practice illustrate further how Maori conservators balanced their professional conservation knowledge and values with serving the interests of the Maori community. They also show where compromises relating to conservation principles and methods have been made.

Now, we went all the way up to the east coast and negotiated that, and there were other concerns they had. Like, for instance, there were some cosmetic changes that they wanted to happen, because a lot of the longitudinal cracks in the carvings went right through the faces of the figures and they didn't like that. That was – from a conservation viewpoint, unnecessary. Minimal interference states that, if it's just cosmetic, it's not necessary. However, with that consultation, I felt that it was necessary because that is what they want and they are, in a sense, the guardians of that house. (Rose Evans)

A practical angle for how I work with the collections is that I observe certain restrictions. I don't work on the carvings during menstruation, and I don't use saliva for removal. I don't blow on the carvings, which is what you often get used to during treatment. You blow away various things. And it also makes you so much more aware of when you're treating a carving, and you've got to use a scalpel. (Rose Evans)

There was another issue which was the *tukutuku*. Because of the nature of the materials that they're made from, they get damaged where people sit against the walls. A lot of people up there stated that they would like to have these remade. I had to state that these were original. They weren't necessarily original to the house. They were made later when the house was reinstated in the Dominion Museum – and were made by Raukawa women, not the same tribal group. So, that brought a fairly controversial issue to it: they weren't necessarily *Rongowhakaata* and they were damaged. And the *Rongowhakaata* people thought they should be replaced. But, when it was

understood that they had been in the house so long and that these panels had been made under the direction of Ngata, who was from the east coast, and that they had kept, in a sense, the house warm all that time then it was agreed that we would retain them. (Rose Evans)

I've done reports that are really just discussion documents where I've looked at the condition of the pieces and some of the different appearances they may have had – these are carvings, for example – and then given them some long-term scenarios about how they could be preserved and what for. One particular place – they had a set of carvings that had come off a building that had collapsed. They'd been kept on the *marae*. They hadn't built another meeting house, but some people are talking about doing that and some just want to store them somewhere. Now, they're equally valid. Keeping them requires a little conservation, a little restorational reconstruction and things like that. But they're not being used in the way they were intended so they're out of context with the rest of the *marae*. So, if they were to be reused on the outside of a building, then you're going to lose some material information because these carvings need to be stripped back – the paint's all cut up. Obviously, if they're going outside, they need paint on them. So, they have to figure out if it's that significant losing the old paint. They also have to realize that the life that they have on the outside is much shorter than they would ever have being stored inside. So, they have to know that information and that's what they ask me is to provide that. So they have that and they'll make their decision on it. But it's equally important – say if they chose to put them back on the outside, I would consider that a good way to go because these carvings are in context again. They're in the right position. They are doing what they're supposed to do – they're not there just to provide interesting information about paint history or carving styles. They're there to function culturally, primarily. So, if they have to go back there, that's where they go. (Dean Whiting)

We had Maori librarians, and we operated as a team. We covered all areas in the library so if we got a big group in we got out everything that they wanted to see and part of that was that I would give them a run-down on why we use white gloves – not that ... you've got to wear white gloves, but why we wear white gloves and why it's important and, if they have any of the other documents at home, they could do this and that. So I would give them a sort of a brief overview on what conservation was, and groups were really receptive to that and you'd tell them things like: "Don't laminate anything!" And they would all go [intake of breath]: "Oh!" Too late. (Vicki-Anne Heikell)

The above examples show that, in integrating conservation and Maori viewpoints, it was almost always possible to do so without compromising

conservation principles and ethics. It is presumed, from the accounts, that other Maori involved were also satisfied with the outcome.

Vicki-Anne Heikell, who is of Maori descent, gave an example of how important it is to make sure that, in negotiations between conservators and Maori, no mistakes are made about what is or is not a cultural belief:

> You've got to decide whether it's because culturally they don't want to or because they don't really understand where you're coming from, your reasons why – You know, maybe they're suspicious that you're just coming and saying you want to take it back, or, if it's for a cultural reason, then you stand back. But you don't want to push the issue, either, so it's a struggle. Somebody's *whakapapa* books were burnt in a fire but they rescued them. They weren't actually badly damaged, but they thought they should let the rest of it burn ... and it wasn't because it was a cultural thing to do that. It was because they thought it wasn't worth keeping them any more because it's all burnt around the edges. (Vicki-Anne Heikell)

A major area within which conservation and indigenous cultural beliefs have been shown to conflict concerns the use of objects in museum collections. In New Zealand, as in British Columbia, "use" ranges from artists and craftspeople handling objects in order to learn from them, to lineage descendants handling objects from their heritage while viewing them, to loaning out objects for significant or ceremonial occasions. The following examples show that Maori conservators, while trying to minimize risk to the object, were not uncomfortable with appropriate use. At the same time, they stated that they would not put an object at physical risk.

> I couldn't put up with putting an object at risk. So, I wouldn't. I think that, to be absolutely honest, I would be going against my cultural background as well by doing that. I just know from the work that I have done here, that no one in the Maori community who I have negotiated with so far has ever put the collection at risk. I have negotiated and discussed all these problems with them. I have stated, "Look, that is going to put that carving at risk." They will say, "Well, if that's the case, we're not interested in doing it." (Rose Evans)

> But I don't make them wear white gloves like a lot of people would. I honestly think that [the] handling aspect of Maori culture is really important and you should be able to handle it or touch the carvings. (Rose Evans)

The Maori conservators have defined "risk" and "damage" both similarly and differently from conventional conservators. Two aspects of their perspective are parallel to that of the BC First Nations people with whom I

spoke. First, "small" types of damage are not considered to be damage but, rather, simply something that is to be expected when an object is used: "I find a lot of physical sort of damage and things like that, that seem really bad, are quite insignificant out there, really," (Dean Whiting). Second, risk is defined to include both physical and spiritual considerations: "I do feel an enormous concern for the collections and their physical and spiritual well-being, and I think that they are so intertwined that I don't think the community is interested in putting them at risk. That's what they've told me" (Rose Evans).

Maori conservators implied that they would recommend against use if they felt that it would pose a significant risk to the physical integrity of the object. In other words, they did not support use simply because it was part of the Maori cultural perspective; rather, they assessed the condition of the object and the context and proposed a position that maximized preservation. However, they did acknowledge that, ultimately, the decision regarding use or non-use would not necessarily be theirs to make.

The fact that damage can be defined culturally as well as physically was recognized by Maori and non-Maori conservators alike: "If you were actually using them, you'd probably be more worried if it was getting older or deteriorated because you might not be able to use it for much longer. It depends on the cultural context" (Julia Gresson).

Conclusion

In New Zealand, the Maori and non-Maori conservators with whom I spoke were in accordance with one another. Their perspective, unlike that of conventional conservators, did not separate the objects from their indigenous social contexts.

> I think it's probably very difficult to try and break down the difference between the community from which the objects have come, and the object, because you've got to respect their wishes as well – you feel as if you're an advocate for the object but as the object, to them, is a living part of their culture you can't really divide it. (Valerie Carson)

> Clients of conservation would be Maori people ... we're a client to them, because they still look after their own objects. We're tools they can use to preserve what they think needs preserving. (Dean Whiting)

On the issue of social context and how museums can reduce a potential conflict between serving the public at large and serving a special interest group (such as a First Nation), Vicki-Anne Heikell said: "I always believed if it was something to do with the *tangata whenua* then the *tangata whenua*'s requests and rights come before the public trust because, nine times out of

ten, the public trust is for the *Pakeha* people and not Maori or *tangata whenua* interest."

It appears that making decisions on issues in which conservation values conflict with indigenous values is an easier task for conservators in New Zealand than it is for conservators in Canada. The official national policy and its sanctions are undoubtedly a contributing factor to this. A second factor for the Maori conservators is, understandably, their identity and lineage in the indigenous population: "It's where your respect lies. Like, I'd like to touch that carving or rub that carving because it has this aura about it I can feel. It's like I feel close to it. It's from my *iwi* and I even want to go up and give it a hug and yes I will! I'll do that! But I don't think I'll touch that painting over there. I have no connection to that painting as I have with that carving" (Rangi Te Kanawa).

A third factor is the knowledge that, for many of the objects housed in museums, Maori ownership is undisputed; therefore the conservator's task is to give advice rather than to make final decisions:

So, we actually need to sit people down and say: "Our conservator, here, has advised that if the cloak is in good condition, it can be let out. Can you make sure that it's handled carefully, that it is kept out of the rain, that it's kept in a clean environment?" If it's not in good condition, then we need to sit down and we need to say: "It's not in good condition. If you're going to take it out and subject it to this and that you must be aware that this may happen." Depending on museum policy, they are the true custodians of the cloak; they can accept my advice but not actually go along with it. (Rangi Te Kanawa)

Even with regard to objects legally owned by the museums, there is a strong sense among the Maori of cultural ownership:

Maoris have a funny thing about ownership. Say land, for example. Land is a treasured thing. Maori people still identify – Dean and I, we're, strictly speaking, we're from the East Coast district, *Te Tairawhiti*. Doesn't matter where we are, that's where we're from. Whether or not we own land there or the legal aspects of ownership accorded to the land, we're still from there. The meeting house that's in the National Museum at the moment is one from my home, *Te Hau Ki Turanga*. That's always going to be our house. Doesn't matter who owns it. It doesn't matter what history says, that we sold it or someone bought it or whatever, it's still going to be our house, and *Te Hau Ki Turanga* is the breath of Turanga, which is the name of the place that I come from and that's always going to be the breath of my people, regardless of legal ownership. There's a cultural ownership that overrides all that. Possession is another sense of ownership. There's just been a

deal with the Rotorua people to have stuff brought back from Auckland Museum to their museum there as well as stuff from the Canterbury Museum, but the ownership hasn't been brought back. The physical object has. Possession for them, that's important. The legal ownership is also important but possession is more important. The thing is they never relinquished a custodianship or cultural ownership, which is all-encompassing. The legal angle is something they'll wrangle. They'll keep wrangling for it and, if they get it, they get it; but, if they don't, they still know those things still belong to them. Every time they see those things they, culturally, they'll speak to them, and do all the things that they'll do to them even when they were in their communities. (Nick Tupara)

Some of the stories that came back from when Te Maori was in America – that the display halls that they [the Maori] had to walk through to get to their exhibition – through the Egyptian hall, the Melanesian hall and so and so and so and so, the Peruvian hall – that they paid respect to all of those peoples as they believed that ownership or that cultural ownership is still with those people and so they had to go through their ceremonies to make way for them to pass by to their own thing. There's that sort of sense of ownership. (Nick Tupara)

A fourth factor contributing to the relative lack of conflict in bringing Maori and *Pakeha* conservation values together in conservation work involves a general clarity with regard to how to make decisions. For example, many museums have Maori *kaumatua* and knowledgable staff who can facilitate the process of working with marae and inform the museum of appropriate protocols with regard to Maori heritage.

For Maori working in museums who are young, recently-trained professionals, it is important that the *kaumatua* be on hand to share their knowledge and to provide guidance. In addition, conservation work receives positive support from Maori community members; in many cases, they support its aims and decisions to preserve both the physical and the conceptual.

Once they had seen the damage, they said: "We'll leave that up to you to treat and we would prefer that *pataka* to be here for our grandchildren and great-grandchildren because we can't care for it back home because we don't have the resources – the human resources – and we don't have the financial resources. (Rose Evans)

People who are carvers working on the marae have said: "What sort of adhesives? We've used this sort of adhesive and we've doweled this and we've done this and this." And I've said: "From my angle and I'm not telling you

what to do but this is the way I see it." And they've said afterwards: "Well, I'm glad you told me because I wouldn't want to harm this carving and I'll go along with what you say." (Rose Evans)

Although two perspectives can definitely be seen, several conservators, both Maori and non-Maori, warned against making generalizations and emphasized the "in-process" nature of their conservation practice: "You do have to be very careful because some people might see that [cloak storage at the Auckland Museum] as cold and clinical and not, sort of, warm enough or alive enough for them. Others might see it as a sign of respect, you know, that we are actually spending large amounts of money and looking after the cloaks and that they will last longer than they might otherwise last. So, you have to be incredibly careful, I think, of making those generalizations" (Julia Gresson).

The conservators brought together two perspectives – the Maori and the *Pakeha*, with their differing emphasis on the material and the social, not only because they strongly believed that both had value, but also because they believed that both, although they concern objects, are directly related to people: "[Re: 'respect'] – treating the object along with the people and the place. The object is nothing without its people so if we don't respect the people, we can't be respecting the object" (Dean Whiting).

All of the conservators stated that they served both objects and people, even though several felt that their institutions demanded that it be considered the primary client. Since the conservators serve people as well as collections, they believed that one of the goals of conservation work should be to establish good relationships with those people, even if it meant minor compromises were made with regard to conservation norms. This was also considered to be the best way to get the conservation message heard: "Keeping the goodwill of those people and not insulting them is more important than maybe a tiny mishandling misdemeanour" (Julia Gresson). The conservators, both Maori and *Pakeha*, felt that it was necessary to make compromises between the two perspectives in order to better serve the Maori people and to better serve the collections. In attaining these objectives, the conservators could also promote the goals of the bicultural institutions they were serving.

Two comments from Rangi Te Kanawa show that, sometimes, the same values underlie Western-based conservation work and the Maori-based cultural beliefs of the Maori conservators:

It's actually the same amount of respect for both. (Rangi Te Kanawa)

We both care a lot for our *taonga*. (Rangi Te Kanawa)

In previous chapters, I have mentioned that Doxtator (1996) refers to parallel paths for museums and First Nations. In other words, a particular partnership project can serve separate but productive goals. In New Zealand there is evidence of both common and separate goals. It is also possible that the many links currently being made between the New Zealand museums and Maori perspectives are partly the result of the increasing numbers of indigenous people who have found work in museums, numbers much greater than within Canada's. And, unlike in Canada, in New Zealand indigenous museum staff work primarily in the larger institutions and influence museum practice from within.

The vision of the Maori conservators with regard to bringing together Maori and *Pakeha* cultural narratives concerning preserving what is valued can be seen in the following quotations.

> Where the code of ethics revolves around the object, there would be a shift to something quite different. It may look on the surface the same but, like here in our section four: "The first responsibility of the conservator is to the object and its long-term preservation." You see, that's not really what we're about here at the moment. That will be a fundamental shift. (Dean Whiting)

> The *waka tupapaku* [the containers that were made specifically for the bones in the old days] – they wanted them separately kept and not to be seen so they're curtained off. So, there're all these other issues that the museum will have to deal with and it's never had to do that before. It's just like a whole, completely new belief system that we [museums] have to develop, if you see what I'm saying. (Rose Evans)

Maori conservators have shown that preserving both the physical and the conceptual integrity of objects involves no inherent contradiction. One does not have to preserve one at the expense of the other. They represent what Mina McKenzie (1990, 170) has called for in New Zealand museums: "A Maori voice that speaks in two ways; it speaks at a level with European academic voices but has its own quality, its own stance and its own viewpoint." The perspectives and work of the conservators in New Zealand, both Maori and *Pakeha,* illustrate a successful model for the conservation of indigenous collections.

7
"For What We Do"

This book has described and compared First Nations and museum conservation perspectives on preserving what is considered to be of cultural significance. Both perspectives value "preservation"; however, this term has two different meanings: (1) that favoured by museums, which involves using physical and intellectual means to ensure that material fragments from the past do not disappear, and (2) that favoured by First Nations, which involves continuing and/or renewing past traditions and their associated material culture; that is, preserving the culture's past by being actively engaged in it and thereby ensuring that it has a living future. Within Western culture, heritage is often described materially, in terms of a cultural product or production; within First Nations cultures, heritage is often described culturally, in terms of "process" rather than "product." One way of stating this is to say that, while Western society appreciates the productions of the past through the type of preservation exemplified by museum conservation, many First Nations appreciate "living the tradition," connecting the past to the present so as to make a participatory whole that they know as their indigenous culture.

Differences in perspective are significant within the context of museums and collections. For instance, with regard to what preservation should focus upon, museums have emphasized the "tangible" while First Nations have often emphasized the non-material, or the "intangible." For many of the First Nations people I interviewed, prolonging an object's existence is not the equivalent of continuing its life. For them, the culturally significant qualities of the object are related particularly to the object's social meaning – a meaning embedded within both past and present socio-cultural relationships. For Western conservators, meaning is embedded in the physical object, and, through ethical conservation methods, one preserves the object's conceptual as well as its other attributes.

For many of the BC First Nations people, the importance of the physical object lay in whether it could be used in maintaining or regaining their

culture. If it could not be used, handled, replicated, worn, witnessed, or seen within culturally appropriate and necessary ways, then there was some question about how much energy should be expended on preserving it, especially within a facility controlled by non-First Nations. At the same time, they appreciated that museums preserved objects that could serve as physical evidence of the knowledge and skills of their ancestors. Several also appreciated "museum values" such as aesthetic quality and the importance of well-known artists. Often, however, the value of preservation was linked to "intangible" qualities evoked by or made manifest through the object. Unlike the connoisseurship qualities mentioned above (see also Chapter 1), these include the symbolic nature of the pieces, such as the representation of a particular family's or individual's rights and status in Aboriginal society (or a band's claims to territory), as well as emotions such as pride in one's heritage and lineage.

While BC First Nations people emphasized that preservation should serve the "use" (in its many forms) of the object in their communities, they often perceived it as a "both/and" rather than an "either/or" phenomenon. In other words, they saw preservation as involving both use and physical maintenance, incorporating such cultural elements as traditional care of regalia and common sense (e.g., not using objects in poor condition). They consistently emphasized the need to have ready access to, and a very significant measure of control over, their material heritage and the meanings attached to it.

Although the people with whom I spoke generally favoured a "both/and" approach to preservation, some favoured a "one-but-not-the-other" approach. It depended on what was culturally appropriate. For instance, one person gave examples of the kinds of objects that could be displayed publicly and those that could not. In general, however, people did not see situations as falling exclusively in one category or another; for example, they saw some objects as belonging in community centres or within families and some as staying in urban museums. Again, however, all this assumed a context within which the social and cultural needs of the community were being met and within which the community and the museum had developed a relationship of trust and cooperation.

From a museum point of view, "any object may have existed in a number of discourses during the course of its physical life, and may therefore figure in a number of interpretation patterns" (Pearce 1995b, 299). A relevant analogy is James Clifford's (1990, 242) observation that differences between urban museums and cultural centres do not preclude overlap and communication: "None can completely cover or control the important meanings and contexts generated by the objects they display. Thus exchange and complementarity, rather than hierarchy, ideally should characterize their institutional relations." Regarding preservation, while the First Nations people with whom I

spoke stated that cultural concerns must have priority, they also believed that "exchange and complementarity" were desirable; that is, they often favoured a "both/and" model of preservation. This "exchange and complementarity" is achievable, in part, thanks to the diverse nature of material culture: for some objects a "one-but-not-the-other" status may be culturally appropriate while other objects permit a "both/and" approach.

The "both /and" model can serve both museum and First Nations communities. This model highlights the process of decision making. It not only emphasizes achieving an acceptable end result (such as an appropriate storage system), but also the process involved in achieving that result. For this model to be successful, it is necessary to conduct the whole decision-making process in a manner that emphasizes the First Nations goal of "regaining the intangibles"; that is, it must be conducted in a manner that has been respectful to the concerns of all participants. A decision-making process that brings together First Nations and museum staff from the beginning encourages the parties to share their knowledge and allows differing points of view to become mutually intelligible. For example, it is useful for a museum to know that, as far as First Nations are concerned, an object cannot be borrowed for use without the borrower proving that she/he has the rights to this object; that is, "borrowing for use" has restrictions. Similarly, it is useful for First Nations to know why museums request that ritual foods be frozen (to kill insect eggs that might be present). A "both/and" model of preservation can only be achieved through mutual understanding of what is significant to each party.

How realistic is it, though, to expect to achieve a "both/and" model in bringing together First Nations and museum conservation perspectives on preservation? Several successful examples have been given in this book, but does this represent a small minority culled from what can at times be a tense and fragile relationship? Certainly, as the twenty-first century begins, there are many difficulties involved in the relationship between museums and First Nations; at the same time, however, there is a great deal of optimism.

The First Nations people interviewed for this book touch upon some of the problem areas between museums and First Nations. As their quotations show, First Nations continue to feel strongly that they do not have ready access to that part of their material culture that is housed in museums. Yet, often there are no older pieces left in a community. In the opinion of some First Nations people, museums continue to guard their holdings with bureaucratic rules and procedures that govern every phase of access. Non-First Nations-controlled museums often remain uncomfortable places for First Nations people. Reasons for this include a continuing sense of loss, of exclusion, of not being listened to and of not being considered adequate decision makers with regard to their own heritage. Others felt that the length of

time museums take to implement First Nations requests reflects a lack of will to change. In addition, the phrase "we just don't have enough money right now" is seen squarely within this context. First Nations people can see the investment dollars represented by many museum facilities as well as the money brought in by visitors: this can't help but look like wealth. First Nations feel they have the legal and moral rights to their own heritage, and it is my understanding that they feel they have to struggle every inch of the way to exercise those rights. And it is often doubly difficult to get recognition of requests pertaining to collections in the museums of foreign countries.

The professional staff of public museums believe strongly in the worth of the museum enterprise, including the role of historical preservation, which many are convinced has kept much material culture in relative safety. Staff members often devote long hours to what they perceive as public service, which they render for less pay and support than they would receive in the commercial sector. Non-First Nations staff may firmly support social justice and the redressing of historical wrongs, however, in also supporting the museum, they may feel labelled as "the bad guys." They may feel they are being held personally responsible not only for not being able to make changes overnight, but also for any of the unacceptable actions of their predecessors and even for the horrors perpetrated by colonialism in previous times. Most museums would agree that, currently, they do not have the financial or staff resources to address First Nations matters adequately. First Nations concerns must be juggled with the many other demands on museums to remain relevant to the multifaceted audiences they serve. Within this situation, non-First Nations museum staff may be left feeling that, no matter what they do, it is never going to be good enough – either for the museum or for the First Nations communities with whom they are interacting.

The frustration felt in museum/First Nations relationships can at times be enormous. Many of these tensions surface when repatriation is at issue or when a collaborative exhibit has not worked well. The statements made above, however, despite their accuracy in some situations, can inadvertently hide the many positive aspects of the changing relationship between museums and First Nations. For example, many strong and positive relationships have developed between First Nations people and non-First Nations museum staff, and there have been numerous mutually successful and rewarding collaborative projects. Significantly, museums in general are changing the way they think and operate. For example, since I trained as a conservator in the mid-1970s, the relationship between museums and First Nations has gone from the former having little or no day-to-day contact with the latter, to First Nations advisors being involved in museum projects, to First Nations being equal partners with museum staff, framing numerous projects and playing significant roles in how these are accomplished.

Despite the frustrations previously outlined, many museum staff remain excited about working in the current climate. As Robert Janes (1994, 155), former director of the Glenbow Museum in Calgary, Alberta, has said: "Sharing authority and collections is much more than a responsibility ... it is also an opportunity." This opportunity enables museums to engage in broader and better relationships with the originators of their collections, to increase their own understanding of First Nations communities and share their museum expertise, and to serve their other audiences by offering the use of the museum as a venue for First Nations to present their perspectives to visitors. Museums now have the opportunity to both highlight the past by continuing traditional museum functions (such as object preservation) and to ensure a productive future by expanding collaborative relationships that acknowledge people and their diversity. In this way they can bring together different ways of working, seeing, and thinking.

For readers who are engaged in the care and preservation of museum collections, I hope this book has encouraged you to reflect upon your own areas of interest and ways of thinking: what you do, why you are doing it, and who you are doing it for. I am hopeful that it will provide a basis for self-reflection within conservation, especially in situations where conservation ethics and authority appear to be in conflict with others who have differing views, whether on preservation, science, or museums. This does not mean that these conservation principles are not valid; it does, however, mean that others may not accept them as valid. This book gives conservators and others engaged in heritage conservation perspectives on conflicts, apparent and real, within First Nations-museum conservation relationships, and it also provides examples of conflict resolution. The First Nations people with whom I spoke asked conservators to share their expertise with indigenous communities, to seek the expertise of these communities, and to broaden their professional and rationalist definition of "good care" to include the preservation of the social and ritual aspects of the object. The latter would normally be preserved by the appropriate members of the First Nations to whom the object belonged. First Nations perspectives have begun, and will continue, to change the practice and parameters of museum conservation.

The integration of the "both/and" model of preservation with Deborah Doxtator's parallel paths model will be significant in continuing museum/ First Nations relationships. Ethnographic collections, until relatively recently, were considered primarily as witnesses to the past rather than as part of the cultures of living peoples. That they can be both, and be important as both, within a dynamic two-way relationship benefiting the originating people as well as museums, is fundamental to the preservation of what is valued by both First Nations and museum conservators.

Appendix A
List of Participants

Except where noted, the ages and occupations of those with whom I spoke are listed as they were at the time of the original interview/conversation.

Canada
Anonymous, at one time had responsibility for collections at a Cultural Centre, taped 1 November 1995.

Donald Bain, Lheit-lit'en (Carrier) Nation, university student, former University of British Columbia Museum of Anthropology (MOA) Native Youth Programme participant and co-ordinator, and museum researcher at MOA and the Canadian Museum of Civilization, age group 20-40 years, taped 19 September 1995.

Rita Barnes, Kwakwaka'wakw, age group 50-70 years, taped 8 November 1995. When asked how she would describe herself as an educator, she replied: "I'm just someone who enjoys her culture. I can't do without it. What I do know, I like to share. I think I'm very typical of a lot of First Nations people in the city, at least from my area" (Personal communication, 17 January 1997).

Pam Brown, Heiltsuk, curator at MOA, age group 40-60 years, taped 1 June 1995.

CL: (anonymous), First Nations educator, British Columbia, age group 40-60 years, notes taken 1 November 1995.

Adelynne Claxton (Coast Salish), Coordinator, Saanich Native Heritage Society, age group 40-60 years, notes taken 3 November 1995.

Dora Sewid Cook, Cultural Director, Kwagiulth Museum and Cultural Centre, Cape Mudge, Quadra Island, British Columbia, age group 70-80 years, taped 27 August 1998.

Doug Cranmer, Kwakwaka'wakw, artist, age group 60-80 years, taped 29 September 1995.

Gloria Cranmer Webster, 'Namgis (Kwakwaka'wakw), founder and former director of the U'mista Cultural Centre, age group 60-80 years, taped 27 September 1995.

Howard Grant, Musqueam Band (Salish), Executive Director of the Musqueam community, age group 40-60 years, taped 20 December 1995.

Chief Ken Harris, Simoigit Hagbegwatxw, Keeper of the Clan Totem for the 'Gisgahaast Clan, Gitxsan, Elder-in-Residence, United Native Nations, and Resident Elder, Institute of Indigenous Government, age group 60-80 years, taped 24 November 1995.

Dena Klashinsky, Kwakwaka'wakw and Salish ancestry, Musqueam Band member, university student, former MOA Native Youth Programme participant and coordinator, age group 20-40 years, taped 6 July 1995, excerpts revised May 2000.

Sandy Jones, elder, Coast Salish, Saanich, age group 80-90 years. Claxton and Jones interviewed together, notes taken 3 November 1995.

Kim Lawson, mixed First Nations and Danish/British ancestry, age group 20-40 years, archaeology liaison, taped 1 November 1995.

John Moses, Delaware Band, Six Nations of the Grand River, conservator, age group 40-60 years, personal communications (letters written 16 June and 5 September 1995).

Juanita Pasco, Weka'yi ancestry, Collections Manager, U'mista Cultural Centre, age group 20-40 years, taped 27 September 1995.

Alfred J. Scow, Kwakwaka'wakw, retired judge, BC Provincial Court, age group 60-80 years, taped 22 November 1995.

Leona M. Sparrow, Musqueam (Salish) Band councillor, band liaison with the MOA, age group 40-60 years, taped 16 December 1995.

Debra Sparrow, Musqueam (Salish), artist, age group 40-60 years, taped 12 October 1995.

Peggy Svanvik, 'Namgis First Nation (Kwagiutl), board member, U'mista Cultural Centre, age group 50-70 years, taped 28 September 1995.

Dolly Watts, Gitwangak Band (Gitxsan), businesswoman, age group 40-60 years, taped 17 November 1995.

List of New Zealand Conservators Interviewed (1994)
(Institutional positions are noted as they were at the time of the original interview/ conversation)
(Maori affiliation noted after name)

Valerie Carson, textile conservator, Museum of New Zealand Te Papa Tongarewa, Wellington, NZ.

Rose Evans (Te Ati Awa), objects conservator, Museum of New Zealand Te Papa Tongarewa, Wellington, NZ.

Julia Gresson, senior conservator, Auckland Museum Te Papa Whakahiku, Auckland, NZ.

Vicki-Anne Heikell (Te Whānau-a-Apanui), Preservation Officer Maori, National Preservation Office, Te Tari Tahu Taonga, Conservation Services, National Library of New Zealand/ Te Puna Mātauranga o Aotearoa, Wellington, NZ.

Rangi Te Kanawa (Ngati Maniapoto), textile conservator, Museum of New Zealand Te Papa Tongarewa, Wellington, NZ.

Nick Tupara (Te Turanganui-a-Kiwa), conservator, New Zealand Historic Places Trust, Wellington, NZ.

Dean Whiting (Te Whānau-a-Apanui), conservator, New Zealand Historic Places Trust, Wellington, NZ.

Appendix B
Conservation Codes of Ethics

The following tables present selections summarizing conservation as seen by the International Committee for Conservation of the International Council of Museums (ICOM), the European Confederation of Conservator-Restorers' Organizations (ECCO), and in the conservation *Codes of Ethics and Guidelines for Practice* in Canada, New Zealand, the United States, and the United Kingdom.

The Codes referred to are: the 1989 *Code of Ethics and Guidance for Practice for Those Involved in the Conservation of Cultural Property in Canada*, published by the (then) International Institute for Conservation-Canadian Group (IIC-CG) and the Canadian Association of Professional Conservators (CAPC); the 1999 proposed changes to and the year 2000 third edition of that code, *Code of Ethics and Guidance for Practice*, now published by the CAC (Canadian Association for Conservation of Cultural Property)/CAPC; the *Code of Ethics and Guidelines for Practice* published in 1994 by the American Institute for Conservation (AIC); *The NZPCG Code of Ethics*, published in 1991 by the New Zealand Professional Conservators Group, and revised in 1995; the *Guidance for Conservation Practice* published in 1981 by the United Kingdom Institute for Conservation of Historic and Artistic Works (UKIC), and their 1996 *Code of Ethics;* and the 1993 *Professional Guidelines and Code of Ethics* from the European Confederation of Conservator-Restorers' Organizations (ECCO). In addition, reference is made to international guidelines found in *The Conservator-Restorer: A Definition of the Profession* from the International Council of Museums (ICOM 1984). The codes of ethics specifically for conservators are also compared with the International Council on Monuments and Sites (ICOMOS) New Zealand Charter for the Conservation of Places of Cultural Heritage Value (ICOMOS 1993).

For reference purposes, in the tables below, the publications are identified by publisher. In addition to the page number, I have included, when possible, the section in which the quotation appears.

Abbreviations

IIC-CG/CAPC 1989	*Code of Ethics and Guidance for Practice for Those Involved in the Conservation of Cultural Property in Canada*
CAC/CAPC, proposed changes 1999; and CAC/CAPC 2000	Proposed changes to *Code of Ethics and Guidance for Practice*, and the third edition of that code, published in 2000.
AIC 1994	*Code of Ethics and Guidelines for Practice*
NZPCG 1995	*The NZPCG Code of Ethics*, published in 1991 by the New Zealand Professional Conservators Group, and revised in 1995
UKIC 1981	*Guidance for Conservation Practice*
UKIC 1996	*Code of Ethics*
ECCO 1993	*Professional Guidelines and Code of Ethics*
ICOM 1984	*The Conservator-Restorer: A Definition of the Profession*
ICOMOS-NZ 1993	ICOMOS New Zealand, *Charter for the Conservation of Places of Cultural Heritage Value*

Country	Definition of conservation	Purpose of conservation
Canada	"All actions aimed at the safeguarding of cultural property for the future" (IIC-CG/CAPC 1989, Glossary, p. 18).	"To study, record, retain and restore the culturally significant qualities of the object with the least possible intervention" (IIC-CG/CAPC 1989, Glossary, p. 18). In 2000, "object" has been changed to "cultural property." After "significant qualities of the cultural property" has been added "as embodied in its physical and chemical nature" to distinguish the role of a conservator from that of a religious or ceremonial leader, "who may consider he/she is retaining or restoring culturally significant qualities of an object by performing certain rituals" (CAC/CAPC proposed changes 1999; CAC/CAPC 2000).
USA		"The preservation of cultural property" (AIC 1994, Preamble, p. 1).
United Kingdom	"Conservation is the means by which the *original and true nature* of an object is maintained" (UKIC 1981, p. 1). "Conservation: all actions aimed at the safeguarding of cultural property for the future, including interpretation" (UKIC 1996, Glossary).	"The fundamental role of each member [of UKIC] is the preservation of cultural property for the benefit of present and future generations but without losing sight of the role or purpose of the cultural property" (UKIC 1996, General Guidelines).
New Zealand (NZPCG)	"All actions taken to recognise, prevent and retard the loss or deterioration of cultural property" (NZPCG 1995, p. 8).	"Conservation safeguards cultural property for the future" (NZPCG 1995, p. 6).

	"Action taken to prevent or remedy the damage and deterioration of items of cultural significance" (NZPCG 1995, p. 6).	"Conservation is the means by which the true nature of an object is preserved" (NZPCG 1995, p. 9).
	"Conservation is the means by which the true nature of an object is preserved" (NZPCG 1995, p. 6).	
New Zealand (ICOMOS-NZ 1993)	"Conservation means the processes of caring for a place so as to safeguard its cultural heritage value" (ICOMOS-NZ 1993, p.4).	"The purpose of conservation is to care for places of cultural heritage value, their structures, materials and cultural meaning" (ICOMOS-NZ 1993, p.1).
ECCO	"Preservation of the cultural object as far as it is compatible with its social use"(ECCO 1993, 1.1.a).	"The preservation of cultural objects for the benefit of present and future generations" (ECCO 1993, 1.1).
International (ICOM)	"Preservation is action taken to retard or prevent deterioration of or damage to cultural properties" (ICOM 1984, Sec. 2.1).	"To maintain them as nearly as possible in an unchanging state" (ICOM 1984, Sec. 2.1).

Country	Included in conservation	Not included in conservation
Canada	"Examination, documentation, preventive conservation, preservation, restoration, reconstruction"[1] (IIC-CG/CAPC 1989, Glossary, p. 18). "Treatment" explicitly added in 2000. (CAC/CAPC 2000, Glossary, p. 13)	Research on the meaning of objects not mentioned (IIC-CG/ CAPC 1989). In 1999, the review committee addressed research, "to recognize the role it plays in safeguarding cultural heritage" (CAC/ CAPC 1999, Glossary, definition of Conservation). In 2000 it appears not as part of the definition of conservation, but in III of the code, on excellence.
USA	"In all aspects of conservation, including, but not limited to, preventive conservation, examination, documentation, treatment, research, and education" (AIC 1994, I, p. 1).	"Including, but not limited to ..." (Domains of research not defined.)
UK	[throughout code]	
New Zealand (NZPCG)	"Assessment, preventive measures, treatments, restoration" (NZPCG 1995, Services, p. 7).	
New Zealand (ICOMOS)	"May involve, in increasing extent of intervention: non-intervention, maintenance, stabilisation, repair, restoration, reconstruction or adaptation" (ICOMOS-NZ 1993, p. 2). "The conservation of places of indigenous cultural heritage value therefore is conditional on decisions made in the indigenous community, and should proceed only in this context" (ICOM OS-NZ 1993, p. 1).	
ECCO	"Diagnostic examination, conservation and restoration treatments" (ECCO 1993, I.1.a). Preventive and remedial conservation (ECCO 1993, I.1.a and I.1.b). Also: surveys, advice, technical reports, research relating to conservation-restoration, education, disseminating information (ECCO 1993, 1.1, "Competence").	
International (ICOM)	"Retard or prevent deterioration ... by control of their environment and/or treatment of their structure. All interventions must be preceded by a methodical and scientific examination aimed at understanding the object in all its aspects" (ICOM 1984, Sec. 3.5).	

[1] Definitions for each of these terms is given in the Glossary on pp. 18-19 of the Canadian *Code of Ethics* (IIC-CG/CAPC 1989).

Regarding the objects:

Country	Responsibility to owner	Responsibility to originator	Responsibility to others
Canada	"The care and treatment of a cultural property is the shared responsibility of the owner and the conservator" (IIC-CG/CAPC 1989, p. 9). "Is the shared responsibility of the owner, the conservation professional, and when applicable, the originator" (CAC/CAPC 2000, p. 5). The owner is either: 1. the person(s) having legal owner-ship of the cultural property,* 2. the person(s), such as the museum director, curator, archivist or librarian, exercising professional custodianship over a cultural property. (IIC-CG/CAPC 1989, Glossary, definition of Owner; CAAC/CAPC 2000) * in 1999, "or his/her authorized agent" added here.	"The conservator shall endeavour to understand the intention of the originator in creating or using a cultural property, and take this into consideration in the conservation of the cultural property" (IIC-CG/CAPC 1989, p. 9). See revision in 2000 in adjacent column. In 1999, the phrase "when legally or morally applicable" was under consideration. "Wherever relevant and possible, the conservator should consult with the originator regarding a proposed treatment" (IIC-CG/CAPC 1989, p. 10, "Examination"). The originator is either: 1. the person(s) who designed or created the cultural property, or 2. the person(s) representing the creator or designer of the cultural property by legal, moral or spiritual right. (IIC-CG/CAPC 1989, Glossary, definition of Originator; CAAC/CAPC 2000)	— — — —

▼ Regarding the objects:

Country	Responsibility to owner	Responsibility to originator	Responsibility to others
USA	Relationship of conservator to owner outlined in AIC 1994 (pp. 2-4) "Owner, custodian or agent" is term used.	"All actions of the conservation professional must be governed by an informed respect for the cultural property ... and the people or person who created it" (AIC 1994, II, p. 1).	—
New Zealand	"The opinions, wishes and views of the owner, custodian or other responsible person must be fully acknowledged and considered" (NZPCG 1995, p. 10). Relationship with owner further delineated in NZPCG 1995 (Sec. 5.1).	—	—
United Kingdom	Relationship with owner or custodian: "It is the responsibility of the conservator, as the person with the necessary technical knowledge, to uphold the best interests of the object, and to advise truthfully as to the best course of treatment" (UKIC 1981, "Professional Relations").	—	The conservator has responsibilities to colleagues, trainees, to the public, to the conservation profession and to posterity (UKIC 1981). "Shared responsibility of the client and the conservator-restorer, who have to balance the requirements for preservation against the need to use, understand, or appreciate the items" (UKIC 1996, General Guidelines).
ECCO	(Inform fully, confidentiality) (ECCO 1993, II.3).	Noted in Preamble (ECCO 1993).	Colleagues, the profession, the public, posterity (ECCO 1993, Preamble, II.4).
International (ICOM)	"Concern for professional ethics and standards for the objects being treated, and for the owners of these objects ... has led to ... attempts to define the profession" (ICOM 1984, Sec. 1.3).	—	—

Regarding the ideas pertaining to objects of:

Country	Cultural significance	Respect	Integrity
Canada	"The purpose of conservation is to study, record, retain and restore the culturally significant qualities of the object with the least possible intervention" (IIC-CG/CAPC 1989, Glossary, p. 18). "Cultural property: Objects that are judged by society to be of particular historical, artistic or scientific importance" (incl. moveable and immovable) (IIC-CG/CAPC 1989, Glossary, p. 18). In 1999 committee considered whether "aesthetic," "religious," or "social" importance should be added to above sentence. 2000: "Objects that are judged by society, or by some of its members, to be of historical, artistic, social or scientific importance" (CAC/CAPC 2000).	"All actions of the conservator must be governed by a respect for the integrity of the cultural property, including physical, historical, conceptual and aesthetic considerations" (IIC-CG/CAPC 1989, p. 5). In 2000 "informed" added before respect. See adjacent column, "integrity."	"Integrity of the cultural property, including physical, historical, conceptual and aesthetic considerations" (IIC-CG/CAPC 1989, p. 5). *Respect for the Integrity of the Cultural Property:* "When conserving a cultural property, the conservation professional shall respect the integrity of the cultural property by endeavouring to preserve its material composition and culturally significant qualities through minimal intervention. The original intention, usage, history and evidence of provenance of the property shall be based upon the study of the cult ppty and on consultations with the owner, and, when applicable, the originator. When relevant, other authorities or documentary sources should be consulted" (CAC/CAPC 2000, 3, p. 5).
USA	"Cultural property ... is material which has significance that may be artistic, historic, scientific, religious or social" (AIC 1994, Preamble, p. 1).	"All actions of the conservation professional must be governed by an informed respect for the cultural property, its unique character and significance" (AIC 1994, II, p.1).	"Integrity" difficult to define or explain (*AIC News*, Supplement 3, January 1992); deleted in AIC 1994 code. "Unique character and significance" (AIC 1994, II, p.1). "Treatment that is judged suitable to the preservation of the aesthetic, conceptual and physical characteristics of the cultural property" (AIC 1994, p. 3, "Treatment"; see also ibid., "Compensation for Loss").

▼ Regarding the ideas pertaining to objects of:

Country	Cultural significance	Respect	Integrity
New Zealand (NZPCG)	"Cultural Property: All objects which have aesthetic, archaeological, historic, scientific, technological, social or spiritual value for any generation" (NZPCG 1995, p. 8).		"The true nature of an object includes evidence of its origins, its original construction and materials, information as to the technology used in its manufacture, and the cultural significance of the object" (NZPCG 1995, pp. 9-10).
United Kingdom	"It is the responsibility of the conservator, as the person with the necessary technical knowledge, to uphold the best interests of the object" (UKIC 1981, "Relationthip's-owner"). "Cultural property: includes all types of works which are judged by society to be of cultural, aesthetic, artistic, historic or scientific value." (Then details two categories, movable and immovable) (UKIC 1996, Glossary).	"All professional actions of the conservator are governed by total respect for the physical, historic, and aesthetic integrity of the object" (UKIC 1981, Conservation and Object). "Show respect for human remains and cultural property which has a ritual or religious significance. He/she should be cognisant of any special requirements, whether legal or social, of such material" (UKIC 1996, 1.1.7)	"Total respect for the physical, historic, and aesthetic integrity of the object" (UKIC 1981, "Conservation and Object"). "The true nature of an object includes evidence of its origins, its original construction, the materials of which it is composed, and information which it may embody as to its makers intentions and the technology used in its manufacture" (UKIC 1981, "Purpose of Conservation"). In 1996, "true nature" not included.
ECCO	"The objects to which society attributes a particular artistic, historic, documentary, aesthetic, scientific, spiritual or religious value are ... cultural property" (ECCO 1993, I.1).		"The Conservator-Restorer contributes to the understanding of the aesthetic, historic and physical integrity of these objects" (ECCO 1993, I.1).
International (ICOM)	"The objects are a significant expression of the spiritual, religious and artistic life of the past" (ICOM 1984, Sec. 3.1).	"Each object contains ... historic, stylistic, iconographic, technological, intellectual, aesthetic and/or spiritual messages and data. The conservator-restorer should be sensitive to them, be able to recognize their nature, and be guided by them in performing his task (ICOM 1984, Sec. 3.4).	"The documentary quality of the historic object is the basis for research in art history, ethnography, archaeology and in other scientifically-based disciplines. Hence the importance of preserving their physical integrity" (ICOM 1984, Sec. 3.2).

Regarding ideas pertaining to the physical preservation and use of the object

Country	Preservation	Use
Canada	Conservation is defined as "all actions aimed at the safeguarding of cultural property for the future" (IIC-CG/CAPC 1989 Glossary; CAC/CAPC 2000). Preservation also defined in 1989. "'Preservation': All actions taken to retard deterioration of, or prevent damage to, cultural property ... in order to maintain [it], as nearly as possible, in a stable physical condition." (CAC/CAPC 2000, Glossary). "Physical" added to acknowledge that the meaning of objects may change over time.	"It is the responsibility of the conservator, acting alone or with others, to strive constantly to maintain a balance between the need of society to use a cultural property, and the preservation of that cultural property" (IIC-CG/CAPC 1989, p. 5). In 1999, "need of society" changed to "in society," to both include society in the global sense and to recognize minority cultures. "To strive constantly to maintain a balance between the need in society to use a cultural property, and to ensure the preservation of that cultural property" (CAC/CAPC 2000, I, p. 1). "Preservation involves management of the environment and of the conditions of use" (CAC/CAPC 2000, Glossary, definition of Preservation).
USA	"[Cultural property] is an invaluable and irreplaceable legacy that must be preserved for future generations" (AIC 1994, Preamble, p. 1). "The conservation professional shall serve as an advocate for the preservation of cultural property" (AIC 1994, III, p. 1).	"While recognizing the right of society to make appropriate and respectful use of cultural property, the conservation professional shall serve as an advocate for the preservation of cultural property" (AIC 1994, III, p.1).
New Zealand (NZPCG)	"The first responsibility of the conservator is to the object and its long-term preservation" (NZPCG 1995, p. 9).	
United Kingdom	"Concern for its future should include protection against damage and loss" (UKIC 1981, Conservation and Object). 1996: cf: "Purpose of Conservation"	"Give advice on the continuing use and care of the cultural property" in definition of Object maintenance (UKIC 1996, 1.1.8).
ECCO	Cultural property "constitutes a material and cultural heritage to be passed on to forthcoming generations," and is "entrusted to the care of the Conservator-Restorer" (ECCO 1993, I.1).	Social use recognized in def. of Preventive Conservation; "preservation as far as is compatible with social use" (ECCO 1993, I.1.a).

There are further principles of conservation practice common in the codes and guidelines, and these may be summarized as follows:

1 Single standard of treatment regardless of value or quality of object: the conservator must adhere to the highest standards of conservation practice (quality of work, not extent of treatment) with every object conserved.
2 Treatment and materials used must be suitable to the object.
3 ,Techniques and materials used should be reversible.
4 The object must be examined before any intervention or recommendation.
5 Methods and materials must be documented.
6 Guidelines for ethical relationships with, and responsibility for, colleagues, trainees, subcontractors, the public, and the profession as a whole must be followed.
7 Modification or concealment of original physical nature of object is unethical.
8 Conservators must act within the limits of their individual professional competencies.
9 Conservators must share knowledge about techniques or materials.
10 Based on the best current knowledge, methods and materials must not adversely affect the object.
11 Conservators must recognize the importance of preventive conservation.
12 Conservators must use safety measures to minimize risk to people and the environment (from chemicals used in treatments, for example).
13 Additional ethical guidelines for interpretation (e.g., authenticity), sampling, testing, and scientific analysis should be followed.
14 Compensation for loss must be detectable within guidelines and documented.
15 Conservators must be prepared for emergency situations and respond according to current guidelines.
16 Conservators must observe guidelines when determining extent of treatment, and recognize that doing nothing may be best.

Appendix C
Glossary of Maori Terms

ahi ka	home fires
hapu	sub-tribe
Hei tiki	pendants made of pounamu, greenstone, or nephrite, and passed down generation to generation
iwi	tribe, nation, people
kaitiaki	guardian
karakia	prayers
kaumatua	elder knowledgable in Maori protocols and culture
koiwi tangata	bones of the people
mana	power
marae	ritual area, especially the enclosed space in front of a meeting house
mauri	life force of an object
mere	short flat weapon, often made of stone
nga toi moko	tattooed, preserved heads; refers to the dignity of these ancestors through the concepts of facial carving as a reverent and spiritual art form (Tamarapa 1996, 168)
pa	secure village of the hapu, often fortified or strategically situated
Pakeha	people of European descent
Papatuanuku	the land, "mother earth," Aotearoa/New Zealand
pataka	storehouse
taha wairua	spiritual force
tangata whenua	first people of the land
tangi	to cry; in the context used in this book, it means funeral
tapu	taboo
taonga	treasure
Te Hau Ki Turanga	meeting house from the Rongowhakaata people housed in the National Museum of New Zealand Te Papa Tongarewa in Wellington
tiki	see Hei tiki above
tukutuku	panel on the inner wall of a meeting house, made of dyed, woven plant material
waka	canoe
waka tupapaku	burial chests
whakapapa	genealogy, lineage
whare	house, meeting house

Internet Resources

The following pages contain a listing of the Web addresses of First Nations organizations and addresses related to First Nations issues mentioned in this book. This section is devoted primarily to resources found on the Internet that were developed by and for First Nations. As this "Internet Bibliography" will grow and change with time, and undoubtedly quite quickly, the reader is encouraged to use this list both as a resource and as a base for searching new or different addresses. In addition, the reader is encouraged to search for conservation and museum organizations, which are not included here.

First Nations Community Home Pages: Canada
Example of Web pages from Nations mentioned by those interviewed.

Kwakwaka'wakw
1 Kwakiutl Laich-Kwil-Tach K'ómoks Nations Treaty Society <www.island.net/~klntssoc>.
2 Namgis First Nation <www.namgis.bc.ca>.
3 U'mista Cultural Centre <www.umista.org>.

Salish
1 Squamish Nation Network <www.squamish.net/index.htm>.
2 Sliammon First Nation <www.prcn.org/sliammon/index/>.
3 Musqueam First Nation <www.musqueam.bc.ca/>.
4 Xá:Ytem Longhouse Interpretive Center <http://xaytem.museum.bc.ca/xaytem/index. htm>.

Gitksan
1 'Ksan Historical Village and Museum <www.ksan.org/>.
2 Office of the Gitanyow Hereditary Chiefs <www.gitanyowchiefs.bc.ca>.

Aboriginal Organizations (NB)
 http://www.gnb.ca/0016/organiza.htm
Canim Lake (BC)
 http://www.cariboolinks.com/ctc/canim/index.html
Canoe Creek (BC)
 http://www.cariboolinks.com/ctc/canoe/index.html
Carrier Sekani Tribal Council (BC)
 http://cstc.bc.ca
Chilcotin First Nations (BC)
 http://www.chilcotin.bc.ca/FirstNations

Columbia Lake Band (BC)
http://www.kktc.bc.ca/index.htm
Comanche Lodge
http://members.tripod.com/~Quohadi
Conne River MicMac (QU)
http://www.miawpukek.nf.ca
Cree Nation of Mistissini (QU)
http://nation.mistissini.qc.ca
Esket (Alkalie Lake Band) (BC)
http://www.esket.com
First Nations Communities in BC
http://www.aaf.gov.bc.ca/nations/nations.stm
First Nations Culture Links (BC)
http://vancouver.miningco.com/local/vancouver/msub21.htm
Goodfish Lake (AB)
http://ellesmere.ccm.emr.ca/ourhome/goodfish/english/about.html
Homalco First Nations (BC)
http://oberon.ark.com/~homalco/index.html
Ktunaxa Nation (BC)
http://www.kktc.bc.ca/index.htm
Listuguj First Nations (QU)
http://www.johnco.com/firstnat/listuguj.html
Lower Kootenay Band (BC)
http://www.kktc.bc.ca/index.htm
Nisga'a Schoolnet Site (BC)
http://www.schoolnet.ca/aboriginal/nisga1/index-e.html
Oneida Indian Nation
http://oneida-nation.net
Ouje-Bougoumou Cree (QU)
http://www.ouje.ca
Qualicum First Nation (BC)
http://www.qualicumfirstnation.com
Saddle Lake First Nation (AB)
http://ellesmere.ccm.emr.ca/ourhome/saddle/english/about.html
Secwepemc Nation (BC)
http://www.secwepemc.org
Shuswap Band (BC)
http://www.kktc.bc.ca/index.htm
Six Nations of Grand River
http://www.sixnations.org
Soda Creek (BC)
http://www.cariboolinks.com/ctc/soda/index.html
St. Mary's Band (BC)
http://www.kktc.bc.ca/index/htm
Tobacco Plains Band (BC)
http://www.kktc.bc.ca/index/htm
Tsi Del Del (Alexis Creek) (BC)
http://alexiscreekfirstnation.com
Tsilhqot'in National Gov't (BC)
http://www.firsnationtng.org/
Williams Lake (BC)
http://www.cariboolinks.com/ctc/williams/index.html
Xeni Gwet'in (Nemiah) (BC)
http://www.xenigwetin.com/

Museums and Cultural Education Centres: Canada
1 U'mista Cultural Centre <www.umista.org>.
2 First Nations Confederacy of Cultural Education Centres <www.schoolnet.ca/aboriginal/fnccec/index-e.html>.
3 First Nations Confederacy of Cultural Education Centres, Cultural Centre Contacts <www.schoolnet.ca/aboriginal/fnccec/centres_contacts.html>.
4 Secwepemc Museum and Native Heritage Park <www.secwepemc.org/museum.html>.
5 Manitoba Indian Cultural Education Centre <www.schoolnet.ca/aboriginal/micec/index-e.html>.
6 Saskatchewan Indian Cultural Centre <www.sicc.sk.ca/>.
7 Woodland Cultural Centre <www.woodland-centre.on.ca/index.html>.
8 Kanesatakehro:non Tsi Nihatweienno:ten Cultural Centre <www.schoolnet.ca/aboriginal/kanesata/>.

Canadian First Nations Organizations
1 Assembly of First Nations <www.afn.ca/>. This site includes the AFN paper *First Nations Messenger* and background information like *Resolution No. 36/99: Repatriation of First Nation Cultural Property* <www.afn.ca/resolutions/1999/aga%20resolutions%201999/res36.ht>.
2 Assembly of Manitoba Chiefs <www.mbchiefs.mb.ca/>.
3 Chiefs of Ontario <www.chiefs-of-ontario.org/>.
4 Federation of Saskatchewan Indians <www.fsin.com/>.
5 Grand Council of Crees <www.gcc.ca/>.
6 Treaty 7 Tribal Council <www.treaty7.org/>.
7 Innu Nation – Mamit <www.innu.ca/>.
8 Union of New Brunswick Indians <www.unbi.org>.
9 Union of BC Indian Chiefs <www.ubcic.bc.ca>. This site includes a timeline of events in BC First Nations history, an on-line finding aid for National Archives Aboriginal (RG-10) records, a links page, and information/transcripts relating to UBCIC conferences.
10 National Aboriginal Document Database <www.landclaimsdocs.com>. Six Nations Geo Systems developed this site, which contains links to statutes/acts, court decisions, treaties, and surrenders.
11 Bill's Aboriginal Links <www.bloorstreet.com/300block/aborl.htm> This site contains links to Canadian, US, and international Aboriginal sites and is very useful despite the fact that it may not have been updated recently and there may be dead links. It should be noted that there is a sizeable amount of legal information on this site that details different court decisions in simple language.
12 First Peoples on Schoolnet <www.schoolnet.ca/aboriginal>. The curriculum resources, cultural resources, and links on this site are particularly useful.

Canadian Government Sites
1 Indian and Northern Affairs Canada <www.inac.gc.ca/>. This searchable site provides information on national Aboriginal issues. It contains news releases from 1995 to 1999 relating to Indian and Northern Affairs activities, background on treaties and claims, First Nation profiles, and information on National Aboriginal Day.
2 Canadian Heritage <www.pch.gc.ca/>.
3 The Final Report of the *Royal Commission on Aboriginal Peoples* <www.ainc.inac.gc.ca/ch/rcap/index_e.html> brings together six years of research and public consultation on Aboriginal issues. This website makes the entire 3,200-page report accessible through on-line search features and download capabilities. <www.indigenous.bc.ca./rcap.htm>
4 Ministry of Aboriginal Affairs <www.aaf.gov.bc.ca/aaf/>. The Ministry of Aboriginal Affairs for the Province of British Columbia contains information similar to the Indian and Northern Affairs site, but with a BC focus. It contains First Nation profiles, news releases, information on treaty negotiations, and a timeline of events (starting with the Royal Proclamation of 1763 and ending with the Delgamuuk'w Decision of 1997).

5 Ministry of Small Business, Tourism and Culture, Archaeology Branch, Province of British Columbia <www.archaeology.gov.bc.ca/>.
6 Ministry of Forests, Aboriginal Affairs Branch, Province of British Columbia <www.for.gov.bc.ca/aab/aab.htm>.
7 Nova Scotia Aboriginal Affairs <www.gov.ns.ca/prio/abo>.
8 New Brunswick Intergovernmental and Aboriginal Affairs <www.gnb.ca/0016 index_e.htm>.
9 Secrétariat aux affaires autochtones (QC) <www.mce.gouv.qc.ca/w/html/w0428003. html>.
10 Ontario Native Affairs Secretariat <www.nativeaffairs.jus.gov.on.ca/english/onas.htm>.
11 Saskatchewan Intergovernmental and Aboriginal Affairs <www.gov.sk.ca/govt/IGAA>.
12 Alberta Intergovernmental and Aboriginal Affairs <www.aand.gov.ab.ca/>.
13 Nunuvut Territory Government Website <www.nunavut.com>).
14 Northwest Territories Government Website <www.gov.nt.ca/research/departments/ index.html>.
15 Yukon Government Website <www.gov.yk.ca/>.

Treaty Negotiations
1 British Columbia Treaty Commission <www.bctreaty.net/>.
2 Indian and Northern Affairs Canada, Treaty Negotiations <www.ainc-inac.gc.ca/pr/ agr>.
3 Ministry of Aboriginal Affairs, Province of British Columbia, Treaty Negotiations <www.aaf.gov.bc.ca/aaf/treaty/treaty.htm>.
4 Nisga'a Tribal Council <www.ntc.bc.ca/>.
5 Indian and Northern Affairs Canada, Nisga'a Treaty <www.ainc-inac.gc.ca/pr/agr/ nsga/index_e.html>.
6 Ministry of Aboriginal Affairs, Province of British Columbia, Nisga'a Treaty <www. aaf.gov.bc.ca/aaf/treaty/nisgaa/nisgaa.htm>.
7 Sechelt Agreement-in-Principle, 16 April 1999 <www.aaf.gov.bc.ca/aaf/nations/ sechelt/secheltaip199.htm>.
8 The Union of British Columbia Municipalities, Aboriginal Affairs Office <www. civicnet.gov.bc.ca/ubcm/aboriginal/index.shtml>.
9 Nunavut Planning Commission <http://npc.nunavut.ca/>.

Repatriation (United States)
1 In response to the Native American Graves Protection and Repatriation Act (NAGPRA), the *U.S. National Park Service,* Archeology and Ethnography Program website <www.cr.nps.gov/nagpra.htm> states the following:
 (a) has completed summaries and inventories of Native American human remains and cultural items in its collections and has notified culturally affiliated Indian tribes and Native Hawaiian organizations;
 (b) is consulting with affiliated Indian tribes regarding planned excavations and inadvertent discoveries on NPS lands. Native American human remains and cultural items will, upon request, be repatriated to the affiliated tribe or organization;
 (c) is acting on behalf of the Secretary of the Interior in preparing regulations, providing staff support to the Native American Graves Protection and Repatriation Review Committee, administering grants to assist museums and Indian tribes in implementing the statute, assessing civil penalties on museums that fail to comply with the statute, and providing training and technical assistance to all affected parties.
2 *American Indian Ritual Object Repatriation Foundation* is "a non-federally funded intercultural partnership committed to assisting in the return of sacred ceremonial material to the appropriate American Indian Nation, clan, or family, and to educating the public about the importance of repatriation" <www.repatriationfoundation.org/>.

3 The (US)*National Museum of Natural History* established its Repatriation Office <www.nmnh.si.edu/departments/anthro.html/repatriation/> in the Department of Anthropology in the fall of 1991 to carry out the repatriation provisions of the National Museum of the American Indian Act (NMAI Act). Repatriation at the museum involves a collaborative process in which museum staff work with tribal representatives to determine the disposition of human remains and cultural objects under the law.

4 *Native American Repatriation and Reburial: A Bibliography.* Compiled by Barb Bocek, Stanford Archaeologist <www-sul.stanford.edu/depts/ssrg/native/appf.html>.

5 *Brian Gill Bibliography: 10/95* <www.geocities.com/CapitolHill/3207/repat/html>. This bibliography was accumulated as a research project dealing with the repatriation issue faced by Native Americans.

Maori: New Zealand

1 Te Puna Web Directory <http://tepuna.natlib.govt.nz/web_directory/>

2 Maori Law Review <www.kennett.co.nz/maorilaw/>.

3 The Waitangi Tribunal Reports Database <www.knowledge-basket.co.nz/waitangi/welcome.html>.

Further International Links

Australia

1 Aboriginal and Torres Strait Islander Commission <www.atsic.gov.au/default_ns.asp>.

2 Our Culture: Our Future – Report on Australian Indigenous Cultural and Intellectual Property Rights <http://icip.lawnet.com.au/frontpage.html>.

3 Journal of Australian Indigenous Issues <www.qut.edu.au/chan/oodgeroo/journal.htm>.

Americas

1 Socioambiental <www.socioambiental.org/website/english/index.html>.

2 Museu do Indio <www.museudoindio.org.br/>.

Europe

1 An Introduction to the Sami People <www.itv.se/boreale/samieng.htm>.

2 Samefolket <www.samefolket.se/eng/index.asp>.

Asia

1 The Ainu Information Link <www4.plala.or.jp/nekoneko/english.html>.

2 The Foundation for Research and Promotion of Ainu Culture <www.frpac.or.jp/english/e_index.html>.

Bibliography

Anon. (1906). "Picture Restoration." *Museums Journal* 6 (3): 114-6.

Anon. (1990). "Twenty Scientific Attitudes." *Rational Enquirer* 3, 3: 5, 9.

Anon. (1991). "The Hands of Mistaken Zeal." *TIGHAR Tracks: A Publication of the International Group for Historic Aircraft Recovery* 7 (1): 1.

Anon. (1993a). "Editorial." *Studies in Conservation* 38 (1): 1.

Anon. (1993b). "Historical Note." *List of Members, International Institute for Conservation, 1993-4.* 3-4.

Anon. (1993c). "The Resurrection of Holy Russia." *The Economist*, 23 October 1993, 109-10.

Abbott, A.A. (1988). *Professional Choices: Values at Work*. Silver Spring, MD: National Association of Social Workers

Alexander, E. (1979). *Museums in Motion*. Nashville, TN: American Association for State and Local History.

Alexie, S. (1992). "Evolution." In *The Business of Fancydancing*, 48. Brooklyn, NY: Hanging Loose Press.

American Institute for Conservation. (1991a). "Ethics and Standards Committee Supplement No. 1." *AIC News*, September.

–. (1991b). "Ethics and Standards Committee Supplement No. 2." *AIC News*, November.

–. (1992a). "Ethics and Standards Committee Supplement No. 3." *AIC News*, January.

–. (1992b). "Ethics and Standards Committee Supplement No. 4." *AIC News*, March.

–. (1993). "Code of Ethics and Standards of Practice." *Directory*. 21-34. Washington: American Institute for Conservation.

–. (1994). *Code of Ethics and Guidelines for Practice*. American Institute for Conservation, 29 June (mailing to members for ratification).

–. (1995). "Code of Ethics and Guidelines for Practice." *Directory*. 21-8. Washington: American Institute for Conservation.

Ames, M.M. (1990). "Biculturalism in Exhibits." *Taonga Maori Conference, 18-27 November 1990*. Cultural Conservation Advisory Council, Wellington, NZ, Department of Internal Affairs Te Tari Taiwhenua, 27-39.

–. (1992a). "Art and the Popular Discontents of Post-Modern Society." Notes for Opening Address to "Art and Audience: Session No. 2, Responsibilities of Institutions to the Community." Winnipeg Art Gallery and Western Canadian Art Association meeting, Winnipeg, 21 March.

–. (1992b). *Cannibal Tours and Glass Boxes: The Anthropology of Museums*. Vancouver: UBC Press.

–. (1993). "The Nature of Numinosity and Its Museological Reconstruction." UBC Museum of Anthropology, 3 February 1993 (notes for a paper to be presented to the panel "Working the Numinous: Giving the Museum Object its Aura," College Art Association Annual Meeting, Seattle, 6 February 1993).

–. (1993-4). "What Happens When the Object Becomes the Subject?" *Harbour* 3 (1): 63-5.

–. (1994). "The Politics of Difference: Other Voices in a Not Yet Post-Colonial World." *Museum Anthropology* 18 (3): 9-17.

Ames, M.M., J. Harrison, and T. Nicks. (1987). "Proposed Museum Policies for Ethnological Collections and the Peoples They Represent." *MUSE* 6 (3): 45-7.

Anderson, C. (1990). "Australian Aborigines and Museums: A New Relationship." *Curator* 33 (3): 165-79.

Anderson, M.S. (1995). "People of Salmon and Cedar: An Overview of the Northwest Coast." In *Native Peoples: The Canadian Experience* (2nd ed.), ed. R.B. Morrison and C.R. Wilson, 547-55. Toronto: McClelland and Stewart.

Anderson, T. (1910). "The Decay of Stone Antiquities," *Museums Journal* 10 (4): 100-6.

Appelbaum, B. (1991). *Guide to Environmental Protection of Collections*. Madison, CT: Sound View Press.

Argan, G.C. (1968). "Art: Art Criticism and Art Theory," In *Encyclopedia of World Art*, 810. New York: McGraw-Hill.

Ashley-Smith, J. (1982). "The Ethics of Conservation." *The Conservator* (United Kingdom Institute for Conservation) 6: 1-5.

–. (1986). "Individual Responsibility in Ethical Conservation." In *New Directions in Paper Conservation: 10th Anniversary Conference of the Institute of Paper Conservation*, D34 (summary only). Leigh, The Institute.

–. (1994). "A Consistent Approach to a Mixed Collection." *Restoration: Is It Acceptable* (Conference and Preprint Title). Conference at the British Museum, 24-25 November 1994, outline of oral presentation (different from published preprints).

–. (1995). "Definitions of Damage." Text of a paper given in the session "When Conservator and Collections Meet" at the Annual Meeting of the Association of Art Historians, London, 7-8 April 1995.

Atleo, R. (1990). "Policy Development for Museums: A First Nations Perspective." Policy research paper, Vancouver, UBC Museum of Anthropology.

Australian Institute for the Conservation of Cultural Materials (AICCM). (1999). "Code of Ethics and Code of Practice." Canberra: AICCM.

Barclay, M. (1989). "Some Thoughts on Conservation and Contemporary Art at the National Gallery of Canada." *Journal of the International Institute for Conservation-Canadian Group* 14: 23-31.

–. (1990). "An Art Gallery Conservator: Roles and Responsibilities." In *Shared Responsibility: Proceedings of a Seminar for Curators and Conservators, Oct. 26-28, 1989, National Gallery of Canada*, ed. B.A. Ramsay-Jolicoeur and I.N.M. Wainwright, 24-9. Ottawa: National Gallery of Canada.

Barnes, B. (1993). "The Co-operative Role of Native Cultural Centres and Museums." In *First Peoples Art and Artifacts: Heritage and Conservation Issues. Eighteenth Annual Conference, Art Conservation Training Programs*, ed. K. Spirydowicz, 1-4. Kingston, ON: Queen's University, Art Conservation Program.

Bedard, J. (1993). Comments at National Workshop on the History of Aboriginal Peoples in Canada, Canadian Museum of Civilization, 22-23 January 1993.

Bell, C. (1992a). "Aboriginal Claims to Cultural Property in Canada: A Legal Analysis of the Repatriation Debate." *American Indian Law Review* 17 (2): 457-521.

–. (1992b). *Reflections on the New Relationship: Comments on the Task Force Guidelines for Repatriation*. CMA Symposium package, Canadian Museums Association Legal Affairs and Management Symposium, Ottawa, 55-84.

Bernstein, B. (1991). "Repatriation and Collaboration: The Museum of New Mexico." *Museum Anthropology* (Council for Museum Anthropology) 15 (3): 19-21.

–. (1992). "Collaborative Strategies for the Preservation of North American Indian Material Culture." *Journal of the American Institute for Conservation* 31 (1): 23-9.

Bomford, D. (1994a). "Changing Taste in the Restoration of Paintings." In *Restoration: Is It Acceptable?* (Occasional Paper Series, no. 99), ed. A. Oddy, 33-40. London: British Museum.

– (1994b). "Conservation and Controversy." *Bulletin* (International Institute for Conservation) 2: 3-4.

Bonelli, R. (1968). "Restoration and Conservation." In *Encyclopedia of World Art*. 180-201. New York: McGraw-Hill.

Bowditch, J. (1991). "Motion: The Soul of the Machine." In *Risks and Rewards: Perspectives on Operating Mechanical Artifacts* (publication of a workshop held on 22 February 1991), ed. M.G. Mapes, 3-13. Wilmington, DE: Hagley Museum and Library.

Bowdler, S. (1988). "Repainting Australian Rock Art." *Antiquity* 62 (237): 517-23.

Boyd, R. (1999). *The Coming of the Spirit of Pestilence: Introduced Infectious Diseases and Population Decline among Northwest Coast Indians, 1774-1874*. Vancouver: UBC Press.

Branche, W. (1995). "Indigenes in Charge: Are Museums Ready?" In *Curatorship: Indigenous Perspectives in Post-Colonial Societies: Proceedings*, 119-31. Ottawa: Canadian Museum of Civilization with the Commonwealth Association of Museums and the University of Victoria, 1994.

Brinch Madsen, H. (1987). "Artefact Conservation in Denmark at the Beginning of the Last Century." In *Recent Advances in the Conservation and Analysis of Artifacts*, ed. J. Black, 343-5. London: Summer Schools Press.

British Association for the Advancement of Science (BAAS). (1922). "The Presidential Address." *Report of the Eighty-Ninth Meeting, Edinburgh, 7-14 September 1921*. By Sir Edward Thorpe. London: British Association for the Advancement of Science.

–. (1924). "The Presidential Address – The Electrical Structure of Matter." *Report of the Ninety-First Meeting, Liverpool, 12-19 September 1923*. By Sir Ernest Rutherford. London: British Association for the Advancement of Science.

–. (1926). "The Presidential Address." *Report of the Ninety-Third Meeting, Southampton, 26 August-2 September 1925*. By Prof. Horace Lamb. London: British Association for the Advancement of Science.

–. (1927). "The Presidential Address." *Report of the Ninety-Fourth Meeting, Oxford, 4-11 August 1926*. By HRH Prince of Wales. London: British Association for the Advancement of Science.

–. (1929). "The Presidential Address – Craftmanship and Science." *Report of the Ninety-Sixth Meeting, Glasgow, 5-12 September 1928*. By Prof. Sir William Bragg. London: British Association for the Advancement of Science.

–. (1932). "The Presidential Address – The Scientific World-Picture of To-Day." *Report of the Centenary Meeting, London, 23-30 September 1931*. By Gen. the Rt. Hon. J.C. Smuts. London: British Association for the Advancement of Science.

BC Hydro. (1995a). "Myths and Misconceptions." *Talking Circle* (Aboriginal Relations Department, BC Hydro) 2 (3): 14-5.

–. (1995b). "The Power of Words." *Talking Circle* (Aboriginal Relations Department, BC Hydro) 2 (3): 8-9.

–. (1995c). "Some Key Historic Dates." *Talking Circle* (Aboriginal Relations Department, BC Hydro) 2 (3): 6-7.

British Columbia Treaty Commission. (1996). *Annual Report 1995-96*.

Brooks, H.B. (2000). *A Short History of IIC: Foundation and Development*. London: International Institute for Conservation of Historic and Artistic Works.

Brown, P. (1994). *First Nations of British Columbia* (map text). Vancouver: UBC Museum of Anthropology.

Burroughs, A. (1938). *Art Criticism from a Laboratory*. London: Allen and Unwin.

Cains, A. (1974). "New Attitudes to Conservation." In *New Directions in Bookbinding*, ed. P. Smith, 164-72. London: Studio Vista.

Caldararo, N.L. (1987). "An Outline History of Conservation in Archaeology and Anthropology as Presented through Its Publications." *Journal of the American Institute for Conservation* 26 (2): 85-104.

Calo, M.A. (1994). *Bernard Berenson and the Twentieth Century*. Philadelphia: Temple University Press.

Canadian Association for Conservation of Cultural Property (CAC). (1999). "Proposed CAC/CAPC Code of Ethics with Explanatory Notes." Review document distributed to committee members. Proposed code also published in CAC *Bulletin*, June 1999.

Canadian Association for Conservation of Cultural Property (CAC) and Canadian Association of Professional Conservators (CAPC). (2000). *Code of Ethics and Guidance for Practice*. 3rd ed. Ottawa: CAC and CAPC.

Canadian Museums Association. (1991). "Brief," prepared for the CMA Annual Conference, Hamilton, ON, June 1991.

Carlson, K.T. (1997). "First Contact: Smallpox." In *You Are Asked to Witness: The Sto:lo in Canada's Pacific Coast History*, ed. K.T. Carlson, 27-40. Chilliwack, BC: Sto:lo Heritage Trust.

Carlson, K.T., ed. (1997). *You Are Asked to Witness: The Sto:lo in Canada's Pacific Coast History*. Chilliwack, BC: Sto:lo Heritage Trust.

Carr-Saunders, A.M., and P.A. Wilson. (1966a). "Professionalization and Technological Change." In *Professionalization*, ed. H. Vollmer and D.L. Mills, 21-7. Englewood Cliffs, NJ: Prentice-Hall.

–. (1966b). "Professionalization in Historical Perspective." In *Professionalization*, ed. H. Vollmer and D.L. Mills, 2-9. Englewood Cliffs, NJ: Prentice-Hall.

Caygill, M. (1981). *The Story of the British Museum*. London: British Museum Publications.

Cernetig, M. (1989). "Letting the Totem Poles Topple." *Vancouver Sun*, 2 December, D7.

Chipp, H.B. (1968). *Theories of Modern Art: A Source Book by Artists and Critics*. Berkeley: University of California Press.

Clavir, M. (1992). "IPAM: International Partnerships among Museums Report." *Report*. UBC Museum of Anthropology.

–. (1993). "The Conceptual Integrity of Conservation in Museums." The Per Guldbeck Memorial Lecture, *Bulletin*, International Institute for Conservation-Canadian Group, September, 1-2.

–. (1994). "Preserving Conceptual Integrity: Ethics and Theory in Preventive Conservation." In *Preventive Conservation Practice, Theory and Research: Preprints of the Contributions to the Ottawa Congress, 12-16 September 1994*, 15th IIC Congress, ed. R. Ashok and P. Smith, 53-7. London: International Institute for Conservation of Historic and Artistic Works.

–. (1995). "Conservation and the Current Museum Context." *New Zealand Museums Journal* 25 (1): 35-8.

–. (2001). "The Future of Ethnographic Conservation: A Canadian Perspective." In *Past Practice-Future Prospects* (Occasional Paper Series, no. 145), ed. A. Oddy and S. Smith. London: British Museum.

Claxton, A. (1994a). "Curatorship: Indigenous Perspectives." Essay written for course entitled "Curatorship: Indigenous Perspectives," May 1994, University of Victoria.

–. (1994b). "Deterioration of First Nations Artifacts." Class presentation and paper for course entitled "Curatorial Care of Artifacts," 30 November to 9 December 1994, University of Victoria.

–. (1994c). "Handling and Care of Cultural and Spiritual Objects." Essay written for course entitled "Curatorial Care of Artifacts," 30 November to 9 December 1994, University of Victoria.

Clifford, J. (1988). *The Predicament of Culture: Twentieth Century Ethnography, Literature, and Art*. Cambridge, MA: Harvard University Press.

–. (1990). "Four Northwest Coast Museums: Travel Reflections." In *Exhibiting Cultures: The Poetics and Politics of Museum Display*, ed. I. Karp and S. Lavine, 212-54. Washington: Smithsonian Institution Press.

Cole, D. (1996). *Captured Heritage: The Scramble for Northwest Coast Artifacts*. Vancouver: Douglas and McIntyre, 1985. Reprinted, Vancouver: UBC Press.

Commonwealth Association of Museums. (1994). "Curatorship: Indigenous Perspectives in Post-Colonial Societies." *CAM Newsletter* December, 1-4.

Copplestone, T. (1985). *Modern Art*. London: Deans International Publishing.

Coremans, P. (1969). "The Training of Restorers." In *Problems of Conservation in Museums: A Selection of Papers Presented to the Joint Meeting of the ICOM Committee for Museum Laboratories and the ICOM Committee for the Care of Paintings, Held in Washington and New York, Sept. 17-25, 1965*, 7-31. London: Allen and Unwin, for ICOM.

Corfield, M. (1988). "Towards a Conservation Profession." In *Conservation Today: Papers Presented at the UKIC 30th Anniversary Conference, 1988*, ed. V. Todd, 4-7. London: United Kingdom Institute of Conservation.

Council of Australian Museums Associations. (1993). *Previous Possessions, New Obligations: Policies for Museums in Australia and Aboriginal and Torres Strait Islander Peoples.* Council of Australian Museum Associations (CAMA), 18 May 1993 (policy). Melbourne, CAMA.

Crawley, M. (1995). "Hunger-strikers Battle BC Museum." *Vancouver Sun*, final edition, 21 July, B1.

Crew, S. R , and J.E. Sims. (1991). "Locating Authenticity: Fragments of a Dialogue." *Exhibiting Cultures: The Poetics and Politics of Museum Display*, ed. I. Karp and S. Lavine, 159-75. Washington: Smithsonian Institution Press.

Crowshoe, R. (1994). *Keep Our Circle Strong: Peigan Cultural Renewal.* Hand-out at conference entitled "Curatorship: Indigenous Perspectives in Post-Colonial Societies." University of Victoria, 16-19 May 1994.

Cultural Conservation Advisory Council. (1990). *Taonga Maori Conference* (18-27 November 1990). Wellington, NZ: Department of Internal Affairs Te Tari Taiwhenua.

Davidson, R. (1993). Letter to Directors and staff of the Vancouver Art Gallery, 19 October 1993.

Department of Indian Affairs and Northern Development (DIAND). Information Management Branch. (March 2001). "Registered Indian Population by Sex and Residence, 2000." Summary Statistics. <http://www.ainc-inac.gc.ca/pr/sts> (accessed August 2001).

Dick, R. (1991). "Flying Historical Aircraft: A View from the Cockpit." In *Risks and Rewards: Perspectives on Operating Mechanical Artifacts* (publication of a workshop held on 22 February 1991), ed. M.G. Mapes, 34-41. Wilmington, DE: Hagley Museum and Library.

Domergue, D., R. Lowinger, and D. Menveg. (1987). "Change the Art or Change the Artist: A Question of Ethics in the Conservation of Contemporary Art." In *Preprints: 15th Annual Meeting, American Institute for Conservation, Vancouver, BC, 20-24 May*, 34-42. Washington, DC: American Institute for Conservation.

Dorion, H. (1990). *Policy of the Musée de la Civilisation du Québec with regard to First Peoples of Québec and their Heritage.* Québec: Musée de la Civilisation du Québec.

Doxtator, D. (1988). "The Home of Indian Culture and Other Stories in the Museum." *MUSE* 6 (3): 26-31.

–. (1996). "The Implications of Canadian Nationalism for Aboriginal Cultural Autonomy." In *Curatorship: Indigenous Perspectives in Post-Colonial Societies: Proceedings*, 56-70. Ottawa: Canadian Museum of Civilization with the Commonwealth Association of Museums and the University of Victoria.

Drumheller, A., and M. Kaminitz. (1994). "Traditional Care and Conservation: The Merging of Two Disciplines at the National Museum of the American Indian." In *Preventive Conservation: Practice, Theory and Research – Preprints of the Contributions to the Ottawa Congress, 12-16 September 1994* (15th IIC Congress), ed. R. Ashok and P. Smith, 58-60. London: International Institute for Conservation of Historic and Artistic Works.

Dykstra, S. W. (1996). "The Artist's Intentions and the Intentional Fallacy in Fine Arts Conservation." *Journal of the American Institute for Conservation* 35 (3): 187-218.

Eastern Working Group. (1991). "Towards a Partnership between Aboriginal First Nations and Museums." Draft of submission to CMA/AFN Task Force.

Echo-Hawk, W. (1993). "Native American Burials: Legal and Legislative Aspects." In *Kunaitupii: Coming Together on Native Sacred Sites*, ed. B.O.K. Reeves and M.A. Kennedy, 38-45. Calgary: Archaeological Society of Alberta.

Edson, G. (1997). *Museum Ethics.* New York: Routledge.

Enge, M. (1993a). "Battle over a Birthright." *Anchorage Daily News* (Anchorage, AK), 4 April, A1-A9.

–. (1993b). "Collecting the Past." *Anchorage Daily News* (Anchorage, AK), 6 April, A1-A6.

–. (1993c). "Master Carver." *Anchorage Daily News* (Anchorage, AK), 5 April, A1-A8.

–. (1993d). "To Sell or Not?" *Anchorage Daily News* (Anchorage, AK), 7 April, A1-A7.

–. (1993e). "Whose Laws?" *Anchorage Daily News* (Anchorage, AK), 8 April, A1-A5.

Erhardt, D., M.F. Mecklenburg, C.S. Tumosa, and M. McCormick-Goodhart. (1995). "Determination of Allowable RH Fluctuations." In *Western Association for Art Conservation Newsletter* 17 (1): 19, 21-22.

Etherington, D. (1985). "Book Conservation and the Code of Ethics." In *A Book and Paper Group Panel Discussion on Ethics*, J. Abt, 127-36. Washington, DC: The Book and Paper Group of the American Institute for Conservation.

European Confederation of Conservator-Restorer's Organizations (ECCO). 1993. *Professional Guidelines* (distributed to members). ECCO.

Evans, J. (1987). "The Institute of Archaeology: The First Fifty Years and After." *Jubilee Conservation Conference: Recent Advances in the Conservation and Analysis of Artifacts*, ed. J. Black, 10-5. London: Summer Schools Press.

–. (1994). "Conservation in a Changing Museum Context: A Case Study at the Museum of New Zealand Te Papa Tongarewa." *New Zealand Museums Journal* 25 (1): 39-41.

–. (1996). "The Ethnographic Dilemma." Paper presented at the annual meeting of the International Institute for Conservation-Canadian Group, Montreal, 24-26 May 1996.

Evans, R., and H. Hilliard. (1994). "Te Hau Ki Turanga: A Maori Meeting House: Museums in Maori Communities." Draft of paper presented at Joint Conference of the New Zealand Professional Conservators Group (NZPCG) and the Australian Institute for the Conservation of Cultural Material (AICCM), National Library of New Zealand, Wellington, NZ, 2-6 October 1994.

Feilden, B.M. (1981). "Principles of Conservation." *UNESCO Courier* March, 27-8.

Ferguson, T.J., and W. Eriacho. (1990). "Ahayu:da Zuni War Gods." *Native Peoples* 4 (1): 6-12.

Ferrell, M. (1991). "History in Details: Preserving the Original." In *Risks and Rewards: Perspectives on Operating Mechanical Artifacts* (publication of a workshop held on 22 February 1991), ed. M.G. Mapes, 42-48. Wilmington, DE: Hagley Museum and Library.

Flores, A. (1988). *Professional Ideals*. Belmont, CA: Wadsworth Publishing.

Freed, S. (1981). "Research Pitfalls as a Result of the Restoration of Museum Specimens." In *The Research Potential of Anthropological Museum Collections*, ed. A.-M. Cantwell, J.B. Griffin, and N.A. Rothschild, 229-45. New York: New York Academy of Sciences.

Freedman, A. (1995). "Max's Moment." *Canadian Art* 12 (3): 47-51.

Galla, A. (1994). "Indigenous Peoples, Museums and Frameworks for Effective Change." Keynote address presented at the conference entitled *Curatorship: Indigenous Perspectives in Post-Colonial Societies*, University of Victoria, May (oral and written presentation).

Gedye, I. (1987). "Forty Years of Conservation at the Institute." In *Jubilee Conservation Conference: Recent Advances in the Conservation and Analysis of Artifacts*, ed. J. Black, 16-9. London: Summer Schools Press.

Geertz, C. (1986). "The Uses of Diversity." *Michigan Quarterly Review* 25 (1): 105-23.

Giffords, G.F. (1995). "Museum House Call: Caring for Your Collection." *Native Peoples* 8 (Summer): 18-9.

Gilberg, M. (1982). "Douglas Leechman: Canada's First Conservation Scientist." *Journal of the International Institute for Conservation-Canadian Group* 7, 1, and 2 (Spring): 42-6.

–. (1987). "Frederich Rathgen: The Father of Modern Archaeological Conservation." *Journal of the American Institute for Conservation* 26, 2: 105-20.

Gray, W. (1991). "It Isn't Right if It Doesn't Run: Railway 'Preservation.'" In *Risks and Rewards: Perspectives on Operating Mechanical Artifacts* (publication of a workshop held on 22 February 1991), ed. M.G. Mapes, 14-9. Wilmington, DE: Hagley Museum and Library.

Greene, V. (1992). "'Accessories of Holiness': Defining Jewish Sacred Objects." *Journal of the American Institute for Conservation* 31 (1): 31-9.

Griffin, D. (1993). "The Future of Natural History and Anthropology Museums." *New Zealand Museums Journal* 23 (2): 2-9.

Haagen, C.E.J. (1990). "Strategies for Cultural Maintenance: Aboriginal Cultural Education Programs and Centres in Canada." MA thesis, University of British Columbia.

Hakiwai, A.T. (1995). "The Search for Legitimacy: Museums in Aotearoa, New Zealand." In *Proceedings of the International Conference on Anthropology and the Museum, 21-23 December 1992*, ed. T. Lin, 283-94. Taipei: Taiwan Museum.

Handler, R. (1992). "On the Valuing of Museum Objects." *Museum Anthropology* 16 (1): 21-8.
Harjo, S.S. (1992). "Native Peoples' Cultural and Human Rights: An Unfinished Agenda." *Arizona State Law Journal* 24 (1): 321-8.
Harris, J. (1993). "Cultural Function versus Conservation: Preserving the Sacred Artifact." *Ontario Museum Annual* 11 (October): 31-3.
Hartin, D.D. (1990). "An Historical Introduction to Conservation." In *Shared Responsibility: Proceedings of a Seminar for Curators and Conservators*, ed. B.A. Ramsay-Jolicoeur and I.N.M. Wainwright, 30-8. Ottawa: National Gallery of Canada.
Heikell, V., D. Whiting, M. Clavir, N. Odegaard, M. Kaminitz, and J. Moses. (1995). "The Conservator's Approach to Sacred Art." *Newsletter of the Western Association for Art Conservation* 17 (3): 15-8.
Henderson, L.D. (1986). "On Artists, Scientists and Historians: A Response to Arthur Loeb." *Leonardo* 19 (2): 153-8.
Herle, A. (1993). "Shaman Insights." *Museums Journal* 93 (12): 24.
Hill, C. (1990). "Museum Curator: Roles and Responsibilities." In *Proceedings of a Seminar for Curators and Conservators, 26-28 October 1989, National Gallery of Canada*, ed. B.A. Ramsay-Jolicoeur and I.N.M. Wainwright, 19-23. Ottawa: National Gallery of Canada.
Hill, R. (1988). "Sacred Trust: Cultural Obligation of Museums to Native People." *MUSE* 6 (3): 32-7.
–. (1993). "Beyond Repatriation." *History News* 48 (2): 9-10.
Hill, T. (1988). "First Nations and Museums" (editorial). *MUSE* 6 (3): 2.
Hillerman, T. (1989). *Talking God*. New York: HarperCollins.
Hodder, I. (1994). "The Interpretation of Documents and Material Culture." In *Handbook of Qualitative Research*, ed. N.K. Denzin and Y.S. Lincoln, 393-402. Thousand Oaks, CA: SAGE Publications.
Hodges, H. (1987). "From Technical Certificate to Diploma in Conservation, 1957 to 1974: A Personal View." In *Jubilee Conservation Conference: Recent Advances in the Conservation and Analysis of Artifacts*, ed. J. Black, 20-3. London: Summer Schools Press.
Hodkinson, I.S. (1990). "Man's Effect on Paintings." In *Proceedings of a Seminar for Curators and Conservators, Oct. 26-28, 1989, National Gallery of Canada*, ed. B.A. Ramsay-Jolicoeur and I.N.M. Wainwright, 54-68. Ottawa, ON: National Gallery of Canada.
Hooper-Greenhill, E. (1992). *Museums and the Shaping of Knowledge*. London: Routledge.
Hoover, A., and R. Inglis (1990). "Acquiring and Exhibiting a Nuu-Chah-Nulth Ceremonial Curtain." *Curator* 33 (4): 272-88.
Horse Capture, G.P. (1991). "Survival of Culture." *Museum News* 70 (1): 49-51.
Horton, D. (1987). "Editorial." *Australian Aboriginal Studies* 2: 70-3.
Hulmer, E. (1955). "The Role of Conservation on Connoisseurship." MA thesis, University of Michigan, Ann Arbor, MI.
ICOM, Conservation Committee. (1984). *The Conservator-Restorer: A Definition of the Profession* (International Council of Museums, September 1984). Paris: ICOM (Document adopted by the Conservation Committee at its Seventh Triennial Meeting, Copenhagen).
ICOMOS, NZ. (1993). *ICOMOS New Zealand Charter for the Conservation of Places of Cultural Heritage Value*. Auckland: ICOMOS.
Ihaka, K. (1989). "Biculturalism and Museums from a Maori Point of View." *AGMANZ Journal* (Quarterly of the Art Galleries and Museums Association of New Zealand) 20 (2): 12-3.
IIC-CG and CAPC (1989). *Code of Ethics and Guidance for Practice for Those Involved in the Conservation of Cultural Property in Canada*. Ottawa: International Institute for Conservation-Canadian Group and the Canadian Association of Professional Conservators.
Inglis, R., and D.N. Abbott. (1991). "A Tradition of Partnership: The Royal British Columbia Museum and First Peoples." *Alberta Museums Review* 17 (2): 17-23.
Janes, R.R. (1994). "Personal, Academic and Institutional Perspectives on Museums and First Nations." *Canadian Journal of Native Studies* 14 (1): 147-56.
Janson, H.W. (1962). *History of Art: A Survey of the Major Visual Arts from the Dawn of History to the Present Day*. Englewood Cliffs, NJ: Prentice-Hall.
Jedrzejewska, H. (1976). *Ethics in Conservation*. Stockholm: Kungl. Konsthögskolan Institutet för Materialkunskap.

Johnson, E. (1986). *Hands of Our Ancestors: The Revival of Salish Weaving at Musqueam*. Vancouver: UBC Museum of Anthropology.

Kaminitz, M. (1993). "The National Museum of the American Indian: Voices of the Museum Different." In *First Peoples Art and Artifacts: Heritage and Conservation Issues, Eighteenth Annual Conference, Art Conservation Training Programs*, ed. K. Spirydowicz, 1-15. Kingston, ON: Art Conservation Program, Queen's University.

Karp, I., C. Kreamer, and S. Lavine, eds. (1992). *Museums and Communities: The Politics of Public Culture*. Washington/London: Smithsonian Institution Press.

Karp, I., and S. Lavine, eds. (1991). *Exhibiting Cultures: The Poetics and Politics of Museum Display*. Washington: Smithsonian Institution Press.

Kavanagh, G. (1994). *Museums and the First World War*. Leicester: Leicester University Press.

Keene, S. (1994). "Objects as Systems: A New Challenge for Conservation." In *Restoration: Is It Acceptable?* (Occasional Paper Series, no. 99), ed. A. Oddy, 19-26. London: British Museum.

–. (1996). *Managing Conservation in Museums*. Oxford: Butterworths-Heinemann.

Keepers of the Treasures (1994). "Keepers of the Treasures Mission Statement." *Keepers of the Treasures Newsletter* 2 (4): 9.

Keyser, B.W. (1990). "History of Conservation and the Teaching of Museology." In *Preprints: 9th Triennial Meeting, ICOM Committee for Conservation, Dresden, German Democratic Republic, 26-31 August 1990*, ed. K. Grimstad, 378-82. Paris: Committee for Conservation.

–. (1993). "Victorian Chromatics: Colour Science and Art Theory, 1750-1850." Unpublished prospectus.

Knocker, F.W. (1909). "The Practical Improvement of Ethnographical Collections in Provincial Museums." *Museums Journal* 9 (5): 191-203.

Kohler, R. (1982). *From Medical Chemistry to Biochemistry: The Making of a Biomedical Discipline*. Cambridge: Cambridge University Press.

Krumbein, W.E., P. Brimblecombe, D.E. Cosgrove, and S. Staniforth, eds. (1994). *Durability and Change: The Science, Responsibility, and Cost of Sustaining Cultural Heritage*. Report of the Dahlem Workshop on Durability and Change: The Science, Responsibility, and Cost of Sustaining Cultural Heritage, 6-11 December 1992, Freie Universität, Berlin. New York: John Wiley and Sons.

Kuhn, T.S. (1962). *The Structure of Scientific Revolutions*. Chicago: University of Chicago Press.

–. (1968). "The History of Science." In *International Encyclopedia of the Social Sciences*, ed. D.L. Sills, 74-83. New York: Macmillan/Free Press.

Ladd, E.J. (1983). "An Explanation: Request for the Return of Zuni Religious Objects Held in Museums and Private Collections." *Exploration* (annual bulletin of the School of American Research) 58: 32.

Landi, S. (1998) *The Textile Conservator's Manual*. 2nd ed. London: Butterworths Heinemann.

Laurence, R. (1993). "Art of the Healing Eagle." *Georgia Straight* (Vancouver) 27 (1332): 7-9.

Lawrence, S. (1994). "The Evolving Role of Conservation in Canada and at the Art Gallery of Ontario." Paper presented at the International Institute for Conservation-Canadian Group 1994 PreConference Workshop, Toronto.

Lawson, L., and S. Baxter. (1989). "Taking Charge of Their Destiny: Canadian Native Peoples Want Their Material Heritage Returned – or, at Least, Control over How It's Exhibited." *Easy Living's Richmond Magazine* 11, 6 (July): 14-9.

Leach, M. (1992). "Aboriginal Title and Rights." In *Towards a Dialogue* (proceedings of a conference on Native issues held in Vancouver, BC, 25-6 January 1991), ed. A. Dutton, B. Mussell, E. Crey, T. Pryce, 23-6. Vancouver: Affiliation of Multicultural Societies and Service Agencies of BC.

Levinson, J., and L. Nieuwenhuizen. (1994). "Chiefly Feasts: A Collaborative Effort." In *Loss Compensation: Technical and Philosophical Issues* (proceedings of the Objects Specialty Group Session, 22nd Annual Meeting, Nashville, TN, 10 June 1994), comp. Ellen Pearlstein and Michele Marincola. Washington, DC: American Institute for Conservation: 9-21.

Lowenthal, D. (1994). "The Value of Age and Decay." In *Durability and Change: The Science, Responsibility, and Cost of Sustaining Cultural Heritage* (Report of the Dahlem Workshop on

Durability and Change: The Science, Responsibility, and Cost of Sustaining Cultural Heritage, 6-11 December 1992, Freie Universität, Berlin), ed. W.E. Krumbein, P. Brimblecombe, D.E. Cosgrove, and S. Staniforth, 39-49. New York: John Wiley and Sons.

Lull, W.P. (1995). "Further Comments on Climate Control Guidelines." In *Western Association for Art Conservation Newsletter* 17 (1): 26-8.

MacDonald, G.F. (1987). "The Future of Museums in the Global Village." *Museum* 39 (3): 209-16.

–. (1992). "Change and Challenge: Museums in the Information Society." In *Museums and Communities: The Politics of Public Culture*, ed. I. Karp, C. Kreamer, and S. Lavine, 158-81. Washington: Smithsonian Institution Press.

–. (1993). Remarks, UBC Museum of Anthropology staff meeting, 20 September (notes by Clavir).

MacDonald, G.F., and S. Alsford. (1988). "Museums as Bridges to the Global Village." Paper presented for the First Global Conference, "Tourism: A Vital Force for Peace," Vancouver, 23-27 October, unpublished draft.

–. (1991). "The Museum as Information Utility." *Museum Management and Curatorship* 10: 305-11.

Macnair, P. (1995). "From Kwakiutl to Kwakwaka'wakw." *Native Peoples: The Canadian Experience* (2nd ed.), ed. R.B. Morrison and C.R. Wilson, 586-605. Toronto: McClelland and Stewart.

Mann, P.R. (1994). "The Restoration of Vehicles for Use in Research, Exhibition, and Demonstration." In *Restoration: Is It Acceptable?* (Occasional Paper Series, no. 99), ed. A. Oddy, 131-8. London: British Museum.

Mapes, M.G., ed. (1991). *Risks and Rewards: Perspectives on Operating Mechanical Artifacts* (publication of a workshop held on 22 February). Wilmington, DE: Hagley Museum and Library.

Matas, R. (1993). "The Day Ottawa Gutted a Culture." *Globe and Mail* (Toronto), 16 January, 1, 4.

McCormick, C. (1988). "Opening Remarks." Paper presented at "Preserving Our Heritage: A Working Conference for Museums and First Peoples," organized by the Assembly of First Nations and the Canadian Museums Association, Carleton University, Ottawa, November 1988.

McGhee, R. (1989). "Who Owns Prehistory? The Bering Land Bridge Dilemma." *Canadian Journal of Archaeology* 13: 13-20.

McKenzie, M. (1987-8). "The Conservation of Cultural Property: The New Zealand Position." *AGMANZ* (Quarterly of the Art Galleries and Museums Association of New Zealand) 18 (3-4): 34-5.

–. (1990). "Mina McKenzie Interview with Henare Te Ua, Radio New Zealand, 25 November 1990." In *Taonga Maori Conference, 18-27 November 1990*, 170-2. Wellington, New Zealand: Cultural Conservation Advisory Council, Department of Internal Affairs Te Tari Taiwhenua.

McManus, G. (1988). "The Question of Significance and the Interpretation of Maori Culture in New Zealand Museums." *AGMANZ* 19 (4): 8-12.

McMillan, A.D. (1988). *Native Peoples and Cultures of Canada: An Anthropological Overview*. Vancouver: Douglas and McIntyre.

Mellor, S.P. (1992). "The Exhibition and Conservation of African Objects: Considering the Nontangible." *Journal of the American Institute for Conservation* 31 (1): 3-16.

Merk, L.E. (1987). "Preserving the Artist's Intent: Henry Moore's Monumental Sculptures." In *Preprints: 15th Annual Meeting, American Institute for Conservation, Vancouver, BC, 20-24 May*, 68-77. Washington, DC: American Institute for Conservation.

Merrill, R. (1990). *Conservation in Institutions Today: How It Differs from the Past, Proceedings of a Seminar for Curators and Conservators, 26-28 October 1989, National Gallery of Canada*, ed. B.A. Ramsay-Jolicoeur and I.N.M. Wainwright, 170-3. Ottawa: National Gallery of Canada.

Merrill, W.L., E.J. Ladd, and T.J. Ferguson. (1993). "The Return of the Ahayu:da: Lessons for Repatriation from Zuni Pueblo and the Smithsonian Institution." *Current Anthropology* 34, 5 (December): 523-67.

Messenger, P.M., ed. (1989). *The Ethics of Collecting Cultural Property: Whose Culture, Whose Property?* Albuquerque: University of New Mexico Press.

Mibach, L. (1992). "Introduction: The Conservation of Sacred Objects." *Journal of the American Institute for Conservation* 31 (1): 1.

Michalski, S. (1994a). "Relative Humidity and Temperature Guidelines: What's Happening." *Newsletter,* Canadian Conservation Institute, 14 (December): 6-8.

–. (1994b). "Sharing Responsibility for Conservation Decisions." In *Durability and Change: The Science, Responsibility, and Cost of Sustaining Cultural Heritage* (report of the Dahlem Workshop on Durability and Change: The Science, Responsibility, and Cost of Sustaining Cultural Heritage, 6-11 December 1992, Freie Universität, Berlin), ed. W.E. Krumbein, P. Brimblecombe, D.E. Cosgrove, and S. Staniforth, 241-58. New York: John Wiley and Sons.

Mickleburgh, R. (1993). "Forum on Breast Cancer Hailed as Watershed Event in Canada." *Globe and Mail* (Toronto), 17 November, A6.

Mitchell, N.M. (1992). "Tea Bag Diplomacy, or the Symbolism of Things." Paper presented at the San Francisco meeting of the American Anthropological Association, December.

Mithlo, N.M. (1994). "Cultural Property and Power." Grant application to Ford Foundation, 25 January 1994.

–. (2001). *"Red Man's Burden": The Politics of Inclusion in Museum Settings.* Paper presented at Smith College, MA, 12 February.

Monroe, D. (1990). "Native American Repatriation: History, Requirements, and Outlook." *Newsletter* Western Museums Association 4: 2-6.

Morrell, J.B. (1990). "Professionalisation." In *Companion to the History of Modern Science*, ed. R.C. Olby, G.N. Cantor, J.R.R. Christie, and M.J.S. Hodge, 980-9. London: Routledge.

Morrison, B. (1993). "Church Returns Native Artifacts." *Anglican Journal* 119 (9): 1 and 6.

Moses, J. (1992). "Indigenous Perspectives on Conservation." *Newsletter* (International Institute for Conservation, Canadian Group) 17 (3): 1-4.

–. (1993). "First Nations Traditions of Object Preservation." In *First Peoples Art and Artifacts: Heritage and Conservation Issues, Eighteenth Annual Conference, Art Conservation Training Programs*, ed. K. Spirydowicz, 1-11. Kingston: Art Conservation Program, Queen's University.

–. (1995). "The Conservator's Approach to Sacred Art." *Newsletter of the Western Association for Art Conservation* 17 (3): 18.

Moses, J., ed. (1999) *Critical Issues in the Conservation of Ethnographic Materials* (workshop at the annual conference of the Canadian Association for Conservation of Cultural Property, Whitehorse, 29-31 May 1998, Canadian Association for the Conservation of Cultural Property). Ottawa: CAC

Nason, J. (1981). "A Question of Patrimony: Ethical Issues in the Collecting of Cultural Objects." *Museum Round-Up* 83: 13-20.

National Archives and Records Service, General Services Administration. (1982). "Intrinsic Value in Archival Material." In *NAGARA GRASP Guide and Resources for Archival Strategic Preservation Planning*, Ed. B.R. Curtin, 1-3. Atlanta: National Association of Government Archives and Records Administrators.

National Institute for the Conservation of Cultural Property (1984). *Ethnographic and Archaeological Conservation in the United States* (report of the Study Committee on Anthropological Conservation, National Institute for the Conservation of Cultural Property). Washington, DC.

National Museum of Australia. (1993). *Policy on the Return to Aboriginal and Torres Strait Islander Communities of Secret/Sacred Material.* Canberra: National Museum of Australia.

National Museum of the American Indian. (1991). "National Museum of the American Indian Policy Statement on Native American Human Remains and Cultural Materials." *Museum Anthropology* 15 (2): 25-8.

Native American Graves Protection and Repatriation Act, The. (NAGPRA), see United States of America.

New Grolier Multimedia Encyclopedia, The. (1992). CD-ROM. Danbury, CT: Grolier Electronic Publishing.

New Shorter Oxford English Dictionary on Historical Principles, The. (1993). Ed. L. Brown. Oxford: Clarendon Press.

New Zealand Professional Conservators Group (NZPCG). (1991). "The NZPCG Code of Ethics." In *New Zealand Directory of Conservators of Cultural Property*, 8-12. Auckland: New Zealand Professional Conservators Group.

Newton, L.H. (1988). "Lawgiving for Professional Life: Reflections on the Place of the Professional Code." In *Professional Ideals*, ed. A. Flores, 47-55. Belmont, CA: Wadsworth Publishing.

Nisga'a Final Agreement (1999): Issued jointly by the Government of Canada, the Province of British Columbia, and the Nisga'a Nation. Initialled 4 August 1998, passed by the BC legislature and the federal House of Commons in 1999.

NZPCG Code of Ethics, The. (1991, amended 1995). Wellington and Auckland, NZ: New Zealand Professional Conservators Group.

O'Biso, C. (1987). *First Light.* Auckland, NZ: Heinemann.

O'Neill, M. (1992). "After the Artefact: Internal and External Relations in Museums." In *The Museum Profession: Internal and External Relations*, ed. G. Kavanagh, 27-35. Leicester: Leicester University Press.

Oddy, A. (1994). "Restoration: Is It Acceptable?" In *Restoration: Is It Acceptable?* . (Occasional Paper Series, no. 99), ed. A. Oddy, 3-8. London: British Museum.

Oddy, A., ed. (1992). *The Art of the Conservator.* Washington, DC: Smithsonian Institution Press.

Oddy, A., and S. Smith, eds. (2001). *Past Practice-Future Prospects* (Occasional Paper Series, no. 145). London: British Museum.

– (1994). *Restoration: Is It Acceptable?* (Occasional Paper No. 99). London: British Museum.

Odegaard, N. (1995). "Artists' Intent: Material Culture Studies and Conservation." *Journal of the American Institute for Conservation* 34 (3): 187-93.

Odell, S. (1986). "Clocks and Musical Instruments: Must Functional Objects be Made to Function?" Paper prepared for the conference entitled "Horological Conservation and Restoration," Greenwich, England.

Office International des Musées (1930). "L'Activité de l'Office International des Musées: Conclusions adoptées par la conférence internationale pour l'étude des méthodes scientifiques appliquées à l'examen et à la conservation des oeuvres d'art, Rome, 13-17 octobre 1930." *Mouseion* 13-4: 126-30.

Olby, R.C., G.N. Cantor, J.R.R. Christie, and M.J.S. Hodge, eds. (1990). *Companion to the History of Modern Science.* London and New York: Routledge.

Orlofsky, P., and D. Trupin. (1993). "The Role of Connoisseurship in the Textile Conservator's Treatment Options." *Journal of the American Institute for Conservation* 32 (2): 109-18.

Orna, M.V. (Rapporteur). (1994.) "Group Report: What Is Durability in Artifacts and What Inherent Factors Determine It?" In *Durability and Change: The Science, Responsibility, and Cost of Sustaining Cultural Heritage* (report of the Dahlem Workshop on Durability and Change: The Science, Responsibility, and Cost of Sustaining Cultural Heritage, 6-11 December 1992, Freie Universität, Berlin), ed. W.E. Krumbein, P. Brimblecombe, D.E. Cosgrove, and S. Staniforth, 51-65. New York: John Wiley and Sons.

Ostrowitz, J. (1993). "Trail Blazers and Ancestral Heroes: A Museum Collaboration." *Curator* 36 (March): 50-65.

Parker, P. (1990). *Keepers of the Treasures: Protecting Historic Properties and Cultural Traditions on Indian Lands.* Washington, DC: National Park Service, US Department of the Interior.

PBS. (1990). *Return of the Sacred Pole.* American Public Broadcasting System program, Omaha, NE. Video available from Canadian Learning Co., Toronto.

Pearce, S. (1990). *Archaeological Curatorship.* Leicester: Leicester University Press.

–. (1992). *Museums, Objects and Collections: A Cultural Study.* Leicester: Leicester University Press.

–. (1995a). "Collecting Culture." Keynote address at the conference entitled "Carry on Collecting," University of Leicester (notes by Clavir).

–. (1995b). "Interpreting Museum Objects: An Outline of Theory." In *Proceedings of the International Conference on Anthropology and the Museum, 21-23 December 1992*, ed. T. Lin, 295-312. Taipei: Taiwan Museum.

–. (1995c). *On Collecting: An Investigation into Collecting in the European Tradition.* London: Routledge.

Pease, M., R.J. Getters, S. Keck, D.T. Easby, H.G. Courtais. (1968). *The Murray Pease Report: Standards of Practice and Professional Relationships for Conservators* (approved for legal sufficiency by the International Institute for the Conservation of Historic and Artistic Works-American Group, 7 August 1963). New York: International Institute for Conservation-American Group.

Phillips, C. (1982). "Advocates for the Artifact: The Role of Conservation in State and Local History." *Museum Round-Up* 86 (Summer): 11-6.

Podany, J. (1994). "Restoring What Wasn't There: Reconsideration of the Eighteenth-century Restorations to the Lansdowne *Herakles* in the Collection of the J Paul Getty Museum." In *Restoration: Is It Acceptable?* (Occasional Paper Series, no. 99), ed. A. Oddy, 9-18. London: British Museum.

Pouliot, B. (1995). "An Example of Cooperation between Museums and First Peoples: The Blessing of Two Wampum Belts from the McCord Museum of Canadian History." Paper presented at the annual International Institute for Conservation-Canadian Group Conference, Calgary, 27 May.

Preston, D.J. (1989). "Skeletons in Our Museums' Closets." *Harper's Magazine*, February, 66-72.

Prown, J.D. (1982). "Mind in Matter: An Introduction to Material Culture Studies." *Winterthur Portfolio* 17 (1): 1-19.

Quick, R. (1906). "On the Hanging and Care of Pictures." *Museums Journal* 6, 3 (September): 97-100.

Ramsay-Jolicoeur, B.A. (1993). "Accreditation in Conservation: Towards Professional Status." Handout prepared for the Canadian Association of Professional Conservators and Part 1 of presentation at the annual International Institute for Conservation-Canadian Group conference, 30 May.

Ramsay-Jolicoeur, B.A., and I.N.M. Wainwright, eds. (1990). *Shared Responsibility: Proceedings of a Seminar for Curators and Conservators, 26-28 October 1989, National Gallery of Canada.* Ottawa: National Gallery of Canada.

Real, W., (1995) "Some Thoughts on the Recent CAL Press Release on Climate Control for Cultural Collections." In *Western Association for Art Conservation Newsletter* 17 (1): 24-6.

Renshaw-Beauchamp, R. (1988). "The Preservation of Nonrenewable Resources." *Symbols* (December): 5-10.

Rhodes, R. (1994). "A la Recherche de Barnes Perdu." *Canadian Art* 11 (3): 62-73.

Rhyne, C. (1995). "The First International Document for Diverse Cultural Values in Conservation: 'The Document of Nara.'" Paper presented at the 1995 annual meeting of the American Institute for Conservation, St. Paul, MN, 7 June. Available at <www.reed.edu/~crhyne/papers/first.html>.

Roche, R. (1972). "Picture Conservation Report: Conservation-Necessity and Functions." In *Library and Archives Conservation: The Boston Athenaeum's 1971 Seminar on the Application of Physical and Chemical Methods to the Conservation of Library and Archival Materials, May 17-21, 1971*, ed. G.M. Cunha and N.P. Tucker, 132-8. Boston, MA: Library of the Boston Athenaeum.

Rose, C.L. (1988). "Ethical and Practical Considerations in Conserving Ethnographic Museum Objects." In *The Museum Conservation of Ethnographic Objects*, ed. T. Morita and D. Pearson, 5-43. Osaka: National Museum of Ethnology.

Ruggles, M. (1982). "The History of Conservation in Canada: Developments to the Early 1970s." *Journal of the International Institute for Conservation-Canadian Group* 5 (1 and 2): 3-12.

Ruhemann, H. (1963). "The Training of Restorers." In *Recent Advances in Conservation: Contributions to the IIC Rome Conference, 1961*, ed. G. Thomson, 202-5. London: Butterworths.

Salomon, J.J. (1977). "Science Policy Studies and the Development of Science Policy." In *Science, Technology and Society: A Cross-Disciplinary Perspective*, ed. I. Spiegel-Rosing and D. Solla Price, 43-70. Beverly Hills: SAGE Publications.

Samuels, E. (1987). *Bernard Berenson: The Making of a Legend,* Cambridge, MA: Belknap Press of Harvard University Press.

Schultz, W., (1995). "CAL Scientists Revise Guidelines for Museum Climate Control." In *Western Association for Art Conservation Newsletter* 17 (1): 23-4.

Sease, C. (1998). "Codes of Ethics for Conservation." *International Journal of Cultural Property* 7 (1): 98-115.

Secwepemc Cultural Education Society. (1991). "Submission to the CMA/AFN Task Force on Museums and First Peoples." Secwepemc Cultural Education Society, 22 March.

Shorter Oxford English Dictionary on Historical Principles, The. (1956). 3rd edition. Ed. J.A.H. Murray, W. Little, and C.T. Onions. Revised, with addenda. Reprinted with corrections 1968. Oxford: Clarendon Press.

Smithsonian Institution Office of Design and Construction, Scott Brown and Associates, Inc. (1991). *The Way of the People.* National Museum of the American Indian. Revised Draft Report, Master Facilities Programming, Phase 1.

SOS! (1991). "Monumental Notes." *SOS! Update* 2 (3): 4.

Spicer, E.H., and R. Thompson, eds. (1972). *Plural Society in the Southwest.* New York: Interbook.

Spirydowicz, K., ed. (1993). *First Peoples Art and Artifacts: Heritage and Conservation Issues* (18th annual conference, 1992, Art Conservation Training Programs). Kingston, ON: Art Conservation Program, Queen's University.

Staniforth, S. (1994). "Group Report: What Are Appropriate Strategies to Evaluate Change and to Sustain Cultural Heritage?" In *Durability and Change: The Science, Responsibility, and Cost of Sustaining Cultural Heritage* (report of the Dahlem Workshop on Durability and Change: The Science, Responsibility, and Cost of Sustaining Cultural Heritage, 6-11 December 1992, Freie Universität, Berlin), ed. W.E. Krumbein, P. Brimblecombe, D.E. Cosgrove, and S. Staniforth, 218-23. New York: John Wiley and Sons.

Stocking, G.W. (1990). "Paradigmatic Traditions in the History of Anthropology." In *Companion to the History of Modern Science,* ed. R.C. Olby, G.N. Cantor, J.R.R. Christie, and M.J.S. Hodge, 712-27. London and New York: Routledge.

Stolow, N. (1972). "The Exhibition 'Progress in Conservation.'" *Bulletin of the American Group* 12 (2): 9-12.

Stout, G.L. (1977). "Our Early Years at the Fogg." *Art Dealer and Framer* (June): 10-13, 16, 92-7.

Sturtevant, W.C. (1991). "New National Museum of the American Indian Collections Policy Statement: A Critical Analysis." *Museum Anthropology* 15 (2): 29-30.

Sullivan, M. (1992). "A Museum Perspective on Repatriation: Issues and Opportunities." *Arizona State Law Journal* 24 (1): 283-92.

Swentzell, R. (1991). "Native American vs. Western European Philosophy and Museum Assumptions." Unpublished planning document for *The Way of the People, Phase 1,* National Museum of the American Indian, 10 July.

Talley, M.K. (1983). "Humanism, Restoration and Sympathetic Attention to Works of Art." *International Journal of Museum Management and Curatorship* 2: 347-53.

Tamarapa, A. (1996). "Museum Kaitiaki: Maori Perspectives on the Presentation and Management of Maori Treasures and Relationships with Museums." In *Curatorship: Indigenous Perspectives in Post-Colonial Societies: Proceedings,* 160-9. Ottawa: Canadian Museum of Civilization with the Commonwealth Association of Museums and the University of Victoria.

Task Force, Museums and First Peoples (1992). *Turning the Page: Forging New Partnerships between Museums and First Peoples.* Ottawa: Assembly of First Nations and the Canadian Museums Association.

Taylor, K. (1994). "Study Suggests a New Approach for Art Galleries." *Globe and Mail* (satellite ed.), 1 August, A1.

Teather, J.L. (1983). "Museology and Its Traditions: The British Experience, 1845-1945." PhD diss., University of Leicester.

Tennant, P. (1992). *Aboriginal Peoples and Politics: The Indian Land Question in British Columbia, 1849-1989.* Vancouver: UBC Press.

Todd, L. (1990). "Notes on Appropriation." *Parallelogramme* 16 (1): 24-33.

–. (1992). "What More Do They Want." In *Indigena: Contemporary Native Perspectives,* ed. G. McMaster and L.-A. Martin, 71-9. Vancouver: Douglas and McIntyre.

–. (1993-4). "Three Moments after 'Savage Graces.'" *Harbour* 3 (1): 57-62.

Tomkins, C. (1987). "Profiles: Colored Muds in a Sticky Substance." *The New Yorker,* 16 March 1987, 44-70.

United Kingdom Institute for Conservation of Historic and Artistic Works. (1981). *Guidance for Conservation Practice.* Report presented to membership, December.

United Kingdom Institute for Conservation of Historic and Artistic Works. (1996). *Code of Ethics* (distributed to members).

United States of America. (1990). *The Native American Graves Protection and Repatriation Act* (NAGPRA). 101st Congress, 16 November (Public Law 101-601).

Vollmer, H.M., and D.L. Mills, eds. 1966. *Professionalization.* Englewood Cliffs, NJ: Prentice-Hall.

Ward, P. (1986). *The Nature of Conservation: A Race Against Time.* Marina del Rey, CA: Getty Conservation Institute.

Watkins, C. (1989). "Conservation: A Cultural Challenge." *Museum News* 68, 1 (January/February 1989): 36-43.

Watts, D. (1988). "Cultural Empowerment within Museums and Anthropology." Paper written for Anthropology 407, University of British Columbia, 14 December.

Webster, G.C. (1986). "Conservation and Cultural Centres: U'Mista Cultural Centre, Alert Bay, Canada." In *Symposium '86: The Care and Preservation of Ethnological Materials: Proceedings,* ed. R. Barclay, M. Gilberg, J.C. McCawley, and T. Stone, 77-9. Ottawa, ON: Canadian Conservation Institute.

-. (1988). "The 'R' Word." *MUSE* 6 (3): 43-4.

-. (1992a). "From Colonization to Repatriation." In *Indigena: Contemporary Native Perspectives,* ed. G. McMaster and L.-A. Martin, 25-37. Vancouver: Douglas and McIntyre.

-. (1992b). Presentation at the Ottawa meeting of the Task Force on Museums and First Peoples, 7-9 February.

Weersma, A. (1987). "Some Theoretical Considerations on the Handling and Care of Sacred Objects in a Museum Context." In *Preprints: ICOM 8th Triennial Meeting, Sydney, Australia,* 567-70. Los Angeles, CA: Getty Conservation Institute.

Weil, P.D. (1984). "'Visually Illiterate' and 'Historically Ignorant': The Need to Reexamine Art Conservation's Humanistic Foundations." In *AIC Preprints, 12th Annual Meeting, Los Angeles, 15-20 May,* 86-93. Washington, DC: AIC.

Weil, S.E. (1990). *Rethinking the Museum and Other Meditations.* Washington: Smithsonian Institution Press.

Welsh, E. (1991). "A New Era in Museum-Native American Relations." *Newsletter of the Western Association for Art Conservation* 13 (1): 9.

Welsh, E., C. Sease, B. Rhodes, S. Brown, and M. Clavir. (1992). "Multicultural Participation in Conservation Decision-Making." *Newsletter of the Western Association for Art Conservation* 14 (1): 13-22.

Welsh, P. (1992). "Repatriation and Cultural Preservation: Potent Objects, Potent Pasts." *University of Michigan Journal of Law Reform* 25 (3 and 4): 837-65.

West, W.R., Jr. (1991). "Press Statement of W. Richard West, Jr. on His Appointment as Director of the National Museum of the American Indian." *Museum Anthropology* 15 (2): 24.

Whalen, T. (1999). "Serving the Profession: A Conversation with Tim Whalen" (interview by James Levin). *Conservation: The Getty Conservation Institute Newsletter* 14 (2): 12-5.

White, L.A. (1959). *The Evolution of Culture.* New York: McGraw-Hill.

Whiting, D. (1995). "The Conservator's Approach to Sacred Art." *Newsletter of the Western Association for Art Conservation* 17 (3): 15-6.

Wildesen, L.E. (1984). "The Search for an Ethic in Archaeology: An Historical Perspective." In *Ethics and Values in Archaeology,* ed. E.L. Green, 3-12. New York: Free Press.

Wilsmore, S.J. (1993a). "Arguments, Principles and the Problems of Conservation." Paper based on a talk to the V and A Conservation Department, 9 September 1993, in preparation for the Ethics Workshop, 16-17 September 1993.

-. (1993b). "The Burra Charter: Its Implications for Theory and Practice." Lecture at the Centre for Conservation Studies, Institute of Advanced Architectural Studies, University of York, 3 November.

–. (1994). "The Principles for the Reshaping of Objects on Archaeological Sites." Paper.

Wilson, B. (1992). Speech during meeting of Task Force on Museums and First Peoples, 8 February.

Wilson, D., and R. Matas. (1992). "Natives Win Land Rights in BC: Ownership Not Included." *Globe and Mail* (satellite ed.), 26 June 1993, A1, A3.

Winter, J.C. (1984). "The Way to Somewhere: Ethics in American Archaeology." In *Ethics and Values in Archaeology*, ed. E.L. Green, 36-47. New York: Free Press.

Wright, M. (1994). "Valuing Cultural Diversity and Treasuring Cultural Differences." *Newsletter of Western Museums Association* 1 (Winter): 1-2.

Wueste, D.E., ed. (1994). *Professional Ethics and Social Responsibility*. Lanham, MD: Rowman and Littlefield Publishers.

Wylie, A. (1991). "Archaeology and the Antiquities Market: The Use of Looted Material." Paper presented at a meeting of the executive, Society for American Archaeology, New Orleans, April.

Index

References to photographs are in italics.

Aboriginal peoples. *See* First Nations; indigenous peoples; Maori
access issues
 democratic access, 32, 82
 First Nations, 93, 144-9, 197, 246
 Maori, 222
 privacy of objects, 58, 82, 90, 178-9, 180-1
aesthetic values, 32, 183-4
 see also fine arts; restoration
AIC. *See* American Institute for Conservation (AIC)
AICCM. *See* Australian Institute for the Conservation of Cultural Materials (AICCM)
Ainu web sites, 267
American Institute for Conservation (AIC), 39, 52, 252-61
American Museum of Natural History (AMNH). *See Chiefly Feasts* (exhibition)
Ames, Michael, 32, 54, 58, 64
AMNH. *See Chiefly Feasts* (exhibition)
archaeological objects, 7-8, 33-5, 137
archaeology, 40-1, 124
architecture, 9, 63-4
 Maori buildings, 229
artifacts. *See* objects
art: relationship to science, 17-21, 23
Australia
 Aboriginal web sites, 266
 code of ethics, 39-40, 52, 57, 252-61
 International Council on Monuments and Sites (ICOMOS), 43n1
Australian Institute for the Conservation of Cultural Materials (AICCM), 39-40, 52, 57

authenticity, 29-30, 33, 53, 79, 84
 cultural significance and, 89, 180
authority, 83
 ethics and, 27, 54
 see also power relationships

Bain, Don, *122,* 192, 250
 views on
 cycles of time, 121-2
 deterioration, 153
 family/community heritage, 192-3
 intangible attributes, 158-9
 museums, 161, 162, 197, 201, 208, 211-2
 objects, 123, 134, 138
 restoration, 174
bands, 99
Barnes, Rita, 110-3, 142, 250
 bentwood box, 142, 205-6
 views on
 cultural loss, 131, 204-5
 intangible attributes, 157, 182
 museums, 201, 204-5
 objects, 127, 135, 137, 142, 160
 potlatches, 204, 205
 restoration, 165, 169
Bauhaus, 19
bentwood box, 142, 145, 205-6
Berenson, Bernard, 20
Branting, Agnes, 12
British Association for the Advancement of Science, 14
British Museum, 21-2
Brown, Pam, 110, *111*
 views on
 handling, 175
 intangible attributes, 157, 160, 183
 museums, 197, 198
 object use, 133-4, 138, 139, 196